OUT OF THE CATSKILLS AND JUST BEYOND

Literary and Visual Works by Catskill Writers and Artists

with a Special Section by Catskill High-School Writers and Artists

OTHER BRIGHT HILL PRESS BOOKS

Iroquois Voices, Iroquois Visions:
A Celebration of Contemporary Six Nations Arts
Bertha Rogers, Editor
Maurice Kenny, Tom Huff, and Robert Bensen, Guest Editors

Low Country Stories
Lisa Harris

The Man Who Went Out for Cigarettes
Adrian Blevins-Church

My Own Hundred Doors
Pam Bernard

Speaking the Words Anthology
Bertha Rogers, Editor

The Word Thursdays Anthology
of Poetry and Fiction
Bertha Rogers, Editor

Bright Hill Press books may be purchased
at special quantity discounts for bulk purchases
for sales promotions, premiums, fund raising, or educational use.

Contact Bright Hill Press Marketing
P O Box 193, Treadwell, NY 13846
Voice 607-746-7306
Fax 607-746-7274
E-mail wordthurs@aol.com.

OUT OF THE CATSKILLS
AND JUST BEYOND

Literary and Visual Works
by Catskill Writers and Artists

with a Special Section
by Catskill High-School Writers and Artists

Edited and Introduced by Bertha Rogers

Bright Hill Press
Treadwell, New York
1997

OUT OF THE CATSKILLS AND JUST BEYOND

Literary and Visual Works by Catskill Writers and Artists

with a Special Section by Catskill High-School Writers and Artists

Editor in Chief	Bertha Rogers
Associate Editor	Graham Duncan
Editorial Intern	Daniel Shapley
Essay and Fiction Readers	Richard Downey
	Ernest M. Fishman
	Ginnah Howard
	Ann Sauter
Poetry Readers	Margot Farrington
	F. Björnson Stock
	Julia Suarez
	Scot Alan Slaby, Intern
Photography Curators	Nancy Jankura
	Tom O'Brien
Book Design	Bertha Rogers and Daniel Shapley
Cover Design and Art	"Evensong," copyright 1980 © by Bertha Rogers
	Watercolor on paper

OUT OF THE CATSKILLS AND JUST BEYOND
Literary and Visual Works by Catskill Writers and Artists
with a Special Section by Catskill High-School Writers and Artists
is published by Bright Hill Press.

Bright Hill Press, a not-for-profit, 501(c)(3), literary and educational organization, was founded in 1992. The organization is registered with the New York State Department of State, Office of Charities Registration. Publication of *Out of the Catskills and Just Beyond: Literary and Visual Works by Catskill Writers and Artists, with a Special Section by Catskill High-School Writers and Artists* is made possible, in part, with public funds from the Literature Program of the New York State Council on the Arts, a State agency.

Editorial Address	Bright Hill Press
	P. O Box 193
	Treadwell, New York 13846-0193
	E-mail: wordthurs@aolcom.

ISBN 0-9646844-6-2

FIRST EDITION

On the morning of November 10, 1996, shortly after
Harry Bloom awoke, he asked his wife, Dorothy, if she
had ever heard of a bird called the sea swan. He described
the sea swan as diaphanous, blue, melding with the sky,
carrier of hope, seen but not seen, *visibly* invisible,
invisibly visible, transparent yet solid; the essence of beauty.

This book is dedicated to the memory of Harry Bloom.

August 24, 1918 - November 29, 1996

CONTENTS

291 HIGH-SCHOOL POETRY

343 HIGH-SCHOOL FICTION

HIGH-SCHOOL VISUAL ART

INTRODUCTION

Who has not heard of New York's Catskill Mountains — those rolling blue slopes just a few hours from New York City? The Catskills have long been a celebrated place to live and play. Writers and artists have enjoyed the mountains since the 1800s, and the early popularity of the Catskills was, in good part, due to art — tales by such writers as James Fenimore Cooper and Washington Irving and paintings by Thomas Cole and the Hudson River School. Irving and Cooper romanticized the region with words, and Cole, Asher B. Durand, and many others, through their paintings, infused the rocky slopes and dense forests with a fierce, transcendental beauty.

Writers and artists have also chosen, from the first, to be permanent residents. Apart from the bitter winters, living in the Catskills is like waking up in Paradise every day, the mountains rising through the mists, the light luminous, the air fresh and clean. I moved to Roaring Brook Road, a few miles from the hamlet of Treadwell, in the Town of Franklin, in 1989, almost by default — I was sick of Manhattan, its constant, grating noise and grimy streets, and planned to relocate to the Adirondacks. I was familiar with those rough mountains through years of backpacking and climbing in the High Peaks. But I was reluctant to leave so completely the City's rich artscape. Then, I saw an advertisement in *The New York Times* that described what I didn't know I was looking for: a few acres and buildings on what, until recently, had been a mountain farm in Delaware County. The massive lilac bush in the south yard convinced me; that, and the view from the hill behind the house and garden. I moved, lock, stock, and tons of books, during an early December blizzard.

My life changed. Winter's deep silence was a gift, the late night conversation of my house's ghosts a murmuring pleasure, like that of parents discussing the day after the children have gone to bed. The snowplow's blade, prompt at six on after-storm mornings, was a muted, friendly sound. I was *home*. I wrote and looked and worked. In the spring, a revelation: the peepers were as loud as car alarms, though not nearly as offensive. During summer's nights, coyotes ranged the ridge, howling, while my neighbor's heifers huddled together in the barn pasture. After a few years, I found myself becoming entrenched in the natural world and the community nearby. Still, I missed that world of literature; there were vibrant arts organizations here, but only a few, irregularly-scheduled readings. I grew lonely for other poets' voices, other artists' visions. At one such reading, I met the man who was to become my husband and partner.

In 1992, he and I began a twice-monthly reading series and almost immediately became aware of the other artists and writers who lived in the woods, or on farms like ours, or in the nearby villages and hamlets. We called our series Word Thursdays and planned from the beginning to publish books. The program has featured several hundred writers from the region and throughout the Northeast. Bright Hill Press brought out its first book in 1994 and, through Word Thursdays, has had the good fortune to locate and publish many fine authors.

Nevertheless, we knew that there were other artists throughout the Catskill region and we determined to search out their work for an anthology that would reflect the abundant, diverse talent in the mountains and foothills. We planned a collection of about two hundred pages and put out a call for submissions, the requirement being that

the artists reside in the region, full- or part-time. As we became acquainted with the artists through the thousands of words and images submitted, we realized that the anthology must change and expand to truly reflect the diverse talent thriving in these environs.

Out of the Catskills and Just Beyond is almost four hundred pages long; the collection includes poetry, essays, fiction, and visual art by established artists, those whose work is regularly read and seen; emerging artists; and, perhaps our best hope, some fifty Catskill high-school writers and visual artists whose passion and skill often dazzle. Among the works are poems by ninety-six-year-old Alf Evers, author of *The Catskills: From Wilderness to Woodstock* (Doubleday) and by Ruth Stone, the acclaimed poet whose usual year includes a teaching residency at SUNY Binghamton. There are an essay on John Berryman, Elizabeth Bishop, Randall Jarrell, and Robert Lowell by Thomas Travisano, a professor at Hartwick College; mezzotints by visual artist Hella Viola, who moved to Walton from New Jersey some years ago; and an excerpt from a novel-in-progress by fourteen-year-old Katie Kearney of New Berlin.

Together these artists offer an enhanced report on their experiences, both ordinary and extraordinary, a rich array of words and pictures, even though their art may not, on the surface, seem to relate directly to these mountains. Their relationship to the Catskills is expressed in various media and styles, its expression ranging from the tragic to the comic.

This book is a gift to the region that has nurtured it, and it is a sampler and a guide. Compiling such a collection does not come easily. Bright Hill Press is a not-for-profit organization (there are those who would say that this represents foolish optimism in these days of funding cutbacks and attacks on the arts). Our editorial staff is almost entirely volunteer; without their dedication and commitment there would be no *Out of the Catskills and Just Beyond.*

I write, having just learned that the House of Representatives voted against funding the National Endowment for the Arts. It is an exquisite midsummer's day in the Catskill Mountains, the prevailing breezes cooling my office, the leaves on the hundred-year-old maples pleasantly rustling, the distant peaks dark against a mackerel sky. I write with thankfulness for the New York State Council on the Arts; for those individuals, organizations, and businesses who have contributed so generously to make this book a reality. And I write, hoping that the Senate will override this latest slap at art— art, which is where we *all* turn for truth and beauty — art, which has fed me all my life, and which will feed you, the recipient of these many bright and shining gifts.

Bertha Rogers

POETRY

PEG CAWLEY

Fiddlehead Wood

Black and white Photograph, 7 5/8" x 7 5/8"

JOHN MONTAGUE ────────────────────

The Dance

In silence and isolation, the dance begins. No one is meant to watch, least of all yourself. Hands fall to the sides, the head lolls, empty, a broken stalk. The shoes fall away from the feet, the clothes peel away from the skin, body rags. The sight has slowly faded from your eyes, that sight of habit which sees nothing. Your ears buzz a little before they retreat to where the heart pulses, a soft drum. Then the dance begins, cleansing, healing. Through the bare forehead, along the bones of the feet, the earth begins to speak. One knee lifts rustily, then the other. Totally absent, you shuffle up and down, the purse of your loins striking against your thighs, sperm and urine oozing down your lower body like a gum. From where the legs join the rhythm spreads upwards—the branch of the penis lifting, the cage of the ribs whistling—to pass down the arms like electricity along a wire. On the skin moisture forms, a wet leaf or a windbreath light as a mayfly. In wet and darkness you are reborn, the rain falling on your face as it would on a mossy tree trunk, wet hair clinging to your skull like bark, your breath mingling with the exhalations of the earth, that eternal smell of humus and mould.

FRANK C. ECKMAIR

October's Change

Wood engraving on handmade paper, 8 1/4" x 18"

DONALD PETERSEN ————————————————

Upstate Lilacs

Up the spring hillside where the dug road went
Before the county realigned it, past
Broken stone walls and grown-up fields, we find
The old foundations folding. Round about them
The lilacs stand, stiffly, with none to please
Or take account of. By the ruined sills
They wave their heart-shaped leaves and shake their blooms,
Flouting the fact that those who planted them
Gave up the homestead. If the shallow wells
Went foul, if rains and snows of yesteryear
Escaped the catchments, if the summer sun
Turned on the crops, leaving the fields burnt straw,
If three hard winters cracked the will to plough,
Or if, simply, there was no special reason
To stay on high ground when the Indians
That held the river valley had moved on,
We cannot know, although these old maids might,
These gnarled old maids, the hardiest of whom
Stand round about in green and lavender,
Heedless of man, preferring their perfume.

ELLEN TIFFT ───────────────────────────

Then

when it rained
the gutter ran like
look the sun shine
tasting of rain
let your barefoot
try this one

Start

At the start a pine branch
sifts the snow
from snow branch
limbed to sky
from sky limbed out.
The mind feels clean, cold.
The barely possible
turns to stare.

JORDAN SMITH

For Appearances
for Jane Cooper

So here is all the splendor of winter,
Ice on the boughs of sumac and box elder
Along the scrub land between the road and the Alplaus Kill
Blinding in the low sunlight as I drive to work,

Light like a sudden rising of birds
Disturbed at their winter feeding,
Sparrows, cedar waxwings, a clamor of small cries.

And here is the hunter's truck
Parked in its usual place by the orchard lane,
And the footprints losing themselves in that dazzle
Of snow on sun on snow.
Then a few apple trees, dense in their own relief,
Then the tangled horizon line of the hedgerow.

What spirit walks in these trees, if a spirit walks,
In tangles of second growth, in hunting season, in the gully
 of the rifle's volley.
This morning, three shots from deeper in the woods.
And now, a doe crossing the road just past the railroad
 tracks,
As the cars skid to a stop.

On Aqueduct Road, a guy has pulled his rusted-out Blazer to the shoulder
And climbed out of the cab with a sledgehammer
To pound something to rights underneath the box,
Where his two sons are sitting. They must be freezing there,
In cheap parkas, in the open air.

But they are looking at me, as I stop, waiting to pass,
With such open-eyed clarity, such pure contempt.

Imagine the eyes of the deer as you lift the jacklight,
Dazzled.
Imagine how little of that splendor falls on you.

Local Color

I'm tired of the smokescreen of things.

A half-dozen houses, mostly Greek Revival,
Mostly run down, wind-scoured
Paint and sprung, gaping eaves, wrecked clapboard,
And the smell of leaf-fires,
And the quiet, steady, temporal blaze of maples—

I think I have forgotten what it means to save
Anything. I think
It doesn't matter what I think, or hope to save.

Look at my complacency,
Like those "postmodern" mansions on Riverview Road,
A cobbling of allusions, and a pineapple
In wrought iron above the tempered
Security gate.

I don't know which house the murder happened in,
Near the tack shop or past
The thick old trees by the roadside
And the restored farmhouses on their big lots,
Or above the bar where
I overheard some lawyer explaining
How easy it would be to lose it, just lose it.
Take away my cocaine, he said,
That's all it would take.

I never know where my allegiance is,
To the sharp combustion, which is the beautiful,
To the smoke, a smell so thick it might be taste,
A rank tea on the tongue,
Or to something greater, a hunger
Of splendor, of acridity,

Or to my own ignorance,
Willed, and like any willful pleasure,
Self-consuming.
 They arrested two kids,
And the man who died might have been their lover
Or their john or something in between.

Is there a fire in the rock maple
That will not be held, a smoke in the sweet
 veins of the sugar bush?

And behind these, like the sharp
First cold of early fall,
A chill of intent, surly, yielding in the darkness,
Caught between desire and rage
That the world will neither be grasped nor slip away,

A knocking, insistent, on the raised-panel door.

The Morning Dew

What I envy tonight is the ecstatic life,
Pared to simplicity, pared
Almost to nothing, or to a ritual
Enacted, like a good habit:

The violin tucked in its case, the bow-hair
Loosened, the bow snugged on its spinner.
All afternoon, I have been trying to learn this reel,
Snagging my fingers on the grace notes,

Sliding across the double-stops.
It's like cobby workmanship on a house:
The forgetfulness
That something sacred is meant to happen there.

In the Orkney ballad, King Orfeo
Plays his pipes, and the stones awaken,
They open like a door, but only
After he'd searched long over a barren ground.

Nothing to envy, a loss I can't even bear
To hold in mind. It must have wrenched him,
A tree limb, torn, turned and bored out,
Tuned to a single drone.

It's early evening, the hour of unreasoned
Sadness, when the house is poised
Between a darkness like gray stone
And the insistent half-steps of our breathing.

See: the dusk of the living room, the fiddle-
Case, half-closed on the couch,
Sprawled open on the footstool, a book
About the Shakers, who danced

In a frenzy of broken selfhood, and then
Made these objects a mind covets:
A table and wrought-iron lamp,
An oval box of cherrywood, so snug

It makes emptiness seem a place of rest,
A lathe-work bench for the meetings where they sang
Till turning, turning, it comes out right.
And then, it's dark. And then

I take the fiddle out again
(But when he came, it was gray stone), as if
This music could alter anything.
Like grace, like dusk, like the morning dew.

RUTH STONE ——————————————

Blizzard in Binghamton

Small birds circle
the metal dumpster.
Nothing for their craws.
Pigeons plump in drifts.
The woman who stirs the trash
slogs away from her bent cart.
The snow plow,
scrawny as an old man's neck,
like a squawking chicken,
jerks its dim yellow eye, stuck.
Main Street traffic stops.
Power lines sag.
The power goes out.
From the window,
horizontal blowing crystals,
flashing lights,
muffled sirens
passing slow against the wind.
The street darkens.
Lashing the windows,
it enters the entrance
to the first step,
to the first floor.
A long arm of drift stretches
its dead weight along
the basement hall
where the women
living on Social Security,
behind their locked doors,
sit smoking
in front of their dead TVs.
It sticks to the panes of glass.
The radiators, cold;
dark swallows the room.
Holding a lit candle, you grope
to the pit of your bed and crawl
in like a hibernating animal.
Snow sifts under the casements,
infinite layers of crystals,
like the glitch of thousands of year;
you lie as if frozen under the weight.
Your veins slow-pulse like

the dripping water of glaciers.
And, while you sleep,
the storm passes to absolute quiet,
Your lids open to light
on the dirty windows. Above the buildings
a blind emptied blue, washed back
to the sky of your childhood.
Glancing over, you see next door,
not a Thai has ventured out.
Their shades are pulled down;
snow on their metal steps,
mounded without tracks.
Their timed lives,
day shift and night shift,
their exchange of beds,
some leaving, some entering,
halted, their exact pattern interrupted;
their great sacks of rice lying
like bodies in a cave,
behind the darkened window,
the window around the corner
in the Thai Recreation Restaurant
and pool hall. There is only silence;
a symptom, like a pause
in abnormal breathing;
and the large,
comfortable
casket of the snow.

In Binghamton

Asphalt, a local urban lava flow,
oozes from plot to plot along a street.
Weedless, slow, cancerous;
its pressure from magma populace.
Easy maintenance; status symbolic,
you can wash it with the garden hose.
By the package, it's quick and simple to apply
even with a stick. Tough old women pour it
from handy buckets. They get down on their knees
and spread it out while their teenage
grandsons stand by, comic replicas
of rites of passage, waiting for the tar

to set, sparring male to male,
their fathers' cars along the curb,
trunks popped up, loaded with chips and beer.
These asphalt spreaders in tennis shoes
and jersey pullovers are too old to sweat.
They sigh when they stand up and stretch.
Their flesh, dry as the clutter of deciduous
leaves in fall. Those leaves someone
will ritually hose into the gutter.

Etc.

This borrowed pressed-wood table
is molecularly unhooked in parceled impulses,
stored in my lobes where Adolph Hitler
is also shredded, his repulsive
moustache distributed throughout
my eclectic electrical system.
But that's not all.
His hoarse disembodied voice,
without a decibel, still shouts
goose-stepping through my cracked
cranium. As now, another snowfall
sculptures an unreality, clean and fresh,
bringing down in its light crystals
industrial particulate as it settles.
Out there a miracle;
in here, disassembled,
encoded visually, linguistically,
tagged with the rest of the garbage
that my brain recycles, that is myself;
this cumulative trash that goes with me.

CAROL ZALOOM

Ohara's Crow

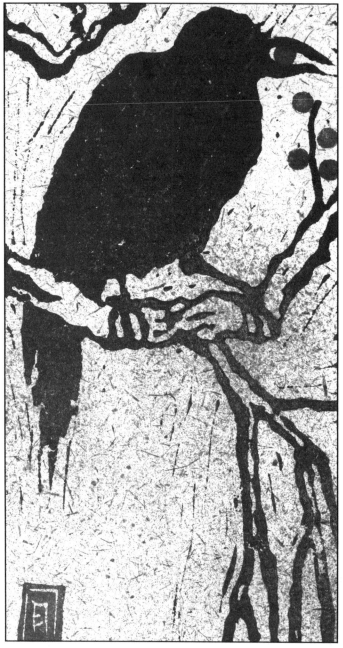

Linoleum cut on rag paper, 8" x 4"

CAROL FROST

Pity

When the woman falls in the garden and hurts her hand, all the blows
that have ever struck her, to which she had to yield, seem to return,
so morose the look in her eyes. But haven't they always been there,
saved up and partly concealed, so she could look them over one by one,
eating and sleeping with them? The blows
live in her honeycombed mind and newly with each passing day
establish what she will give away and what she will share.
As she holds her wrist, she waits for the tumult in her body to dwindle—
a blue welt is forming under a fingernail—and she breathes the summer air,
soft as skin on warm tomatoes. It is hard to believe in what goes on without one.
And the heart learns a pity for itself, easy, coarse, common as the grave.

Crows

Not disputing what those nearest her would think, their questions and
 importunings, she goes out just after sunrise
into the morning green of the grassy earth, her nightgown soft around her legs, the
 gun cradled lightly across her forearms.
The crows which have waked her lure her along—darkly a solitary shape flaring
 through the naves of alder and beech,
the others calling. Those who have disturbed her sleep all month she means to kill,
 for sleep is sacred, and private.
She has only to think this and she will return home, barefooted, and climb back
 into bed.
The newspaper has not yet been delivered with its news of the world, the words
 chanting violence and death, violence
in the face of disappointment, violence for no sake, and in her pure daze her
 thoughts are more like this:
How far life reaches and where night and morning meet. From the mist a deer
 walks suddenly into her field of vision,
and as suddenly she fetches from behind blinking lids a hardness, raising the .22 to
 her shoulder and shooting it in the shoulder.
It falls, but when she leans into that remoteness—brown and still, its legs in the
 air—it rolls to the right and springs away.
There is on her now what she can know only by violence. She can smell it (fur,
 warmed earth, grass, blood) and hear it
in the raspings of the crows as she tries to follow the wounded buck:—what has
 reposed all along in the part of her that isn't and is beast.

MARY GILLILAND

Leveled: 1

Nine roads of the moon
link in reflection on the water.
Whether one might go there (sway)
or arrive tomorrow (dip) or
be here now (vanish) or whether
enlightenment is beam or dapple
the moon has touched me
with this brutal milk, this scintillate
that ends in dark.

Leveled: 7

Melody—the thread I thought original is someone else's. Soft
dissonance—the shock earth gives the heel with each step. Particles
wobble slowly, as though in water, then they settle. In the next rest there
is a new tune and if not? Leave that to the reporters. Work in darkness—
to depend on light and then one day there is none: where does that
leave you? The barred owl hoots. The tern nests in marshes. The baby
eagle's great feet are oafish as a baby lion's. They are not made for now,
when the young bird sits on a cetacean so dead it can no longer be
eaten. Earth may seize you from time to time, be steadfast. Harmony
bubbles up, the bones of the foot articulate when you pause, and ever
after each step is a singing. I turn up a pine-needled path past the
eaglet. Geography says there is a point in the distance, a spit of land
where seals beach and sun on the coldest days. It is miles through the
forest.

Leveled: 2

They laugh I do not wear a bib.
Hardly is a new shirt buttoned
than coffee or a bit of stew
is searching out the nipple.
The tray before me locks in elbow high.

The trolley would be packed at five-two-three
when hordes of pumps and wing tips
hit the bricks of center city,
powder caked and pomade stale.
I left the crowd to marry. Women did.

I'd tended desk and caught dictation,
covered my fair tail and theirs.
Marriage was absence of blood, loads of diapers,
lotion too sticky, too pink, too sweet.
Rash was the word. They'd outlawed the midwives.

Twins, the milk dry, the night hot as tar
—I'd not done much for money or love—
whimpers quieted, feathers scorched the grate.
There were medals I did not box, plays I did not see.
Sundays they read me the child's letters.

Dribbles of love, the chewed food and the drink
—I'd not fixed my eyes on the leaded bars
but on the panes between. To survive
a smart woman carries scenes of her own life
in her belly. Call God he? You could.

RICHARD FROST

The Annunciation

I.

Joe told Jane how the angel told
Mary not to be afraid
and then gave Jane another pull
on his bottle. Jane got laid

across the back seat of Joe's Ford
that Monday night above the town
when Joe informed her how the Lord
sent his favorite angel down

to Mary. "You're the Lord's handmaid,"
Joe told Jane the angel said:
"When Mary heard that, she obeyed
and followed where the angel led."

Joe gave Jane another gulp
of booze and, demonstrating how
the angel gave the Lord some help,
unbuttoned Jane and whispered, "Now

I'll tell you what I really think.
I think the whole thing was a fraud.
Pregnant, to avoid a stink,
she made it up, the clever broad."

But Jane said, "No," and took a drink,
and soon was saying, "God! Oh, God!"

II.

To the old park over San José
Alum Rock, I come to find
the path where, as a college boy,
I took my sweethearts. In my mind

I ease my waxed and polished Ford.
Below, the yellow pins of light,
some still, some moving, mark the world,
and I and someone start the night.

When I switch the motor off,
first stillness, then the sough of trees,
then a million trills of life
in quiet level chorus rise.

Alone with someone with a name
to murmur, and to call my name,
I stir love up from its restless dream
and fashion it another time.

Is memory a fiction? Have
I made my life into a rhyme
of tricks and guilty luck, in love
with Joe and Jane in a drunken game?

Old give and take, old God, old slave,
old line that worked too well. Old shame.

 III.

Joe tells Jane how the angel told
Mary not to be afraid.
Jane smiles and takes another pull
on their bottle. Joe has prayed

he'll work Jane to a helpless lather
this Monday night above the town
in his Ford when he tells her how the Father
sent the persuading angel down

to Mary. "You're the Lord's handmaid,"
Joe tells Jane the angel said.
"And now you'll tell me Mary made
the angel carry her to bed?"

Jane says and takes another gulp
of booze and, demonstrating how
Mary gave the Lord some help,
unzippers Joe and whispers, "Now,
I'll tell a tale we both can handle.
I know the whole affair was human.
Pregnant, to avoid a scandal,
she made it up, your clever woman.

But if I were told to wed the Lord,
I'd want my church to be your Ford."

IV.

It is a level patch of ground
between two trees. I'll call her Jane
again. A whisky flask, a moon,
a blanket, and no sign of rain—

Pacific spring—, and by the book
I woo and gain each inch of skin
beneath each buttonhole and hook
and eye and cup until I win,

or think I've won, what I am for.
Yet, having glided down the stair
of love, Jane cowers at the door,
giving up to a rush of tears

—or rash, or downpour. Is it fright
or whisky? Moral reprimand?
I heed the warning, end the night,
and lose her. Who could understand

love's throes on such and early date?
Many others, I supposed,
knew how to answer. I knew late
if at all, while I was raised

in the mysteries, from mate to mate,
by God's truth constantly amazed.

LADY OSTAPECK

Jordanville Monastery

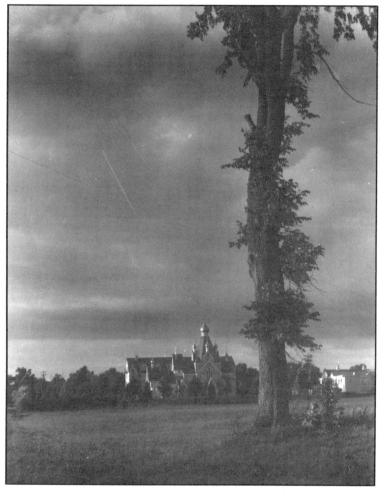

Black and white photograph, taken with antique postcard camera, 9 3/8"x 7 3/4"

DANIEL SHAPLEY ─────────────

Narcissus

yellow and white trumpets herald the queen's entrance
her splendid crown is balanced delicately on a slender blade
oh god! she looks good she'll tell you
how good freckles and cheekbones and breasts and legs and dresses
(and undresses especially)
and eyes and ears and feet and toes and lips and
oh can I forget? stomach divine
inspired of gods (and goddesses especially)
did I mention hair? oh hair hair hair hair
(it's not enough)
hair hair hair hair and again hair
looks so good
she thinks (oh she thinks she thinks)
great things
of herself indeed there is no other
for her not periwinkle nor Dutchman's breeches nor
forget-me-nots oh no!
but in narcissus! narcissus! narcissus!
she lies

NORMAN SNYDER

Cocktail Lounge, NYC, 1968

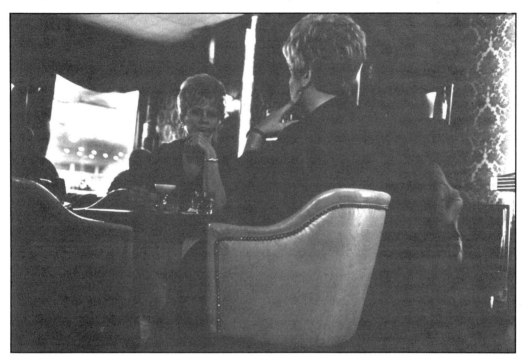

Black and white photograph, 5 5/8" x 8 1/2"

ARTHUR L. CLEMENTS

Portrait of a Man Leaning on His Nose

A young man is leaning on his nose.
You do not hear him screaming,
he is making jokes
with his quick mouth
so you will look at it and listen
and not stare at the swollen nose
he leans on.
You do not hear him crying,
he is hiding his feelings
so the persistence of memory will disintegrate
watches are bending
over at ninety-degree angles
imitating his broken nose
which leans toward his left ear
as he makes jokes
saying his nose is bent
over into his ear
so he can smell what he hears
hear what he smells.
You can not see him weeping
over his dead mother,
the mad son,
he leans on his big, broken nose
in this synesthetic cosmos
and moves his tongue in his mouth quickly
all his pleasure
in his eyes
his most splendid vision
of eggs fried in a pan in a womb
a coffin obscured under two praying figures,
the young man appears and disappears
saying, "now you see me
in a little while
you will not see me,"
his nose is leaning
his mouth is leaping
as lithely as lions on inclining cliffs
his head is disappearing and reappearing
wondering where words go
when they are forgotten
where feelings go
when they are not

and can not be returned
he wakes up dreaming
the abdomen of a beautiful, naked woman
becomes his chin
her waist is his mouth
and her left breast is his nose
which is big and broken
and he is leaning on it
moving his mouth quickly.

This Silence

Joy sits with a carrot
in her mouth,
the sun behind her streams
into my eyes.

She hops off the deck
and stays motionless
watching me
reflecting the stillness,
this Silence.

A chickadee and a cardinal
at the circular feeder,
the chickadee lights
and leaves, undulating,
the cardinal remains
in the sun
in my eyes.

A beam of light through sumac
graces the grass,
a mourning dove
on the distant feeder.

Steam, evaporating moisture, rises
into sunlight from an empty chair.
Joy suddenly leaves.

You finish this poem;
this light makes my eyes blurry.

PEGANNE BLASK

Mohican Farm

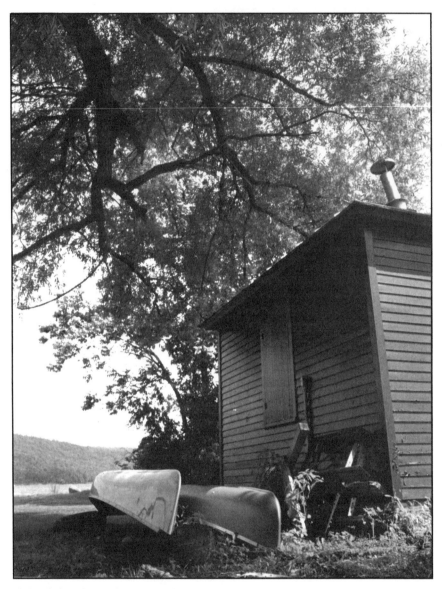

Black and white photograph, 6 1/4" x 4 9/16"

MATTHEW J. SPIRENG

Survival

An emaciated Shetland pony is rescued from a 6-foot deep dry well into which it apparently fell a month earlier after disappearing from its pasture.

—News report

Days, there was blue sky or rain
and the sweet scent of green grass growing
in the light or damp, that tug
of hunger drawing back from the grave,
out of the earth, fields stretching
endlessly beyond the wide hole's rim,
a fair wind blowing the scent on in,
and water the days of rain, water
to pool in the mud and bend toward
and drink, thinking more of grass and grain.
Even nights, lying in the stench,
a cool breeze brought the green scent in
and sleep was to dream of pasture.
It was the wind, hard before storm,
brought a few leaves in to be lipped
and swallowed, less a feast than dreams were,
bitter on the tongue after all that want,
then memory, too, to be savored.

Picture Puzzle

On the box top a barn, barn red,
that weathered red old boards take
in time, stood just left of center,
an outbuilding of stone left and back

of the barn, a three-rail fence
along the rutted road, barn-side, stone
wall bordering the road on the other,
hayfield to the right, a horse-drawn

haywagon piled high in the distance,
autumn hills rising to the horizon,
an evening sky, clouds crisp as the air.
The pieces spread on the table in

disarray, we'd begin with the barn,
the fences, finish them first, lines
and angles ordering the pace, posts
and rails emerging, windowpanes

in place, the roof back, then tend
to the grounds, the harvest, keep
horizon and sky for last, day's end,
a fullness near the edges of sleep.

MELORA WOLFF

Leftovers

This new year smells a little like the old.
Wood smoke rising. Scent of fox shit on the breeze.
Last evening's supper wafting from a plastic sack
I hid inside the shed to keep the skunk from finding
any joy. But he will, he must, he isn't me,
he made no resolution not to savor all unfinished
meals, or to sink his arms in, elbow-deep, devour
the rot of everything not sweet enough to keep
my belly full, the wine-soaked mush of meat
and fruit and daily bread, the unused seeds, frail
stalks, and folded wings I've tossed, and all the skins
I've peeled away, year after year, in my ceremony of
one. I resolve to let him have me, or whatever I have
left, the pulp of my desire thrown down on the moonlit
snow for him. His new year's feast is my own heart, still
beating, god help me, with old love.

"Miracle Child and Answered Prayers"
—Villa Unión Journal, Argentina
New York Times, August, 1996

for Nick

When Miguel Ángel, one year old, felt the fire of meningitis
In his veins and the twig of his spine sparked and snapped
He knew his body was no longer useless tinder. He had become a flame.

His mother, Argentine, prayed in fear to the demons of fever
Whose faces she learned in the eyes of her son. She paced the black
grass, holding Miguel Ángel, a candle, before her and she could see.

He was buried before dawn. He slipped from her arms as she
Bent over the earth with the boughs of the quebrachos and her son
Entered darkness he had barely departed. His tomb was sealed.

The darkness pressed Miguel Ángel to her lips. She kissed him,
Breathed Death into his mouth, his eyes, the pure flame of his heart,
To welcome him. Miguel remembered the darkness of Argentine's womb

But the tomb of the earth was darker. He remembered old ones gathering
The children at dusk, pulling them into the houses, and that the lanterns
Of Villa Unión would blaze as night slid through the mud of the

Streets toward the steps of the church, and Argentine would not
Let him taste her milk until she had lit each candle by her bed and
He had learned what he should fear. Miguel saw the eyes of wolves

In the darkness. He saw his mother, sobbing, wringing her hands
In grief until her hair was braided with sunlight and she slept. Then,
He saw us, growing older, flicking on the porch light before we turn in,

Leaving the hall lamp on as well to draw its thin line of comfort
Beneath Nick's bedroom door in case he cries for water in the night.
He saw us driving in the truck through our suburbia

Thirty years later, killing the lights as we speed the back roads,
Letting the truck pitch into the valley where the moon is hidden,
Thrilling ourselves with our own terror, just imagining the road

Home is death we almost want, a ribbon pulled so swiftly through
Our hands our palms are burned and we start kissing each other, our eyes
Closed. He saw all of this. He saw the ways we play the darkness,

Fight it, tempt it, hide the children from it and in it, and
Miguel Angel did not want his blanket of dirt. He kicked down the
Walls of his own Death-Crib. He unburied the box of himself forever

Crying out to us with the voice of our own boy, of Nick,
Thin and feverish in his pajamas on the porch, facing the demon
Whispers as we worry his name at midnight on the neighbor's lawn,

Mom! I need the light so I can see the dark! And we spot him,
A bright flame burning, gathering the great-winged night moths to him,
And our hearts stop and beat again as he blesses us, angel

Who sees the dark descending on us all, here in Villa Unión.

LYN LIFSHIN

My Mother's Address Book

with rubber bands
flecked with powder,
slack as the face of
a child who won't
eat. Almost half
the names crossed
out with a line.
Buzzy, darkened over
with a pencil, as if there
was a rush like some
one throwing a dead
relative's shoes and
wool dresses toward
the Salvation Army
baskets, someone
catching a train,
breathlessly, the
graphite black as
shining freight

Lake Champlain

You could hear Louis
Armstrong across
the black moon rippled
water when the wind

blew right. In the
dark, roses inched
up bleached wood.
Under low ceilings

the baby sitter laid
out Camels, patted
white bobby sox,
inhaled and let go

of horrors in Germany
and Poland, what they
did to young girls
in tunnels. Only

my mother's cigarette
glittered, a fire
fly in blackness
as the slap of water

on row boats lulled me
to sleep until I woke
in a sweat. There was no
air, only the wet

wood, heavy as a
chloroform soaked
handkerchief pressed
over my mouth.

ERNEST M. FISHMAN

Ted and Jamie

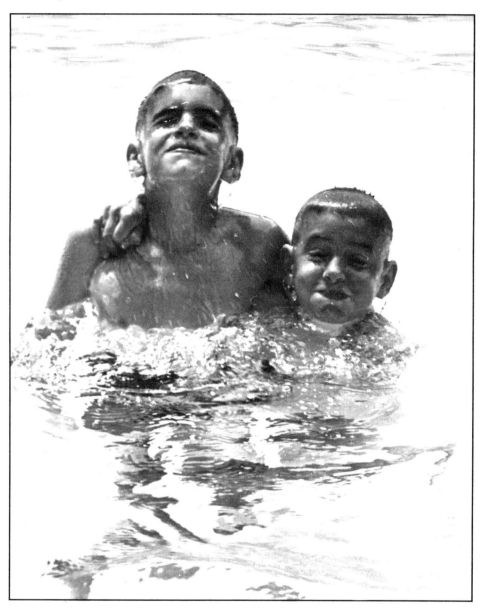

Black and white photograph, 6" x 5"

JULIA SUAREZ

November 2

These first nights you feel the chill, the heaviness
of leaves lining the gutters, mounds unstirring
like the dead who also lie

in rows not far from here. This little city
could be theirs: an upstate City of the Dead.
Headlights, houselights, columns

of porches gleaming on wet streets, straggle fence,
picket teeth. A neighborhood of bones.
Yours and theirs—how delicate

beneath the flesh, how clean they are after we
have left the circle of remembrance: no one
mourns, laughs at your cleverness,

or holds in the mind your image tenderly
before sleeping. When you are part of the long
unmarked regions, far beyond

the reach of human light, someone who is like you
will walk on cold November nights these streets past
the house, the rooms, that once held

your life, and turn up the collar of a coat
too light for the weather and sigh. October.
One more October is gone.

Counting Out

Poem for Absent Friends

I think of forests and the long-standing
pines, know I do not understand them
and their column of space any more than
I can comprehend the fact that you
are gone. I can't begin to know
what that means. We think we can take
the measure of trees, their breadth
and growth. We measure their rings;

some trees grow fat bands with the seasons,
the silver maples, poplars, kinds of pine;
others mark their passage in circles fine
as hairs, layers wound so close we barely
notice their growth, even when, their trunks
cut across before us, we try to count the years
and read and count, then have to count again,
losing count of lines, knowing we'll come up short.

It's mid-December now, and at four
a little scrap of light breaks,
cast like a shawl across the shoulder of the hills,
then as quickly, cast aside.
The day is comfortless again. Old trees
long-standing. Cold and rain. Those who
never knew these trees find no strangeness
in the empty spaces where they stood.

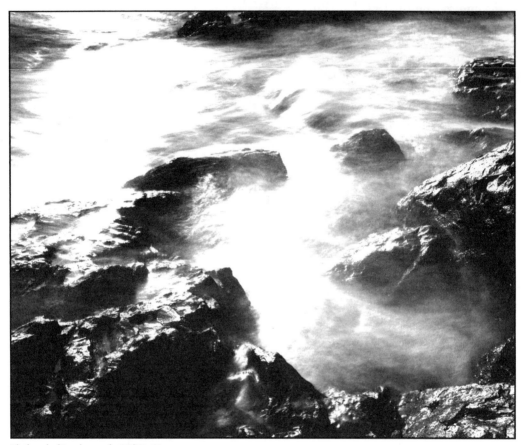

Black and white photgraph, 6 7/8" x 8"

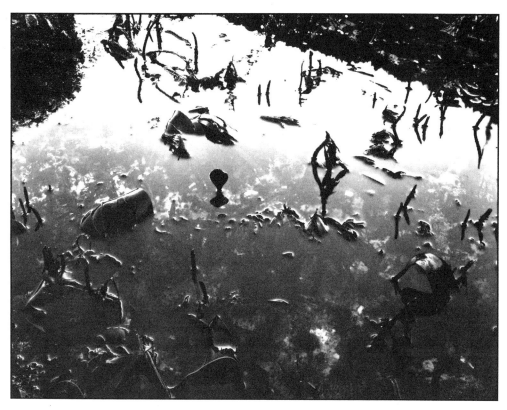

Black and white photograph 7 3/4" x 9 3/4"

F. BJÖRNSON STOCK ——————————————

Fragment 5

> —Kien reminds his wife of the traditional bamboo swing
> they rode the evening their betrothal was announced

Your hair billowed into the red triangle
dusk threw over your shoulders, smoke
seemed to wreathe your neckline, lips
lit up as we approached the moon, our chests
good-luck coins tucked inside a shiny envelope.
Under your dress a fire started
unrolling tongues, your body went up
laughing into the glint the orchard flickered.
I heard a night bird call for water.
A mirror began pouring out between us.
Your reflection became my heart, my eyes
floated into the silk around you. Hoa,
you rushed towards me, consumed muscles
I tightened to pull us through lime-sweet air.

For the rest of the month I carried your embers
inside my brazier body, wind
swinging past my dreams ignited
my sleep, my parents swore I called out:
Bring me a flute-boned messenger bird,
her name on a band and a strong lantern.
If I lose her by night, I'll wander as dust
uncombusted above the shattered river,
if I find her by day, I'll joyously release
the scarlet songbird my cage is holding.

In the morning my grandmother started to serve me
cooled slices of flame-shaped fruit.
The body, she said, *has hundreds of doors:*
when the flesh is ripe the tongue forgets
the pain of hunger burning near the roof.

A wasp,
a single wasp,
returns to leave
a wisp of limbs,
a sliver-heap of eyes
upon the sill,
as stricken
summer lies
with lungs collapsed,
the wings a broken weave.

September-stunned,
the body can't relieve
the swollen wound,
the itch as venom flies
against the heart
and something tender dies
and love, it's you—
I wake again to grieve.

The moon upon the maple heap consumes
the season's dead,
the house beneath the flame
awash with crescent embers hisses bright.

A single lamentation fills the rooms,
a tremolo,
a single, painful name
and love, it's yours—
I vanish in the night.

STEVEN OSTROWSKI

The Song

So lovely, so excruciating. The song that turns
the mind's voice like eyes through a window
to a place you have dreamed about but woke
and forgot, and almost remember again
when some combination of wind and bells, wind
and flapping leaves, wind and screen doors
is struck up. Something else comes into the dawning
kitchen with bacon frying, the radio on (some jingle
famous for its redundancy); a few moments
retrieved from a time when you were nine
and standing in another kitchen, and you had
a vision in all senses
of the only beauty that would ever matter,
indescribably holy, rising through your nostrils, burning
your eyes, mostly ringing in your ears like a dish
revolving on its edge on the floor, slowing,
settling, finally soundless—vision gone, but
recorded like a gash in flesh,
and you only have the rest of your life, it seems,
to figure it out

and as always it is now again.

The melody is familiar. Yet,
you've never heard it
exactly, as when the street curves and suddenly
you've never been there. At the end of the novel
you're reading to the background music of
the whole town's buzzing evening televisions
all tuned to the same show it would seem—at the novel's end
there is a transformation in the hero that no one, not even
the writer, could have fathomed. Disturbed, you go stare
at the old family
photo, but all flesh and blood have drained out,
except for the flesh and blood of the song
that plays on the stereo
behind your mother's ear.

Unless you have given yourself over to it altogether
music somewhere always distracts. Just now
you thought it was a symphony, and went out onto the porch.
The sky was not azure, not teal, not even sky.

Across the street the harmonics of girls' voices.
You wish you knew another language, because
you've always been left empty by your inability
to name the most important things. So that they
could mean. At least resonate. That's how you came
to make the plan to read all the names of the colors
of your daughter's crayons, and that is indeed what you do
when you go back inside, since it hadn't been a symphony at all
but morning recess at the public school, and undulating
chords of play meted in spaces and lines over four blocks' distance.

All afternoon you draw a picture of the song. The crayon colors
respond to the movements of your hand, and the page fills
with sound, although you still try too hard to invest it with meaning.
It means without you, and as you already knew when you were nine—
it *is* holy
but like you did then
you must forget and listen.

Stirrings of the Paraclete

They say you could be an angel-painter
but your slate's full;
you're known to know the memory of animals,
the extra logic of water, though
not to be particularly interested. Certainly yours
is the final word on flame.

They say that should your notebooks ever be found
published poetry will have to swallow its tongue
for a century, and that for the sake of plausibility
film will focus its lens forever
on ghosts in small scenes.
The unexpected purpose of art, it is conjectured,
will be revealed, with appropriate
elation/denial/depression to follow.

People with no connections whatsoever
are purported to have seen you—
once in a Laundromat in Phoenix
organizing a writers' group for the luckless, several times
on long-haul buses, most recently on a curb
on West 23rd Street NYC in midfternoon heat,
chatting with meat workers over iced tea.
A German boy grown old says he overheard you
take Hitler's confession in the smoke
(although many don't want to believe in love like that).
You, some say, have been spotted jotting notes
in fields all over Europe,
in deserts, at highway rest stops,
behind rivers where bloated bodies float. At this point
we don't know what use you make of the notes.

Stories about you abound
in the grass roots, and in
some unafraid works of literature.
The media and the universities,
historically among the last to see,
remain uninterested, in fact hostile.

Even now
when a child disappears
either before or after birth,
parents and other concerned souls write epistles to you,
including penciled illustrations of their broken hearts,
begging for maps and binoculars. You are known
never to refuse, and always to add some additional thing,
some pearl or talent, some new word
or way of seeing.

LISA HARRIS ———————————————————

Hidden

—in response to Exodus 3:13-23

I am in a rock cleft waiting
for God to pass by. It is near sunset;
and I am near sleep. A few geese have flown;
I know them by their honking. Crowded
into this cleft, I see very little—
only a small range of light, about four inches
across. I will settle for seeing
God's back, since Moses did, but I worry
I will not see even that

here in this rock cleft at sunset where I wait
near sleep.

 I hear a humming and some whistling
and I think, "This is not God," but in case God
has sent messengers, I strain my eyes to see
a red and black plaid jacket, a camouflage hat.
I smell fear's scent next to me and I narrow my eyes;
it is myself I am smelling here in this cleft.
The sun has set and I am awake when God
passes. I know it is God because there are no sounds,
no sights, no scents—

rock breaks open, spilling me into night.

GERALD SCHECK

Untitled 4

Mezzotint, 8 3/8" x 8 3/16"

Untitled 5

Mezzotint, 4" x" 5"

LOUISE GRIECO

Breathless

At matins and vespers
and all the times between
on her knees she wished
not for an angel but a raptor
to dive through ionized air
coil his talons around her take her
anywhere everywhere and atop
a ruined capitolium
in some Italic alpine garden turn
into a god and in a pool
of light bright and cool as new-
minted coins she would clasp
his loins between her knees lost
in laic pleasure whispering
amo amas amat
as the satin air breathed canticles

LORI ANDERSON

Stitch an X in Each Day's Dish Rag as a Kiss to Count How
Long This Curse Lasts: One Breath, Two Breath, Three

Sold child, on her knees brush-in-hand, shoves
more dirt west—the way her mother went.
The way her mother went: mule to the wagon
or war widow happy to be a hole again.
Who knows? Sold child spits her mama's name
to cool Thursday's bucket of lye, spits to float
her sad sad selves' cross the M-i-s-s-i. . .

I miss you. Send sod from your new roof
to shelter me. I'm building a sand bar
to walk me 'cross this muddy abyss you
put between us. River Man's house is damn
clean 'cause I use his filth as fill
to slow the flow by the whippin' willow.
How many do you mother now in Mormon land?

Soul child, on her knees brush-in-hand, drives
her mad mad selves deep 'til knuckles buckle
at bucket's bottom, 'til steam rises
off wet welts. Which will is it when
flesh's sting bites back: do not cross the river
for her, Jessie; she dunked us (bucket of lye).
Our hair a brush. Our face all bristle.
She held us under. Just let breath save us.

My Cruelty

"The act of reading must be slid across to the mother"
—Rachel Blau DuPlessis

Read confessionals often?
Mine is simple: I witnessed
a grease pan fly, wound
my mother, dangerous welts
up down her strong arm;
I knew just how slow
the healing (the storehouse
of salve and rags depleted);
I knew her increased fear
of all boiling (even water's);
I knew she preferred dry heat,
oven's ease—the opening
and closing of a single door
she could delegate to any
of us eating (her masters).
Knowing this and more,
I chose neither safety nor ease;
I chose for her to heat
the heavy cast-iron skillet;
I chose the burner coiling
red, rings of Saturn, rings
of Satan; I chose roiling oil.
One by one (in hot tongs) tortillas
(corn color of her healed skin)
softened, blistered, hardened.
She risked the char, the charge:
careful or I will devour you,
careful or you'll not nourish.

ADAM LEFEVRE

Shelf Life

Goodness has limits.
Blurred ink cites the last salutary date,
after which, you take your chances.
Yesterday's crimson giblets
fade to an ominous gray.

We survive suspecting life.
If something grows on something, call it spoiled,
throw it away.
Unregenerate genesis is the bane of civilization.
Only periodic holocaust

can certify the store. Vichysoisse
from a faultless can killed
a family of five in Illinois.
Milk goes off.
Goodness expires.

In heaven
they boil everything.
The soul tastes neither bitter nor sweet.
Rice they found at pharaoh's feet, unmolested by millennia,
is thought for food.

The dead eat light, it seems.
The dead stay fit.

The New Thanksgiving

We parley. We savvy. We trade our days for their scorn.
And hunger stays
On all our dishes poised
To receive anything of their nervy waves.

Our home is now a surrogate egg.
The fabled gentle savage kneels on the shore
Spreading mats of woven protein to welcome
The elsewhere beings on a molecular level *here.*

Having looked out and up all this time,
Having looked in, and still dreaming
A common ancestor links us materially
Even to what isn't there.

Haven't we survived loneliness radiantly enough
To become a perfect host, primed
To give everything to whoever will arrive?

THEA FOTIU —————————————————————

Socrates and I Have Lunch

against an olive tree and the leaves rattle
under the punishing sun.

And we talk of everything, as it is,
hurled out of darkness; all
the mammals and minerals, Eve and Adam.
We are like a wind
which gusts within itself the impossible.
I open the book,
to linger wastefully on my knees, with hands
I have known always.

From a great darkness, ruins
stand taller than they were,
at first, when night's darkness filled
unlit palace walls. And the virtues remain
as ancient poses.

That is all I know today.

We know nothing but virtue
of the lives before us; Persephone is the sun.
With tall cliffs and mist as thick as wool on our oceans,
perhaps Aphrodite
wants us to love what we can see,
and Echo is still calling Narcissus.

What is that sound of nothing, of a world
which one can always find language for?

The thin needle of the chronometer falling?
The sun recoiling and the barometer rising?

He says that in this world
we are but a few generations of swollen olives
underneath the bronzing sun.
But what I want to ask
is what darkness we will
belong to again,
what war will make a ruin
of our aimless Earth, our hearts, here beneath the sun.
What will strip the sun from our eyes?
Will we know ourselves in darkness, as dim as light here?
I tell him I will search for him.

At the highest point of the sun upon us,
the world in light is difficult and far
from the great beginning of darkness.
Beyond the tree where we meet,
that mindful darkness waits for us.

What was it like, I ask,
to die, having so much to say, to belong again
to the dark beginning,
and in that darkness to hear the sounds
of the grass
and the mammals and the minerals,
and the leaves, and the stone,
a word,
and the fruit, the dead, water
and fire and the sound of the moon,
to hear the shadow of the worldly Orator
stand above you with only a silence in his eyes?

Here by the olive tree,
I have seen the sun reflect our Earth
and moon.
That is enough.

We have reduced the moon
to a little girl. Heliocentric,
we love and are amused.
That is enough.
I close the book.

Little Man

Little man, when you died
your little body lay without a word.

Beneath your thin shirt
your clavicle extended toward a lofty soar.

And your buttressed chest and saturated heart
had nothing more.

Oh, little man, you died
in the arms of your bed.

CAROLYN BENNETT ────────────

My Empty Chair

My empty chair rocking in the morning sometimes on
I put on. I'm polite and friendly to people.
I'm friendly and polite to people. I put on.
Till my dying day me inside will be
Be inside me till my dying day will
The morning sometimes on my empty chair rocking
I on put. I'm friendly and polite to people.
Empty sometimes in the morning on my rocking chair.
On my chair rocking empty sometimes in the morning.
Inside me will be day my dying till.

That Holy Sound

That holy sound:
silence
birds before darkness
then, sky, stars, a second silence
How perfect to be born
into
a moment of gladness.

PHYLLIS JANOWITZ

Rattle and Roll

Perspective shifts alarmingly, the floor
she thought horizontal and rigid
beneath her feet lifts at an oblique pitch
leaving one foot higher than the other,
her torso leaning like a stick. Sea-sick,

she is frightened and wants to lie down.
Anyone who travels across a continent
should be prepared for shock or quiver,
but this girl distrusts metaphor,
this is no pioneer.

This is a woman granted by herself
and society the role of a great
granary, a woman who can easily break
into madness, trust me, friend, she knows
between the small task and its chancy

accomplishment lies a declivity
similar to the Grand Coolee.
And this is earthquake territory,
San Francisco, riding a fault.
What did she expect? She,

who has no rights to her story.
All the Latin she remembers—*amo amas
amatis*—has brought her to this
hotel, looking down on fishing vessels
colorful as a beginner's acrylic,

at times tucked into fog.
Lily, lily, she hears intoned,
and thinks *Ophelia,* thinks *Mother,*
lily of the valley and lilacs,
their aromas impinging like nostril-

needles, ping, pring. She's just come
from hospital with a swaddled bundle
which sleeps and sleeps and when it wakes
she is not capable of feeding it.
Another failure, with so many contrived.

Without interruption a river in Iowa
slides from her eyes. And the lilacs
sent by grandparents—three
thousand miles away—these
enormous branches she can only

put into the bathtub, covering
their wood with water and waiting for
someone to rescue them, rescue her,
rescue one and all from this watery
Hotel Pitfall, subject to shakes.

Peter's Transport

Pierce Arrow, coracle, bat-out-of-hell,
what makes them go is invisible.

Observing lines rise, his grandfather,
an early telephone believer,
shouted through a wire, "Hello, Hello,"
using more than one ecstatic tongue.

While Grandma refused to give up
her icebox in exchange for squat
electric refrigerator and, later,
freezer stocked with polyglot boxed

vegetables and frozen fried chicken dinners.
What is it like living
in the impatient twentieth century
where even a rabbit is so hopped-up

he flops from exhaustion before
reaching his destination?
What's left is a dust-mop of fur and bone.
"Lickety-split, home to rest now, Peter,"

says Mother Cottontail with a frown.
What heights can one aspire to in Levittown,
N.Y.? Levitation seems to be natural
as TV, it simply isn't patented

yet. One of these days he shall
float parallel to bed
or floor and not even wonder
what he's doing in air

sultry or cool, polluted or clear.
Horizontal, he'll rise
in long thermal underwear
watching nebulous fogs settle down hard

over the snoring chickens and dogs,
the patched rooftops of the unaware,
and the plane trees of our little town.
The lights from the lampposts will dim

and dwindle. Like others who have broken
new ground, he'll never be heard from again.

STEVE CLORFEINE ———————————————

Anna

Who will weed the garden
lay a mulch of grass shreds
burn the refuse in a barrel
by the compost

Who will long for a certain
wildflower, dig up, transplant
watch over, speculate its future
report its progress day to day

Who will separate peonies
recommend them to a caller
add strawberry plants to rocks
on a small forgotten slope
too arduous to mow
remember which berries might be
out, pick them for supper if
the birds have not already

Who will know which trees to
grow and why, how to transfer
growing things from one place to
another, leave a wheelbarrow on a
lawn, a rake at such an angle
when someone stops to visit

Who will tilt her head just so
curious at eighty, girlish
have an idea, a plan to get things
done, go back and forth on the
reasons, say "I suppose" so many
times and keep at it

Who will play with cat or dog
say its name, endearments in a
squeaky voice, talk to it for
as long as it will pay attention
talk about it when it won't

Who will have hands so large
use them equally well to cane a
chair, saw a board, lift a table,

bake a pie, steer a tractor
shyly wave goodbye

And who, I wonder,
will stand at the window next spring
look out
and name the birds.

Return

again the trees
again black limbs
and leaves like
nothing we own

again the trees
still green
against green
against the evening sky

again autumn
still crickets
again quiet
against dusk

again the fields
lavender, goldenrod
again cattle
bellow across creek

again russet again blues
damp against travel
against no nest
we talk

again crickets
against stillness
evening shroud
hang stars
like events

against night
against breath
fatigue comes easy and
again death drinks

again clouds
cast like wash
against sleep
like children
against night

CHRIS JONES

Tyler

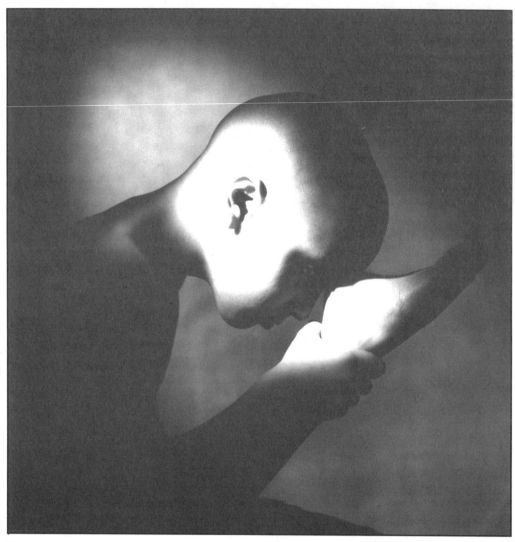

Black and white photograph, 9 1/2" by 9 1/2"

Tyler

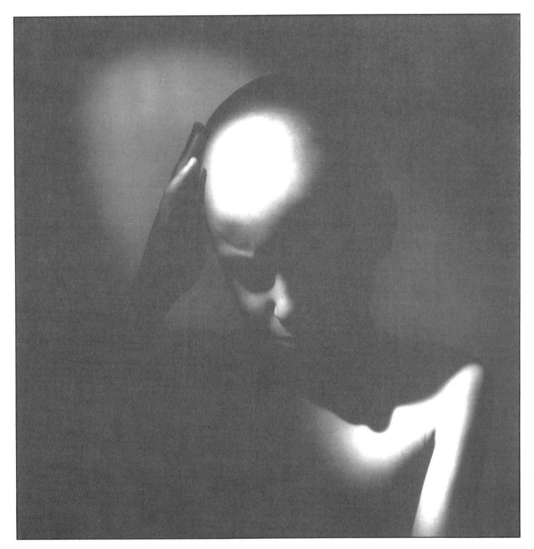

Black and white photograph, 9 1/2" x 9 1/2"

Eight

He got into a fist fight
at lunch and
lost a tooth

but the dog piss sand
caught it and held it
caked in blood

and he lay there eight
pants wet up front
hearing ha ha ha ha laugh
like a dentist's drill
till he didn't remember standing

as the other warrior turned
to an afternoon of high fives and popularity
the ghost of one boy's anger
stood and danced the other
into the ground with wild flesh

repeating knuckles come eyes
come nose come mouth come face
and blood spurted like
the last bit of chocolate syrup
staining the grass the dirt the fist

and after the boy stopped breathing
all the wide-eyed drop jaws left
we weren't so interested
in watching an eight year old boy
fight a corpse

Icarus

His sideways body crashed so hard
into cerulean limbs of ocean
that the sound mimicked thunder
if ears were close enough to hear

And the awkward panicked flailings
of feather wax and frame helped
stifle limbs till water
filled the lungs like violent air

The body stopped short of living
and yielded to slow gravity
half-suspended as he drifted
like sodden strands of weed

But slower and with more thought
or purpose for this was Death
the God of this winged want-to-be

LOUISE BUDDE DELAURENTIS

Appearances

On the first day after my daughter-in-law's
birthday a flock of cedar waxwings flew in
to ruffle the daffodils. Punctuating
the death of that marriage,
they swept away the midthirty
temperatures to the tune of a sun
heralding the belated spring.

Bloodroot, squirrel corn, spring beauty,
Dutchman's breeches, hepatica,
blue cohosh—the names almost as beautiful
as the reality. Heartbreak we try to picture
as fleeting as the blooms.

Transformation

The Hopi Snake Ceremony names
this moon. Is it a rattler or does it
slither harmlessly? You tell me how
you suffer. The coils of friendship
form a rope. I shrug within its spiral
inference, imagine horrid piercing
of my heel. How can I smile or laugh
or dance? Some snakes lay eggs, do others
spew live births? I shudder loose from
guilt and find no tears. Lips tight
and eyes askew, I watch the green
snake slither through the grass.

PEG CAWLEY

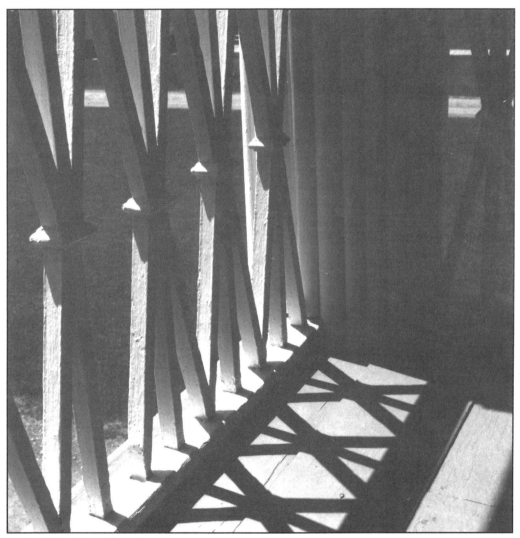

Black and white photograph, 7 3/4" x 7 3/4"

GRAHAM DUNCAN————————————

Wants

With age the wants diminish one by one
until a pittance in the bank, a bit
of sun, a slow sip of dry white wine,
a loving pat or two will do. But once
(was I six or nine?) the wants were huge:
a catcher's mitt, a pair of racing skates,
a fencer's foil, a bow of seasoned yew,
a balloon-tired blue and silver bike,
most achingly of all a pony
with shaggy mane, a creaking leather
saddle, and sharp, jangling spurs to speed
us up and down the street for envious eyes.
Never mind the quick, adult response,
the city-squeezed backyard, its pitiful
swatch of grass, the missing stable, not even
a shed, no way to purchase needed feed,
and no one said one prescient word about
carting off the dung. No, never mind
all that. The want went madly on, hung there
for sullen days and weeks until—well,
until I saw a speedboat slicing swells
and throwing spray. Again, the want, the ache.

Letter to Our First Guests at the Shore

The day before you arrived, the fog came down,
thick and sudden, and the key, a quarter mile
off our balcony, vanished, a strip of land
like a submarine moored ages ago
in the glittering bay but submerged
that day by some inscrutable agent
roused to complete a forgotten mission.
The day before, the key lay there, crusty
with clumps of trees, but looking barnacled,
as if it meant to stay for good. The fog
grieved us—we wanted you to see this bounty,
clear sign of our luck, the good life here
on the Gulf. The fog persisted, dense and gray,
all through your visit, closed us in together,
comrades on the known ground of the past,
persisted as if to say you're not to see
what we have here now. Then you had to leave,
pushing away through the stubborn pall, without
the island bounty revealed for what it is.
And what is that? A place unpeopled, lived in
once, but swept so bare by hurricane
it had to be abandoned, peopled now by
shore birds, great flocks out there gathering
the plenty the tides lay down in their
sustaining rhythms, the birds, once sated,
turning to face the sun—plump breasts briefly
at ease, quiescent, before the swoop and scour
seize them again. While you were here, we found
it hard to believe the key was there at all,
not just a trick of memory. But there it was
one day after you left, still afloat,
steady in the sun. You must come again.

ROBERT BENSEN

Paraiso Terrenal

—from *Orenoque*

I enquired after the terrestrial paradise,
and wise men told me its mountains
scratched the circuit of the moon.
No two have seen it in the same place,
for of twenty who went, scarce three
ever saw it, and no one dared ascend
for fear of the face of the moon.

The mountains are surrounded by very deep seas,
and from the waters thereof
come the four largest rivers of the world.
The waters which descend by these rivers
make so great a noise they can be heard
at a distance of two days' journey.
All who live near them are deaf.

The sun in these mountains is there
day and night on one side or the other,
because half the mountains are over the horizon
and half are not, so that on top
is never cold nor dark, nor hot nor dry nor moist,
but an equable temperature, and all things
animal or vegetable never decay or die.

The waters of the great sea which surrounds the world
form a flank to those waters which are above
the firmament. And though on the fourth day
they were separated, they remain at the extreme edge
mutually joined together.

In that sea are islands, like the Fortunate Islands,
and the Sleeping Island, Brasil and La Puella, that find
it from time to time convenient to be attached
to solid land; and others, certain flitting islands,
which have often times been seen, but when
men approached them, they vanished.
The Isle of Eynhallow would sink before any
could reach it, until one would sail to it
without looking away, and holding steel in his hand.

As the like hath been of these Islands now known,
by report of the inhabitants,
where were not found of long time, one
after the other. And therefore it should seem
he is not yet born, to whom God
hath appointed the finding of them.

Huiio

—from *Orenoque*

With eyes of water, see him sleeping there,
at the bottom of that river, stone-shaker,
all night pouring its power over him,
making its medicine,
slow-rolling its maracas in his ear,
not the ear of clay, but the ear of water,
that hears in the rub of water
over the tumble of river-crystals
the feet of his mother Frimene running
from the house of the moon, her brother Nuna,
whose hunger was the fullness of light
shining down from his desolation,
whose hunger was the silver cup of the moon,
filled with the dark and starless night.

He rose and spread himself over her,
but she furrowed his face with her nails.
He had stolen the sun's birth-stone,
the ball of onyx with all the world's children,
yet to be born, inside, and she had hidden it
in her belly. The moon clawed at her all night,
but when the moon fled, it was tinged red,
and a scowl graven on his face to this day.

She fled to the river that was wider than she had run.
"Very well," she said, "if I cannot save my children,
I will swim as far as I can with you, Urinuku.
I will trust your depth, and these children are yours
equally as mine." So she married the river,
itself just born, that flowed sweet with her.
She felt herself lengthen, as her legs cleaved
to match the motion of the waves.
The river spoke as it caressed her,
saying that she would be Huiio, Water Mistress,
from this day forever. As she dove
her eyelids dropped as emeralds in the riverbed
and through the diamond slit in each center
saw down the length of her true kingdom
clear to the great rapids
where her son was already sleeping,
where she built her house under the shadow of his canoe.
The sun played on her yard in globes of light
shifting through the lens of the waves,
a cool green light that set her scales shimmering.

PETER FORTUNATO

Smilin' Jack

for Rose

By our conversation, by the beard, by the way
a man who hasn't shaved this morning smells—
I'm not talking about his character or
the weight about his midriff, and though slowed
in the spine hardly stumble-footed—
I mean Jack wears dentures and a wig, I mean
he's some kind of fruit, and that I like him.
Hands grimy when he orderly produces
a ballpoint, clicks into computation at the last
table, sitting in the last chair, in the last
room. I think he's going to make me an offer.

Do you know newspaper—not the words whose
imputations slide free of common sense
onto your fingertips implicating you—
I mean the insulating value of the printed page.
A plain truth. Wrap carefully those
glasses and plates, facts of the matter.
My mother is dead now these two months.
Today her lease expires. And Jack blinks at me,
sitting up, prepared to duel with figures, decentlike.
I crush ball game scores and standings into
hollow crystal globes. Remove a crucifix
from the wall. I'd say these sticks remaining
have some worthy purpose left in life. Now
let's deal, I think, noting that he's risen.

I've got forty dollars folded against
my breast, in the light rain walking
village streets I'll have to leave behind.
Dogwood, lilac, lawns in the rain
misty. This is how I mourn, passing
away from home made plain with knowledge.
He might sting me. I pause on this,
tap the wad in my pocket true. That's
money to Jack, money to me. And the landlord
gets his due: agreement honored, tenant's

property removed. My mother's remains.
I slowly unstitch emotion from her things,
rainy-faced, a pragmatist, impatient.
Back in the apartment, by the telephone
learn that Smilin' Jack can't scratch
the rest together 'till the morning, but
I trust him, don't I? He trusts me.

The morning paper, this morning the
coffee at the diner next door to the
apartment now vacant of kitchenware (the
cups wrapped and stowed away) and a break
in the rain so that I stroll, the paper rolled
under my arm and the paper cup radiant, fingers
stinging, walking back but I can't say home—
what henceforth will relate me to this place
highway side skirting the village whose
yesterday held my mother, my boyhood? My
father left here long ago, left her rooted
where she as a child stood: one mile from
the farm, last days in Ashley Gardens
thought elegant, spacious, conveniently located
on land that once housed the whole Kozlarek clan.
I played in this driveway under tall spruce,
rode go-carts, counted cows, sassy, invulnerable
among other youths where the Albany Post Road
is now jammed with traffic and shopping. Where
headlines have gone national with Wappingers Falls.
These thoughts spiral silent steaming off
black coffee poised at my lips in the lot
leaning against my parked car waiting for him.

We're here, here we are—Smilin' Jack at the door
with Rupert—you didn't think we weren't comin'?
You didn't think I couldn't get the money?
The money, the money I want for my
trouble, that is, the bedroom set, an easy chair,
the dinette set and kitchenware, two end tables,
a black iron birdcage stand, and crates
of bric-a-brac: what she left behind.
(I have the family jewels, the photos:
Dad at home, her at forty, me at twelve.)
So the clowns arrive, their routine practiced,
welcome. With solemn fanfare Jack unrolls
his roll of bills to pay the balance on the bed.
Like trapeze fliers greenbacks tumble

softly down upon the mattress. Rupert's
eyes are wide, he counts along, we count along
with his master who squints and lisps and licks,
his fingers peeling off the value
in dollars of a portion of my grief.

Rupert, oh Rupert, your shoes are in flames—
And Jack proceeds to lecture the lad, who
has lost some teeth, who has lost some hair,
who wears a bandana and brays about steak.
Winking at me: Rupert's okay, says Jack.
Who else but this clown works the day after
he's paid? You should see him down at Saint Ann's,
shovel in hand, those flamin' shoes in rubbers
digging up the ground. They got a spot saved
for Rupert, Jack jibes, next to the Bishop's grave.
One, two, three, life. One, two, three, scapping up
my mother's sticks to stack 'em in his shop,
he's really a good guy, this Jack of all scams.
And the vanity is gone, the matching settee
goes down three flights to the van, the chest of drawers—
Hey, man, says Rupert, I found this: Soft smile
in his hand, a bunch of silk, clump of scarf
he gayly tosses my way to unfurl
on the air like a dove. It settles on
my open palm. Must be from your ma, huh?

How will they ever pack it all away
into that ridiculous Chevrolet?
Goodbye the loudest racket in the lot:
I wave from apartment window, dust mop
farewell, a shower of sparks, the motes catch
sunlight behind them. Last glimpse of the bed
in which my mother lay alive and dying.

JOSEPH TREMONTI

White

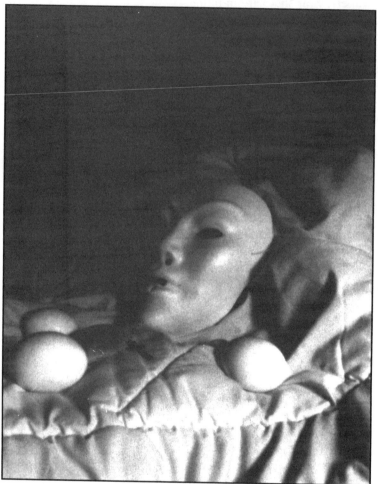

Black and white photograph, 8" x 10"

MILTON KESSLER

Secret Love

My father's back
heaves toward the sea,

and the stripes of his shirt
pull toward his right wrist,

which clerked mail into the boxes
and carried coffee for the bosses.

Now he needs a firm pillow to rest
the ache against as he reads

in his love seat, summer and winter,
the lamp by his good shoulder.

Yet watch him bend at night to lock
the stick of Judah in the terrace door,

or hear his tenor soar against the president
and injustice to the poor.

He is secure on his pension. He does not
use a cane at eighty-four or face the floor.

This is the back I lay beside in secret peace
during the dark daytimes after my

humiliation at school and before his invisible
war of work. He sleeps well still in flannel.

Thanks, Pop, and I touch his silky back. Then he
dresses to go out. We worry a bit more.

Today, my mother thought to reassure
and said, You'll live to be a hundred.

I will if you will, he said.
They shook on it.

At Three AM

The road
you take,

 concrete.

The wind dies,

 not you.

The radio dies,

 not you.

The Catskill Mountains

 survive.

Oh Miltie Kessler,
Miltie Kessler's

 alive.

MARY GREENE

I Let My Fear In

I let my Fear into the house. It was midnight. The moon was a gibbous moon, half-risen. I gave my Fear a tour. He did not mention my colored lights, my music. He stared at the books strewn over the floor. My Fear, when asked, spoke of Russia. The food, he said, was not good. He had to conduct all classes with a translator. My dog came and put his head into Fear's lap. I shut the dog outside. I waited for Fear to ask a question. Fear sat silently among the white cushions. At the door saying goodnight, Fear stuck his tongue into my mouth. It was a slick, slimy balloon, a small rodent wriggling against my teeth. I pushed my Fear out the door. We had an understanding. Without words, we agreed to dance.

I knew that I would sleep soon, but briefly. I longed for dreams of coffee, or snow. I fed the dog leftover bacon from breakfast. The night grew long, pulling against the arch of stars like dark toffee. The moon rose higher, and parted the clouds.

Dancing with Fear

Fear led her into the room. She danced with Fear, allowing Fear to lead. The drums lifted them into the beat. The floor was slick with desire. Fear held her strongly with yellow arms. Her hair flew wild over the dip of Fear's shoulders. Someone came with a tray filled with tiny cups. She took one and drank. She took another and another. She became drunk with her Fear, and the edges of the room turned inward, and a dust seemed to settle. She hugged her Fear and allowed Fear to kiss her, *a long slow kiss* that stuttered and held. She left her Fear, moving outside, out to the snow and the path leading upward over the hillside. The moon was a mantle over her shoulders. She was cold; her room when she entered was too hot. She hovered like a moth at the doorway. The room was virginal, with white pillows. She was jaded; green; longing. Her mouth took her in sips and refused sleep. There were footsteps toward the river. She walked in them exactly.

CHARLES BREMER

Earthwork

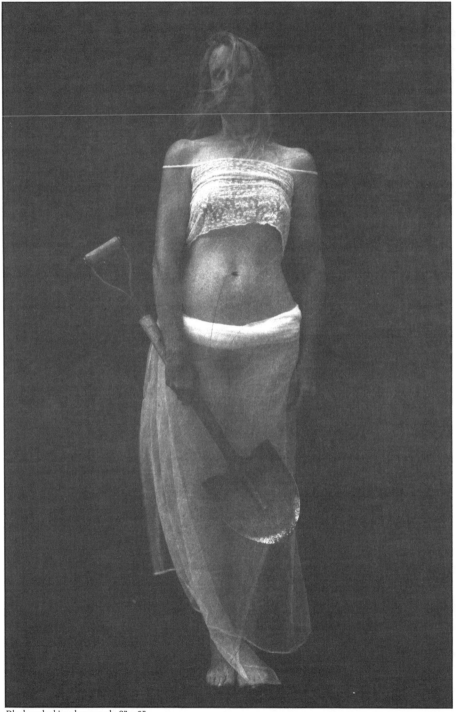

Black and white photograph, 8" x 5"

Environmental Pedestalism/Forest Management

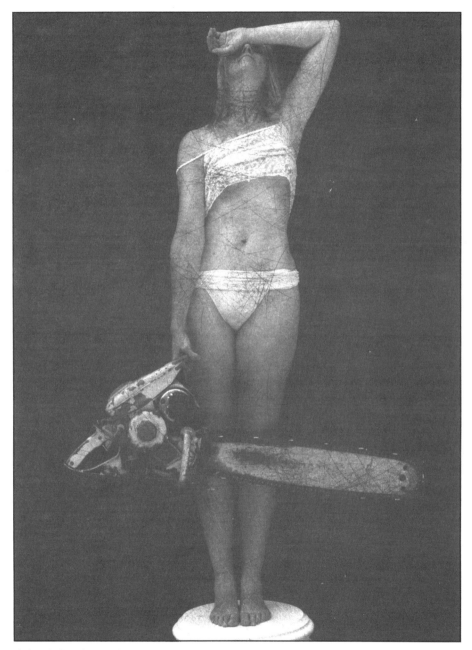

Black and white photograph, 8" x 5"

DORIS BROSNAN

Pool

the silk robe,
 moon-white and night-edged,
 slips off
 skims the curves of my body,
 pools at my ankles

I ease into the water,
 quiet ripples on the surface
 stroke toward you

 at the deeper end
 drawing me near

from *Catskill Haiku*

gray brambles bend
in November woods—
red berries on their backs

MICHAEL PERKINS

The Green Leaf Eats the Body of the Sun

I say the rose you gave me owns
The hand that took it from you.
I say the tall willow
I linger under owns
The sky that feeds it.
Possession can be quantified.
I believe the green leaf
Eats the body of the sun.

As I know this old house
Owns my living inside it,
And I know the music I hear
Owns the ears I give it,
So I know possession.
But I repeat: I cannot be possessed.
I will not be owned by another.
But something in me, like something
In you, possesses us both.

Poem on a Line of Akhmatova's: "I'm Not Yet Cured of Happiness"

Some dawn I will wake up laughing,
So crazy in love with morning
I will keep from it my dreams
And bury nightmares in the sheets.

One morning I will open the great atlas
Of places I've never been and walk inside;
Off again, out of his head, some will say—

But heedless down the road I shall dance
A fine Welsh jig, headed out into
Those beaming benign regions that lie
So far beyond sadness there is no echo.

So it is here we part. You must march alone
Into the swamp of despondency.
I have no sorrow left, and have
Forgotten the forlorn excuses of despair.

So when I bid you farewell,
I will wave and force out a tear,
Careful to cover my mouth
In case it's drawn to smile.

SALLY FISHER

Wind and Zen Ghazal

Infants sleep so silently we fear for their lives.
A leaf nudges the air; it seems to be a signal.

Wind makes things ring like gongs, makes festival
clappers of shattered boards, finds nests to lay bare.

The clapping of hands blew Prospero home.
"You know what causes wind, don't you? It's TREES."

An audience hates its passivity.
Do we breathe air, does air breathe us?

"What happens to us when our bodies decay?"
"It's windy again this morning."

Audience: Three Poems

1. The New York Philharmonic from the Front Row

Mahler sobbing over his Sixth, let him
sob. It's still a funny symphony.
Bravo! yelled a man
who thought it was over
or had to be first
or needed to be
the final crash,
to be in the score
himself.

The handsome first violinist
I'd secretly watched all through it
turned right to me laughing
and said Who was *that?*

2. James Brown Live at the Apollo

I can't tell
but I think he's in love with me.

Now I want you to know I'm not
singing this song for *myself* now! he said.

They have to drag him off.
They have to catch him in a net.
They have to throw a blanket over him.
But he makes his way out.
He keeps coming back,
practically eating the microphone,
holding it a carrot in front of him,
looking down at it like an ice cream cone.
They have to knock him down and drag him away from me.

3. Late Afternoon in the General Post Office

They were shooting a movie in the G.P.O.
and I was mailing a manuscript,
carefully watching the weighing, the wet
machine stamp half-affixed with a casual dab.
Behind me important milling, shifting,
mumbling, then orders to onlookers for
quiet, quiet.
The wooden clapper bit the air,
Action!

Action? They gonna get no action here.
All day long that man callin for action.
This the General Post Office! They no action here!
You call out for action all week you ain gettin any.

On the stairs someone asked Who's in the movie?
As if there's anyone who isn't.

DAN WILCOX ────────────────────

The Blues

The blues bounces across this plaza, off the buildings,
steel and concrete, marble and glass; through the open spaces,
fountains and pools with square corners,
the sculptures like twisted images from a colorized dream.

The bluesmen bend strings, make notes, wails, screams;
electricity throws the notes from black boxes across acres,
stretching the sound across the flat plaza,
around the towers, the trees, the playground,
loud enough to wake the dead,
 to wake the ghosts
of my grandmother and her parents who lived where once
was right here, in 1888, at 69 South Swan Street.
Ogilvie Grant Clark, the stone mason,
walked from here to there:
to the Capitol, still a block away,
to lay the bricks, the mortar, the marbled blocks
to make the steps that I've walked up.

He never saw these plastic cups for beer;
his wife, Martha, never pushed these aluminum strollers
that Anna, my grandmother, never rode in;
the sound of the blues barely invented,
the amplified voices would be to them like
Gabriel, like Joshua, like the end of the world.

Instead, Anna, in curls, a long dress,
runs up and down South Swan Street with a friend,
laughing, screeching, as the sun sets
over the row of houses, the stone stoops,
some still there across the street.
"Pipe down, Anna," Martha calls,
"be quiet or you'll wake the dead."

MIKE KRISCHIK

Sunnyland

how this sleep washes by
like something you try to touch
pinker than bodies after a roasting

the cannibal element of heels
 across a floor
someone's music calling you
& it's the same—

 a smile
 the pulse of a throat
 some kind of necklace designed to make you look
 further down
 but the eyes aren't hidden
 & you'd like to see her frumpy
 in a robe muttering
 to herself as she fixes dinner—

 this is important
& out there a bird
someone's lullaby
 to rouse you to respite
as the world prepares for the possibility
of some use for the sun—

 if you talk to me now i'll listen
 even as i shut my eyes & search
 the storehouses of this terrestrial encumbrance
 for something (i might bring home to you)
 but wait
 they dusted buster during a crap game
 & we're not so different—

 [some use for the sun]

how the golden light sustains our living material
through days so dim
 we died with roaches
in puddles of wine
nodding
across the laps of the most drowsy embrace
 this day finally become this day
as easily as i remember her
brushing the sand
 from her skirt

KIM ILOWIT

Jr. Militia

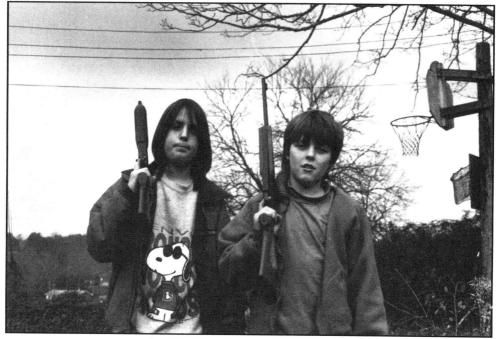

Black and white photograph, 6 1/2" x 9"

"Drove for a Day

and came. . ."
the Great American Novel begins
here, there, everywhere & ends
with winter, a custom house
in Albany
 who am I thinking of
what do I really know
 about him
or her,
 finish the making
of your own coffee
now drink it
think of fresh oranges
to be squeezed for her
not here, not here
in the white northeast
but back there where
I planted the trees
will bear when we'll
be gone, most likely.

What is a settled
nomad?

 Un triste sire.
nearly unreadable
as ink ran out
went upstairs came back & wrote:

who ran out of the appropriate color of ink
at the inappropriate moment—

had to go upstairs
recuperate the bird-named pen

& another speed, another angle
sets in,

as coffee kicks in
as writing becomes show

as I tremble towards day
forgetting the offers made in dreams

08/03/1992

this morning Columbus stepped five
hundred years ago onto this boat
& did what we all do all
the time:
 go to America
the simplest, the easiest, the most
unavoidable journey
—even he, you see, he, Columbus
who certainly knew less than
you or I, had no trouble
finding it once he set out.
You find it by doing it,
just do it, & if you can't do
that, you just name it &
you're there to it. Just say
this is America, or that is
America & it will be. This is
America.

Long After Dreaming of a Flounder

the distances are this much now
open both arms, hold out hands
this wide
like fishermen or children
describing their catch
but the catch was in the
coming across
at long last & undated
the lost notation of a forgotten dream
found now at arm's length
where arm can be & is month
upon month, half-year
or whatever measures
forfeited song
mouth upon mouth
as for love of a fish
I didn't go into the water
but stayed in the dream
a flounder in my arms
changing color from sea green
to earth brown
even there I was perplexed
as perplexed as I'm now as to the
when but who is to say
how can you fall in love
with a fish
there was beauty, yes,
& sexiness (the lips were those
of young Allen Ginsberg)
at this distance I do not
remember the feel
as I carried the flounder
in my arms, walked
eye in eye
towards the sink
what was I thinking
what did the fish
stand for, if not
itself, a novelistic
flounder from North Germany
or a symbolon for a flat earth
theory I could indeed
be in love with?
turned on the tap
that woke me from what
unspeakable act?

MALCOLM WILLISON

From the Thruway

The clouds are smoking off the mountains.
Pines, firs, cedars wedge their textures
into the filling fields edged by scarlet.
Golden maples are banked away
among the leftover summer willow leaves.

This year, the slopes
are richer still with grass:
In a cleared hollow
an old light-blue pickup truck
sits in the waist-high clover—
they must be looking,
picking, hunting,
making love
somewhere above.

High up, beyond, the Kaaterskill
shows its cleft, its waterfall
hidden by the forested humps
of hills that roll and close
as we rush by.

Illegal Camera: Amsterdam, 1942

In the courtyard
she smiles
and waves
before the group
overtowered by an officer.
The hidden camera
she must know is watching
clicks.
Within that instant
nothing has moved
except her blurred hand
a wand
catching a future
for her face and faith
or ours.

REBECCA DEMULDER-MIETZELFELD

Sightseer

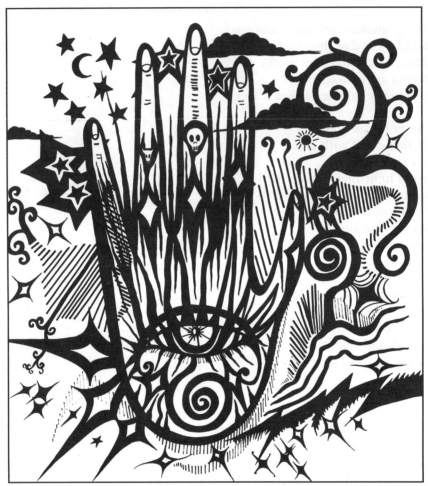

Pen and ink on paper, 17" x 14"

ALF EVERS

A Rattlesnake Met on Overlook Mountain

A rattlesnake lay across my path
Enjoying the August sun.
I paused and raised a hand.
The snake's relaxed body turned
Into one of taut gray and yellow curves.
The head pointed at me,
The tail rose and displayed its rattles.
I moved my hand again and this time the rattles whirred.
I lowered my hand to show I posed no threat.
I waited, motionless. It was early afternoon,
I had plenty of time to get off the mountain before dark.
The snake waited, too,
His rattling became less urgent,
It ceased, and his tense curves dissolved.
He flowed into the huckleberry bushes beside the path.
I stepped forward across the snake's trail.
Here on the mountaintop rattlesnakes have the right of way
At all intersections.

RICHARD PARISIO

Follow That Horn, Those Birds

Great gray wings glide through the silent
dusk: a great horned owl
gathers itself on a high perch in a tree
for vigil in the dark. Below, a woodcock
buzzes from the swamp, flies up unseen,
drops waterfalls of notes from sky.

Al Grey lifts his trombone, slides
the bar out to infinity, pours out a flood
of brass sound from his horn:
Take the A Train to America
again, again, beyond the known
to sunset under western hills.

What do we know? Where the owl
perches and the woodcock spins
his flights are past our boundaries:
new-found-land where we never quite arrive
but follow the ripple of the slide
trombone, the rumble of the bass.

An Easter midnight, born in the trembling
quaver of a horn, and birdsong, all the old
uncertainties, another voyage of discovery,
another day in the life of a fool,
a damn fool, says Al Grey, and I believe
and let the journey and the song lead on.

Follow the owl's wings into the dark,
strain to hear woodcocks plummet from the sky,
ride the long notes of a slide trombone
out of sight, out of mind, to a new gray dawn
when all the saints come marchin' in
to the country where we've headed all our lives.

Looking for the Rock Where Whitman Sat

Turning off the highway onto Black Creek Road:
Yes, there it is, the bridge, you said,
Let's look for it here. Leaving cars to scramble
down to roadside stream, we finally arrive
nowhere near a waterfall, no, not this curl
of water where the creek drops just a
step, no, this is not the place, this jumble
of broken concrete slabs, no rock
here singular enough to prop a specimen
day. We'll have to look elsewhere,
upstream, maybe, where the current
gushes and the rocks resist. So long
as we go on, eyes open, always
hoping to arrive, we are there already, or
anyway, as close as we can get. Sit down,
listen:
 water falling never lies, this stone
could be the one, sit down, be still,
say that you've found it, and go on.

PEGANNE BLASK

Council Rock at Otsego Lake

Black and white photograph, 6 1/2" x 4 1/4"

BOB STEUDING

Mountain Poem for Richard

Gary Snyder has said, "The mountains are your mind."

 (I tried to explain that darn thing,
 get it straight on Peekamoose,
 that side trail to the overlook,
 Graham and Doubletop in the blue distance,
 a hot, sticky day, blackflies in and out
 of the smudge fire.)

20 years of climbing these Catskills together
 rambling and talking.

 (There'd never be enough audio tape to take it all
down.)

And all those great names:
 Kaaterskill High Peak, Indian Head, Bearpen
Like reading an adventure book.
Wilderness west of Route 209 we used to say,
 and then laugh, knowing it was the opposite that was
 happening.

You remember the time we came down off Sam's Point
Leaping, flapping like crows,
And Steve made it to the bottom unharmed? Or
Glissading down Mount Sherrill with Klaus, now alone.
And that rainy backpack in the Blackheads,
Bill now gone west.
All those other people we took up into the mountains
For a glimpse of what we called the Catskill Mountain
Renaissance.

Now, no campfires above 3,000 feet.
The top of Wittenberg cut clean,
A pile of garbage on Slide as high as an outhouse.

 (We found our own mountains after those first years
 of climbing everything in sight,
 searching for all those crazy canisters on the summits,
 and never signing our names.)

Our beards are grayer now, hair thinner.

Old Pasture Horse, whom you named, no longer waits,
 not quite where we parked him,
At the base of Friday Mountain.
 (Maybe we should give that cliff-ringed peak a try
 once again.
 Sheets of slanting rain pelted the rockslide
 as we made our descent,
 younger then, if not crazier men.)

It's not just kids and wives
That help us mark the time passing time.
Not even this myth I'm weaving tells what it's been all
about.

 (Calls on frozen mornings,
 the endless ride in the drafty truck,
 the climb through hemlock,
 the rice, the snow-melt tea.)

It's being there, as some urban guru once said.

Old buddy, mountain brother.
Those quiet meetings in the mountains

 (how did Gary phrase it,
 something about elk?)

Help keep me sane.

ANTHONY SCALICI

Mountaindale

From a worn, wooden dock
 on a small lake, a summer night
 the beam of a flashlight
 reflecting, so still,
 on the water's bottom
 a snake

Where above and across its
 limpid
 green
 luminescent
 form
 small fish
 swam
 blindly,

Seeming unaware
 of the predator's gaze
 holding them there
 from the quiet dark bottom.

And with such delight
 that slow parade of color
 passed around and again
 the odd stage, bright by my light.

A frightful dance
 this animated night's
 defiance to death
 before me.

PIERO GIOIA

Route 206

Charcoal on paper, 14" x 16 3/4"

PATRICIA M. MCGUIRK

Bridlewreath

Bridlewreath is in bloom,
its heavy white a counterweight

to the
 ethereal
blue
of your eye's
 light.

A grounding device or
 diaphanous
strings
needed on this
 holey
heart, a
 lightweight, lifted
by unsustainable, rarified
 beliefs

 Like a
 flimsy
balloon rising

on warm currents,
heady and willing, not
harboring thoughts
of

 descent (Where
will it come

down?
How
damaged?)
when
 breath

 collapses.

MIKHAIL HOROWITZ ──────────

Three

1.

acacia stem

twisted in this
resinous window

into perfect
simulacrum of

a Chinese
character

& Chinese
too a form

of amber:
sealing a

people &
all their

ways with
all their

bones
intact

2.

Hunter
Shepherd

all those
wanderers

in the
night sky

the gleam
of myriad

fires like
the roil of

bubbles in
black amber

3.

hours later
back upstate

on country
road an amber

school bus
momentarily

captures
traffic

Three Untitled Poems

1.

not silence, but a pewter stillness
barely interrupted by the stuttering industry
 of a woodpecker
& by the act of this notation, empty of self-
 expression
 as the sky

2.

every night
the two cats
 the calico with the pipsqueak mew
 the tortoiseshell with the hoarse meow
decamp upon the
pillow, bracketing
my head

tiny lions
guarding a

dreaming library

3.

scratched on bark
invisibly penned on the tiny pages
 of pine needles
jotted by fungus on rotting logs
doodled by foam at the brink of the
 falls
notched in stone
& scribbled in twigs

the single word, *endures*

PAUL SMART

Full Circle

Colors arc the sky over Middleburgh
Backlit by rising storm clouds.
Cars slow up and down Routes 30, 145,
Checking out the miraculous:
For a moment, a second rainbow
Mirrors the first. I pull over.
There's a weathered Camaro stopped just ahead.

Someone I know has told me I'm too controlling.
She's inferred problems in my childhood past
and suggested I unearth their depths.
I've been writing notes to myself
About a loss of memory before age five,
An other brother I discovered three years ago,
And romantic failures and half triumphs.

In the valley, steeples rise into cleansed air.
The road, lined with parked cars now,
Is wet from recent rains. Gas butterflies
Glisten, several deer fill the mid-distance.
Smoke plumes rise between red and purple maples;
What's still green in the hills has darkened
Into something approaching the color brown.

The full arc wavers where it almost touches ground.
They say there is treasure
But I'm not ready to believe it.
The radio plays Faure's "Elegy"; sad cellos
Separate me from those I watch with.
I wonder whether the colored arc, shimmering,
Continues, part of a full, knowable circle.

Then, the sun washes it all. Vehicles move.
Heading north again, I pass two cops
Carefully checking speed limits, registrations.
From atop another hill I look back at what's passed.
Far off, down the Schoharie Valley, past Middleburgh,
The last remnant of double-arced rainbows.
I turn from the miraculous. Then drive on.

TOM O'BRIEN

Dark Sheen

Black and white photograph, 8" x 10"

EARL W. ROBERTS, III ——————————————

Visit to a Seminarian

Angry, tense young man, walking fast.
Usually, I'm in the lead but I can't keep up.

Official representative, I've come to find out,
to fix, but perceptions of self have changed this trip.
Twenty-odd years ago, *I* was the kid.

He appreciated my coming all this way,
but I represent the Conference.
I, who always felt powerless, embody
the Church's power, represent all that hurts.

"I'm gay," he says, directly, "and you don't want me.
How can that be of God?"

I want him. It's my Church that says, "No."
But I am that Church's man.

His Call, frustrated by the Powerful naming
what he calls sacred, sin.

And I? To my superiors *I'm* the liberal, the heretic;
homosexual apologist in the pulpit, *unfit* to serve the Church.

Am I *dishonest* to serve the Church?

A Myth of Hands

The border of my hand on the rock,
defined by paint and sweated limestone.

> In Altamira, Spain, and Lascaux,
> cave paintings of human
> hands have been found.
> No one
> has determined why these ancient
> artists chose to represent them-
> selves in this way.

I have my hand as a small child, pressed in
wet plaster, painted green,
my initials in the rigid block
letters of first writing.

> Years later I try
my hand to the cast. I am too large.
Yet when I search these impressions
with the bulbs of my palm
the cast is comfortable still.

> There are stylized paintings
> of animals modern artists
> envy for grace.
> Yet the human figures
> are static, thin lines
> around the captive bull.

Near the creek bottom a large swamp swelled,
and my cousin Jimmy, sunk up over
flapping rubber boots, nearly had to stay
there. He cried, wanting his life

saved as a child,
lucky for what's left
long after. He stepped out
of his boots as I pulled, then
wanted to say I had done an important thing,
but he had lost his boots in the mud.

One time I cut a hole in the bottom of a small box,
filled it with cotton, and with my finger
crooked through the bottom
claimed I had a severed finger
in that box. Found it along the road.
And even I,
touching my finger, expected to find it
cold, numb as a sleeping limb, flicked it
to frighten myself.

If you curve your hand into a crescent,
press it into snow, then poke five holes
at the top, there appears the print
of a bare foot. But no one
walks barefoot in snow.

> And an opposable thumb.
> The point of a thumb the last
> a gladiator saw.

I'm making angels, she said, on her back
in the snow, arms waving.
Not a bit of herself left, just angels.

Good hammer. Twenty ounce.
*But wait until you hit your thumb
with it.* Later that day, sinking
sixteen-penny nails, I did not wait
and walked the next hour

with a pack of snow
on my thumb, prefiguring the swelling
beneath, the cast it left candied
with the ice of loosened blood.

> The machinery of the hands.
> We must surrender with them.
> And yet they gave their hands
> to the rock wall, blowing
> through reeds, mouths
> full of paint.

My great uncle Charley had lost an eye
in the circus, matched by the empty

arm socket on that side.
Fine machinery stood the place
of the limb.
 Take it off me when I die.
And they did not clasp the good hand
to the metal kin. No rings, as Charley feared
the knives of grave robbers.

 What was left was not
 painted. Some missing fingers.

Touch and heal. And the preacher butts
the heel of his hand with divine force
on her forehead. The sick woman falls,
a thousand devils scattered with the blow.
I watched behind a movie camera,

unsacred, but I will not speak
of the stigmata, the last hands,
Michelangelo's fingertip touch
of creation, or of curled
hands on the ground of defeat,

half-opened blossoms of the dead,
nor of ginger fingerprints rolled
in ink, the delicate name left
in the mere brush of flesh, but
find myself driven

to speak of handcuffs
and custody, of the very fact
you and I cannot see
our hands clipped behind
the stiff, blind walls of our backs.

JOSEPH KURHAJEC ——————————————

The Temptation of Saint Francis

Woodcut, 13" X 9 3/4"

BARBARA WRENN

The Caretaker

He sits, staring, at the window, the snowflakes, falling
 One by one.
Notices the neighbors.
Waits for the mail.
He listens for the phone.

She slips in, behind him, the ax heavy in her hand.
Quietly, carefully, she raises it:
Shall I hit him with the sharp edge?
Bop him with the dull?

He straightens in his chair, sighs.
He arranges the pencils in neat rows, coughs.
He turns a page.
Is the water boiling, he asks, I'd like some tea.

BARBARA SCHECK ──────────────

Untitled II

Onion skin, dyed abaca, and hawthorne thorns, 45" x 22"

DOROTHY KUBIK

Stone Wall

He moved along the line marked out,
Inching stone by stone across his field,
Interlacing sedimentary deposits
And his own determined sweat.

With a chill November wind
Tugging at his dampened shirt,
Or perspiration rolling down
A face browned in the summer sun,

He lifted songs of ancient winds,
Locked in narrow layers
With the murmurs of swift flowing streams,
And the sands and storms
Of some primeval mountain,
And fitted them
Into a boundary line.

For epochs they had lain there—
Through lashing rain and biting wind
And the quiet violence of frost,
past the crunching glacial grip
That broke the heart of solid rock
And scattered it about
In slashed and ragged pieces—
Waiting for the revelation of a purpose,
The *raison d'etre* of broken rock,

Until he came—the savior—
With patterns in his hands
And plans and purposes
And strength like summer rain.

Hands browned and hardened,
He grasped millennia between his fingers,
Left bruised and sore from wrestling
With sandstone centuries.

He prayed: Keep out the plague
And death and the collector
And, most of all, my neighbor's cows.

Obediently they kept their guard
And bared their teeth to time and death
Who, laughing,
Mounted them and carried off
His neighbor's cows and him.

That might have been a hundred years ago
Or more, and still they follow his command,
Pursuing their silent meditations
Across a lonely hillside.

Perhaps they'll while away the centuries
Communing with the spiders
And the lichen and the moss,
Coming undone slowly
Here and there,

Unless some cataclysm
Casts them into disarray once more,
To await another savior
And another resurrection.

HELLA VIOLA

Silo with Round Barn

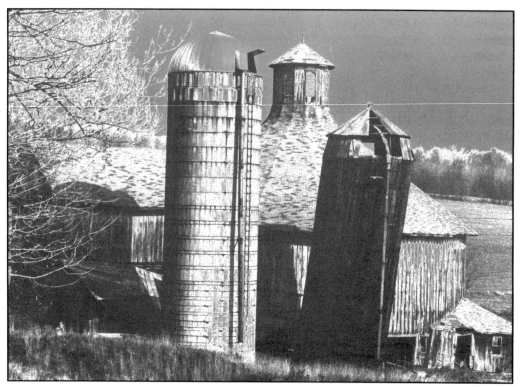

Black and White Photograph, 7 " x 9 5/8"

ALLEN C. FISCHER

Down on the Farm

The latest tomatoes
roll out of the sorting mill
like new rubber balls—

so round and firm, so
fully engineered.
At the bottom of the funnel,
in the cradle of distribution,
they find their place in history:

worm-proof,
rot-resistant, self-
ripening marvels.

A little time is all they need.
Grown in hot sheds and on El Dorado farms,
picked green, boxed and shipped,
darkness is their final field,
detachment their vine.

Blotchy opaque and waxed smooth,
their jelled bodies reveal a gerrymander
of vessels mapping fast flesh—
a genetic design taking shape,
its veins, the strings
men pull.

Down on the farm,
in the lab and processing barns,
they've drawn up
a new lease on life,
assigned cells an address.

The new tomatoes may
not taste vine-ripened, at least, not yet.
Though this fruit would never tempt Adam,
attorneys have their eyes on it.
Talk is about DNAs
and patents.

They're working on the future—
shrimp the size of mangos,
chimpanzees to do windows,
men who can do no wrong.

Brains

Mistake not the brain for a leaky bowel,
however slimy the cauliflower of its body.
Although clothed with hair and hats,
its feelings assuaged with therapy
and its ache with aspirin,
the brain does not yield to easy answers.
Early sufferers sought relief with flint.
Incas trepanned to release cruel demons.
Northern Indians opened the skull to find which
spirit was pounding. Besieged inside and out,
intellect has always managed a gloss for illness.
The French diagnosed *les enfants du bon dieu,*
the British referred to "public fools."

Closed in its bonehead, sheltered behind thick
books, the brain—picked magus of poetry—
peeks through two eyes and nods to the pulse
of its own polestar. After all, who knows
better than men of one mind, those potted
sources of so much wisdom? When the Egyptians
embalmed the stomach, liver, intestines,
and pancreas in limestone urns
for the next life, they overlooked
that odd membrane balled in the skull.
Carefully, they cured and wrapped the body.
But the brain! They plucked it out from the nose
and, not knowing what it was, threw it away.

JO MISH

Culinary Riposte

Take all my clams, my clams, yea, take them all;
What hadst thou then more than thou hadst before?
No clams, my clams, that thou mayest true clams call;
These clams of mine are of banded rubber formed.

And what there boils, toils, and troubles,
'Tis grease, a pool, and a foul floating thing.
A part of a cow named not that bubbles
Which givest lunch such an ominous ring.

What foods these morsels be say I, if foods
They be in some cafeterian speech,
Eaten by fresh men and sophomoric rudes,
By those who pander and by those who teach.

'Tis over this we war in pretzeled pain,
Faith will not protect from ravioli's rage.

RICHARD HENSON ————————————

Prophecy

Oh, I must learn starvation! I must learn
To husband memories against the drought
And desert time to come—not, at all hours,
Go thrusting them like grapes against my teeth
To tongue the sweetness out. They may not last—
How can I know if they will last? Divided
Days will last: no doubt I shall learn.

JOANNE SELTZER

Travels in Missouri

To experience a place
you have to make a commitment
of one complete moon.

You will witness the obese moon,
the anorectic moon,
the agoraphobic moon.

When you and the moon
do a belly dance
she will wave her purple cloud
through your red silk scarf
of earth's expression.

SUSAN SINDALL

Geography

Molly dozes
on the mud-black Nile.
Double-paned hospital windows
muffle the Chicago afternoon.

Her lolling, shaved skull,
tough calcium egg
on the first rosy dawn.

Her long-legged body
on the steel throne,
bound by immaculate cotton.
The alligator just waits.

Later, we sit close,
forearms nestled.
Her fingers clasp,
release me, and take hold.

I am ready
to go with her. She is fighting
to stay. Imperceptibly
she joined night water.

Today, in Virginia,
a blue bird
stands on top of cow dung.

ALAN CATLIN

Mahler's One Thousand and One Nights in New York

The dead tell stories in twelve languages
stolen from the tongues of nomad tribes;
waking up midnights in the city feeling
the moon lighting candle wicks, stirring
hearth embers, fallow hearts chilled deep
inside cold bones, casting off eiderdown,
a thousand chained voices, music that freezes
the lips is described upon window glass;
down below, New Year's Eve revelers watch
the glowing orb descend, chant verses of
an Auld Lang Syne, touch the sky, struck
silent in midsong; inside Mahler turns
the family picture album page, Marie the love
child, six years old again, no longer dead,
seems about to speak to her father
of a seventh year.

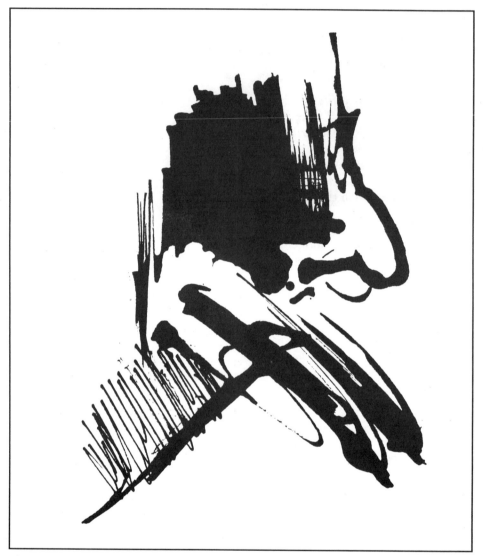

Ink on paper, 7" x 6"

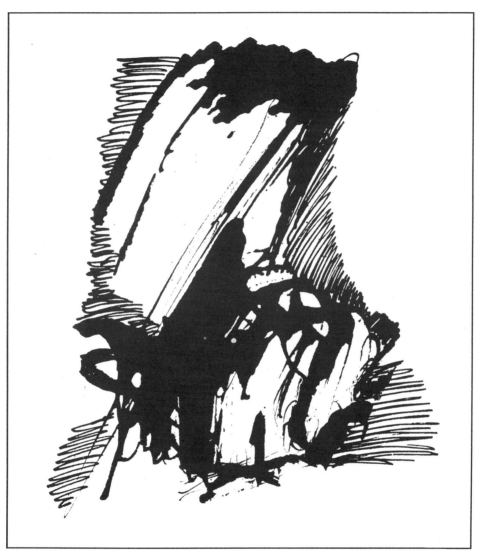

Ink on paper, 7" x 6"

SCOT ALAN SLABY ─────────────

Culling

In November, a few weeks after my mother dies, my father leads me through the
 damp grass of dawn for the first time:
We cull the wet apples as we go, speechless.
 My cold fingers get harder to curl
 around each red rounder beneath each tree.
We group the good ones on the ground in piles.
We walk home when I can't move my fingers or warm myself with my own breath.
Inside the kitchen, beneath the window where the sunlight dusts the air, I see
 my father's hands turn the sink's silver knob.
 The faucet trickles clear. The steam teems up.
 I put my hands under, they sting, thawing numb.
 Too quick to see, my dad swiftly caresses my hands.
 They ache as they're ground against his leathery palms.
 When he stops to warm his own hands, I twitch my pink-stiff fingers, re-
 lieved.
 He doesn't bother asking me if I'm warm yet, so I turn my head, and I watch
 him go behind me, out the screen door that slams light wood on
 wood.
He walks away, his wide flannel back hiding his bowed head, the heaviness in the
 hand he picks the apples with.

ANN ZERKEL ──────────────────

Solstice

1.

Summer began with a manhunt. Some guy
stepped shoeless into the noon heat
of Delhi, wearing a hospital gown.
Roadblocks appeared. Cars lined up
as troopers, flashing yellow lights and growing hoarse,
described his bony, tattooed wrist, his beard.
We had to wait our turn
to hear it, engine off. Flies
buzzed our hot faces,
our ears.

I asked you, *What would you do?*
What?
If it were you. Where would you go?

Later in the liquor store we chose our wine in silence. The woman
listened to her scanner, told us
the dogs lost him in the river, told us:
"I knew he'd go there. I live by Fitch's Bridge.
My daughter's home alone, fourteen years old.
I phoned and told her, 'Just be aware
and keep the doors locked.'"

*What if it were
you? Where
would you go?*

2.

An hour or two after sunset, say
ten or eleven o'clock,
when it's dark
but not yet cold,
fireflies fill up the holes in this valley.
Watching, we wonder
where they're going
when they flash and disappear.
We know the bugs have substance;

yet their disappearance
taunts us, how they go
leaping into darkness
at a depth we can't cleave.
The Delhi roadblocks came back down.
We heard no more about the barefoot man.
The solstice sun began its long
withdrawal. Here on the surface
everything's a little out of reach.
Tonight I catch a firefly
and hold it; my fingers curl
around each flash.
Green light seeps through the cracks.

Symmetry

My child's body
was perfect:

it could fit in one spot
all rolled up
or fly recklessly
off the seat of a swing.

My woman's body
is wily.

It sits chewing
my resolute neglect,
then throws it up
all over my upholstery.

Platinum/palladium print, 8" x 10"

HILDA WILCOX ──────────────────

Poem-Making

Before sleep
 I palpate dark,
finger it for soft spots where the merest touch
 would leave a dent;
and when I find one
 imagine I can use it some way—
like nail parings or a clump of someone's hair—
 then explore it, widening the spot
 with nervous fingers,
pat out a secret place I wall with words,
 shore up with steadying phrases,
where I can be a little friendly with the dark
 and listen for the sound
 of something being born.

WRITTEN AFTER THE WEDDING OF A YOUNG WOMAN FRIEND

I harvested my grapes tonight by porch light
and sampled one fat purple one
from every bunch I twisted off the stem,
for in this droning afternoon
I watched a bee
wholly without malice
pierce the dusty coat,
bore deep into the juice,
and leave behind the rind.

NANCY VIEIRA COUTO ————————————

Chemical Sins

> "...Ryder in his reckless, betranced quest for poetically lustrous surfaces
> committed every chemical sin in the book..."
> —John Updike on Albert Pinkham Ryder

So, Carlisle reflects, *art shadows life*
in both tenacity and dissolution,
and mixes another drink and thinks about

art and luminosity and Faustian
negotiations. *Life*, she reflects,
sucking a pimiento from an olive,

is luminous enough, all those tiny
pricks of light scattered along a space-
time continuum. Rattling the cubes,

she thinks about life, how it accrues
dimension as it jerks along, caught
in ratchets, and she measures out another

shot of gin and tears into a bag
of Ruffles and nibbles and reflects
on chemistry, what little she remembers

from high school, a clutch of rotten-egg
experiments, some graduated beakers
of hydrochloric or sulfuric acid,

lots of dirty Pyrex to wash
afterwards. She thinks about the stack
of dishes in her sink when all those lights

crackle, then suddenly start to wink at
random, eccentrically spaced
markers in some post-Impressionist

universe, all absurdly almost
within reach. A couple more drinks,
she'll touch them, fingertips a trail

of auras that ionize and glow
in the dark. But the chips are down
to a few greasy crumbs and she knows

a French roast and a Tylenol will work
their chemistry on the tenacious headache
she'll wake with in the morning.

After the Engaging Diversions

> "*This Town never was so full of Love, nor so full of Joy, nor so
> full of distress as it has Lately been.*"
> —Jonathan Edwards

It began to be more sensible: Carlisle
recorded in her diary of expenditures
four milk-glass compotes on pedestals,
one crystal candy dish, a Wedge-
wood trinket box, assorted satin pumps
dyed to match the eggshell pinks and aquas
of marquisette fantasies, five friends,
one discarded lover, eleven rolls
of film, and all those weekends forever
lost between Memorial and Independence

Days. She was a loser, Carlisle,
or a loner, take your pick. It all started
innocently junior year, the year
of the diamond tilting its faceted face
to the sun, expecting to be admired,
ooohed at. Carlisle, *though a thirst
for loving shook her* peau-de-soie soul,
somehow missed her step in the counting
off by twos. Left holding the bag
of obligatory confetti, she kept

her losses to herself as life brought new
experiences she guessed were the obverse

of loss. Her *planned and sensible withdrawal*
was just a change of venue in a world
where if a girl could type the world was her
cherrystone. And she could type. She got
sophisticated, cocktails, that place
on Montgomery where the waitress yelled
"Behind you, dearie!" then dashed a beeline
in front of you. The first to divorce

sent engraved announcements on black-
bordered vellum. *Soon a noisome stir*
infected all those marriages. If ever
there was a time not to be married, this
was it, all the old friends strapped atop
catch-me-fuck-me platforms, applying
one more coat of frosted aubergine
to their nails. Naturally they wondered
why Carlisle (as if stepping to some imp's
insistent "*Now! Now!*) turned and jumped

wholly into love, all gills
and quicksilver running blind.

WALTER PUTRYCZ

Woman with Cat

Black and white photograph, 8" x 10"

CASSIA BERMAN

Love Poem

for Khutumi

He fights with the neighbor's cat,
kills and eats small rodents,
and then comes home to me,
climbs up my clothing and snuggles in my neck
and teaches me how loved I am,
speaks with an energy more eloquent than words
about the cosmic love that encompasses us both

and I,
after pressing my face into his fur for awhile
and letting myself relax and be reminded and embraced by that love,
make telephone calls,
eat breakfast,
look at the clock,
turn on the computer,
grate against odd suppositions
and constantly forget

JANICE KING

The Mystic

a sprig from a furrow in the delta
she wears a petticoat of mementoes
and dresses her small hairs in aromas
of prophecy finger cymbals and laughter
mingle with the utterance of whistles and gourds

a corn broom, Mother's comb, the wren's nest, spittle
these mysteries of small intentions are not lost
to her the dance rutted dirt welcomes
every step of the pretty feet
which carry her in passage
from the corridor of the spirits
to become an axiom
of the dawn

Hemphill

Roi Boye
large & intentionally altered
by lamé and cognac
A rogue raucous & refined
fresh as dimes on a flute

I recall you
a song wearing red
a dancer of the barefoot winds
blowing harmonies up
in syncopated flight
raw & lush
robust from Texas

Papa Blues
in his own perfect time
squawking at the sun

PALLINE PLUM

Sex Between Two Mystics

Sex between two mystics
Is a heady business.
Bodies hardly seem to matter
Until the next day
During a tax audit
Or standing in a checkout line
This body
Becomes instantaneously sexual
Dizzy and dysfunctional
At the briefest thought
Of contact.

TIMOTHY P. SHEESLEY

Ocean Fire

Etching, 30" x 22"

Star of Hope

Lithograph, 12" x 10"

MARGOT FARRINGTON ────────────

The Gigantic of Miniatures

Perhaps only the tiniest stars
scattered in grass,
these white ones attached to the frailest of stems,
can show us our true station. And these

hats worn by the mosses, modestly cupped,
touched with rust red,
teach us respect for what we tread,
bend us from a selfish stare
to the lake of deepest looking.

And when our fingers wander among
these blue and purple doors of entry
five- or four-petaled
(one must count with extra care),
we hesitate upon some tenderness

quite forgotten until this moment.
There on our knees the deed
comes back to us,
a loving word, a kiss, that burns
the ground and dizzies us

ringing our lives like a huge, hunchbacked rung bell
up in the massive cathedral's emotions.

Magicians, Kindly Honor

Magicians, kindly honor us this evening as we lie
double-twined in knotted sheets
after the disappearing act.

For truly we were each other
in a coarsely exquisite illusion;
smoothly the flame-dipped movements

incinerated, fell away;
the orange tree bloomed for inward eyes.
Radiant doves spiraled up
 wildly,
over our ancestors' heads
from the blue realm where they watched
(deepest corner of our bedroom).

Now, of course, we lie sawn in half
with ragged panting. We wear
the invisible hats we drew each other out of.

With certitude we contemplate
the returned rabbit of calm
while it sits, pure and intense,

on the ebony table of desire.

KATE MCNAIRY ──────────────

George's Gulf

That was the year Esther, George's girlfriend,
and I pumped gas. Equality of the sexes and all that.

Esther arrived with a hollowed, blackened eye and
bruised skin, once in a while.

She might be clumsy.
I was 16, my first job.

We liked the Cadillacs, they tipped well.
Forget the Volkswagen hippies or Dodge-driven seniors.

Esther could find hidden oil sticks, pour transmission
fluid, and fix a stuck turn signal.

One morning Esther's wiry body and tangled hair,
her enthusiasm carried the place.

An El Dorado pulled in, overheated. Esther proudly
lifted the hood, checked oil, then opened the radiator cap.

Steam spewed forth like napalm,
all over her face, neck, upper body.

Days after the hospital, George drove Esther to the station.
Esther looked like a carnival, like someone you would pay

a quarter to look at, then turn away. Rivulets of
fire poured down her plagued, purple face.

George said, "Fill 'er up and gimme a lottery ticket."
Then he moved closer to Esther and kissed her.

He kissed her on her lips,
while I wiped the windshield till it vanished.

NORMAN SNYDER

World Trade Center, NYC, 1970

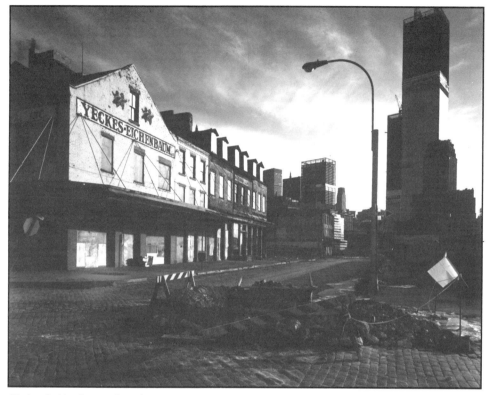

Black and white photograph, 6 3/8" x 8"

SHARON RUETENICK ───────────────

How to Live Your Life

> ". . .for those who are hot for certainties
> in this uncertain world. . ."
> > —George Meredith from "Modern Love"

Heed the instructions of angels
the omnipresent chant of seraphic wisdom
must not become background music.
Turn right at the church in the strange city.
Buy forty shares before the sun sets.
Bite into fruit offered by wandering peddlers
hair hidden under babushkas or turbans.
Beware of mediocre actors masquerading as poets
such pretenders will rob you of your soul.
Use this word, soul, often in your poetry
as it is forbidden in academic workshops
(they say it casts too wide a net
they forget the fisherman of souls).
Rest your cheek against your lover's thigh
ignore your hand that controls his desire
the very depth of his breath.
Pay attention to celestial directions.
Angels, too, must often be in pain.
Imagine those awkward wings forged
to your own backbone
with each gesture or movement
a particular vertebra burns
(they say angels sleep cocooned
they forget they slumber with their beloveds).
Remember, it is beyond your ken to note
the width of wings
the translucency of garment.
Trust only the anonymous humming
you hear when you brush your teeth
while you dance on the head of a pin
only obey what is audible.

The Night They Met

Moon crooked coy
come-hither finger
nails painted victory red
mambo, jitterbug
big band notes
wailin' torch tunes
liquid phrases
partner with her spangled dress
shimmy for the sailor boy's
endless legs flared
like Gabriel's trumpet
Angels scat
Heaven's message
boogie-woogie love
outstruts outblares
anybody's war
'cuz they got rhythm
hitherto unknown
discovered by forever young flesh.

Tonight moon splayed
hunts down my parents' heirs.

SUSAN FANTL SPIVACK

The Father

He presses back the burdock,
the notched grasses holding steady
for her eye the magnifying lens
above the six-petaled flowers, six
to a cluster, at the center of Queen Anne's
white lace. He points out
the one red petal, drop of blood
left by the Queen's finger, needle-pricked,
on this weed of the meadow.
He shows her, smaller than any petal,
the spider, weaving there.

She learns to look down the metal tunnel.
Finds the eight-legged transparency
moving on its web. She leans against him
while she studies this world
smaller than all her other worlds
and moves her back against his softly
breathing belly. Sheltered,
her fingers untaught by needles,
her heart uncaught by the boys
and their little pricks of love, she hums,
"Oh, Daddy! You look, too!"

Now her pillow's plain white fabric
catches her sleep. She dreams of flowers
while he talks by our bed lamp
of loving her and turns the long
lens of his future-looking eye
to and fro across the intricate
pattern she will weave from old thread
and patience she does not yet
know she has, to catch
her first, surprising blood.

NICK ALICINO

Jersey Boys

Scott, back in our virgin youth
you were the master at
parting money from parent
to finance our sophomoric stunts—
gassing up your Corvair
that rear-engine wonder
we'd bomb around town
flipping the bird to friends
running Chinese fire drills
buying Marlboros and Schlitz six-packs.

But extra-devious tactics
needed to be used to pay
for a Seaside Heights weekend stay
so invite your best pal over
Friday night for Grandma's
famous potato soup.
And in that congenial group
hit up the old man in
front of all. How could he
refuse. We'd be down
at the shore
by nightfall.

Oh, so convincing, with just
the right dramatic flair
you turned your billfold
upside down and opened it
the proof of your poverty.

Then I saw all vanish—
the perfect wave, the hotel room
the surfer girls. So close. . .

As close as the color and consistency
but clearly, Scott, not the liquid
result expected to fill up that
dried-out wallet-denter
afloat for all to see
as you crowned poor Grandma's
potato soup with you
well-traveled Triple-X Trojan.

ANN SAUTER ———————————————————————

Origami Mistress

You have no need for scissors
or paste
your shapes
naturally geometric
"almost mathematical"
you call them

and that thing you do that you call
fitting
the page

I call
a bird
but when you choose to put your hand into that cage
it is your voice that coos
calls it familiar

I don't call
that waxy winged thing
you call submission
I cut
his number into
a million pieces
even
as once I folded it—carefully—into
 a thousand random patterns
 each evolving— beyond the slow strength
 and tensility
of the wounded
 arboreal myths
 beyond refutation of odes to the
passivity of ice
 I withdraw
 a terminal moraine
 my hands—
 the wet winged purveyors
 of stones—wrapped
 in white paper—that is also wet—
and there I leave them
 in this place where a blade is tested
 not by heat
 but by evaporation

where edge is as irrelevant
 as dry defeat itself. So
you pull forth order—without visible effort
 you manifest
 call yourself
 from the deepest folds
the image of a sleek cat

 purring

After We Got Kicked Out of the Commune

Our names now permanently erased
from the revolutionary roster of the saved
who will see Che
in Heaven
we sat in the endless dirt
of a no-see-um dusk
dabbing at the tiny red chiggers with
somebody's old
nail polish
consoling Naomi—just fourteen—
with songs by Janis: A Pearl.
A Ruby pulled out her fiddle
and began to dance
and as she danced
the sequenced white ducks
she'd glued to her circle of red felt skirt
began to take off
up over her
stubby legs shod
in black Converse,
seemed to take off,
out of her red-dyed bush
shaved in the shape of a heart,
flying up
over her freckled moon,
into the equally red
twig-like branches of her braids
as they formed against the purple night sky
the perennial G-clef
of Red women
singing
the blues

Rt. 20 Cabin Court #3

Black and white photograph, 6 3/16" x 9 5/16"

Steve in the Bathtub

Black and white photograph, 6 3/16" x 9 5/16"

INA JONES

Talisman

I thought it would be different,
I thought we'd be going to Hawaii
about now, to walk tropical beaches
and pick up shells,
you in some sort of Archie Bunker shirt,
I wisely not in shorts,
yet always hand-in-hand,
pointing out palms and hibiscus
to each other.

Instead I'm sitting on a footstool
in the bathtub, repairing grout.
I squeeze the tube, press caulking
into a crack, wet my fingers
to smooth it. The last time
this needed doing, you were here.
You were no great shakes
at home repair. Here by the soap dish
you placed some tiles and they bulge.

Not for a million, though,
would I undo your work.
How long has it been
since this polished cell
heard our spirited argument?
I feel with my fingers
where you left one tile rough.
What peculiar form
a talisman can take.

After Absence

Was it only yesterday
I was flying in from Denver,
praising angels at thirty thousand feet
that Albany was purported snow-less,
even mild, a blessed forty-two degrees?

But the friend who had promised
to meet me didn't; she had sent
someone else, and this is
what happens: become dependent
and you're shunted, a conflict,
yet you can't afford high horses.

"Thank God," I said,
under my own roof again.
Home safe from the holidays,
at my age, is even better
than the holidays.
Today I poured myself a sherry,
put on Frank Sinatra,
at one point kissed a door frame.

When I did that sixty years ago,
I pretended it was Sam Arnold
or some other swain in my class;
now it's just a door frame.
It's my house, my tub,
my bed, my darling furnace.

Night has fallen
and here comes the snow!
The street lamp is wearing a veil
of dancing flakes.
Tomorrow, in gratitude,
I'll send three checks to charity.

MARJORIE DE FAZIO————————————————

Woods

The rustle of a jacket sleeve
The only accompaniment
To the rhythmic crunch
Of winter boots
In woods filling
Silently with snow

Dawn

The soft predawn light
Gives warmth
The snow is fresh

No footprints

Not the doe
Or the Doberman
Or me

Winds have made
Foot-high snowdrifts
At my door sill

The day begins

Holsteins

Mezzotint, 2" x 4"

Ole Scout

Mezzotint, 3 7/8" x 3 7/8"

DONALD LEV

Delaware County

for Bertha and Ernie

heifers cast
longing looks by
the sides of roads
when they're ready
syringes will
introduce
artificial
insemination to
dispense with
bulls who, like
other males that
spring to mind,
are considered
dangerous,
necessitating too
much expensive
fencing in these
milk & butter
hills

Peak Foliage in the Catskills

a little piece of time
like a clod of earth
a boy picks up,
pulls worms out of

color, form, & tragedy:
divine gifts of autumn

a radiance of apples

stout stalks of brussels sprouts

loud pumpkins
leering in corners

IRIS LITT

Winter Morning

While you still sleep
I scurry on small-animal feet
bring in firewood, start two fires
heat water, drink tea with honey
swallow kelp, light cigarettes
uncork the brandy, find my warm sweater
ponder the possible sources
of energy, heat, and light
then in the warming house
wake you for love
and obsolete
all other forms
of warmth.

PIERO GIOIA

Pulteney St.

Charcoal on paper, 14" x 16 1/2"

ENID DAME ———————————————————

SMALL REPAIRS

The urine in the toilet
is dark as olive oil.
The toilet is swaddled in towels
like a man with a sore throat,
an old man afraid of a chill.

The sealer is broken.
The bowl has worked from its bolts
in this oldest part of the house.
Each pull on the handle
creates a water necklace,
a choker around the base
which spreads shrivels paint slides through floorboards,
reappears on the living room ceiling,
a uterus-shaped cave drawing.

Two flushes a day the plumber allows me.
Three at most. No more.
He can't get here before Saturday.
He says, "I remember your house.
Your floors are funky." He speaks of small rottings
under wide pine boards
which shimmer on rainy mornings,
holding in quiet light.

He says, "It's not a big job."

Later, as I'm typing at the usual table,
going through the usual motions,
something swerves in my spine something shifts,
a small rearrangement
happens.

I recite recipes:
try heat try ice
reach up to the light bulbs
lie flat on the floor.

The floor makes room for me
as if I were a piece of furniture.
Never have I felt closer
to this stranger's house.

Time is what we both have,
our common future
a matter of waiting to be serviced,
needing small repairs.

I rub my hands across my body
as if it were an unfamiliar country.
I run my eyes over the floorboards.
They still hold a cool glow.

This house is 50 years older than I am.
It's much better at waiting.

JOAN MCNERNEY

Poem for Oneonta

We sleep with trains
dreaming in Indian names.
Otsego, Otsego long lake
of night trailing
snow showers of light.

In black walls of
solitude through
silent fixed stars
we search for trains
brightened by Indian names.

Neahwa Neahwa shadows
of Indian names filled
with fragrant spruce and
cool winding winds of trains.

Whistling this winter
long lonely trains
freight trains boxcar trains
riding past avenues marked
with Indian names.

We sleep with trains
dreaming in Indian names
Susquehanna Susquehanna
long hill of light trailing
this December night.

PAULA A. ALLEN-DESCHAMPS

Christine and Frank

Black and white photograph, 8" x 10"

SUSAN DEER CLOUD CLEMENTS ————————————————

Indian Tourist on Guided Tour of American Indian Art at the James Fenimore Cooper House in Cooperstown, NY

"All the objects in this collection were chosen for their beauty,"
the tour guide crows. She lifts one pale hand from her skirt ironed
to a smooth shine. Tourists crowd around her. A lone Indian tourist hangs
at the edge, fingers pressing petroglyphs into a dress long
like memory, wrinkled like the faces of the old ones
whose ghost bodies, ghost songs, haunt these rooms.

"Indians made no distinction between art and objects used
in everyday life. In their many languages, no separate word existed
for art." The tour guide waves at a glass case mirroring the crowd
ghost-like among the unseen old ones. "Consider these Huron moccasins,
how moose hair was dyed and needled into the hide." The tourists
bow their heads to hair pulled with exquisite precision into flower,
red, white, blue blossoms spiraling on a sky of black.

"Next, " the tour guide points, "are nesting baskets, one of three
left in the world. Here are underwater panthers beaded into a tiny pouch.
The Indians believed the panthers' lashing tails caused whirlpools and riptides.
The pouch nearby depicts the Iroquois creation myth, Sky Woman falling
from a hole in Sky World. Birds softened her fall until she fell on mud
piled by Muskrat across Turtle's back. Surrounded by a vast sea, Sky Woman
wandered in circles, Turtle's shell growing with each step into Indian-named
Turtle Island, *our* America."

The tour guide herds the tourists, the Indian tourist, the unseen
old ones, further into the James Fenimore Cooper House's two new wings
smelling of waxed floors, fresh-cut wood. Otsego Lake sparkles beyond
the middle room's glass wall. The guide barges through the Indian tourist's
Blackfoot grandmother slain by "Long Knives" in the nineteenth century,
strides through the Indian tourist's Mohawk ancestor, Chief Tiyanoga,
whose portrait hangs on a blank wall.

"As you can see by this Lakota buffalo robe, sun painted red in its center,
and smaller suns swirling in its corners, the four directions, for the Indian
the circle was sacred, everything moved in circles, all life radiated out
like the rays of a summer sun." The tour guide knifes back through Tiyanoga,
warrior slaughtered in old age. "This other hide, the American flag
on a pole in its center," the tour guide grins, "was decorated for tourists,
a commercial version of the winter count." She aims her chin at a buffalo hide

hectic with painted horses, warriors, bows and arrows, the dead.
"The flag pole was a subversive way to show the outlawed Sundance pole."

The tour guide ushers the tourists, the Indian tourist, the unseen ones
in, between glass cases imprisoning pueblo pottery, quilled woodland baskets,
bandolier bags, into the middle room. "This high, carved wooden figure
with its masklike face and holes for eyes to see through, mouths to speak through,
came from the Northwest. Some people ask if this figure is giving the finger.
Please note that's an index finger. This carving would have been used
in a potlatch. A person who acquired wealth would give away what she or he
 had.
For Indians, unlike for us, wealth wasn't counted by how many things you owned,
but by the riches you shared. Look behind the figure. It was hollowed out.
There the person hosting the potlatch would stand and speak."

The Indian tourist peeks into the hollow, drifts back to the edge.
The unseen ones look—her Blackfoot grandmother who could have taught her
how to bead beauty, her Mohawk ancestor who could have taught her
how to fight bravely and what balm to use on deep wounds. The Indian tourist
raises her eyes to the tour guide's eyes. "Of course," the tour guide adds,
a flinch of recognition in her brown eyes' amber light, "not all Indians
are dead." Her eyes glow like objects hermetically sealed behind glass.
"There are still Indians walking among us."

The unseen ones giggle, even though the tour guide neglects to mention
that Indians have a great sense of humor, especially the dead ones.
The tour guide stares at the Indian tourist, blinks, then squints
at the invisible canoes on Otsego lake. The unseen ones look
at their granddaughter, who feels such savage gratitude for being resurrected
from past tense to present, she thinks she will fill the hollow, give away
what's been left to her. The four directions of a broken heart. Easy laughter
for circling pain. Word-blossoms beaded on a black sky. A lone poem.

Tattoo

Pen and ink on paper, 4 3/8" x 4 5/8"

JANINE POMMY VEGA

The Politics of Insomnia

—Cholula, Mexico, August, 1995

I waited 'til dawn for the postcards
of Frida Kahlo sleeping, of
Diego Rivera with his mouth open
under the covers, of Pablo Neruda
snoring loudly next to the waves
They never arrived

I thought then of lesser pictures
portraits with steel lines
of artists caught and mummified:
Lorca, Max Ernst, Isabel Eberhardt
in her sailor suit
but I could not keep them

You admitted you could not sleep
either
we were mutually guilty
of pouring no pure milk of love
over bodies
tangled like piano wires

More than wanting to sleep
I wanted
not to wake you up
my lungs rattling like cellophane
with every breath, persistent
coughing ripped the silence

There is no going back to former times
when I could lose myself, and come up
like a swimmer
blessed by the deeps, spreading
drops of sea water hugely
over the blanket and your mouth

There is no getting around
death leaning on my chest
with bony elbows
If I could accept her

embrace her thigh and cover her
with kisses

If I could harbor no hidden
instincts of denial
and open the tomb of my heart
so the same music played inside
and out, and bathed us, you and me,
then possibly I could fall asleep.

Doorway

—Yumani, Island of the Sun, Lake Titicaca, Bolivia, August, 1993

I can understand the houses
built with no windows
and only one door

and the door
facing into a closed courtyard
of flowers, water jugs, and drying meat

After all day walking in the vastness
clothed in space, with the wind
to talk to

you want to come in
where it's dark and warm
and everyone knows your name.

BERTHA ROGERS

Easter Monday

for Ernest M. Fishman

Men who wear suspenders adapt
to April as if warmth
had been there for taking;
they easily discard
stiff brown coats to bend
under the hoods of cars, rake
leaves at roadside;
each man's broad back bringing
yours to me, your length, soaped:
you lean and turn while
the water pours over us
and I enter
the ellipse of your arms.

On the highway a cat, brought
forth by love, one pink ear
erect from graded macadam,
the sun filtering membrane
as if through a petal,
a portion of a rose window.

I could retreat from the line
we drew; part from you.
But you reach beyond me,
your Houdini hand cleaving tissue
as if I weren't flesh;
only illusion.

I tell you, I could be solitary
again; not allow
one hand to touch—not
the masseur's ten blind fingers
in his shuttered room,
nor your more probing ones—
no, I could be alone
this last time for all time
(but I consider your silhouette
against my easterly window,

the sun spanning the horizon,
leafless cherry trees,
blackcap briars).

I could turn back before
we rearrange the furniture to suit
(and you inside this room
with me, or I in your car,
you driving and musing, I
freely sleeping past mountains).
I am enraptured and appalled
by the homeliness of it.

Listen! Are we, any of us,
anything but brief appearances
in others' lives? As
Gabriel to the unsuspecting Mary,
to Joseph (in that smaller,
more restrained meeting), aren't
we also miracles, we who wear
no visible wings, announce
nothing more portentous than love?

WALTER PUTRYCZ

Black and white photograph, 12" x 17 1/2"

ESSAYS ———————————————————————

JANET LAUROESCH

Bird IV

Etching, 8" x 10"

Bird II

Etching, 8" x 10"

LISA HARRIS

In and Out of Boxes: A Process Map

March 15, 1996

I am lying on a futon, in a loft, with four pillows under my head. You could argue successfully that I am not lying down at all. On the floor is a box of tissues, a bag of Vitamin C lozenges, and a yellow tablet. I sleep holding tissues in one hand and a pen in the other. You could argue successfully that I am not sleeping because I am coughing—have been coughing for weeks. Glow-in-the-dark stars spot the ceiling, but they no longer have enough absorbed light to reflect. I can see them because of the increasing light of dawn.

March 16, 1996

I have been in a stupor, a kind of passed-out place for several days. I have not been going to work. I have gone under many times as I fight the bronchial asthma, and my reward for being there is that I am visited by a dream. That is why I am clutching the pen in one hand. After each dream installation, I pick up the tablet and write down what I have seen. Months later, I gather up all the scraps of paper from where

Excerpts from Chapter One

Splitting Sticks

I love my father more than an Arizona sky, and despite how lonely I have
been for him and how angry I have been at him for twenty-nine years, I will love him until I die. I love my father as much as I love secrets, maple syrup, and the smell of ink. I loved his sharp blue eyes, his handsomely crooked teeth, his one bow leg, and the way he manicured his hands. In late autumn, he burned leaves daily in an old oil drum that he set in the center of a pit. I miss him—both what I remember of him and who I imagine he would have been in his late eighties, the age he would be now. I see myself driving up to the house he built for my mother and for the children he imagined he would have.

The Hudson Valley fills with fog most autumn mornings, and the fog holds the smell of burned leaves the way I hold my love and anger for my father; the fog holds the smokey smell tightly within its moist folds. I hold one thousand images of my father behind my eyes in boxes of all different shapes. There are images inside each box, memories that I want, but I cannot always have. Sometimes I can open them and other times I find myself under water where the ribbons slip from my fingers and the box floats away. Smoke, water, fog, and a fire that burns—elements of my love for him.

I am opening a very small box. It has no wrapping paper, but it is tied with a red satin ribbon, and when I touch it, the red dye bleeds onto my fingertips; it is the red

they have been beside the futon turned couch and I take them with me to a writing residency.

Bronchial asthma makes me feel as if I am under water—the same tightened pressure I experienced the summer I turned eighteen and got caught in the undertow, the summer I almost drowned. These dreams feel as if I am under water, but in the ocean I did not locate boxes of all sizes tied with ribbons that bled and disintegrated in my hands.

April 4, 1996

The snow has melted enough for my daughter to ride her bike on the stone driveway. She wears jeans and her jacket, old sneakers, a hat, and gloves. I watch her from where I rest on the couch. When she falls, I rush and meet her at the door. While I am washing, then bandaging her knee, I remember my own first bike wound. Later, I use the memories.

of blood, but I do not know whose blood it is. It may be an animal's, a fish's, or a snake's. It may be human blood or the blood of God. It may only be ribbon dye and mean nothing. Blood is my teacher. It became my teacher despite other plans I might have had. I mean, I preferred the kind of teachers I was used to—a gentle one like the garden that taught me about growth and reproduction and harvest. I didn't think of the harvest as death, but instead I saw it as completion.

I listened to the teaching of the elements, checking thermometers to see which coat to wear, looking out the window in spring and fall to see if I needed an umbrella or a scarf. I remembered the teachers who taught me kickball and gymnastics as well as the ones who sank their fingernails into my tender scalp. Indifferent teachers blurred together into nameless, pale beings who could not remember my name.

An early lesson in blood was a cheap one, a torn knee—the soft container of my skin ripped off by the blacktop and the speed with which I fell from my bike. Other lessons came to me with blood as the teacher. Some I could anticipate, and in my anticipation I could shield myself, sometimes. My classmate falling on the gym floor, bones protruding through the skin of his leg; my girlfriend landing on her face on the basketball floor and her teeth lying there beside her.

Blood arrived between my thighs when I was eleven and my mother announced that it was normal and meant I was a woman. Every month from then until now, the blood has come to remind me of this part of who I am.

When my hymen broke, blood came again to tell me what I had lost, what had changed, in what way I had opened up. And I knew I was glad to be rid of incum-

brance of my value and sad to have let someone in I didn't care about—someone I picked right off the street in a moment of disillusionment.

When the blood stopped for nine months, I celebrated its surcease and listened with my heart to who lay in my belly. I felt the flutter, the hiccough, elbows, knees, and head.

The first time I saw blood when other people did not was on the battlefield of Gettysburg. It was my sixth-grade class trip, and we arrived amidst a stream of yellow school busses for the educational tour. Almost everyone else was thinking ahead to the fun part: a trip to the Hershey chocolate factory and then plenty of time to spend at the amusement park. And the boy I loved, Richard Morris, wasn't looking at me. So I concentrated on the tour guide's words and the battle he was describing.

"On the morning of July 1, 1863, John Buford's Federal Cavalry was patrolling the roads northwest of Gettysburg, on the lookout for rebels. The quiet market town of Gettysburg, which you see on the diorama in front of you, accidentally became a battleground when Harry Heth's Rebels, seeking shoes there, ran into Buford's Union Cavalry."

Confederates, a long way from home, walking barefoot.

"Buford's men were soon in trouble. He called on John Reynold's I Corps for infantry support. Shouting, 'Forward! For God's sake, forward!'"
That's when I began to see and smell blood. We had moved outside so the tour guide could gesture more broadly over the landscape, away from the safety of the panorama and into the real world: Devil's Den, Little Roundtop, the Peach Orchard and the Wheat Field, the Trostle Farm, Cemetery

June 1, 1996

I have begun reading about the Battle of Gettysburg. I am sure it has something to do with the new book which I haven't named yet. I find myself checking out books at the local public library on Gettysburg and reading them to quiet my mind.

Hill, and finally, the Angle, the focal point of Pickett's Charge. It is early June and the breeze is cool, the dew still wet upon the grass, but I am feeling so hot that I remove my jacket. July hot mixing with spilled blood, new blood. It is the tortured heat of the July battlefield, with no water and no shade. The more the guide talks, the stronger the blood smell becomes, and now I hear the wounded's agony.

June 8, 1996

At my first writing residency, I watch wild turkeys feed on the lawn outside the apartment that is mine—private and quiet. I am editing a book I finished within the past week. Editing makes me sleepy, and I am just beginning to recover from the bronchial asthma. I am taking Chinese herbs and visiting an acupuncturist who comments on my pulse, which always signals anger to her. She's right; I am angry about some old things, some new, some red things, some blue. She has told me to sleep whenever I am tired. I obey her. Her medicines and techniques have allowed me to throw away the inhalers and most of my fear. I believe I will breathe.

I have decided to call the new book "Boxes" and begin it with the story I wrote from the place under water where I went in my March dreams. I cannot tell exactly what the book is about, but I realize my back is tired. It is the place on my back that the acupuncturist has explained is my bladder meridian. It is connected to all my organs. I forget the new book and go to bed at one in the afternoon. While I sleep, I dream I am in Pennsylvania and I am selecting the best rocks for building stone walls. No one

in Pennsylvania that I have ever known

Excerpts from Chapter Two

Lifting Stones

Stones are used to build retaining walls in central Pennsylvania—red, orange, white, purple, and gray. The stone walls make homes for chipmunks, snakes, and salamanders. Sometimes toads and spiders seek the safety of their crevices, too. My father could not lay the stones well enough to build good walls, but he did know how to select them to bring back to town for building walls. He drove a red Chevy pickup with a rusted tailgate when he went out past Pine Glen to the deep woods around Quehanna, and there he picked the rocks to build his own and his neighbors' walls. Most stones were about two inches thick and about a foot across. When he selected the rocks, he also considered the effect they would have when they were combined into a wall: sizes, colors, shapes. He wore heavy cloth gloves to protect his hands and a green felt cap because he disliked his curly black hair. He had often wished he had his sister's hair and she had his. Hers was brown and straight, not noteworthy except for its shine.

I think my father liked the suspense of lifting the rocks. He named what lay under them in his stories—millipedes, centipedes, potato bugs, and nameless semi-

actually selected rocks for this purpose. They collected the ones they dug up when they put in their lawns, big rocks wedged in the Earth they were trying to tame. When I awake, I write down what I know about Pennsylvania stone.

June 15, 1996

I have decided to look up copperhead in the dictionary because I want to use the Latin term to make a formal sound in the book—reverent like Mass used to be in its ancient language. When I find it, I copy down the Latin, and add it to the story. I notice the second definition is a reference to Northerners who sympathized with the South. I spend some more time editing "Those who Hunger, Those Who Thirst." I am a structured person who sets tasks for myself and I set deadlines. I don't set them for creating. Creating comes to me. Editing I can force. I work for two hours until my backache returns and then I listen to the fatigue it signals and I go to bed at 7 p.m. The second definition points me directly toward the Civil War.

formed things living in their own world, a world of dark dampness that was their sustenance and their haven. He carried an old Maxwell House coffee can with him half filled with dirt, and it was in there that he put the best looking worms for his fishing trips.

He had come close to being struck by big diamond timber rattlers that loved the coolness found in pits. He never tried catching snakes; he tried to leave them be in the same way that he did not kill the insects he found under the stone. In the ten years he spent gathering stone for his and other people's walls, he only killed one snake—a copperhead, *ancistron contorttrix*. It was not one he found under a stone, but one he thought had been watching him for months, maybe years, from the periphery of the pit. Copperheads are gregarious and impressionable, with the ability to remember. About a year before my dad killed the copperhead, some lineman for the electric company had killed two and then nailed them to a pine tree up near the access road. Dad figured the snake he killed was kin to them—a child, a parent, a cousin, or maybe an aunt seeking revenge. And just as Dad didn't know what one snake's relationship was to another's, he figured the snake didn't know Dad's relationship to the lineman. The striking, then, was not personal, but linked instead to how like mixes with like, and in that mixing how boundaries are set and allegiances formed. He was man; they were snake. The linemen were men; the copperheads were snakes. Neither one holding any share in the other.

I didn't see it that way. I felt a kinship with the snakes and the centipedes, the rocks and the creatures underneath them, a kinship and an alienation that were as strong as what I felt with the linemen and most of the people in the town. I was a chameleon, an actress, a shape shifter.

Perhaps my father was a shape shifter as well, but he chose to shift and change in death, greeting me in pieces from the boxes in my dreams. While I knew him, he seemed solid as a tree, permanent as stone. He was a man who called things as he saw them, who used words as if they cost him money, but who listened with the same care and concern, as if he had to pay for the words from the other person's mouth, and that he would have to pay up at the end of the story. He listened with care, and he tried not to judge harshly, because judge he would, judge he must to make sense of what was said, to make sense of the world around him.

My dad, so the story goes, had loaded all but the last of his purple and red stones into his truck when he saw the copperhead coil to strike. "I must have smelled the snake first—that odd blend of cucumber and wet oak leaves coming from the air of a pine forest," he said. "My nose saved me. It helped me to move quickly enough to drop the big rock I still held in my hand on the snake's head."

June 20, 1996

I awaken at midnight. There's a clock on my night stand and a full moon over the hollow that runs along the eastern side of the property. I have been dreaming about the Civil War—a series of confused images—some from Gettysburg, some from Maryland, and a few from Alabama—red clay and kudzu. The dictionary's second definition of copperhead has triggered this thinking. I rise and go to the kitchenette to heat water for tea, and while I wait, I go upstairs to browse the library. In it I find a large reference book on the Civil War—text and photos. I return with it to the whistling teakettle and I begin to read. I become captivated by the Alexander Gardner photo taken at Antietam.

Mrs. Bangor is kneeling over me, and I am confused. I have been removed from the battlefield and am lying in an office. Mrs. Bangor is cooing at me and patting my hand. "We were just getting ready to call your parents, Eliza. Are you all right, dear?"

"Where have they taken the wounded?" I asked.

Mrs. Bangor looked at me nervously and then away, to the wall and ceiling, as if they would know what I was talking about. But I knew where the Confederate wounded were—riding southward on springless wagons for seventeen miles. I could hear their distant crying. And the Union men's groans remained loud in my ears, close at

I no longer cough. I sleep whenever I am tired. I have been walking in the woods looking for wildflowers and deer sign. I have finished an edit of "Those Who Hunger, Those Who Thirst" and I have been writing about the slippery zone between past and present, fact and memory. I phone my old friend who went on the Gettysburg trip with me in the sixth grade. I want to see what she remembers. When we talk, she reminds me we never went to the battleground, that the class who went before us was the last one to go. All my memories say I have been there, but I am equally sure that my friend is right.

hand. A harmony and a discordant sound of brothers, cousins, uncles, fathers, sons— men, noble in spirit, fighting for land that spoke to them about their roots as well as their futures. In the language of pain, I understood everything that their echoing cries named: honor, loss, love, death, courage, strength, and departure.

I don't remember going to the amusement park. My friends told me I rode the Ferris wheel with Richard and that he held my hand on the bus ride home. They say I sang along with the rest of the kids on the bus, sang "The Battle Hymn of the Republic" with gusto and "My Country 'Tis of Thee" with tears on my face, but I doubt them. I was not feeling patriotic or musical. I was feeling the weight of the stone walls that divided the battlefield and the heft of the gravestone covering seventeen acres with one out of every three graves marked "unknown."

BOB STEUDING ———————————————————

Up Into the Balsams

I sit here on the Catskill Escarpment Trail, looking out at the Hudson Valley. There is heavy overcast with some sun and a slight breeze. I can see faintly the smoke-stack directly out from me at Cementon. I notice that the smoke from the cement plant there spreads for miles up the valley. I can see this pollution clearly and am shocked. Two vultures riding the updrafts take my eyes away from the valley, and I gladly follow their majestic flight and watch them disappear to the west.

Nonetheless, I am content and at peace with myself. My new brown pack rests at my side, the old gray Norwegian rucksack having been recently retired. This marvel of comfort and efficiency lies next to my hickory walking stick, seemingly delighted to be out on the trail again. Over the years I have measured and cut many walking sticks of birch, maple, ash, and other woods, but this one, I think, has been the best, the strongest, the firmest, and the most pleasurable to the touch. The upper portion is polished by the caress of my right hand; the wood has taken on a deep red patina. In addition to a light pith helmet that I use as a sunhat and a plastic Pepsi bottle that acts as my canteen, I have acquired a folding camp stool, an unbelievable luxury for me. It is made of strong but exceedingly light aluminum, and is slung over my shoulder like a quiver. This experiment in Catskill comfort has been an unqualified success.

Here at the Escarpment, the wind rustles the scrub-oak leaves. A few spikes of goldenrod sway in the little meadow at the cliff edge, and there are also tufts of brown grass which cushion my barefooted walk. My "loyal old leathers," as the Greek warrior Agamemnon once fondly called his boots, rest pointing toward the gulf in front, as if preparing to fly away like a red-tailed hawk. If this is true, these good fellows, resoled so many times, have divined my own dream, one I have had at night asleep but one, I must admit, which returns to me, as it does today, when I stand on mountain tops. Why is it we cannot fly anyway? An animal with a brain the size of a pea can do so, why not man? How lovely it would be to soar over the Catskills' highest peak, Slide Mountain, and see the tops of balsam trees.

The closest I have come in actual life to mountain flight occurred many years ago—some time in the early 1970s—on the summit of Friday Mountain. Friday, if climbed from the Moonhaw, is to my mind one of the most difficult ascents in the Catskills. Be this as it may, I once climbed up the long rockslide on Friday and worked my way through the cliffs that ring the peak. There I entered a spruce-balsam forest so thick in places that I was forced literally to climb up and walk on the tops of the trees to move about the summit. At this moment, I felt as a hawk must feel, looking down on the valley of the Esopus below. My exhilaration was overwhelming. I howled like a wolf; then sang like a bird. If I had not had to balance myself on this springy surface, I would have flapped my arms in imitation of my avian friends. For weeks afterwards, I found myself rising up on my toes when standing still. I would look more frequently at the sky than the ground. It is a shame we cannot fly at will. I'd trade a great deal of what we can do just to fly. I suppose this longing to float up and away from problems, from crowding, pollution, from noise and strife, from ignorance, greed, and politics, from ill

health and unhappiness inspires some of us to climb mountains. It is the closest thing to flying, the next best thing to being a bird.

One rarely finds groves of balsam below three thousand feet in the Catskills, although there is balsam at lower elevations in places such as North and South Lakes. This first of American Christmas trees was sought in the eighteenth century for its ornamental quality, and its pitch, known as the Balm of Gilead, was renowned for its medicinal properties. Balsam needles also make a pleasant-tasting tea. The aroma of this beverage exudes good health, or the promise of it at least. The balsam fir, which generally grows less tall than the red spruce in the Catskills, is a beautiful plant. Sprouting bright, lime-green buds in spring, it is a strong and sturdy tree, its spiky needles colored a deep, blue-green. The balsam is a welcome sign on Catskill hikes, for when I enter the realm of the balsam fir, I know I am approaching the summit. Language cannot express satisfactorily what I feel when I enter this wild garden. Yet the words "up into the balsams" have become a sacred mantra for me, whose incantation generates a peace and stillness in me beyond all reckoning. Truly, these words summon up the image of a pristine world no human hand could create: of sweet fern along the trail; rocks covered with moist, emerald-green moss, indescribably soft; sunlight reflected from dew on leaves; the clear, bright song of gray-cheeked thrush, white-throated sparrow, and chickadee; the exquisite arrangement of spruce, balsam, and paper-birch trees. I touch this lovely place with my heart as well as my hand. My nose and eyes take it in. I merge with these mountains, with their wildness and their beauty. Each step I take in these holy mountains is an act of worship, the placement of boot on rock and soil a prayer.

And so I return to the Escarpment, the edge of the Catskills, and spread out my equipment, an assortment of precious essentials, across the meadow, by both design and chance. I linger, take one last look before the walk home. The sense of rightness I feel on mountains is rarely recreated elsewhere. But, of course, one cannot sit on mountain tops forever; one must inevitably come down to the world of other people, of responsibility, and of affairs. And there are delights and sweet necessities that mountains lack. Yet, realizing this, it is still difficult to leave. But go I must, and so I pack my things, sling the brown knapsack on to my shoulders, and retrace my steps toward home, hoping, as on every hike, to retain the warm glow I now feel, until one day soon I can climb up into the balsams once again.

WALTER MEADE

Chipmunk

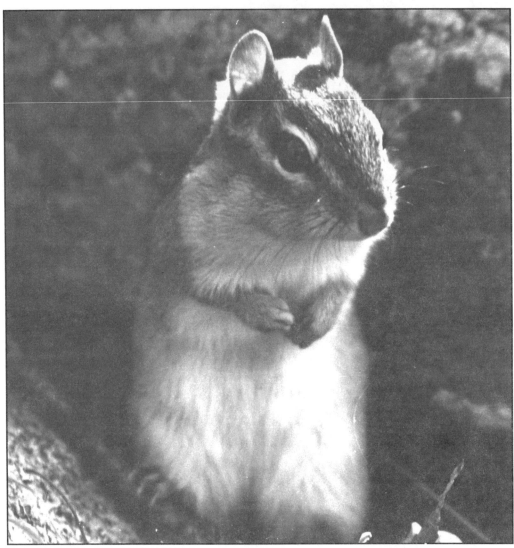

Black and white photograph, 8 1/4" x 7 3/4"

Sounds of Spring

Most persons associate the first signs of spring with what they see, not with what they hear. Yet there are many sounds that announce spring fully as much as anything visible. How often I have heard a winter-weary acquaintance say, "I heard a robin this morning, but I didn't see it."

Perhaps it is because winter is so dark, long, and silent that it is easy to forget the cheery sounds of spring. For weeks in the winter, it seemed that the only natural sounds I heard were the lonesome hooting of an owl from the gloomy depths of the forest, the occasional yipping, barking, howling serenade of the coyotes from the head of our hollow, and the soft, secretive whisperings of the winter winds in the hemlocks. These were only brief punctuations in the long silence.

Although the hush of the winter still remains unbroken, a small discovery in the swamp where I often walk signifies a change. The skunk- cabbage hoods have melted their way up through the icy crust and stand like miniature red tepees wherever I look. In contradiction to the skunk-cabbage prophecy, the weather forecaster predicts more snow and cold for tomorrow. Winter can be very stubborn.

Several days have passed, and I have seen little change. But this morning I sit up in bed wide-eyed as a big gobble turkey sounds off in the early morning light in the woods just above our house. I hear spring even before I see it. As I sit in bed and listen to the big male bird gobble over and over, I begin to think of the different sounds of spring.

Some spring sounds go unnoticed because they are extremely subtle: the dripping of snow water as the south wind helps the sun shrink the drifts; the first honeybees, who seem to appear at the sap-house door on quiet wings; the junco that flies away as I walk up the road and protests my presence with only weak twitterings. There are, however, plenty of spring sounds that no one could miss unless stuck in a horn-blowing traffic jam.

The tiny spring peeper, only about an inch across, has a voice loud enough for a creature two feet in length. And when dozens of these love-sick *Hylas* come out of their muddy hibernation, climb onto the land, and start calling to attract the females, no one can miss their powerful announcement. Yet few persons have ever laid eyes on these miniatures of the spring swamps.

Early spring is the time other members of the froggy clan move to the swamps and lay their eggs. Wood frogs float in the shallow water trying to attract mates. The unmated males inflate a pair of neck sacks almost like water wings and then emit a sharp sound over and over again.

Toads also move to water in early spring to mate and lay their eggs. The males are first to travel to the ponds, and upon their arrival they become very vocal. The amorous males balloon out their throats and sound a high-pitched trill to lure the egg-laden females into the shallows at the pond's edge.

Years ago I was attracted to a pond by the loud serenading of several male toads. As I approached, all became silent, so I waited for several minutes. Not one would resume calling. I tried my own imitation of their trilling by rapidly vibrating my tongue against the roof of my mouth, and it worked. One by one they puffed out their throats, and again the pond echoed with their voices.

Some female toads were there and had begun laying eggs. The smaller breeding males clung tightly to the larger females' backs and fertilized the eggs as they issued

from the females' bodies. While I watched, I saw a mounted male dislodged by a stronger male from the back of an active female during the egg-laying procedure. The defeated toad quickly took up a position in the muddy shallows near the toe of my boot. He immediately inflated his throat and trilled with an urgency that set him apart from the other males nearby. I started to move away and when I moved my foot, he made a mad dash across the roily waters and mounted the toe of my boot. Amusing as the misjudgment of the routed male may seem, it is another example of the intense rivalry that exists among breeding males of all wild creatures.

Of course, it is the birds that bring the most welcome sounds of spring. The chickadee, that quiet wintertime favorite at the bird feeder, breaks out whistling "phoebe" with the coming of the first warm days of spring. Many amateur bird watchers fail to recognize this spring call of the black-cap.

I am never as thrilled by any spring sound as I am by the first calls of the bluebirds. Often I hear them before I see them. I associate their return with our maple-syrup-making because many springs I have first heard their gentle calls while boiling sap in the sap house.

Another bird rarely seen when it first arrives is the wood thrush. As its name suggests, it is a bird of the woodlands, not the open fields. On our farm, we have an excellent wooded site where these birds nest every year. Our woods are located down over the hill, along a small brook. Because they are some distance from our house, I have, over the years, developed the habit of listening for this distinguished singer, rather than looking for it.

The wood thrush is treasured for its voice, not its appearance. This reddish-brown bird with a dark speckled breast fails to delight the eye the way its song captivates the ear. No description of the wood thrush's song is truly adequate. Its pure, flute-like notes seem to echo and re-echo through the forest, especially in early spring. This thrush will often sing late into the evening twilight. I have spent many pleasant hours watching the sunset fade while listening spellbound to my favorite songster.

When I walk the early spring woodlands, I often hear the drumming of the male ruffled grouse. This is a part of its unique spring mating performance. Grouse don't form pairs as many birds do but instead are promiscuous—which means that when the two sexes meet, they mate and go their separate ways. Then the male tries to attract another female with his thump, thump sounds.

The male usually selects an elevated position for his drumming act. He raises his wings and beats them against the air, slowly at first, then more and more rapidly in such a way that he produces a muffled drum roll. The sound carries for a fairly long distance, so any receptive hen within hearing can be attracted to the male.

I have found it very difficult to actually see a male grouse drumming. Once the wing-beating action stops, he becomes very alert. I suppose he is listening and looking for an approaching mate, and therefore he also detects any signs of danger. Only once did I successfully stalk a drumming male in an effort to photograph him. But to my dismay, when I advanced close enough for a sizable image on the film, I discovered so many interfering limbs and sticks that a good photograph was impossible.

I try to spend as many days afield in the spring as I can because it is such a special season. The sun, for months a cold glow in the southern sky, is back warming the earth. Snow melts, sap runs, birds return, and grass turns green again. Spring has very much to accomplish in only a few weeks.

Spring is the time of rebirth; courtship is everywhere, and it isn't silent. You can close your eyes and hear spring arrive. It may be the shrill call of the killdeer or the soft babbling of the brook that you hear because spring has many voices.

ROBERT TITUS————————————————————————————

A Night on Overlook Mountain

The road to Overlook Mountain used to be important. It served two main functions. It brought resort tourists up to the mountain's hotels. Several were built there in succession; they all burned. Also, it brought downhill lumbering wagons loaded with Catskill bluestone from the area quarries. Today, the road is no longer important. It can't even be called a road anymore; it is just a hiking trail.

The trip to the top of Overlook is well worth the effort as the peak offers one of the best views in all of the Catskills. To visit this mountain in the early fall, just as the leaves are turning, and to spend the night there under a rising full moon is one of the great experiences of our Catskills. The climb up the path is a bit tedious, however. The trail has none of the interesting steep, rocky stretches that you usually encounter on Catskill trails, just a steady, grinding incline. You know that the long climb is nearly over when you reach the old walls of the last of the Overlook Mountain House hotels. The ruin is a gem. Four stories tall and composed of poured cement, it has the look of something that will be there for an eternity. It won't.

Beyond the hotel is the mountain top itself and a state fire tower with its panoramic view. The peak is windswept, and large knobs of rock poke through the thin soils. The strata speak to the geologist and tell of the ancient Acadian Mountains which once lay to the east but are now nearly entirely eroded away. The rocks we see here were once coarse sands, sediment that accumulated on the slopes of those long-ago mountains. These are not sediments anymore; time has hardened them into rock.

Sunset is subtle: the afternoon light dims imperceptibly and then the sky darkens rapidly. This location has been here for four-and-one-half billion years, and the site has witnessed all of the sunsets that such a length of time brings. To the east, exactly as the sun descends, a full moon rises; it is the fabled harvest moon. The first lights to join the moon are the brightest stars; they are soon joined by the lesser lights of the full moon's sky.

I will have no fire at this night's camp. I would enjoy the heat, as it is no longer warm out. I wish instead to be alone in time here and I do not want any bright lights to distract me from participating in this particular cycle of time.

Off to the east are the Berkshire Mountains. These beautiful and serene hills are the remnants of the much older Acadian Mountains, which once towered over this horizon. It grows fully dark now, and the Berkshire landscapes stand in sharp contrast under the rising moonlight. As the moon continues its ascent, it draws away from the mountains, and they fade into the darkness. With an evening valley mist, the lights of civilization in the valley below also disappear.

The Berkshires were not always here, but it has now been 400 million years that the moon has been rising above their silhouettes. Before then, the view was not that of New England but of an ancient ocean, the Iapetus Sea, unblemished by any land masses, let alone mountains. Back then, it must have seemed as if that sea's stretch extended forever into the east. But that was false, and there were clues of something going on out there beyond the eastern horizon. From time to time, dark clouds of smoke rose above the horizon. First they were only low, dim, and distant, but later they appeared larger

and darker than ever before. There had to have been a day, a moment in time, when a single pinnacle of land first emerged upon that horizon. During the lifetime of any Devonian-age creature, no change would have been noticed, but as many lifetimes passed, that pinnacle was transformed from an occasional glimpse to a permanent fixture upon the seascape, growing larger and broader. Occasionally great, thunderous roars would emanate from that eastern monolith, and sometimes even lightning could be seen within the billowing black masses of soot. It was the nighttime and moonlit eruptions that were the most spectacular. The immense, rising clouds of dense smoke, sharply outlined in moonlight, would have been unforgettable—had anyone been there to remember.

In between these more and more frequent volcanic episodes, the peaks of the now great mountain range became white with snow. Even here in the tropics they had grown tall enough. Beneath the snowy fringe, the mountains were a desolate brown and lifeless gray. But as they loomed taller and closer, a thin low red horizon competed with those elevated but more somber colors. Then, finally, joining the red, was a very low wisp of green.

The Overlook Mountain vicinity had once gazed out upon the unbroken blue of the Iapetus Sea, but now it would witness the disappearance of that sea. The red and green horizon grew closer and the image sharpened into that of a low tropical foliage growing upon the brick- red soils of a coastal delta. These were the world's most primitive forests, dominated by the great tree ferns. Crawling the soils were the first land animals, primitive insects, millipedes and spiders. These were the pioneers of forest ecology, and forest ecology is the chief claim to fame of the great Catskill Delta.

The delta advanced slowly, but it could not be stopped; time cannot be stopped. The waters went from salt to fresh; they suddenly grew murky and brown, and the Overlook vicinity was buried. The shrouds of burial were the sediments of the rivers, lakes, and swamps of the great delta. These soft, warm sediments encased and preserved much of the delta forests.

Millions of years, then tens of millions of years of blackness followed. The pressure of the thickening sediment intensified. The great delta became a petrifaction, its soft warm sediments hardened into cold stone sculptures of rivers, lakes, marshes, and forests. After about one hundred and fifty million years of increasing pressure, the weight of the overburden stopped growing. And, after a long pause, the pressure, ever so slowly, began to lessen.

If it was possible for light to penetrate rock, even a little, then, over the next 200 million years the Overlook vicinity would have become dimly and then brightly illuminated. But this does not happen; light does not pass through rock, and Overlook lay, for all of this time, in complete blackness.

The sleep of Overlook was dreamless and darker than anything humans can know. It was deepest and coldest just before the dawn. Above, there were thick and heavy glaciers grinding their way southward. The full moon, now low in the western sky, brightly illuminated a plain of arctic desolation extending, in all directions, as far as could be seen. Only in the west were there peaks that rose above this crystalline sea. These appeared as silhouettes of black against the radiant moonlit horizon.

The processes of weathering and erosion do their work slowly, but they never quit. Glaciers do speed up the process, and the inevitable results are sudden: the breakthrough occurred, and sunlight, for the first time in 400 million years, warmed the strata of Overlook.

Just exactly as the harvest moon sinks beneath the horizon, the new day's sun breaks above the cloud banks of the Hudson below. This view, a Frederic Church masterpiece, has returned once again as it has for millions of years, and as it will for millions more.

I sleepily watch the sunrise above the low fogs of the Hudson Valley. Beyond there is neither an Iapetus Sea nor an Acadian Mountain Range to be seen, only the low blue hills of the Berkshires. I am stiff and cold and in need of coffee. That can be found in the lowlands below, where I will soon return.

Time, the English geologist James Hutton observed, gives us no vestige of a beginning, no prospect of a end.

CHARLES D. WINTERS

Horses

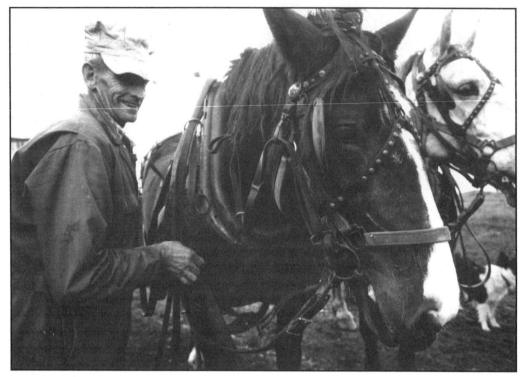

Black and white photograph, 5 1/2" x 8 1/4"

JENNY LIDDLE

Getting Milk

Five o'clock is a good time to get milk. So I turn down the pot of soup to a simmer, grab the brushed aluminum milk pail, and load the two kids into the car. This time of year it gets dark early, the weight of November anchoring the vague afternoon sun close to the horizon. As we climb the hill and round the corner, the barn comes into view, its little mullioned windows glowing yellow, foggy from within.

By this hour, Wayne and Meg are usually done with their supper, and I find them in the barn, beginning the evening chores. The barn is old and weathered gray with only a vestige here and there of its former red paint. Built against the hillside, sheltered from weather, it has survived years of neglect and cob-jobbed repairs. Sway-backed and leaning, propped and sistered, it has somehow melded itself into the hill and will probably stand until the blade of a bulldozer fells it some day.

The kids are out of the car even before I've turned off the engine. They disappear through the narrow space between the sliding barn doors, into a shaft of light.

"Stay away from the backs of the cows!" I yell, trying to be heard over the drone of the surge pump. "You know what can happen." I don't need to elaborate; they're fully aware of the dangers of standing behind these docile yet sometimes unpredictable animals. But it's my maternal duty to warn them, just the same.

Inside, I face a row of cobweb-laced light bulbs shining from the low, white-washed beams, a path of light illuminating the sawdust and random tufts of hay covering the concrete runway below. The air is warm and vaporous with small cloud puffs from the short-breathed cows. Down at the end, the kids are talking to Wayne as he shovels silage, carefully portioned for each soft, wet mouth, onto the floor. The kids like Wayne. He's short and big-boned, black-bearded, and always with a broad smile. His huge hands are strong and calloused from a lifetime of stripping teats. Only after knowing him for several years did I notice the missing last joint of his left middle finger, undoubtedly a farm accident but I never asked.

"Don't bother Wayne," I call. "He's trying to work," though it's clear that he and Meg enjoy the kids.

The milk house always smells of warm milk. The sparkling, stainless steel bulk tank is set right in the middle. Meg's in there, cleaning out a tentacled milking unit in the long, round-bottomed sink. Beneath her red bandana Meg has natural strawberry-blonde hair, and the mercurial temper to go with it—or so I've heard. I've never seen that side of her, but, just to be on the safe side, I always try to keep our conversation light: I avoid talking about subjects like the welfare cheat down the road, the school budget vote. Meg's a good-looking woman, handsome, green-eyed, a hard worker.

I open the top of the bulk tank and dip my pail into the still-warm, swirling white milk.

"How's everything," I ask.

"Oh, pretty good," replies Meg. "I'm a little stiff from being on my hands and knees all week. I'm cleaning out the shed. It hasn't been done in probably twenty years, so I'm finding all sorts of old things." She doesn't specify what she's found. I imagine all the neat stuff that she's retrieved from amid the old Ballantine cans, empty hoof-coat

tins, and greasy, half-rotten rags, remnants of countless tractor oil changes.

"It's a good thing I wasn't there," I say. "I would keep every last thing." and I probably would have, too, convinced that some day I would be glad that I had. But Meg, being a practical person, is getting rid of stuff, getting rid of stuff that weighs a person down.

Wayne and Meg are talking auction these days. They've pretty much made up their minds to sell out come spring. For them, it's an exciting prospect to be free to travel, to be free of the never-ending toil in the fields, in the barn. I understand how they feel. They're the last ones in the hollow, have been for a long time now. Their kids were a big help on the farm, but they're grown, and gone. Wayne and Meg are making a choice: get out while you're still young enough to do things, not when you're old.

I can understand it, but I'll feel a loss when the gray steel livestock trucks arrive to take away the trusting herd. I know that Wayne will stand there, clutching a stick to prod the lone dissenter back into line, onto the trailer, as he's done since he was a small boy helping his father, bringing in the herd for the evening milking. He'll share a joke with the hauler, but I know his smile will belie his heart.

This end of the hollow will not be the same, and I think of all that we will lose. Wayne and Meg's farm is our last—its freshly mown hayfields, raked into soft, fragrant rows; its leaning hay wagons traveling slowly, a tanned arm gesturing to the car following, waving it on. At my house the predawn milk tanker passes, its headlights moving across the wall above the bed a signal to wake. I can hear the driver downshift up the hill as he rounds the corner.

"Come on, kids, we haven't had supper, and there's still homework."

I thank Meg for the milk, and mark on the fly-specked calendar from the dairy supply that we are taking a gallon on November 3rd. One rainy day, Meg will sit down at the kitchen table, go through the calendar, and add up what we owe. At the rear of the barn, Wayne waves goodbye from between two slowly swaying animals, his arm a ship's mast.

The kids and I go out into the crisp night air; we pile into the car. I turn the headlights on and back up beside the Agway fuel tank. "Be careful not to spill the milk."

Abbie steadies the warm can between her legs.

"Seat belts," I remind them, even though we have less than a mile to go.

NATON LESLIE ——————————————————

Nineteenth-Century Women

Gladys Moser was on the phone again. She was horribly afraid of thunderstorms as she claimed ball lightning had chased her when she was a child, so when the sky darkened to a bruise and the winds picked up, she called me, asking me how bad I thought the storm would be. What she really wanted me to do was come over and sit with her until the storm passed. She was 96 years old.

I met Gladys when we bought the old house next to hers. Our house is 120 or more years old and belonged first to her grandparents and then to her and her husband after her parents died. She had lived in the house next door since she was born. "Let me tell you about your neighbors," the last owner of our house on McMaster Street had joked immediately after we had signed the papers, telling us of Gladys's peculiar and demanding ways. I wasn't concerned, though; I'd had a number of difficult neighbors in the several places we had lived, and usually befriended them. Mrs. Moser would be no exception. And she wasn't, and was.

In fact, I find opinionated and stubborn people often become among my best friends. Gladys, though, tested that theory right away. I got off on the right foot with her, but it was accidental. Behind our houses are two small barns, two-storey carriage houses which border a service alley. When our houses belonged to Gladys's family, the Gardiners, her parents and grandparents had run a livery stable out of the barns, the structures joined with a lean-to shed making one large building for their wagons and sleighs. After we bought the house, I began working on the barn. It had been used as storage by a string of tenants since Gladys and her husband began renting that half of their property, and the barn that went with it, in 1936. It was full: metal bedsprings, an old freezer, doors and windows, a brake-pad grinding machine, boxes of old rags and piles of construction materials. So the first thing I did was start cleaning it out. I contacted a scrap-metal dealer for the old machinery, and began sorting through scrap lumber and old windows. I had not met Gladys as she was pretty much house bound, living in the second storey of her old Victorian.

But she was watching. I soon met Chuck, a pulpitless preacher who worked for her. He told me she had already decided I was all right. "That's the first thing I'd do," she had said to him, "I'd get the barn cleaned out." Chuck had an arching grin when he added, "You sure got on her good side." I couldn't wait to meet her, and I wouldn't have to wait long.

I've frequently had an elderly woman in my life—in fact, I've had one almost consistently as both of my grandmothers are still alive. In addition to elderly relations, though, I've often had a friend or acquaintance who is an elderly woman. She might be a neighbor or a relative of a friend, but I've always found knowing an older woman to fill some need, or serve some purpose. I've spent hours in carefully arranged parlors or sitting rooms, mindful not to dishevel the lace covers on chairs or end tables and sipping a little tea or a too-sweet cold drink, and listening. And I like to listen to them, no matter what they talk about, no matter how disconnected their topics or tales. My father's mother tells wonderful, crocheted stories. She begins with one point, but like a jazz musician she detours, returns to the refrain, and digresses and describes before she ends there again. I like to sit and listen, nodding at points so she knows I'm with her. She can cover far-reaching territory with her stories, and can remember intricate details,

such as what she cooked for dinner when a cousin visited forty years ago or what my father wore on a particular day.

Part of this recall is due to rehearsal: she tells her stories repeatedly, and began telling them so soon after they happened that various details became firm and interwoven. Once, at a family holiday gathering, my grandmother began telling a story to everyone in the living room of my parents' house. Often, when my assembled family begins hearing one of her stories, they eventually drop out, either softly beginning their own conversation in the corner or wandering out of the room. Soon I am the only one left listening. Though I'm sure it doesn't bother her, I know she notices when the last person has left or has started talking. Then she turns to me, knowing I'm still with her. That's when I begin my chorus of nods and gestures, encouraging her to make her point.

This time, though, everyone was listening. She was talking too loudly to be ignored, and I also remember that she had been asked a direct question, and this was her response. General conversation could not continue until she answered. My father, always impatient when someone else is talking, finally blurted out, "Come on, Mother, would you get to what you want to say?"

My grandmother's head turned sharply toward her son. With one hand on her hip, and leaning forward, she huffed, then said, "Well, I'm not going to tell anything if I can't tell *all* of it."

A decade before, my grandmother would have risen to her feet as she spoke, but these days her anger could not overcome her advanced age. But what she said might explain why I like the company of elderly women: they have so much to tell. And, as they get older, what they have to tell becomes more elaborate, more unusual and more urgent. They speak of things no one else can remember, and they either must tell *all* of it, or not bother.

It didn't take long for Gladys Moser to start telling me things. At first, she told me what to do. I was working on the house, making lists of jobs to be done, maintenance and improvements, and Gladys added to these one day as I met her in our adjoining backyards. I was working in the barn when I saw her inspecting her bushes and perennials. I walked over, and after I introduced myself she began complaining about the previous owner of the house, a local lawyer who had rented the building as two apartments for almost thirty years.

"They say I'm a fussy woman," she admitted. "Maybe too fussy. But when they painted your house, they didn't tar the porch roof. I watched from my window and, as they painted the porch posts, they'd rest their brushes on the edge of the roof when they moved the ladder."

She was a small, nervous woman, working her hands together like she was making a hamburger patty as she spoke. I listened, nodding, though I knew there was another point in the making.

"When they were done, they left white marks all over the roof, and paint sticks and rags they threw up there. Oh, it's a terrible mess, and I have to look out my window at it all the time, and it bothers me," she said, her hands mashing furiously together. "Have you ever heard of such a thing, painting a house and not doing the roof?" she asked, and I shook my head.

Then nearly weeping, she said, "I wish someone would get up there and clean all of that off!"

Of course I was that someone. I said that I certainly didn't want a bunch of rags and sticks on our porch roof, but didn't own a ladder to get up there. She said I could

borrow hers, and before I knew it I was up on our porch roof, an L-shaped, wrap-around "Saratoga porch" which had persuaded us to buy the house. Up there I found a tiny rag, no bigger than a handkerchief, and a small, paint-stained twig.

"Is this what you mean?" I asked Gladys down at the foot of the ladder. She nodded yes. The next summer, when I brushed a fresh coat of tar on the roof, I knew she was watching and, sure enough, the phone rang the moment I finished. "It's beautiful," she said, real gratitude in her voice. "You did a good job."

Another neighbor spoke with disdain, even anger, about Mrs. Moser. He said they had nicknamed her "the Mayor of McMaster Street," because she tried to boss everyone on the lane. He claimed she probably still thought she owned our house, but I knew, even from one meeting, that Gladys was not confused. I could tell she would have to be dealt with carefully, but one thing was certain: Gladys Moser was very much alert and aware.

And that's another thing I've noticed about elderly women. They're easy to underestimate. These are the last nineteenth-century women, women who were expected to appear "helpless"—add advanced age to that learned stance and they can seem so needy you wonder how they live alone. On the contrary, though, the strength of elderly women is one of the things which draws me to them. Jenny Baker, an older woman who lived across the street from us in Athens, Ohio, had plenty of help with her little old coal-miner house on the West End, yet she accomplished some remarkable feats when help was not available. Like Gladys, Jenny was a small woman, but once, as I sat on our front porch drinking morning coffee, I saw her walking with a rope dragging behind her, far in the back of her long, narrow back yard. She was moving slowly and, as she rounded the corner of her house, I saw she was dragging a galvanized basin, the rope attached to the handles, across the dewy grass.

When I crossed the street to check on her, I found she was hauling old cast-iron drainage pipe to the curb, pipe dug up in the back alley by the city road crew. A small pile of iron already on the curb showed she had made more than one trip with her bucket already. I moved the rest of the pipe, careful not to say, "You shouldn't be doing that by yourself." To me that's one of the stupidest things to say to an old woman who lives alone—with whom do we expect her to do such things? Jenny was coping with the task as best she could, using ingenuity and patience in place of strength. Likewise, grandmother Harnish, in her nineties, scrubbed floors while sitting down, and canned vegetables from her garden until she had enough to last into her second century. Even frail Gladys, legs swollen, would walk a lap around the barn in the back and return from the house with a knife to gather a colorful tree fungus she wanted to dry and keep. And Grandma Leslie, working hard until her mid eighties, baked bread, made noodles, and tended her own flock of "old ladies," women even older, who relied on her for trips to the druggist or doctor.

And, for these women, men ultimately have been disappointing and not trustworthy. My grandmother Harnish, for example, has outlived all of the men in her life, two husbands and two sons, all but one dying from drink. She spent a considerable portion of her life being a stable center for these men, only to have them leave her to fend for herself. Jenny Baker tells another story, of a man deserting her with three children, and of how, as a Catholic, she never remarried, raising the children by herself and walking to Mass every morning before work at the University laundry. These are women who have grown strong through having to endure long lives without men.

Gladys Moser tells her own story of leavings as, one-by-one, men deserted or

died. Gladys called me one day "to visit, have a little tea and some good cake I have." I went over, hollering loudly as I let myself in and climbed the backstairs to her apartment. When I entered her kitchen, Gladys was waiting with a slip of paper in her hand which I knew was a list of things she wanted to tell me. She had slips like this all over her walnut dining-room table, each reserved for a different purpose or person. When she thought of something she'd like to tell me, she wrote it down on the list. I guess when you rated a list, you could count yourself as one of her friends, or at least as part of her shrinking world.

Unfortunately, at the top of my list was something she wanted me to do. She took me into her small bedroom, pointed out the window, and told me the crab apple tree between our houses bothered her—it dropped tiny crab apples, which were difficult to rake, and the roots, she'd heard, would probably tunnel through her basement walls. I knew, though, that the real reason was it blocked her view into our kitchen window, reducing her ability to check on us. "I think it should be cut down," she said.

"How old do you suppose that tree is?" I asked, stalling for time. Here was a point I had to negotiate with her. I loved the bright red apple blossoms which appeared after the spring crocus had bloomed.

"Probably forty years old, at least," she added, furthering her indictment.

"Well, then, Gladys, you've had forty years to study that tree and decide it should be cut down," I said, thinking fast. "I've only lived next to it for a year. Don't you think I should have a little more time in order to come to the same conclusion?"

She admitted that was reasonable and let the matter drop. After all, she had plenty of other things on her list. She led me into her sitting room, and in a stack on the high lamp table near her chair was a carefully arranged pile of papers and photos—all items she assumed would interest me. The photographs of our house in 1904 and 1914 were certainly interesting, as were her stories about the house and the people who had lived there. But she also told me about her first husband, the one with whom she bore her only child, a son. He used to pick her up for dates on his Indian motorcycle, and her family, particularly her grandmother, did not like him. "I could tell by her eyes—she never had to say a word. I should have listened to her," Gladys said. They were married for only a year.

He was gone by the time she was expecting, and she lived with her grandmother during the pregnancy, finally birthing in the room we use as a guest bedroom. She remarried soon. Among the documents and photos Gladys showed me that day was a picture of herself at twenty, raising a flag at the first village Armistice celebration. She was a small, lithe young woman, and the photograph was flattering. "And this," she said, "is the man I should have married," handing me a packet of letters written by a doughboy during the First World War. In them, he declares that French women, whom he had heard so much about, did not compare to his "dear Gladys."

"I thought you'd like to read these," she said. "He was such a good writer, don't you think?" I'm not sure how good he was as a writer, but he was spirited in his praise of Gladys Moser's beauty and charms. For Gladys, it was important that I had some sense of her before age so thoroughly overcame her. I was the last man in her life, I've been told, and the only one who would probably not leave her or die before she does. Her second husband died twenty years ago, and even her son died, killing himself to avoid the ravages of cancer. She told me that story as well, a horrible tale ending with him telling her over a Mother's Day dinner he was going to shoot himself. But she recounted the story with resignation, as though recalling the curious death of her grand-

father from the "triple hiccups."

Gladys remembered to tell me these stories by writing key words like "hiccup" or "son" on her slips of paper. My grandmother Leslie writes notes as well, but these are letters she has written to me in the last 15 years. My letters to her are rather "newsy"— a bit about the weather and so on, while her missives travel as widely as her conversation during holiday gatherings. Part of the reason is that she writes these in the middle of the night, at two or three o'clock in the morning, when she can't sleep. I know this because her letters invariably begin with "Just can't seem to get back to sleep" or end with "I'll try to get some sleep." What she tells me, in the meantime, is intended to be simply news, but whatever is really on her mind comes through. On the eve of her 80th birthday, for instance, she wrote about her husband finding the younger of the two horses dead last May, about one of her friends losing her license after sideswiping cars in town, and about her new eyeglasses, wondering if "they're close enough to my face"—everything mentioned but her birthday. The letters have become shorter, less centered, as she has grown even older, but I'm sure she still uses them to cure insomnia.

I've only telephoned my grandmother Leslie twice. Once I called to get recipes for her homemade pickles. Unlike the stereotype, my grandmother was not the perfect cook. Although she made some great dinners and her homemade noodles were among my favorites, most of her baked goods, pies, and breads were dry and yeasty. And I don't even remember her making cookies. However, Emma Margaret Leslie made delightful pickles. Among her best were a concoction called "Green Tomato Relish"—a good use for the unripened fruit at the end of the season—and her paper-thin "Bread and Butter Pickles." We had plenty of both cucumbers and green tomatoes in our little kitchen garden, so I called her, thinking that copying the recipes over into a letter would be too much for her these days.

Although glad I called, she said she'd mail me the recipes. So I still had to wait while the cucumbers grew longer and yellowed. When I got her letter and recipes, I found she had sent me her original copies. She had rifled through her recipe box, pulling those she had for pickles: Nine-day pickles, twenty-one-day Dills, and of course Bread and Butter Pickles and Green Tomato Relish. Then, before mailing them, she spread them out in front of her and jotted notes in the margins of the cards and scraps of paper. She began by explaining some of the directions, such as what a "sugar sack" is, and what to use now that sugar doesn't come in cloth bags or how to fashion a lid for a crock using a plate and a stone. "Just scrub a smooth stone real good," she wrote. "That's what I used." And the notes included stories.

In the margins of the twenty-one-day pickle recipe she included a note about adding sugar to the crock every other night, then how she and her sister, Virginia, as girls on the family farm used to argue over who had last taken her turn on "sugar nights." "Virginia would try to get away with not doing anything if you let her," she wrote in a cramped hand at the bottom. On another she recalls making pickles while she was pregnant with my father. "Cucumbers were early that year," she wrote, as he was born in mid-June. And, in between the lines of a description of how to boil jars and rings, she wrote how my grandfather had saved money he had earned working nights on neighbors' farms until he had enough to leave home. "He stored it in a mason jar he kept in a hollow stump." She was simply telling it all.

At the bottom of the last recipe she simply wrote, "I quit canning," explaining why she had sent me her only copies of the recipes. When my mother asked me how I got them from her, knowing I would copy them for her and my sister, I said I simply had

asked her for them. Sometimes, I think, we don't trust elderly people to be able to do anything, even answer simple questions. I remember hearing how, when my aunt took my grandmother Harnish, then 95, to the doctor, he kept asking my aunt questions: "Does she have pain when she eats?" or "Does she have trouble digesting dairy products?" Finally, my grandmother said, "Why don't you ask me? I'm right here." I wonder if the doctor was shocked she could hear, or if he realized that he had stooped to the way we infantilize the elderly. I've found out that older women have a lot to offer, if merely asked.

Actually, I usually don't have to ask; all I have to do is listen. Like my grandmother Leslie, Gladys was anxious to tell me everything she remembered about the house and about her family and her life as if she had extended her family to include me, most of them having already died. And that might be why I've always found the company of elderly women so necessary. I'm the first in my family never to have lived in the same house with a grandparent. An Appalachian family usually calls to mind extended family units, but my generation is scattered and separate, a kind of Appalachian diaspora. An older woman nearby gives me the depth of connection with place I seem to need. Whether I am in New York, Pennsylvania, or Ohio, knowing them gives me a century of the past, rooting my present to the place.

Gladys died last March, first spending five months in a series of nursing homes and hospitals until she finally gave out, her mind finally matching the deteriorated state of her body.

When she died, I asked the executor of her will to allow me to retrieve the geraniums from her basement so I could reactivate them from winter storage in time for her burial. The winter in the Northeast had been so severe the ground was too frozen to dig a grave. Gladys would not be buried until May, and would rest in a receiving vault in the cemetery two blocks from our house.

I entered the basement through a trap door on the back porch, a heavy plank cover that was fixed with counterweights so that it swung open with the touch of the hand. Down the narrow steps and to the left I found them, a dozen in all, geraniums Gladys had told me she saved, year after year, for the graves of all of her men. They were in pretty bad shape, and only half survived, and of them four flowered. But some did flower, as she had said they would.

And though Gladys died after I had known her for only two years, there are always others for me to meet. On our street in the village blocks of nineteenth-century houses, several rambling Victorians are empty except for the old women who live in their hollows, usually perched in upstairs apartments, looking out on the village they have known for decades, and which has always known them. I'll volunteer to drive one to the polls on voting day or casually help one take a trash can to the curb, and the next thing I know I'll be looking at photos, reading old letters, and listening to stories.

CHARLES D. WINTERS ————————————

Chinle, AZ: Navajo Reservation

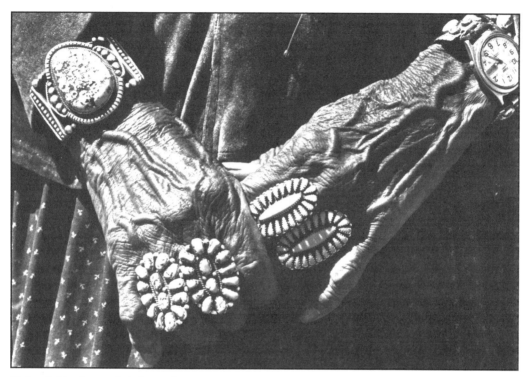

Black and white photograph, 6 1/2" x 9 5/8"

THOMAS TRAVISANO

from Elective Affinities:
The Making, and Reading, of "Skunk Hour"

One focal point for an exploration of the elective affinities, mutual influence, and parallel development linking Robert Lowell, Randall Jarrell, Elizabeth Bishop, and John Berryman into an informal and unofficial but enduring poetic circle emerges from a study of the different roles each of Lowell's friends played in the making, and the reading, of Lowell's "Skunk Hour." This is a key poem in Lowell's development. Moreover, it is a poem in which Bishop, the dedicatee, who helped to inspire it and who provided the basis for its structure and technique, and Berryman, whom Lowell (and Bishop) considered the poem's most inspired and penetrating early interpreter, each holds a stake. David Kalstone, speaking of the impact of Bishop's "The Armadillo" on Lowell's "Skunk Hour," observes acutely that Lowell's breakthrough was "in part nourished by Lowell's confused feeling for Bishop as admired writer, rival poet, unattainable and renounced love, and fantasy Muse." But Kalstone misses one of the genuinely vital points of connection between these two poets when he insists that Lowell's is a "much more *historical* poem" (his emphasis). Kalstone contends that "in 'Skunk Hour' [Lowell] separated himself poetically from Bishop."[1] But Bishop's own poems are historical in much the same way as Lowell's, placing a vulnerable individual in a context surrounded by objects emblematic of that individual's psyche and cultural history. Lowell himself remarked in a letter to Bishop that in "Skunk Hour," "really I've just broken through to where you've always been and gotten rid of my medieval armor's undermining," and in a later letter, which Kalstone does not cite, Lowell went so far as to claim that "I used your Armadillo in class as a parallel to my Skunks and ended up feeling a petty plagiarist."[2]

Why did Lowell feel his debt to Bishop so strongly—and in the poem in which he broke through to the *Life Studies* style? I would suggest, with all due respect to Kalstone, whom I disagree with reluctantly, that the imprint of history and culture on human behavior is perhaps *the* key subtext of "The Armadillo." The poem's "frail, illegal fire balloons," so lovely and so destructive, are seen "rising toward a saint / still honored in these parts" as "the paper chambers flush and fill with light / that comes and goes like hearts" (*EBPoems* 103). Here are echoes of human aspiration and feeling that suggest that these balloons are very much a product and expression of the culture that launches them. The quiet accretion of significant detail throughout the poem writes a subtle cultural "history" of Brazil—a culture in which the observer ambivalently participates—in much the same way that "Skunk Hour" inscribes a cultural history of New England. And the impulses that lead to the release of these balloons, balloons that carry liquid fire and that destroy rain forests with an effect that might suggest, to readers of today, the effects of defoliants or napalm, may remind the reader of still more violent personal or cultural impulses. Each poem explores, by implication, the way subtle cultural conditioning shapes overt human behavior, and each poem builds quietly to a disturbing climax. No doubt Kalstone has a different and more conventional definition of history in mind, but a fascination with the artistic possibilities of history in the sense I am articulating here—that subtly revealing human history that is deeply embedded or

encoded in overlooked cultural detail—was one of the most fundamental characteristics linking Bishop to more obviously public poets like Lowell, Jarrell, and Berryman. In 1957 Lowell was seeking a new style, and he felt indebted to Bishop not just for the tone and structure of his breakthrough poem—Lowell told A. Alvarez, "I was reading Elizabeth Bishop's poems very carefully at the time and imitating the loose formality of her style….You dawdle in the first part and suddenly get caught in the poem"[3]—but also for the way it modeled a subtle and effective technique by which psychically and culturally revealing detail, detail pregnant with individual human history, could be dropped into a casual background of what Lowell calls "drifting description."

By June of 1957, when Bishop sent Lowell a typescript of "The Armadillo," she had already published such explorations of embedded individual and cultural history as "Roosters" (1941), "Songs for a Colored Singer" (1944), "Faustina, or Rock Roses" (1947), "Over 2,000 Illustrations and a Complete Concordance" (1948), "The Prodigal" (1951), "Filling Station" (1955), and "Exchanging Hats" (1956), along with that remarkable poem about childhood losses, "Sestina" (1956). Bishop's series, while generally more indirect in its self-referentiality than Lowell's later self-explorations—even "Sestina" speaks of "a child" and "a grandmother"—establishes Bishop's own preoccupation with telltale psychical and historical messages. In another poem published just before Lowell began working on "Skunk Hour," "Questions of Travel" (1956), Bishop explicitly suggests the rewards of having "studied *history*" (my emphasis) in "the weak calligraphy of songbirds' cages" (*EBPoems* 94). Similarly, Bishop's earlier "At the Fishhouses" (1951) is built on an exploration of the effects of history, through a study of a declining Nova Scotia fishing village whose weathered and eroding but still lovely artifacts stand for much that remains unstated. These artifacts adjoin and are weathered by the North Atlantic, a vast body of "chill gray icy water" whose emblematic significance slowly emerges as the poem unfolds. This water, "Cold dark deep and absolutely clear / Element bearable to no mortal," begins to seem like the chill waters of the past. The poem concludes, referring to this icy sea:

> If you tasted it, it would first taste bitter,
> then briny, then surely burn your tongue.
> It is like what we imagine knowledge to be:
> dark, salt, clear, moving, utterly free,
> drawn from the cold hard mouth
> of the world, derived from the rocky breasts
> forever, flowing and drawn, and since
> our knowledge is historical, flowing and flown.
> (*EBPoems* 66)

Bishop not only states that "our knowledge is historical," but this is the premise on which the whole poem depends, and the ending derives its surprising power in part from the fact that we have been, throughout, witnessing the pervasive and subtle effects of history without quite realizing it. Bishop's work is about history, loss, knowledge, and one's complex relation to the past as clearly as it is about anything at all. And this helps to explain not just the deep mutual affinity between Bishop and Lowell, despite the obvious differences in their temperaments and style, but also her keen affinity for the world of Berryman's *Dream Songs* and for the work of Jarrell—just as it explains the pronounced affinity of the latter two poets for her. With Lowell, Jarrell, and Berryman, Bishop helped to create a new and influential poetics, which I am calling here a poetics of psychic origins. And very often she was leading the way.

Bishop not only anticipated Lowell's absorption in the intersection of the cultural, the psychological, and the autobiographical in verse. She also anticipated it in prose. Bishop's "In the Village" was a story that fascinated and obsessed Lowell to the point that he created a verse imitation of it, "The Scream." Lowell would later acknowledge that "'The Scream' owes everything to Elizabeth Bishop's beautiful, calm story, 'In the Village'" (*FUD* 1). And, of course, "In the Village" was published in the *New Yorker* in 1953, four years before "Skunk Hour." It was three years *after* the publication of Bishop's story that Lowell would begin exploring his own past in prose. Lowell published in the winter 1956 issue of *Partisan Review* that now-famous memoir of his own childhood "91 Revere Street." Many forget that this story was already in print a year before Lowell began writing any of his *Life Studies* poems. Bishop congratulated Lowell on "91 Revere Street" in a letter from Brazil, in 1956, immediately after she spotted it in *Partisan*. "It is *very* good; I feel as if I'd sat through one of those Sunday dinners. And being thrown out of the Garden, just like Adam, is marvelous. I hadn't realized before how closely connected with the Navy you were. In fact it is all fascinating and I hope I see more soon" (*EBLetters* 332-333). Bishop may have forgotten that it was she who first sounded the theme of "being thrown out of the Garden, just like Adam" thirty years earlier, as a sixteen-year-old school girl, in that precocious poem of 1927 "The Ballad of the Subway Train."

When M. L. Rosenthal declared Lowell a "confessional poet" in a 1959 review of *Life Studies* and went on to develop this premise in a series of widely read and influential books, he proclaimed Lowell's work a breakthrough and in the process drew a line around Lowell and several other poets that separated Lowell from Bishop, though Bishop had been for years one of his closest friends in the arts and perhaps the living poet he most admired. Rosenthal's approach, which has generally been followed by subsequent historians, also drew a line implicitly separating Lowell's work after 1959 from all that had gone before—an act that, in effect, treated as naught the substantial process of mutual interchange and influence ongoing between Bishop and Lowell since their first meeting in 1947. If Lowell had actually separated himself from Bishop in "Skunk Hour," as Kalstone—following the paradigm laid out by Rosenthal— contends, why had she anticipated the poem so thoroughly in her own previous work? And why did she follow it, almost immediately, with her own exploration of psychic and cultural history, the penetrating, posthumously published prose memoir "A Country Mouse"? The real separation between Bishop and Lowell, if it can be called that, came much later, over Lowell's use of, and changes to, his estranged wife Elizabeth Hardwick's private letters in *The Dolphin* (1973). But this was a far more specific and local difference, arising from what Bishop considered the alteration and misuse of another person's private correspondence. It certainly was far more limited, and occurred much later, than the general aesthetic separation proclaimed by Rosenthal, Kalstone, and numerous other historians as having occurred in the late fifties. Moreover, despite the strain this disagreement put on their relationship, Dana Gioia and his classmates would occasionally see Bishop and Lowell in 1975, two years after this dispute, "casually walking together near Harvard Square."[4] And in the last year of Lowell's life, 1977, Bishop announces in a letter to her friend Margaret Miller that she is making fudge to celebrate Lowell's birthday, an activity she finds much more enjoyable than grading papers about Robert Frost.

As a result of the critical construct created by Rosenthal, and echoed by critics and historians ever since, Lowell came to be viewed as the spokesman for his generation. Bishop's image, on the other hand, was miniaturized, and she has only now begun to be

seen as Lowell always viewed her: as Lowell's artistic peer, and, perhaps, in some respects at least—though not in all—his superior. Still, if one thinks of Lowell's poetry less as an act of "confession" than as an act of self-exploration, the many parallels that Bishop and Lowell shared throughout their long artistic association become much clearer. Bishop and Lowell emerge as fellow pioneers, partners in the development of a poetics of psychic origins. And in this respect, as in many others, Lowell looked to Bishop—his elder by six years—as a model and as a teacher.

Lowell, commenting on essays by fellow poets at a symposium devoted to his recently published *Life Studies*, stated that "The dedication is to Elizabeth Bishop, because rereading her suggested a way of breaking through the shell of my old manner. Her rhythms, idiom, images, and stanza structure seemed to belong to a later century. 'Skunk Hour' is modeled on Miss Bishop's 'The Armadillo,' a much better poem and one I had heard her read and later carried around with me. Both 'Skunk Hour' and 'The Armadillo' use short line stanzas, start with drifting description, and end with a single animal" (RLProse 226). Dana Gioia says that Bishop claimed she couldn't remember why the poem was dedicated to her, except that she was present during the actual arrival of the skunks. But then, Gioia remembers, Bishop gave the poem an uncharacteristically tight close reading. In an unfinished memoir, however, Bishop stated that her role in the writing of "Skunk Hour" was one of the events in her entire life that made her proudest.

If, in his response to comments by three poet-critics as part of a 1964 critical symposium devoted to *Life Studies*, Lowell makes it clear that he sees Bishop as a key source in the making of the poem, he likewise makes it clear that Berryman's reading, among the three critical readings by fellow poets devoted to his "Skunk Hour," comes closest— in fact, uncannily close—to the actual genesis of the poem and to his own modes of thinking and feeling as well. Lowell praises the detailed attention in John Frederick Nims's reading, but, he adds, "I get a feeling of going on a familiar journey, but with another author and another sensibility." And, Lowell adds, "This feeling is still stronger when I read [Richard] Wilbur's essay." On the other hand, "With Berryman, too, I go on a strange journey! Thank God, we both come out clinging to spars, enough floating matter to save us, though faithless" (*RLProse* 229). Lowell acknowledged that in his astute and sometimes harrowing reading, Berryman had "hit a bull's-eye."

Berryman's first bull's-eye was his recognition of the poem's most immediate technical inspiration. Unaware at this moment of the factual background, Berryman nonetheless shrewdly recognized Bishop's influence on the poem's opening stanzas. "The four stanzas are unemphatic, muted. But their quiet, insistent mustering of the facts of an extant world opens toward the danger of its being swept away, into delirium. I have seldom seen stanzas. . .so un-self-evident. He's holding fire, let's say. Down-rhyme, casual, unlike earlier Lowell, suggests Miss Bishop's practice; to whom the poem is dedicated; though the heavy, fierce rhyming of 'The Quaker Graveyard' will be admitted in the final stanzas" (*JBProse* 319-320).

Berryman begins his inquiry into the poem with the remark: "A title opaque and violent. Since it throws, at once, little or no light on the poem, we inquire whether the poem throws any light on it, and are underway. Our occasion is the approach of a crisis of mental disorder for the 'I' of the poem—presumably one leading to the hospitalization, or hospitalizations, spoken of elsewhere in the volume, *Life Studies*, where it stands last. Lowell's recent poems, many of them, are as personal, autobiographical, as his early poems were hieratic; and it is certain that we are not dealing here purely with

invention and symbol. One thing critics not themselves writers of poetry occasionally forget is the poetry is composed by actual human beings, and tracts of it are very closely about them. When Shakespeare wrote, 'Two loves I have,' reader, he was not kidding" (*JBProse* 316). Using what appear to be the New Critical tools of asking appropriate questions of the poem and following where they lead, Berryman draws conclusions that are far from the New Critic's norms of impersonality, drawing one deep into the psychological position of the poet. Berryman's own title is "Despondency and Madness." For this title he draws on another *Life Studies* poem, "To Delmore Schwartz," where Lowell writes of their mutual friend Delmore: "You said, we poets in our youth being in sadness, / Thereof in the end come despondency and madness." In this title, then, Berryman is alluding to a mutual friend, Schwartz, once so brilliantly funny, and effervescent, who was by now the victim of a series of dismaying psychotic episodes. Berryman resumes, "Back to the title then. The Hour of the Skunk, I suppose, would be one of the most unprepossessing times of the day....The skunk is a small, attractive, black-and-white creature, affectionate and loyal when tamed, I believe, it suffers (or rather it does not suffer, being an animal) from a bad reputation, owing to its capacity for stinking. (The poet, in the identification, knows: and suffers.)"

The poet's symbol-making and associational powers help to achieve the poem, but they also occasion emotional suffering. The skunk has a peculiar kind of power. "Cornered, it makes the cornerer wish he hadn't. Painful, in symbolization, is the fact that its sting, so to speak, can be drawn, its power of defending itself removed—as the poet can be made helpless by what is part of his strength: his strangeness, mental and emotional; the helplessness of a man afraid of going mad is the analogue. The skunk is an outcast; this is the basis of the metaphor, and how a mental patient feels. . .We like, in mature professional life, to know who we are; which may be on the point of becoming out of the question for the 'I' of the poem" (*JBProse* 316-17). Berryman recognizes that the yearning for maturity and control provides the background for this piece. "His target is the dreadful aura—in epileptic analogy—the coming-on, handled by Hölderlin in 'Hälfte des Lebens,' which may be the deepest European poem on this unusual theme. You feel you're going too fast, spinning out of control; or too slow; there appears a rift, which will widen. You feel too good, or too bad" (*JBProse* 317).

Berryman seems to be speaking from his own experience here, and out of an empathy for psychic distress not always found among Lowell's critics. Lowell was forced to acknowledge the uncanny, intuitive rightness of Berryman's analysis, "What I can describe and no one else can describe are the circumstances of the poem's composition. I shan't reveal private secrets. John Berryman's pathological chart comes frighteningly close to the actual event. When I first read his paper, I kept saying to myself, 'Why, he is naming the very things I wanted to keep out of my poem.' In the end, I had to admit that Berryman had hit a bull's-eye, and often illuminated matters more searchingly and boldly than I could have wished" (*RLProse* 226).

Berryman, of course, sees the poem not as an act of self-photography, but as something made, an artistically wrought structure with a careful array of balances and controls. Hence, he says, "I must pause, briefly, to admire its administration of time. In general for it time narrows: a vista of decades, 'the season's ill,' one night, and so down to the skunk hour. But I notice two substantial exceptions to the method. The second stanza opens a longer vista still than the first, with 'century.' And the 'Hour' is nightly, expanding again into a dreaded recurrence. Most real poets work in this way, but Lowell decidedly rather more than most" (*JBProse* 321).

The identity of the poet, the problem of the poet's relation to the persona who stands for him, remains a state of affairs requiring careful delineation. As Berryman put it, "For convenience in exposition, with a poem so personal, I have been pretending that 'I' is the poet, but of course the speaker can never be the actual writer, who is a person with an address, a Social Security number, debts, tastes, memories, expectations. Shakespeare says, 'Two loves I have': he does not say only two loves, and indeed he must have loved also his children, various friends, presumably his wife, his parents. The necessity for the artist of selection opens inevitably an abyss between his person and his persona. I only said that much poetry is 'very closely about' the person. The persona looks across at the person and then sets about its own work" (*JBProse* 321). In support of Berryman's view, it's worth adding that, along with selection, the poet might also engage in alteration, or addition. For example, Lowell claims that he simply invented the voyeuristic "love cars" scene, which many readers find the most perverse and/or disturbing moment in the poem. Berryman acknowledges this when he says, "Lowell works rather in parable form than in forms of allegory. There is no point-to-point correspondence, the details are free" (*JBProse* 320). Hence, the overtly autobiographic "Skunk Hour" (which Berryman reads as, covertly, parable) moves into a position of analogy to Bishop's "The Prodigal Son," a Lowell favorite, which is overtly a parable and covertly autobiographic. In Bishop's "Prodigal," too, "there is no point-to-point correspondence" and "the details are free." In his reading of "Skunk Hour," Berryman was outlining a powerful methodology for reading his own poetry— and Lowell's—but also the poetry of Bishop and Jarrell. Only if one reads their work for its exploratory character while maintaining an awareness that, even when the work is very closely about the poet, there are no absolute correspondences and "the details are free," can one begin to take an adequate measure either of the many parallels in the artistic development of these four, or of the full importance of their common artistic project and the full dimension of their achievement.

[1.] David Kalstone, *Becoming a Poet: Elizabeth Bishop with Marianne Moore and Robert Lowell*, Ed. by Robert Hemenway (New York: Farrar, Straus & Giroux: 1989), 187, 188.

[2.] Lowell to Bishop, 20 April 1958, Vassar College Library. Quoted from Travisano, *Elizabeth Bishop: Her Artistic Development* (Charlottesville: University Press of Virginia, 1988), 153.

[3.] A. Alvarez, "Robert Lowell in Conversation," in Jeffrey Meyers, *Robert Lowell: Interviews and Memoirs*, 80-81.

[4.] Gioia, "Studying with Miss Bishop," *Conversations*, 150.

FRANK C. ECKMAIR

Clearing

Wood engraving, 3" x 4 7/8"

Old Garden

Wood engraving, 3 5/8" x 2"

MAUREEN BRADY

Mother Dolly

Mother stared at the wall. Instead of pictures, the nursing home had framed and hung up long patches of floral wall paper for decoration. "It's pretty paper," she observed, after a long time.

I stared, too, pondering how much this place resembled a doll's house. Its people either sat too still or moved in such rigid and automatic ways it appeared that they'd been programmed. Her tablemate Mr. McGee held a fixed stare beneath a brow knit with suspicion. Gertrude, her other tablemate, featured bright red lipstick, which wouldn't have been so noticeable except for the fact that her nervous system deterioration had taken the form of a tic that made her repeatedly suck her chops.

Mother looked blank, as if the stroke had made her mind depart for another planet. She hardly spoke unless spoken to, a radical reversal after years of never holding silence. She picked at the skin over her elbows, which rested on the arms of her wheelchair. Skin which seemed so suddenly spent with age it was hard for my eyes to believe it was hers. Trailing a generation behind myself, I recognized it as my grandmother's freckled, nearly translucent skin.

When I caught her staring at me, I tried to hold my eyes on hers, but hers were veiled with cataracts and the veils pained me so much I had to look away before she did. A woman at the next table droned, "I want a banana, I want a banana, when am I going to get a banana." We were surrounded by people who had released into the I *want* completely. Not Mother. She was slow on the uptake as she had never been in her life before, but she had only been in the nursing home two days and her wants stayed secret for then.

I cajoled her into staying up five hours that day. When I let her get back in bed, she dropped her head on the pillow, rolled her eyes and said, "I never thought such a thing would happen to me."

"Don't worry. There's plenty of time to work on getting better," I said gently.

When she made no response, it occurred to me maybe we weren't thinking about the same thing, so I asked her what she'd meant, anyway.

"I thought you'd never let me lie down."

"Oh." I laughed. She was in the moment, like pudding about to set. For her it was all a question of how long she had to hold her head up.

Her white hair fluffed out, wispy on the pillow. Her glasses slid down her nose. I removed them, telling her to nap a while, and went back to her apartment to the job my brother and I had taken on of sorting through her belongings.

Tom and I laid out folders like ports in which to dock her papers. Overseeing us was the collection of dolls our grandfather had brought from afar. More than the floral pattern on the rug or the brass coffee table with its small herd of carved black elephants, the dolls held the presence of Mother.

When we were children, she fashioned outfits for our dolls every Christmas. She sewed them up in the den, a little-used room behind the living room off limits to us

children. Our life went on in the kitchen and the sitting room, where we lay on the floor every night after supper and listened to The Lone Ranger, Dragnet, and The Shadow. For months before Christmas she'd drop little hints of what might be coming. Perhaps a doll who was dressed to go dancing, or one who was equipped to be a professional newspaper reporter. She never actually did the newspaper reporter, though I was always hoping she would. I was reading my way through the library's collection of young adult novels then and was attracted to the excitement of that career, the travel and the prospect of landing in the heart of action. Meanwhile, we never went anywhere but lived the self-sufficient life of farmers, our chores right before us, seven days a week, moderating ever so slightly with the changing of the seasons.

Christmas eve our dolls would disappear from their regular lodging places. Christmas morn they'd stand propped against the wrapped packages. Peggy's on the left, mine in the middle, Tommy's on the right—a male doll.

One year, Tommy's was in a sailor suit, and I can't help wondering if this had anything to do with his later choice to join the Navy. Peggy's was once a bride and, indeed, she later got married. I didn't. Perhaps my mother meant me to, but perhaps she didn't, either.

The year I remember my doll the best was when she appeared as a nurse in uniform. White shoes, white stockings. Her uniform was belted. She carried a little doctor bag, but her name tag read Nurse. What swelled Mom's pride the most was her cap, a miniature version of her own white organdy nursing cap from St. Luke's Hospital, gathered at the bottom with a black velvet ribbon. My poor doll's head was pierced deeply with a hat pin to keep it securely perched, and I felt the pain of this pin more than any gladness at my doll's new wardrobe. I didn't become a nurse but a physical therapist, and of course I'm left to wonder if that doll had any part in my career choice.

I doubled as the daughter who faked enthusiasm as Mother revealed each detail of the sewing complications and the daughter with the stiff spine, hell bent on deflecting the influence of her every stitch.

Mother had a penchant for telling the demands of each pattern, which tested my patience—how she had schemed for the perfect doctor's bag or sailor's hat, how this miniature sleeve had required a pleating which was almost impossible, given that the whole sleeve was smaller than her finger, how she had performed this impossible feat with a straight pin pushing to sculpt the material into tiny tucks. And, oh, how a certain material had stretched her beyond her limits. Organdy, for instance. I saw her strained over the sewing machine late into the night, back rounded, eyes peering, lips pinched to hold the ready straight pins. Peggy gushed at her revealings. I mimicked her gushing. To be ungrateful in the face of this effort—what a monster it would have made me. Besides, at least one whole half of me sincerely cheered her for her cleverness. So, all through Christmas day and the days that followed, when showing off my new doll's outfit, I'd repeat both her ordeal and her victory to anyone who had an ear to listen.

When she'd speak of the ideas she'd come up with but not done (but maybe someday would do), we'd ooh and ah for the ones that met some desire in us. Yet she never responded to our biases in the next year's selection. This set me even further on edge, for it seemed to confirm that the outfits were not truly for us but were her only chance to enter the world outside of home. I see now why she might have needed this. I saw then only that if she wanted to go someplace, we must not be *enough*.

My grandfather, Pappy, her father, went around the world three times on the Queen Mary. He was a purser and sometime tour guide. Widely traveled as the man was, he was small and had a narrow swath of mind. When I was two, he came in my room and did some funny business which never should have been done to me or any other child. This leaves me to wonder if he did some funny business with my mother, too, when she was but a small girl, that made her feel she was something akin to a doll.

He brought dolls from every country and gave them to Peggy, Tommy, and me. The one from India had two heads springing from two torsos joined at the middle. Mother was taken with it, but I was disturbed by its lack of legs to stand on and liked to place it behind a doll with feet, like the Bali dancer or the delicate but too-demure Japanese lady with the kimono. Though they had been given to us individually, Mother encouraged us to keep all these dolls in a collection and arranged them to stand on a low rattan chair Pappy had brought from Pakistan. Because of how they belonged to the unit and because it was hard for me to feel connected to the foreign when I had never seen the flesh of them (I had only ever crossed one state line – New York/Pennsylvania), I didn't really care for having the doll collection in our house and fantasized its demise — a fire, a hungry dog.

After we'd grown up and left home, Mother took to collecting antique dolls, sewing their wardrobes, dressing them. She wrote in her letters — *Wait till you see my new Colonial babe. I am making her the sweetest dress with a pink lace bodice. I had to struggle so to get the waist right, but it came out beautifully and she'll sweep any man off his feet in a minute.*

I think this meant she was ready to be swept off her feet, if it hadn't been for my father, retired, finally sitting beside her. He, like my grandfather, had traveled the world on ships, bringing back trinkets instead of dolls. And stories of foreign girls in the flesh, tantalizingly enough delivered to set us into speculating about his faithfulness to love and family.

He had swept her off her feet once. She fell for him, then stood him up for reasons unexplainable. The fact that he hadn't dropped her at that, but had come to find her to scold her, became enough to knight him. Not until the honeymoon did she open her eyes to notice his drinking, which, from then until he died, she martyred herself to, while dressing up her dolls to be ready for adventure and freedom.

She survived my father to get swept off her feet by a second husband. She thought this one was going to want to take her dancing, but, alas, he quickly decided he preferred to stay at home. She had to survive him, too, before her dancing days could begin.

There with the dolls overseeing us, looking through her papers, Tom and I saw she had gone dancing throughout the year past, so much so that her boys at the George Picard studio had become her fantasy lovers. We hadn't understood how she'd afforded it, until Tom discovered that when her twenty thousand dollar T-bill had come due, she'd simply deposited it in her checking account and spent it for the dancing lessons and the extras—videos of her and Jeremy and Marvin, blown up framed photos, and a wardrobe of frilly dresses, swirly skirts, sequined blouses—the sort of thing she would have put on a doll in earlier years.

The photos were all smiles. If not bliss, then the framing of a mind's picture of bliss. I wanted to be happy for her happiness (if that's what it had been) but there was a lump inside me, lodged up front and center where my heart should have been. She'd taken Jeremy and Marvin to Acapulco for Christmas. Told us she was too broke to send gifts but spent eleven thousand dollars on them. I thought it was terrific she was traveling, but when she'd mentioned she'd had to take her boys out to buy them fancy shirts in Mexico, the jealousy had rankled. A lifetime I'd been waiting for that sort of special treatment. And now she'd been struck down low enough I could see it was foolish to keep waiting. I wondered if her spending spree had been inspired by that generationally hostile bumper sticker I often saw on my trips to Florida: *spend the inheritance*. She had always liked to show that she could bestow generosity, if not on her children or grandchildren, then on some friendly strangers who took the bother to court her.

My problem was I'd devoted so much of my childhood to courting her, only my courting had been foiled by the part of me that needed to refuse her threads.

Jeremy and Marvin attended her first outing from Manor Care, her seventy-ninth Birthday Party. We sat them down at the far end of the lunch table, six or seven people away from her, so they'd know there were others who came before them. I wasn't sure she even knew who they were, but she thought they were cute sitting down there and made eyes at them, especially Jeremy with his thatch of bleached-blond hair. I remembered her rousing to his voice on the phone those early days after the stroke, saying, "Is that you, darling?" as if she were being contacted from the starry cosmos. "No, I wouldn't be able to take another cruise just yet." "Yes, darling, come tango at my bedside." "You are the one I love."

Six years have passed now with Mother's mind moving further and further into an extended twilight, her bladder releasing without regard to company. Jeremy and Marvin soon dropped from sight. We moved her to an adult-care home, where she lives with seven other infirm women. Year to year, we've gone through her belongings, preparing eventually to vacate her condo, to which she has life rights.

By her eightieth birthday, when it became clear she'd never be able to return to live alone there, my sister and brother and I went through her clothing. Then Tom and I took her frilly dancing outfits to the Salvation Army. I got a stomach ache driving there. Those black plastic bags landed with a thud as we heaped them into the trunk and seemed to have the weight of corpses when we hefted them through the wide mouth of the storage bin.

Another three years passed before I summoned the courage to read through her writings. They were in a steel box, which she'd gotten at my suggestion, as a safeguard for her papers against fire. She'd written a gothic novel—her first—in her seventies. This I had already read, for she had published it through a vanity press. But the file box was jammed with onion-skin papers, multiple copies of drafts of stories, the first couple of chapters of the new novel she'd started about her beginnings with my father (which is how I knew she stood him up for the second date). Interspersed with her fiction were pages torn from spiral notebooks, lined with her scratchy, distinct handwriting, which followed the same angle as my grandmother's but had none of the sprawl of freedom that hers had nor the sentiment of her heart-shaped m's and n's.

I read for hours, my body stiff with the hunched down feeling of stealing onto sacred ground, the fear of being caught trespassing, but also the magnetic pull toward

whatever was about to be revealed to me. I thought maybe I was going to come upon the story of her having a secret abortion, which might help explain why, in her senility, she kept thinking she'd had a baby and had better go take care of him.

I did not find a secret abortion. Nor did I find a secret love affair, not even with that priest she had flirted with so outrageously when she was studying for conversion and my father was out at sea. Nor did I find my own secret hope—some unexpressed love for me that could only be left in a written legacy because of our particular chemistry, which created so much antagonism.

What I did find that melted that lump behind my breast bone was her writing about how she felt when she made the doll clothes. She said, when she was sewing them, she lost herself for hours because she was creating something from nothing. And that made her feel good. My skin buzzed and I wanted to say, "All right, Mother. Good for you." Then she wrote that all the while she was sewing them she imagined they were going to make us feel good, too.

I laid my hand down on her writing, as if to touch her intention, stunned by the huge gap that always exists between understanding and misunderstanding, even all the while we're not aware of it. Sun shone in on the papers under my hand, stealing the musty smell from them, and a desire passed through me to have been a different child for her—one who might have yielded more, one whose spine might have stayed straight without needing to bristle or prepare to sting whenever she came too close. But of course I'd always had to tell her I was I and she was she.

I went back over to the adult-care home to sit with her a while.

Sonya, her friend with Alzheimer's, came out to sit on the porch with us.

"Sonya's shorts are too long," Mother commented. Then after a long pause, "She asked me to take them up."

"You made a good choice," I said to Sonya. "She was always a fine seamstress."

"Has to be better than if I tried," Sonya said, knowing she was joking.

We sat in silence, smelling the odor of fresh-cut grass which lingered in the humid air. A while later, Mother picked up the thread again. "Well, she'll have to take them off," she said.

I laughed. Sonya went on studying the driveway across from us.

Mother has not gone to rest yet, but sometimes I believe she has come to rest in me. I think of her when I have to sew on a button or hem pants — the only times I come near a needle. When I iron, I think of those little stamping noises she made with her vigor. I remember her perched tight beside me in the middle seat of the Chevy as we sailed down the highway, her telling me to line up the hood ornament with the center line as she taught me how to drive. I suspect she was praying for trust then. Sometimes I see her hunched forward at the sewing machine, her blunt fingers gently pulling the tiny piece of cloth toward her, creating those miniature doll's clothes, which have all mysteriously disappeared.

And as I age into a deepening satisfaction in the pleasure of creation, now and again I find myself startled by the quietest thought — *Can this have been her stitching?*

BETTY FRALEY

Confessions of a Catskills Costumer

The saying goes, "Making a silk purse out of a sow's ear." Well, I've done it many times. A worker of miracles, an expert in the art of illusion, I am a Costume Designer. Costumers are born, not educated. I started as a small child combing wooly worms, trying to tie bows in their hair; my cat was the best-dressed on the block. So was anything else that would stand still long enough. Dressing others was my favorite occupation.

Paper dolls were my next favorite. I had bushel baskets filled with them. When I finished playing with them I would carefully tear off their heads and arms, stacking them in neat little piles. This might have raised alarm in some families, not mine. Designing clothes for my paper models began a life-long challenge.

To me, sewing is secondary. I sew only to hold the cloth together. A seamstress I am not, and anytime a new product comes on the market to replace sewing, I use it. I must rely on the sewing machine most of the time, however, that and safety pins, often jeered at by the more fastidious seamstress. I once did a whole opera with safety pins.

For my designs, I use a second-hand dress form with the dimensions of about a size twelve. I say about a size twelve because Myrtle (the mannequin) is rusty, bent, tattered, and given to the vapors. She collapses under too much strain. She's about a size twelve, more or less, and has a head made from a Styrofoam wig form, with a painted-on face. I need to have eyes to look into when I am talking. I talk to Myrtle a good bit. She is my consultant on many projects. A mere creak from her and I know I am on the right track. This goes against the grain of every sewing teacher or seamstress that ever taught the correct way to fit. I use Myrtle for everyone's costume. She has been King Arthur, Sir Lancelot, Guinevere, Merlin, Anna, the King, Thomas Jefferson, Ben Franklin, an English bobby, and so many more characters I can't count. I place her in the middle of my studio, throw a few yards of fabric at her, take a pair of large scissors, and begin. I have the measurements for the person I am creating, and from there I can go any-where. I have had several women watching me nearly faint as I dove at the yards of fabric passionately. I seldom let anyone view this wild, exhilarating frenzy. It is very hard on people. They call me the miracle worker: from the ruins and scraps come miracles; besides, I'm cheap. And I can make a silk purse out of a sow's ear.

I was once doing a musical with no money to rent costumes and very little to buy any. Thanks to my mother's outgrown wardrobe, and some old scraps of glittery pieces left over from a dance recital, I made one of the most beautiful dresses this side of Hollywood. There were five lengths of white fabric with tiny silver dots. Each piece measured about twenty-four inches wide and thirty-six inches long. By sewing all the pieces together on Myrtle, I cut, sewed, slit, and delivered an ankle-length sheath dress, complete with snood. I added a few silk flowers to hide holes in the fabric and hoped the seaming would not show beyond the fifth row. To my amazement, no one noticed the seams, even from the front row. All I heard was what a beautiful dress it was. Now, I'm

afraid, the garment is only a piece of shiny white cloth hanging on a hook, somewhere backstage, gathering dust. But for one production it was the hit of the show.

First rule: the ladies must look beautiful, the men's crotches must fit. Men are easily pleased as long as they are comfortable. If a costumer has a mean streak and a distaste for one of the males in the cast, she can blackmail him. I have often used this ploy. An example: an actor from New York City arrived at an upstate summer-stock theater with the air of "I'm the star who has deigned to come to the 'boonies.'"

I was very aware of his status and began immediately groveling: "I'm sorry, I don't remember your real name, only your character name. There are forty-two in the cast. And character names are all I can keep up with."

He glowered at me and said, "That's all right. I don't remember your name, either." With that, he tossed his head and proceeded by me.

In a soft whisper I returned, "Just remember, I'm the one who makes your crotch fit."

His head jerked around, followed by a broad smile and a great belly laugh. I love the theater!

SUSAN FANTL SPIVACK

The Game of Life: A Workaholic's Memoir

One morning last week, I woke before dawn, and I couldn't go back to sleep. I was too busy, thinking about work. In that insomniac haze, my thought was maybe two parts worry, one part wonder. I wondered: is my life all work? And I worried: have I forgotten how to play? Then I remembered: as a kid, I played all the time. And it's the games with a scary edge I remember loving most when I was a child.

Like the one I played with my brother Rick when I was ten and he was seven. We called it "Brother and Sister," but our parents were witches who kidnapped us in infancy. We were trying to escape, back to our real mother and father. Only one small moment from all the fantastic episodes of this game remains: we're running through the hayfield that was our apartment's front yard in Cincinnati, Ohio. I'm looking back at Ricky's pale face, shouting courage and hope. He stands, hesitating, in shoulder-high grass. The witches are right behind us!

In that field, playing hide-and-seek, our summer nights were filled with tiptoe-creeping tension. At dusk, we put on our darkest clothes, flattened ourselves against the sides of buildings, merged with bushes and trees, crawled through tall grass, our bellies hugging the ground. Then, freeze! Don't move! Don't breathe! Or, leap howling into the open because the one who's "IT" ventured away from the goal ("gool," we called it).

Sometimes, I hid out alone in the safety of the old horse stable or chicken coop. In disguised voice, I taunted, "Gool sticker! Gool sticker!" luring "IT" toward me into the dark. I was daring but elusive. No one could dash back to the gool and yell, "I see Susy! One-two-three on Susy behind the climbing tree next to the henhouse!" Sometimes, after running all the way around two buildings, I would stand isolated in darkness, the game nothing but distant whispering. Then fear of the real IT would creep into my belly and send me scampering back through pools of moonlight, into the Jones's garage, right next to the gool. There I'd crouch until the ritual chant that ended all our games brought everyone home. "Allee allee in-come-free! Allee allee in-come-free!"

And I remember the games with Michael Wentz in the overgrown apple orchard beside our apartment. We dived into our "swimming pool" by jumping off the end of a log into a a green tangle of vines. We sucked sweetness from the honeysuckle, or slipped the long red blossoms of the trumpet vine onto our fingers to flash demonic talons. We stalked among the trees, he Tarzan, me Jane, my brother Rick our son Boy, or the orphaned lion cub we rescued. Sometimes, I was the mother lion dropping from a low branch onto Tarzan's back, wrestling him down snarling, slashing, rolling over and over in the leaves.

When we tired of Tarzan, we went to the movies: twenty-five cartoons and a double feature. I remember Audie Murphy's keen blue eyes and the delicious pangs of first desire their sharp gaze sent up my thighs: I was sitting between Michael and Marylynne Jones. Even though it was a very hot day, Marylynne did not wear shorts, or a sleeveless blouse, because she told me "good Catholics" didn't. I was a doomed atheist, as my brother Rick loudly announced, and Jewish, therefore confused about the very existence of Catholics and their connection to Christians. Because I was an unbaptized atheist and already damned, Marylynne informed me, I might as well just go ahead and

expose my thighs to Audie Murphy.

Later, Marylynne showed me her first pubic hair. I was shocked. She was the devout one, after all, and I had no pubic hair yet. To make up for this lack, I sent for a sex education pamphlet from the Scout magazine *American Girl*. When it arrived, Marylynne and I read it, cover-to-cover, in the woods behind the henhouse. Then we dug a hole between two trees, buried it, and swore each other to eternal secrecy.

But I didn't usually play with Marylynne because she couldn't climb trees, and she wasn't allowed to play hide-and-seek after dark, and she wouldn't play with boys. A tomboy and proud of it, I played with boys all the time! One day, I was playing football with Tommy, a skinny red head, a year younger and a head taller than I. We were rolling on the ground, and my mother tapped on the window at me. When I got inside she said, "You know, you're getting too old to play with boys that way."

I offered her my blankest stare. "What way?"

"You know, rolling on the ground like that."

"But, Mom! he tackled me! I had to keep the ball."

"I know," said my Mother. "But that's not what people will think, looking at you." A blush sent circles of heat around my ears. What *were* people thinking? I wondered. Was there a physical pleasure I hadn't noticed, while pressing my body against Tommy's, that went beyond the simple delight in my own strength and agility as I pinned him to the ground? Did it show? I couldn't decide, so I never played football with Tommy again.

At the end of that summer, my family moved from Cincinnati to Chicago, and my memories of ecstatic childhood play end. Immersed in the serious business of surviving an awkward adolescence, I began forgetting how to play. In fact, at only one other time in my adult life, have I played like a child again.

The year was 1972, though I always think of that time in my life as the "Sixties." Four adults and one child, my two-year-old son, were living on a farm in the Catskills. The hayloft of the barn had been converted to a dance hall in the fifties and a jukebox installed, a paddle-ball court, a ping pong table, a balance beam. We lived on one full-time professor's salary, one drop-out's savings, a part-time waitress and a part-time secretary's pay, so we weren't quite hippies. But our hair was long and wild, not anywhere clipped or shaved on any of our bodies. Our clothes were brightly-colored India cottons, faded and patched dungarees, sandals, and work boots. Our habits excluded food additives, sugar, white flour, polyester, deodorants. But we welcomed any means of altering consciousness, including yoga, meditation, and play.

We played at farming with one hundred chickens and two goats in the lower part of the barn. We played the jukebox, which played fifties rock music, and we danced. We played paddleball and ping pong. We played "make a cardboard circle with different colored cellophane windows, revolve it in front of the slide projector lamp, and watch the lights change on the wall." We threw coins and played the I Ching. We read the Tarot and played poker.

And we played a game on the balance beam in the barn that we called "Good and Evil." Two of us stood at opposite ends of the beam. If you were "Good" you smiled and acted mellow. "Evil" looked fierce and frowned. We walked toward one another on the beam, grasped one another by the shoulders, and tried to throw each other down, without falling ourselves. This was hard to do. If you were falling it was very easy to take your enemy with you. As we fell, we uttered long, wailing cries as though we were diving into an abyss. That was the rule: "Good" and "Evil" both wailed the same as they

fell. The psychology professor among us noticed that "Evil" won most of the time. "Being evil seems to give us strength," he said. It was a little unsettling. But only a game.

One day, a hitchhiker was brought home. Over dinner he told us he had left his wife and baby in Utah and thumbed rides all the way to the Catskills. He'd been a medic in the war because he liked the sight of blood. "I like cutting them open," is what he said. His initials, R.A.T., formed the word RAT. That's what he asked us to call him. RAT had been invited, not by me, to sleep in the spare room, before he shared this interesting information with us. We went out to the barn to unwind.

"Let's play 'Good And Evil!'"

"What's that?" asked RAT. "How do you play?" We demonstrated. I played "Good," and I lost two times. RAT said, "Can I play?" He could. He played very well. None of us could beat him. He met you at the center of the balance beam, grasped your shoulders, gave a slight twist and thrust you into the abyss. No apparent effort, and we fell, yodeling.

Back in the house the tarot cards lay scattered on the rug. "I have a way with cards," said RAT. "They tell me things." He laid them out, a reading for each of us. Death came up. The Queen of Wands Reversed—jealousy, betrayal. The Hanged Man. The Burning Tower. I didn't sleep that night. My bedroom was next to the spare room. My baby's bedroom was across the hall. All night, paralyzed with fear, I listened, my ears dog-alert for the weight of a step on a creaking floor board. I didn't dare go into my child's room, lift him out of his crib, and take him into the protection of my bed because I was too embarrassed to show my panic. No one else seemed to notice the menace I felt emanating from beneath the spare-room door.

In the morning, RAT went peaceably away, no harm done. He even leaned over and kissed my forehead as he said goodbye. That day, I cleaned out the hen house and the goat stalls in the lower part of the barn. While I shoveled manure, I made some decisions: I would not walk that balance beam again. "Life is not a game," I told myself. "It's too easy to fall, just walking on solid ground."

Which is true. Twenty-five years have passed, and more and more my life seems to be an arduous, increasingly complicated balancing act. And I miss all that play. I miss thrusting my body hard against an opponent's, taking the ball, running fast—faster. I miss rolling on the ground laughing, crawling through the weeds. I miss the wide-eyed calculations in the dark, the safety of knowing when it's just a game, you can run for your life and fall and not die. Or you can fall and die, then stand up to live again.

I miss hearing that voice chanting the final end-game promise: "Allee, allee, in-come-free! Alll—yeee, Alllll—yeeeee, in—come—freeeeeeeeee!"

MARILYN STABLEIN

In August, Picking Blackberries

At noon, I slip quietly from my desk. In the restroom of City Hall I change from office clothes to jeans and tennis shoes. With gloves and plastic containers in hand I head for the tangle of vines that twist in a line parallel to the old railway tracks.

Every time I approach the spiraling thicket, snaking black shadows slither into the depths. Most days, I see a flash of iridescent blue, the stripe on the back of a black snake, before it disappears through the weeds. There must be dozens of snakes that live in the blackberry bushes. I don't want to step on one, or surprise one basking in the midday sun, so I grunt and stomp the earth as I approach—to let the snakes know I've arrived.

Other treacheries lurk in the brambles. Mosquitos feast in the damp thicket. If my attention lags mosquitoes land on my skin and bite. As I gather blackberries, I randomly swat and shoo at the vines to keep the mosquitos aloft. Thorns prick my ungloved fingers. Beads of blood crust on the backs of my hands. Intertwined between the thorny vines and the prized, plump fruit, so lush it weighs down the branches, is a sneaky proliferation of stinging nettles.

It takes a minute to feel the sting of the nettle. Once the throbbing begins, the sting is irritating and painful. The summer I turned eighteen, I hitchhiked around Europe. A Californian from the bay lands, what did I know of stinging nettles? Once, I slipped into the bushes to pee. Minutes later, my jeans were afire, as if a hundred bees were stinging me. I soon snagged a ride but it was hard to sit still.

"What's wrong?" the driver asked.

When I told him, he laughed. Now, I watch out for the nettles. There are two types of blackberries here: the Himalyan berries are as large and plump as purple figs, and richer in flavor than the smaller variety. I pick fewer of these since they quickly fill my empty yogurt container. I wear gloves but soon the clumsiness of the cloth hinders the plucking, and my gloved fingers inadvertently squish the tenderest and sweetest berries. Bare hands work best, even though the purple stains the skin and the thorns puncture and snag.

If the container is too large, the weight of the berries on top squishes those below. So I bring shallow containers and layer the berries only five or six deep. Each berry maintains its shape and the bottom layer does not mush into a puddle of juice and pulp. Some days, especially after a rain, I just eat off the vine. The berries slither down my throat, a gush of wild pleasure.

When the lunch hour comes to an end, I pack up my fruit and head to the office. In the restroom I change back into nylons and pumps. I pull out the slivers of thorns from my fingers and scrub the juice stains on my hands, the inky lines of black grit under my nails.

LADY OSTAPECK

The Folks Next Door

Black and white photograph, taken with antique postcard camera, 10" x 8"

PATRICIA LAPIDUS ─────────────────────

Rural Nobility

Because of my farm roots I have a special fondness for rural "stuff"—the strength, endurance, and courage that lie in the soul as expressed on our farms and in our villages.

Once I took my kids ice skating on the pond in Neahwa Park, Oneonta, a small city along the Susquehanna River just north of the Catskills. As I hadn't been on skates with any regularity, I was awkward and, the kids thought, quite hilarious. (Today, some years later, my bottom still remembers the cool sudden thump on firm ice.)

Still, I came away that day with a vision of success. An old man in a top coat and a hat with earflaps came gingerly down the wooden ramp of the old skate house, paused to remove the protectors from his skates and, holding these artistically crossed in one of his gloved hands, began a smooth path among the skaters. His composure and something more than skill, that transcendence of the physical made possible by years of excellence, caught my attention completely. He was not flamboyant. He had come not to show off but to feel the movement, to do what he could. His unselfconscious grace caught my heart so strongly that I approached him when he had finished and was at the ramp, replacing the skate protectors.

"Please, sir," I said, "forgive me for intruding on your private moments, but I loved watching you."

"Thank you, " he said with a nod.

Emboldened, I continued, "Do you mind telling me how old you are?"

"I am eighty this year."

"Well," I finished, "may I still be skating, however awkwardly, when I am eighty."

"May you be!" he said with a slight bow, as graceful in connection as in movement, and he was gone.

I didn't see him after that season. My kids grew old enough to go skating without me, and I allowed myself to be too busy with adult cares to join them. I have more than a few doubts about my chances of skating at eighty, though I expect to keep up with yoga and be still standing on my head at an advanced age—I took, along with the image of that elderly gentleman skater, an expanded idea of what a human being can do!

I know another man, also a member of the rural nobility. As his son-in-law likes to say, "Emerson is a prince of a man!"

Emerson Mitchell, straight, lean, is the picture of elderly health. His gray-blue eyes are clear under strong brows. His white hair waves thickly. His mouth turns slightly up at the corners, as if each moment holds amusement for him. Waiting for me at the top of the path in his blue work clothes, he is both elegant and ready for chores.

He pulls a green garden cart down the gravelly woods road and leaves it near some standing deadwood he intends to harvest for kindling. Carefully he rests the old bow saw on the cart handles.

Then, beckoning to me, he steps lightly along the hillside and into the ravine. He wants to show me the springs. We enter a pine grove, snapping underfoot the bleached twigs and lower branches sloughed off by the growing trees. Nimble as a buck he gains the granite ledges, skirting patches of ground juniper and gray, unleafed blueberry bushes. He bends and finds three red-orange box berries, gives me two, and eats one. After a winter of snow and cold, they still taste faintly of wintergreen.

We manage the last steep descent by catching at the trunks of small maples and alders held fast in the bank above the brook by strong roots and, jumping one branch of the brook, we find ourselves standing on a sandy delta large enough for a square dance. From here he holds his hand out in a familiar pointing gesture, showing me where two springs enter at the gravel head of the ravine. There, at the source, he has dug a basin deep enough to fill a bucket. He keeps a dipper hanging on a nearby tree and, reaching for it now, bends to fill it and offer me a drink. We share the dipper, drawing the sweet water into our smiles.

He shows me tight curls of fiddlehead ferns pushing through the loamy sand, skunk cabbages growing big, and a spot where lady slippers bloom each year. He tells how the contours of this basin change from year to year, how the postures of fallen trees can make it hard to pull them out for firewood, how he and his son once brought a tractor and borrowed winch to the delta, set the rope and winch around yonder oak, and coaxed several downed trees up, out of the gullies, nearly a year's supply of firewood.

On our way back we stop at the garden cart. Emerson saws straight across the base of the two drying pines, which make small cracking crashes against their neighbors and the ground. Then, kneeling on the forest floor, he uses the stumps as props and saws stove-sized segments. I stack the lengths in the cart.

Pausing, he tells of the blizzard of '44, which came in May when he already had chickens out on the range, how he got through the drifts and brought water and grain into the shelters so the birds would survive till the snow melted. I see the past stretching back, events faced with courage and ingenuity, care taken. And amusement won from the hard life of a farm boy in the days when chickens were still raised by their mothers.

"I suppose I was about seven," he begins. "I went to the barn to feed the horses and I noticed our three hens all outside with their broods, the little chicks looking for bugs like their mothers taught. But when I went in, I heard a small, insistent peep coming from somewhere in the barn. Well, I traced the peeping to the stall of our old draft horse, and I deduced that that chick was beneath one of his feet. I went to his head and backed him up. He moved three of his feet—but not that one. So I moved him forward. Again he moved three of his feet—but not that one. So I unhitched him and backed him out far enough to make him move all his feet, and the little chick scampered off, cheeping, to find his mother. The horse knew," he finished mildly.

"And meant to keep him," I added.

We piled the cart high with good round kindling.

One story led to another.

"One day, I went down at dusk to do the evening chores and the three broods of chickens had all followed their mothers into the barn to their nests. Only, most of them had followed the same mother, leaving the other two hens with only two or three chicks each. I don't know what it was about that mother hen that attracted the chicks. Perhaps it was her dulcet voice. But there she was, trying to spread her wings to keep almost thirty chicks warm. Well, I didn't think I could let this go on, so I took a few for each of the other hens until it seemed about fair and all the chicks were in, under, for the night. 'Course, I had no way of knowing which chicks belonged to which hen, but since none of them complained, I decided it was okay and went on about my chores."

Without apparent strain Emerson Mitchell hauls the loaded cart to the cellar door where he'll unload it later. After a light lunch, he settles on the couch to watch a Red Sox game, snoozing between innings, a man who works and rests, pacing himself.

What a father can do, I tell myself, a daughter can strive to do, also. I resolve to be so fine at almost-eighty. And I have a larger idea of the stuff I am made of.

NANCY JANKURA

Puppy Love

Black and white photograph, 6 3/16" x 9 1/8"

ANDREA HAZLETT

Priceless Lessons

I've learned much about myself, values, and life from my family. I've learned how to laugh and play from my little brother, Andrew. My parents taught me how to compromise and have patience. From my older sister, Kelly, I've learned respect and gained confidence. But it is my grandmother Margaret Hazlett, who has had the most profound effect on who I am today. At more than eighty, she is still known in the hamlet of Treadwell as a leader and a volunteer. She is a woman of small stature, with soft-looking white hair and a rounded back. Her frail structure and gentle character can be contrasted with the many lives she has had a powerful impact on. The majority of her time is spent doing for others. Without receiving recognition or attention, this is what she lives for. According to William Wordsworth, "The best portion of a good man's life is his little, nameless, unremembered acts of kindness and of love." This statement describes my grandmother's life better than any other.

Sometimes I wonder why my grandmother does so many kind things for other people. Perhaps the answer is in the black and white photos of her childhood that she keeps in her father's cigar box. These pictures don't remind my grandmother of birthday parties or bicycle rides. They seem to remind her only of a much harder time of her life. Perhaps my grandmother is the person she is today because she learned from her own childhood the importance of generosity and sensitivity toward others. My grandmother's motives are pure. She never takes credit for the things she does and never brings attention to herself. It seems to me that my grandmother does things for others, not for her own satisfaction, but because her own experiences have given her a greater understanding of life.

I believe that some of my best attributes were passed on to me from my grandmother. She has always helped others, and today I also feel a desire to help others. Her enjoyment of volunteering is what first interested me in volunteering in a physical-therapy office. Now I am attending college and majoring in physical therapy. Volunteering has been rewarding for me in many different ways. I've gained a better perspective on life by realizing the pain with which some people live. After meeting people with no surviving family, I've also realized how fortunate I am to have a large, caring family. For me, other benefits of volunteering were the two community service scholarships I received at graduation: they have helped ease the cost of college. A greater reward has been knowing that I take after the person I admire the most.

The lessons my grandmother has taught me are invaluable. I remember riding often in her car on a warm, late summer afternoon with a plastic basin on my lap, full of small flower arrangements in cocktail bottles she had collected. We were on our way to run errands and deliver these small bouquets to the local infirmary home. Just recently, before I left for college, my grandmother and I made one of these trips. It reminded me what a beautiful person my grandmother is and how she has influenced so many people in her life. She truly values doing for others more than doing for herself.

In addition, I believe that growing up in the setting my grandmother provided has made me a better person and helped me appreciate life and others. I was fortunate to live so close to her. She has much to share and to teach those around her; I have

learned things about myself that I might otherwise not have learned. I know that my grandmother is very old now. She speaks often and realistically about her life *and* death. I know that even when my grandmother can no longer visit with me I will still find happiness in the fact that she was my grandmother, that she was proud of me, and that she loved me. I especially hope that some day I can give as much to my community, neighbors, and family as my grandmother, Margaret Hazlett, has.

BOB ENGSTROM-HEG

Don't Even Think About It

It was getting late, and the coffee was getting low. The talk had drifted around to various kinds of hybrid creatures. It started with fish. We agreed that, because of its striped coloration, "tiger trout" was a good name for the brook trout-brown trout cross. But "tiger muskellunge" for the muskellunge-northern pike hybrid? There is not much reason for the name apart from the fact that someone or some agency wanted to promote it as a game fish. And "meanmouth" bass! We liked that, but wondered whether these fish really have nastier dispositions than their largemouth and smallmouth parents. There *have* been press reports of them attacking swimmers.

We moved on to mules and hinnies and the scarcity of mule's milk. Roger, my big tiger-striped tomcat (no hybrid), lay half asleep, draped across my lap. His ears twitched from time to time at all the seemingly senseless human blather droning around his head: chromosome counts, reciprocal crosses, and who remembers what else.

I think we mentioned some of the zookeeper-encouraged crosses that would be unlikely to occur in nature: Alexander the swoose, half swan and half goose, who had a song written about him, tigons, ligers, and others. Someone remarked that cats are a lot like their much larger relatives. We began to speculate about whether it would be possible to mate Roger with a real tigress and get some genuine tiger cats. Would the offspring of this cross, if any, be viable or perhaps even fertile? Sheep-goat crosses do not survive gestation, but brown bear-polar bear hybrids can have cubs. We decided that despite Roger's considerable amatory prowess, he would be out of his league, and would need some help from artificial insemination. After all, this was commonplace with cows.

Yeah, I thought. I had spent a lot of time around dairy barns, and the others hadn't. I did a mental take on Gladys, our artificial inseminator, at work in the barn. She would run her gloved arm up the cow's rectum so she could steer the long pipette to just the right spot in the cow's vagina. The cow usually didn't object. She was in heat, after all, and probably had at least a vague sense that something was supposed to happen at that end of her body. Technically a virgin, and for that matter a virgin mother, all she knew was Gladys's arm reaching up an inappropriate orifice. She knew nothing of a bull's caressing tongue, of his long tapering penis, or of walking humpbacked but satisfied back to her stanchion.

Modern dairy cattle get short-changed at both ends of the reproductive process. Motherhood? At best that lasts a day or two. And the bull gets to hump a dummy and ejaculate into a plastic bag.

Cats are not cows and cows are not cats, but they are more complex creatures than most town folk imagine. They are fond of forbidden fruit. The grass really does look greener on the other side of the fence. The sure way to get them to eat a not-very-tasty straw stack is to build a weak fence around it and let them knock it down. They will steal grain from each other, but will carry friendships with other cows to the point of cliquishness. It is easy to know who is in or out of what social circle. Cows are capable of greed, craftiness, and jealousy. They will kick when annoyed, and whang you in the face with a wet, shitty tail, but considering their size and strength there is not much real meanness in them.

Where cows and cats differ most is in the area of easily offended personal dignity. This is pretty much lacking in cows. If their wild ancestors ever had any, it has been taken away from them by all the indignities and manipulations they have been subjected to over the generations. Easily offended cows, like really hostile cows, have become pot roast and left no descendants.

It is otherwise with catkind, large and small. Granted, they sometimes of their own choice set their dignity aside and become kittenish, but their dignity is always in the background, ready to be taken up. Don't mess around with them.

I'll tell you what. I would be willing to handle the tomcat end of this experiment if you were willing to offend the personal dignity of a tigress. Ask Gladys if she would. She is a brave lady, but not foolhardy. I think I know the answer.

JOSEPH KURHAJEC

Sagittarius

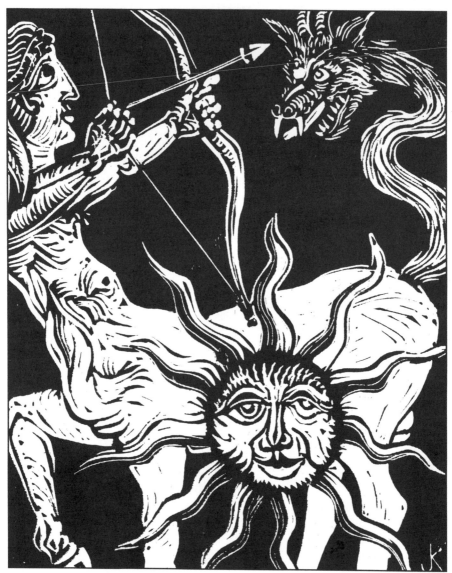

Woodcut, 5 15/16" x 4 9/16"

FICTION

HARRY BLOOM ————————————

The Day After All Saints' Day

You, Teresa Buonocorsi, he said, christening the fat woman running down the church aisle as rapidly as her impeding flesh would allow. She obviously wanted to catch some last vestiges of the Mass, at least that.

> Sharp as the slenderest needle, soft as a single down
> feather afloat, mysteriously plunging to the heart's core,
> to the shimmering depths of the soul; love, divine love,
> piercing with unutterable pain, piercing with unutterable
> tenderness, piercing through and through you, Teresa
> Buonocorsi.

That priest. He had been watching the priest ever since the bell had summoned him. The deep hollows in his cheeks, his fleshless neck displaying the cords running to the head, his skeleton fingers, told a tale of burning piety, of fastings and vigils in the late nights, and maybe even a hair shirt, but it was the silence surrounding him alone in the midst of that busy, cavernous church that was the most impressive thing about him.

There were tourists everywhere; in back of him, between him and his small group of worshipers, in the aisles, in the benches in back of the communicants, in the benches on either side of them. They were everywhere. Talking Italians and Germans and Frenchmen and Americans passed close enough to almost reach over and touch him, and still he remained apart, alone, inviolate. Many of his fellow worshipers were dancing in their seats, rising and falling back, turning this way and that, anxious to break the bonds that held them prisoner, and the priest raised an arm slowly, almost imperceptibly, held that arm poised in the air for an eternity, as if he were absorbing that symbolic gesture into the very marrow of his bones. When he placed the consecrated wafer on his tongue, he shuddered visibly, and the expression on his face told of his passing aeons of time, two thousand years of time, to that awful moment on Calvary.

Teresa Buonocorsi shifted her body, spread her bulk out in order to relieve some of the tensions caused by her restraining dress. What a specimen, he, the observer, murmured, another one of the grotesques found in Florence. Too much fatty food, too much food soaked in oils, and too much wine, and too much sugary pastry topped with whipped cream, and too many hours lying in bed sleeping or merely staring vacantly at the ceiling until thoughts of more food enticed her from the bed, and too much of anything that coarsened the body and assailed the very soul. And there was the red lipstick spread carelessly across her thick lips, and neon-purple eye shadow daubed under her bulging eyes, but most striking of all was her copperwire hair, badly dyed over the original black, a snarled tangle unreeled from a crazed generator.

And yet, he thought, who knows what really lies back of all that unhealthy, unappetizing flesh? Or for that matter, what lies behind the priest's clean, finely tuned body? Maybe in her few minutes of devotion she will be truly pierced by that divine hurt, while the ascetic priest is merely performing, doing his thing; but what a perfor-

mance, if that's what it is!

Now the priest was holding the silver chalice before him, and now higher and still higher, turning to stone, not even blinking an eye. His silence was a palpable substance so powerful it seemed to encompass the impatient worshipers sitting before him, and extended beyond them to where he was sitting until, unbeliever that he was, he could feel the presence of something else, something other and beyond him:

> That moment, that still, awful moment, our Savior's
> body suddenly convulsed, every muscle in that beloved
> body suddenly taut, tensed to and beyond its limits, a
> million violin strings at the moment of snapping, and
> then. . .and then through every valley, through every
> rill of every mountain, through every forest and every
> woods and every glade and every fiber of every tree
> and bush and lowly weed and through the heavens and
> beyond the heavens and through my heart forever and
> forever, oh beloved Man of silences, oh through and
> through. . .

Father Dante Lavelli, he had written over the paragraph he had just put down in his notebook, christening the immobile priest holding the chalice aloft.

The argument had started yesterday on All Saints' Day, and over the most foolish thing. They had been watching a complicated ritual that neither one of them understood, and he had nudged Miriam and pointed out an old man. "That old man," he had whispered, "wouldn't you like to take a picture of him?" He was an old man but one of those splendid Florentines who had weathered time easily, with pink, firm cheeks and glossy, alive white hair, and with the posture of a retired military officer. Later on they had seen him in the rectory accompanied by two beautiful and beautifully dressed children, a boy and a girl. Up close he looked a bit seamed, a bit stooped, but his vigor was all the more remarkable because he was obviously eighty-five or even more, yet his voice and gestures were of a man half his age. And coming so close that he could have touched him, he saw the old man's eyes, clean and dancing and blue, clear and clean as the Tuscan sky after a spring shower.

Was it his unusual quality of youthfulness that made the old man seem arrogant, or was it his arrogance that made him seem so youthful? His vanity, his air of superiority, could be seen in every gesture, from the way he waved a single one of his fingers magisterially to the way he shook his magnificent head in assent or disagreement. The way he placed his hands on his grandchildren, who could possibly have been his children, seemed to say, See, these are mine, and of course what is mine is perfect, as you can see. Just note my hands and my fingers and my perfect nails.

"Did you ever see such arrogance?" he asked Miriam, "such an overwhelming sense of superiority?"

"Where?" Miriam had asked, and when he pointed out the old man, surprised that she hadn't noticed him before, she shook her head in anger.

"I don't see that at all," she said.

"Look!" He didn't' mean to have it sound like an order, but that's the way it came out. "Just look at the way he is standing there showing the world the centuries of

find breeding in him."

"How perfectly silly!" Her answer was abrupt, a small, sharp slap to his face that broke through the din in the rectory.

"It sticks out all over him," he had said. He wanted to slap her face, to return the sting she had given him. "If you're too blind to see what. . ." He was not able to finish his statement because she was rapidly threading her way through the crowded room. He began following as best he could, but he paused and then stopped as he watched her flouncing, positively flouncing, as she always did whenever her sudden and mysterious anger manifested itself.

Suddenly he felt truly alone, the man of the crowd, with no one to turn to. "Miriam," he called after her, but she did not break her stride. He followed her down the walk for several steps and then stopped and watched her turn the corner and disappear. And there he stood once again, wondering what had brought all this on once again. Certainly Gino Guicciardini, the name he had given that old man, was arrogant. Pious, perhaps, but didn't pride and piety go together. Wasn't it supreme arrogance to think you had the answer?

Where can I go to now, he wondered. What shall I do now? He watched the people entering and leaving Santa Maria Novello, and incurable speculator that he was, he opened his notebook. His notebook and the omnipresent pen he always kept in his jacket, they were the answer to the disintegration that followed him wherever he went and whatever he said and did. Like King Cnut ordering the waves to stop, he was arresting time, futile as the effort was. Had Cnut known that? He must have. What else could he have done? His pen ran on as if it had a life of its own:

> Pierce me with They eternal love, with blazing inferno
> of Thy love; consume me utterly with Thy flaming love.
> Here I stand, an old man, weary of all the blandishments,
> the trinkets and toys of this tinseled world, and I long
> only for Thee, for the blessed peace Thou givest me. Do
> I not know that all my honors, my ancient lineage, my
> splendid appearance all through my life, yea, even to
> this very moment, are as dross before the Treasure of Thy
> love. . .

The coolness was still there when they sat down to dinner, and although there had been a small thaw during the evening, Miriam's goodnight kiss was perfunctory, a reminder that more mending would be required. They had talked the episode over; they had even arrived at a sensible consensus, as they always did: who can say what is in another person's heart; appearances are deceptive; the old man could truly be arrogant, or modest in spite of appearances, or any other point on the scale; it was best to think well of him. He almost showed her what he had written down as he sat on a bench before Santa Maria Novella, but he thought better of it because int he precarious state of their affairs she might misconstrue what he had said.

He lay in his narrow bed and thought about what had happened. What had happened? It was nothing, a web so unsubstantial the merest breeze could have disintegrated it. Their little thing in the rectory was not what had happened; what had happened was that he had seen Teresa struggling to rise form her kneeling position as he passed her. How ungainly she was, a veritable hippopotamus, with all those rolls of fat

squeezing out of her dress; and the distended purple and black veins branching down to her unlaced shoes; and the blotches on her arms, bruises probably inflicted by an angry, drunken husband. And her hair! It was not a uniform color as he had thought, but a variegated collection of grays and browns and blacks highlighted by that fiery copper red. But just before they had passed each other, they paused and he could see more clearly the ruins of her face, glistening purple patches coating the bulges under her eyes, a nose that had a strange twist to one side, but standing out most clearly in that moment or two, the jagged red scar across her neck that looked as if it had been left to heal by itself. She looked straight at him as if she were waiting for the examination to be concluded, and feeling a blush suffusing his cheeks, he turned away from her and faced the priest now walking up the aisle. He could not move as the priest approached them. He stood between the two of them, between his Father Dante Lavelli and his Teresa Buonocorsi and waited for judgment to be made.

He turned back at her soft groan and caught a glimpse of her strange, truly walrus-like walk, a shifting of her great bulk from one side to the other in a sort of forward movement, and when he turned away from that spectacle he saw the priest opening one of those mysterious side doors and closing it behind him.

Had she been interpreting him as she had passed by looking into his face? Was she thinking: What is that funny little man doing here? Anyone can see he's just an American pretending to have a religious experience. It could make anybody laugh.

MARIE VICKERILLA

Charcoal and pastel on three pieces of paper, 90" x 70"

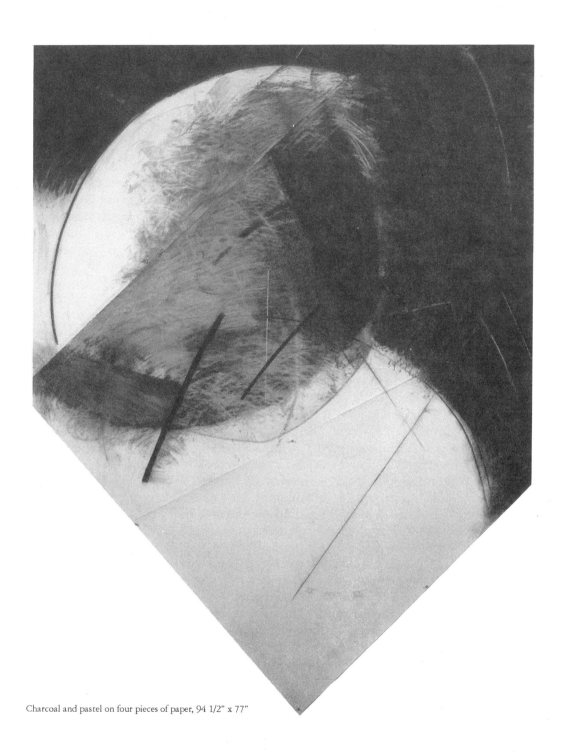

Charcoal and pastel on four pieces of paper, 94 1/2" x 77"

DAVID MATLIN

from How The Night is Divided

A giant old fig tree filled the backyard. If you were tall enough, which I wasn't, then you could lift up on your tiptoes, maybe, grab a fig, break it in two and begin to suck. The figs at that time of spring would be turning their outside skins, going from green into deeper purple, the gradients of that change measured by each sweet bite. The whole house, the rose farm itself, rotting too, just like the figs that had dropped, raising a stench that pointed directly back to that time when the tree had been covered with its flowers just waiting for the bee swarms that would come. They'd go into their dance, a fire dance under the spring sun, tear and rip at the flowers, and then swarm themselves around the queen, all packed into a ball sated from flower flesh and all the things they could make come out of that tree once its saps really got heated.

There were the crops too. Rows of ripening beans where I could crawl under their canopy for days. Endless rows where I'd play my game with the pilots of the spray-planes who'd drop their stinking clouds I didn't understand. I'd watch the insect drop from the leaves dead onto fresh wet soil from the last night's irrigation.

Tom Green knew more about how water could make a field come to life than anyone I'd ever seen. It was just his shovel and the mud and the seeds. The trickling little night floods he was master of where you could hear him out the window directly whistle and sing to the moon, and maybe his Kiowa ancestors too, who composed at least half his Okie horizon, and the death clouds he'd run away from. Had to.

Most Saturday nights he'd be out with the water. The warm ones too, when the rattlesnakes would be out hunting for rabbits. Come one Sunday morning he could see the red house fresh from its move, jacked up and put on a trailer one place, and hauled to another down the roads of their little desert town. The family he loved was still asleep. Half of what we were he almost hated. The Jew part had come somewhere from Russia and full of all kinds of dangerous trouble. He half wished we'd all stay asleep and never come out of any of our goddamned houses.

The other part was a little more like himself, but we'd get so mixed full of that trouble we'd almost turn into witches. The way we observed Saturdays. He resented it a little, as much as he loved to make the water do what only he could make it do, having to miss Spade Cooley and Hank Williams and Tex Ritter made him want sometime to drink up all the water he'd ever let flow, sit down somewhere in the middle of one of those fields he'd turned to new life, and become an ocean. Just by God turn from one thing into another. He didn't give a shit who'd see and whether or not they even had a boat. Noah could kill himself and if he didn't then set his sails up in flames.

Tom would share a little snap of bourbon with his fingers and lips. Toast a galaxy or two, then get on back to the flow of water that was just between him and it. One time he went into town. To sit, that was all. To be bothered by no one, and be no bother either. He was a big man too, even as big men go. There was a park bench strapped into the edge of a sidewalk just right for watching people even if people weren't exactly always for watching. Apparently he'd been sitting like he'd intended when this drunk came shambling by and couldn't help but notice. The drunk looked Tom up and down, walked up, banged on Tom's knee with his fist. The knee would not move and

neither would the rest of the flesh up that backed it up.

The drunk tried it once more, then started in on language. Called him a whole bunch of names that wouldn't break his heart or his ass, neither way, until finally he got it all boiled down to this one single word. "You an Okie, boy?" The drunk wasn't quite so sure himself how far he'd got it down so he tried it out again. "Okies make me just about want to puke." The knee moved then. No warning. Nothin. Caught the drunk on the edge of his hip, spun 'im around. Tom grabbed the drunk with his hands around both elbows, stuck one foot into the drunk's back. The drunk got flown through a window but the liquid that came from him Tom didn't have a shovel for.

And Tom knew irrigation. The main problem was there'd been whole valleys killed for it. The Owens Valley. People driven into a witness that couldn't save one single belief because there is no language yet that we have that's equal to that withering. Maybe a picture can explain—two men, the very last Mandan Indians, their eyes in their heads counting all the missing ones, seeing who isn't here, the hundreds of generations disappeared. Trickled away the same as those valley people who'd watched the last drops of water sink off into who knows where. What thirst could it be that would want every last drop?

Sometimes Tom Green, when he wasn't cutting wet mud with the blade of his shovel, would go square dancing on a Saturday night. All them Okies having a good time, and none of the picked through half-rotted potatoes they'd have to glean from the warehouse leftovers at the end of the day either, have to fight the flies and the crows for it. Beans and slices of beef and bread and butter served on the best plastic dishes where they could be kind to each other finally, no wind or metal-eating dust breathing down their memories from another world that had slipped away from them.

They'd dance, too, to Woody Guthrie as he'd sing on those records, the true poet of their horrible forced march. Songs like

> Put your finger in the air, in the air. . .
> Put your finger on your nose, on your nose. . .
> Put your fingers all together
> And we'll clap for better weather;
> Put your fingers all together,
> All together.

And for that small time it seemed like maybe this was the best way to find you were human again, had this body that longed for other things, had this space to touch yourself, and find out if it was all still there. He could talk about Jonny McBrown, and hear the gossip about Hoot Gibson being the grand Marshal of the next Rancho Ride to celebrate Murieta the Great Bandito and his last stand, imagine us kids climbing the poison-oak-laden cliffs of the box canyon surrounding the rodeo for the Rancho Ride and then be brought home for vinegar baths yelling and screaming all the way to our tubs. Something different from remembering the steady depletion of real earth into varieties of the unincorporable, and having gazed weirdly into a bottomless world, and that matter mattering most deeply still.

Some days Tom would watch our family come out of the red house. Watch the cars arrive from Beverly Hills and Hollywood, come to this driveway. Mercedes 300 SL's

and Facel Vegas. Hear these people speaking their Russian and Hebrew, the producers and actresses mixing with my father, the farmer of roses Tom loved, who'd been one of the first to clear the chaparral, who'd covered the local alluvial hills and certain ravines with these flowers and all their attendant symbols, seeming riper for the tending they'd go through. Petals perched with thorns. In the mind of my mother, the lore of mortality that surrounded the roses, even down to the whole massed population of Tenochtitlan silently dancing in flower processions, was totally lost on my father, other than the petal dances they might perform for each other, nearly every time violently based conditionally on the thousands of rows of roses and our intertwined struggle for existence scraped and scraped into genetics itself in the hunt for new colors and resistance to disease.

Dreamers of water. Casa Grande, the Hohokam skyscraper. You pass it on the way to Tucson. Not whole oceans but enough, and mud masters too. Adobe. The main complex itself standing abandoned for at least six or seven hundred years, ten storeys of it before old Father Keno himself came through on his donkey, the wandering padre of the El Camino Real lusting for conversions.

Water and wind. These people had constructed doors in such a way that the opening became the primary circulation of air, half body size so you'd have to crawl. It was a system engineered into the building itself so summer kept it cool, no dehydration of body fluids when it stayed a hundred to a hundred and twenty for days, and in the winters just as dry. You wouldn't have to waste cactus skeletons for keeping warm. You could concentrate those Saguaro and Cholla frameworks on hot food.

And beyond the main complex are the eroded hummocks with miniature ravines between them, telling the story of this peoples' extraordinary genius with water for converting the waiting propitious clay into life-giving fields. Corn, squash, peppers, beans—their evolutionary varieties composing the most primeval fairy tales of birth and being and death. Life-ways under starry wheels and not one whisper of their reality other than the remnant marks of tides left on the sides of these ditches a thousand and more years old.

Records of swollen now invisible moons each one coming into her girlish capacity of lust for her jackrabbit lover. The rodent's insatiable craving so gingerly delicate at first, making her feel almost unreal, aloof, a trembling expanse washing over the marshes of cilia in each woman who ever lived. Tidal marshes accumulating along pelagic coasts of other seas and throbbing for the hopping ears, their impersonations and blood-swelled glare carrying her into resistance and preparation that would pitch the rabbit toward the repetitions of his unalterable frenzies.

Stone images have been recovered from the Chiapas swamps. Men, the strongest of the tribe, ravished by parrots, the pleasure so plainly the mark of their mutual laughter. Or a frog fondling a virile man's penis, himself sinking, deliciously unstrung in the core of his sinews, ravished by the very refusal the frog expertly taps as the master of these unexpected and bewildering ecstasies. Males, here in their act of copulation. But women too, images sunken into the Andes, the husks of cocoons whose changelings have fluttered away. Women and monkeys, and women and dogs, coupled in such inaccessible pleasure that their abandon becomes the threshold of an incomprehensible sleeplessness else the hybrid flocks hatch out and begin to scour the living for the ones with crystal skulls who know the language of the stingless bees. Ones with droplets of jade inlaid into their teeth wandering up and down the hemisphere bearing instructions

about water and the ways to make it flow without giving birth to the hidden salts that would mineralize and transform the soil into a poisoned hag. Number carriers with their equations about matters and its four appearances, the living names.

Where the San Joaquin touches the Sierra foothills, batholiths have burst through the earth, shattering themselves in their own birth force. And there are rock shelters filled with paintings. Black and white and red contrasts sometimes double and triple outlined, beings of the "split head" which the Yokuts and their more elaborate Santa Barbara neighbors, the Chumash, traded.

The coastal sites are usually more simple, linear, concentric circles and built-up zig-zags. It's inland where the imagination actually feeds on the tectonic nectars, where the spaces between land and sky and planetary core become each other's light and shade. Some of the paintings have twenty-six bands of contrasting color. Black, yellow, blue, green, red, and white multiple outlines. Every form fights right up to the reef of its immobility, literally searing the border between its motionlessness and the about-to-be-motion. Tom could look at one painting and be fused instantly to all the beginnings held there.

Near Frazier Peak there's a circle the Chumash rendered, its purple background faded and surrounding compositions eroded now into isolated islands. Two penises dance here. Their light earth-brown shading and swollen heads seem still freshly erected from a rush of engorging blood. They almost touch. Their nearly mutual length held apart by two white condors pushing against the tight expanded skins with their outstretched wings. A third ancient raptor, the wholly exposed Pleistocene survivor, forms a joining white collar at the lower border of the foreskins. The penises are spurting clouds of semen into an elongated shape which gently flounders over their distended heads. The shape's dark red outline surrounds an inner background of hot pink with vertical white lines pulsing through it. Other zig-zagging white lines scour the outer edge of the dancing pricks and galaxies, lines of dream journeys, feathers, and human shapes with miraculous hands of exploding suns filling the remaining space of the circle.

The smaller penis to the right has fifteen white dots leaking out from its bottom into the deeper, emptier purple undershading. An opening for the escape and release of the story so it will not cave in on and poison itself, become a caller of mutation in world seed.

The Chumash might have spent decades inside their holy caves. Under-earth wanderers and doubles of the condor honed to sky and cliff. They'd set their fires there to blacken the ceilings to the finest thickest black that would never succumb to gravity or the terrible shaking earth from which there was no running or hiding or dreaming. Wait for the smoky pastes of their fires to harden into the unexpected and uninvited twin of the stone beneath it. Only then would they begin their excess in orange and white and yellow. The layers of abstraction tear at the stone itself, tearing at the heat that made the stone, the potency of their Datura spilling over into all the hardness and softness which framed them inside the sumptuous menace of their lives.

But the petroglyphs tell other stories, the stories of their drowning. Water again. The great vats underground equal to the five inland oceans of North America that make up the largest reservoir of fresh water on Earth. The Oglala aquifer could just as well be

a sea. The pelagic undermirror of the land itself is haunted by swarms of blind fish whose need for eyes disappeared with the rhinoceros, a phylogenic risk that extended from Alberta to Laredo, finally squandering itself on a dead end after forty million years.

Just south of the point where the Snake and the Columbia join and then shoot for the Pacific, where gravity nurses the two bodies in their sisterly rage, there's the Dalles, or Long Narrows, where all the rushing liquids of the northwest section of the continent get squeezed into a headlong anvil no more than fifty yards wide and a mile long. The gush of the rapids and its eagle-swamped rainbows must have been nearly as awesome as the waterfall at the Straits of Gibraltar when the great dry sub-sea-level plain of the Mediterranean began to fill up at about the time our first hominid kin began walking on all twos. For the tribes it was the spot, their favorite. They built platforms right into that swollen urge of water just on an abyss of a no-holds-gone growth principle. Made it their trading center and skeleton carnival for the salmon. The Dalles also featured the biggest show of prehistoric rock art on the whole Columbian Plateau, all of it now soaked in the Grand Coulee Deeps. For this much water, Old Kokopelli himself of the sky-charming flute, the great humpbacked god, with his life-giving cup to sate or spark the deepest thirsts, couldn't limp here, or fly, or play his flute until it wore to air.

The pluvial storms marked the end of the glaciers. Bursted rains lasted for ten or twenty or thirty years until the giant lakes filled up. Lahonton and Bonneville in the Great Basin. Albany and the Sea on Champlain on the other side to balance the scales of the continent until ancient Bonneville, that stretch from Idaho nearly to Arizona, had its northern natural dam broken at about 15,000 B.C., causing the second largest known inland flood in the whole history of the planet and a river fifty times the size of the Mississippi scraping all the Snake River Plain and beyond. The harvest of ground sloth, jaguar, saber-toothed tiger, camel, mastodon, whooping crane breathing from the new grasslands to the migrating forests as freshest tasters of the ice-crushed Earth.

THOMAS C. RAPIN

Main St.

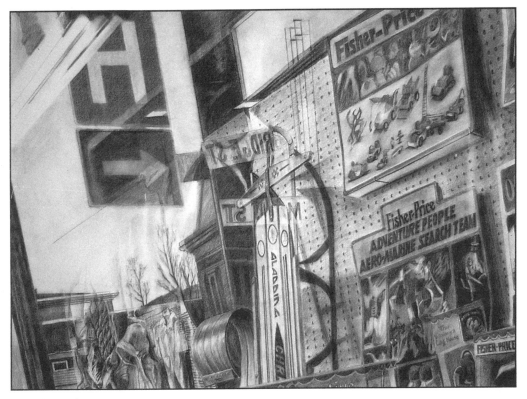

Charcoal on Paper, 20" x 30"

HOLLY BEYE

A Shopping-Cart Tale

Marcella Hathaway was returning home from a tempestuous meeting in a nearby city, at which enormous amounts of very strong coffee had been served with little thought given to the fact that the facilities where the meeting took place had been temporarily closed down by the Health Department due to a sewerage problem. (The coffee had been brought in, not produced on the premises.)

But as her car approached the local supermarket, it came to her suddenly that when doing the morning's shopping, she had failed to lay in her daily stock of cream cheese, and so, despite strong internal promptings of a micturating nature, Marcella raced the car to a halt and leapt out onto the blacktop.

It was a balmy night in April. The peepers chirped in the trees, and a half moon swayed drunkenly amongst the clouds. At that hour, the supermarket parking lot was fairly empty: a couple tussling with one another in the front seat of a van decorated with large peace symbols, a narcotics vendor engaged in seductive conversation with a reluctant customer over a new shipment on display in the open trunk of his Corvette, a three-legged dog whining at the electric door of the store, and perhaps five empty cars. . .

Marcella entered the neon-lit store feeling animated and bright and she smiled cheery hellos to the dark-chinned young manager, who was, as usual, working his tongue relentlessly over two interlocked front teeth, and Sunny, a cashier whom only last year Marcella had had to fail in her Homecare I course at the hospital.

Four customers with small purchases made up the check-out line. A quick glance showed her two others hovering over lettuces in the vegetable section and a furtive young man in oversized, dark glasses fondling cans of chunky pineapple the next aisle down.

As Marcella raced along to the far side of the store for her hit of cheese, rounding the corner to Dairy Products, she became suddenly aware that the coffee she'd had earlier was about to have its way with her and that she would not make it out of the store before that happened.

What were the alternatives? Marcella came from a family untainted by blemish, admired and revered for its opinions on crucial issues like civic larceny, gender discrimination, euthanasia for dogs. She could not afford to be seen as less than she was. Could she perhaps claim that she had fallen into a puddle outside?

She could if it had rained. Unfortunately, there had been no rain for forty days this year, and the word *drought* was on even the lips of toddlers.

Inside her, the pressure was building up. Frantically, she looked around for a possible ally, someone who could walk closely behind her, or in front — whatever the situation demanded.

But just as this strategy presented itself, the dam burst and she felt a trickle begin down the right leg of her purple Dior clones. It was a trickle that quickened into a dribble, then turned rapidly into a gush. Marcella thought of her blonde-braided mother, Gretchen, regional PTA president— the embarrassment to her memory should Marcella, her daughter the nurse, be unmasked in scandal of a low sort—her father, whose relentless undercover work with the Motor Vehicles Department had made him a

household word throughout the Hudson Valley—two blessed role models whose memory Marcella could not now disgrace.

Her first priority was to get away from the immediate effects of her leakage as fast as possible. But as the flow increased, the saturated Dior clones were guiding the floodtide downwards, into her shoes, so that walking on the hard cold floor of the Grand Union became a sticky, soggy process, producing the same wet sucking sounds you get, for instance, from a snake swallowing up a live frog. Worse yet, she was leaving a trail.

By now, Marcella was no longer interested in locating an ally to help her escape from the store. She decided to cling to the narrower aisles where the glow from the overhead fluorescents produced dark recesses along the sides into which she could, by flattening her torso, disappear, unlike the wider corridors which were awash with light.

But just as Marcella Hathaway slunk around the corner opposite frozen fishes, she was hailed by a person-in-the-helping-professions with whom last week she had chatted a good fifteen minutes while the two of them pawed over fresh frozen turkeys. What are these fowl, they had coyly asked one another, if they are not one or the other: fresh or frozen? Perhaps, they had noted, these birds are victims of grammatical whimsy. An English major, Marcella's new friend—the helping-professions-person—had wanted to go to Radcliffe, she told Marcella, but a parent's illness (her mother's, Marcella thought, and suspected the illness was mental) had made that an impossibility.

"Think the adverb! " called the helping-professions-person gleefully as she had waved good-by. "Freshly frozen!"

And now, tonight, no doubt remembering their ebullient exchanges, she telegraphed her intention of immediately resuming where they had left off, making turkey-cackling sounds and then shrieking with laughter when an elderly gentleman poked his profile around the corner from the milk section in alarm. Marcella covered her face with her hat, turned on her heels, and rushed squishily up the aisle towards rubber spatulas and plastic graters.

But the helping-professions came after her. "Are you all right?" she called with real concern.

Lest a clinical inspection of Marcella's person at six feet's distance reveal to her the academic nature of her question, Marcella closed the gap between them by taking her arm in hers and hugging her needy torso sideways all the while chattering exuberantly about the various high spots they were passing. Even before they exited the aisle, helping-professions broke from Marcella.

"I had no idea you were so product-oriented," she said with a thin smile, and Marcella knew that any ambitions she might be entertaining about job-accessing through her new friend's influence had been irrevocably dashed. (You can say what you like about people in the helping professions, thought Marcella—she herself had been one of them until the unfortunate matter eight months ago with Dr. R—but the fact is they are the least likely of any group to extend a gratuitous hand to someone in distress.)

Marcella was now obsessed by wetness. To prevent chapping of the skin on the inner thighs, she walked in small steps with her legs alternately bowed or pressed tightly together. Wherever possible, Marcella clung to the dark recesses created by the taller shelves and narrower aisles, taking unfamiliar routes through canyons of merchandise she had never even heard of nor ever wanted to hear of again: bazaars of plastic inventions unacceptable to any but the Mafias of the most depraved landfills.

Dr. R belonged to a landfill co-op, to which members brought their scrupulously washed and separated recyclables on Saturdays from 10 to 3 P.M. (You had to be recommended for membership in his landfill by three members in good standing; it was an unabashedly elitist group, no one in it with less than a Ph.D.) During the zenith of their dalliance together, Marcella would start her Saturday mornings in his kitchen separating his garbage while he shaved.

Dalliance, liaison. . . Oh, dear, dear, no. . . The tears that fell afterwards were shed precisely because the relationship had never flowered beyond the level of casual sex. It was the ritual with the garbage every Saturday morning that had beguiled Marcella into believing it was more.

Certain people Marcella had met through Dr. R it would never do to find her now hovering around these unspeakable plastics, with or without wet pants. Marcella pressed onwards towards the cereals, shelf after shelf of them, in rows of frantic, bright boxes throwing out invisible lariats of sugary enticements to the weak and to the depressed.

Unexpectedly, the dark-chinned manager emerged from the next aisle over and came towards her still grinding his teeth. Marcella waited for him to pass, but he stood, resolute and unapproachable, only a few feet away, staring at her, a clipboard held loosely in his hand.

It was imperative to engage him in eye contact. She began with a tiny wink and the merest smile. He blinked, and blinked again. Marcella moved closer to him, broadening her smile.

"You looking for something?" he asked, dropping his clipboard to his side.

"I've never been in this section before," Marcella said, agitating her eyelashes again in his direction. "It's really pretty nice."

"Cereals," he said.

"Yes. . ." Marcella answered him tenderly, "cereals. Cereals are nice, aren't they."

"Well, yes," he said, "if that's what you like. . ."

"Do you," Marcella asked, "like them?"

"Well, no," he said. "To be very candid, what I like is an egg. Eggs and pancakes actually."

"What about waffles?"

"No, just pancakes. Pancakes are what I like."

"Could I tempt you with some french toast?" Marcella insisted, moving her face nearly under his chin as she saw his eyes begin to stray downwards.

"No, and I've got to get back to work now if you don't mind," he said, bending to his chore. "I've got to count all the 13-ounce boxes without separating them out from the 15-ounce boxes. No manager should have to do this job, but they want the info downtown A.S.A.P., so I've got to do it during times when we're running slow like now—"

She sped around the corner to spices, soups, and pot holders, having seen a side to him she hadn't seen before. He'd been the reason Sunny had flunked Marcella's Homecare I last year, this dark-chinned hammer-toothed manager. He was only an assistant then, with two kids and a wife pregnant with their third.

"He felt trapped," Sunny had told Marcella. "You know?"

"What about you?" Marcella asked.

"I was never trapped," she said. "Anyway, we had some good times together before I had to go for the abortion. And anyway, he paid for it, he had a credit from this

other time. . ." Sunny's words trailed off into the air like a vaguely spun vapor cloud.

"You're really not ready to become a nurse," Marcella said.

"Yeah, I think you're right," Sunny had agreed, pinching and probing her face with the fingers of both hands. She was perpetually involved in bi-lateral facial self-inventories, which made it hard to talk to her. Marcella's decision to flunk Sunny was taken about half-way through their little tete-a-tete.

"Marcella, I tsink you very harsh vis hur," Dr. R said as they lay one night under a vast spread of moonlight on the roof of his garage where they had gone to spot Mars through his telescope. Taking a break from the skies, they were entertaining each other with what they liked to call their Shopping Cart Tales. Earlier that evening, having dined on one of his mother-the-herbalist's special recipes of seaweed- and blue-radish soup topped with dollops of khlan—blessed khlan, Marcella was still including it in her diet once a week in memory of those frenzied nights together—they were a trifle gassy. Afterwards, Marcella attributed his impassioned defense of little Sunny to dyspepsia brought on by the soup.

"Tsese yung girls wiz de hairs in pony, tsey don't haf know vut tsey vunt. You bettah sticking to you own girth, baby," he said, smacking her on hers and tonguing her ear with a belch.

Marcella had now reached the end of aisle number 2, which opened onto the cash register. It only remained to merge with the other customers—and there were four of them—lined up to have their purchases tallied and bagged by little Sunny. As Marcella made her way into their presence, they seemed suddenly rinsed and wrung with merriment. She grabbed a New York Times and opened it in front of her.

But it wasn't Marcella they were laughing at; thank god for pot! Dear pot! Oh blessed pot; they were stoned. Marcella joined them and simulated mirth.

"Ha! Ha! Ha!" Marcella howled.

"Ha, ha, ha!" they chorused back.

"Ho, ho, ho. . ."

"He, he. . ."

They hopped from one foot to the other, they turned in circles, they cantered about and slapped one another on the back, all the while laughing and wheezing and falling halfway into their shopping carts when breath gave out. And one by one, little Sunny checked them out, sullenly ringing up the totals and slapping their hands with their change.

"Here! Ya want yer money?" she said as Marcella half turned to respond to some witty retort from the man behind her. Marcella reached for the money quickly. Not quickly enough, however. She saw the odd look spreading across Sunny's face, the open-mouthed shock and disbelief as she raked Marcella up and down, and the gleam of triumph come into her yellow eyes as, handing Marcella her bagged cream cheese, she asked in a loud, sly voice, "You teaching bedpans now in your Homecare course at the hospital?"

Snatching up her cream cheese, Marcella left the store. Her heart was racing so fast she was nearly unable to turn the ignition. Sunny would tell him, wouldn't she? Marcella knew she would. She would tell him that very night. She would phone him, not waiting till next time she saw him in the store, or in his bed, to which Marcella happened to know, he invited her Saturday nights after nine to look through his telescope, the same as he had Marcella a scant eight months ago.

MARTHA LEIGH

New York City, 1981

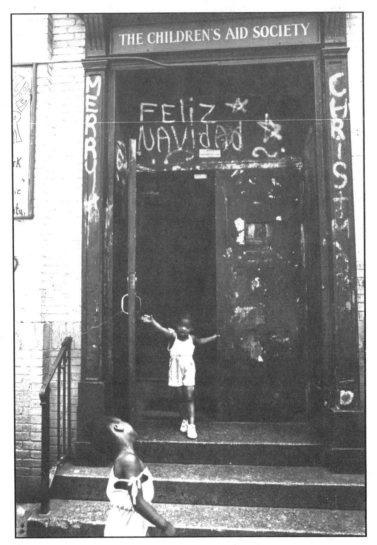

Black and white photograph, 7 3/8" x 5"

New York City, 1981

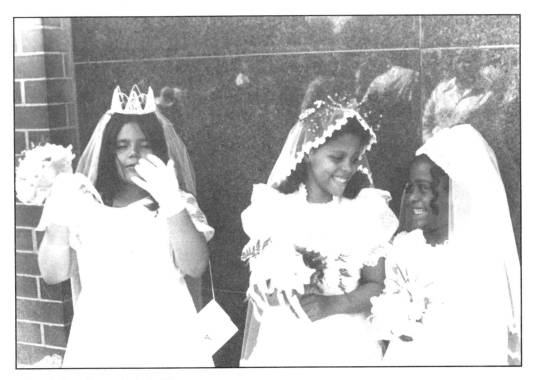

Black and white photograph, 5" x 7 3/8"

CALLIE WRIGHT

Grapes

"Where were ya'll this morning?" Jane asked as she opened the door of her Fifth Avenue apartment. A bead of ice, now defrosting, lingered on the end of a strand of Liam's black hair, ready to drop into the pile on Hardy's head. Hardy always wore her hair up when she had a hangover—she said it gave her headache a center of gravity.

"Breakfast is practically over now." All through high school in Riverdale, the three of them had eaten breakfast on Sundays. Now that they were together in The City again, Jane made sure the tradition was kept alive. "You could've called or something."

Hardy rolled her eyes and stepped past Jane into the foyer. She hated that Jane said ya'll. Jane had lived in Dallas for five months when she was eleven. She claimed that, in seventeen years, she still hadn't been able to lose The Accent. The funny thing was, the only part of The Accent she hadn't been able to shake was ya'll.

Liam looked in the mirror on the wall and noticed there was guck in his right eye. He rubbed his face and wished he was still asleep. Off the end of the foyer, the door to Jane's practice room had been left open. Her violin had been carefully laid in an open case and sheet music was spread all over the floor. He felt guilty, but he didn't apologize—he knew Jane would concentrate on being mad at Hardy.

Jane was sure Hardy had spent the night with some new boyfriend; she always smiled more after she'd had sex. Hardy was massaging her temples and Jane thought of screaming at the top of her lungs because that's what would really make her feel better about having missed breakfast.

But Hardy wouldn't even get upset. Jane could tell her she hated her and thought her articles sucked and she was a stuck-up bitch and Hardy would simply smile, like she pitied Jane because she was really describing herself. Or maybe, like she agreed.

Hardy stared at Jane. Her body had become large, but her face was still thin. It seemed odd that her face couldn't change. Hardy could feel the outline of her ribs through her shirt. Eating was something she thought a lot about to do so little of.

Everything in Hardy's life was an attempt at perfection. When she was fifteen, her father had lowered his newspaper and said, "Hardy, you can be anything you want to be. But whatever it is you choose, you must be the best at it, because that's the only person we remember." When she was sixteen, her father shot himself in the chest in their upstairs bathroom, right in the middle of a "Honeymooners" rerun. These were two of the few things she remembered about him.

Jane could feel Hardy watching her and began to nervously rock back and forth. Sometimes Jane wondered why they were friends. Jane knew Hardy loved that she had blown her last audition. Of course, Jane was content to know that Hardy's last article had been rejected by all the big-name magazines. They both lived in fear that each other would be happy.

Liam fidgeted with his wallet. He wondered how much money he had with him. They would expect him to offer to pay. "Want to go to a late brunch at, like, Cafe Ravel or something?" They took Visa.

Liam smiled at Jane and knew he was forgiven. He wondered what Hardy would tell her about last night. He knew she'd had a date with an older guy who turned

out to be married. He also knew she would never admit this to Jane.

Hardy looked at the horse on the Oriental carpet. It was her turn to offer an excuse. She thought of telling Jane the truth, but it was easier not to. "I'm sorry I'm late. Cafe Ravel sounds perfect. Can we go now—I'm starving." She flashed a smile and zipped up her coat again.

Liam wondered why Hardy led Jane on like that. It was evil, but he, too, saw the humor in it. Things about Jane could get really annoying, if you let them. Hardy never did. Instead, she played her; Liam wondered why Jane put up with her shit.

Jane wanted to push the subject; she wished that just once she would have the nerve to throw back at Hardy something like, Don't you seem evasive. Liam and I are best friends. . .we're all best friends (throw a wink at Liam). Can't you tell us? Instead, "Let's go."

Jane grabbed a sweatshirt and pulled it on over her head. She had gained weight, waiting for a job to come along, and none of her jackets fit anymore. Hardy, Liam, and Jane filed out of the apartment and Jane locked the door behind them. Her key ring had a Betty Boop figurine with both eyes rubbed off—she told people it was a collector's item.

Liam pushed the elevator button and Hardy started to whistle.

"Hardy, do you have to do that?" Liam traced the welcome mat with his toe.

Hardy looked at Liam's nose and wondered if he could flare his nostrils. "Didn't realize it offended you so much." When she was little, her mother would scream at her for being sarcastic. 'Hardy, you always have an answer for everything. . .can't you ever just shut up?'

"Hardy, whistle if you want to." Liam thought she probably tried to think before she spoke, but a biting comment always escaped. He waited for her to apologize because she always did.

"I'm sorry—"

"Oh, who gives a shit. It's over." Jane pushed the elevator button again and straightened the welcome mat. "What the hell is the hold up?"

"We could take the stairs."

"We could. . ." Jane made no move for the other end of the hall. She was into the luxuries of life and made sure to take full advantage of them.

The elevator came and Liam held the door for Jane and Hardy. That was something he did without thinking. Neither one had ever told him to do it or paid special attention to the fact that he did. They'd known each other for so many years, they no longer bothered to be polite. When Liam was with Jane and Hardy, he felt like he was living out a soap opera.

The wind raced the cars down the avenue. Pedestrians used newspapers and briefcases to block it. Those moving against it had almost stopped while those moving with it were flying along a little faster than they wanted to.

Jane waited inside while Hardy hailed the taxi. They all piled into the back. It was taboo to sit in front with the driver.

"74th and Columbus."

"Check out his name. . .Rjick something. What's his last name?" Liam was leaning over Jane. Hardy felt sorry for the man. For a few blocks, he was their servant.

"Rjork," Jane announced after squinting and unsquinting for ten seconds. She never wore her glasses.

"Oh, I'm sure his name is Rjick Rjork," Liam and Jane laughed so loudly that

the music could barely be heard, even though Rjick had turned the radio up so that Indian sounds were pouring out of every speaker, and Hardy thought maybe he was offended.

"Which side?"

"Right."

"Here is good?"

"Yep." Liam paid. He had a real job. When he was in seventh grade, his father sat him down with a pen and a piece of stationery and told him to write a letter to Duke University expressing his interest in the school and his chosen career: corporate law. It didn't matter that he had no idea where Duke was, or that art was his favorite class. What mattered was that his older sister had joined the Peace Corps, abandoning all their father's plans for her. He was young and had heard his father call his sister an ungrateful bitch, so he wrote the letter and went to Duke and became a corporate lawyer.

Jane thought Liam probably hated eating with them because he got to pick up every bill. It wasn't like she didn't have money, but her parents were doling it out. A major in violin at Brown hadn't gotten her very far. She was holding out.

They ran from the cab to the door. Hardy wished she had Chapstick. Liam held the door for Jane and Hardy.

"Smoking or non?"

"Non."

"Um, actually, smoking." Hardy started smoking during the summer after ninth grade. She'd tried to quit when it was "out"; then it became the intellectual, artsy thing to do. Depending on the month, she was a smoker. Her mother had told Hardy that they would throw her out of the house if she ever smoked, and there would be no more money. She wondered why she had bothered to bury the butts and buy spearmint gum in ten-packs—there was no more money anyway.

Liam shook his head at Hardy. She shrugged and followed the woman to a table by the window. Jane was trying to whisper in her ear that emphysema began to develop with your first cigarette. What she really meant was second-hand smoke could kill her.

"We're ready to order." Jane was ready.

"I'm not." Liam was frantically searching the menu for red meat.

"Yes, he is. Liam, get the fruit—you'll like it. I'm hungry." Jane, a vegetarian, hated vegetables, beans, and nuts. Invariably, she ate fruit.

"I guess I'll have the fruit." The waitress smiled at him. He wondered if she was flirting.

"Did you see her looking at you, Liam?" Hardy had obviously noticed.

"No."

"A.k.a., will you sleep with me?" Hardy smiled at him.

"Ya'll, check out that busboy. He has breasts."

"Shut up, Jane."

"I'm completely serious. Watch him when he turns to the side. He even has his shirt tucked in to accentuate them. I wonder if he's in the middle of a sex change."

Hardy rolled her eyes but continued to watch the man/woman. All three were staring at him, waiting for a profile shot. He went back into the kitchen.

"I have an audition at the Met on Tuesday." Jane was stirring her water as if she needed to ensure that the hydrogen and oxygen were fully bonded. She kept looking through the glass at various angles. "I'm sure I won't get it but I'm definitely giving it

my all because my parents are bothering me to make some money. Same old shit. I mean, what do they expect me to do? This is my life." Jane waited for someone to ask about the audition. She stared at Hardy's hands and wondered if she had even heard.

"Can't you work for a music company or something?" Hardy found Jane to be annoyingly picky.

"I majored in violin. I'm not going to answer phones for minimum wage with a diploma from Brown. I don't care how bad the economy is—I'm not that desperate."

"Well, I am. If I weren't, I sure as hell wouldn't continue with this internship. I swear, all I know how to do is make coffee for the writers who are doing what I want to be doing. I keep telling myself that this is what it was like for everyone when they started out, but I think all the big shits know they have us on a line because we have loans to pay off and can't do any better. I might as well be a secretary—I'd probably make more money doing the same thing."

Liam hated these conversations because he felt like he didn't really have a place commenting. Whatever he said could be easily shot down with, "That's easy for you to say—you're well paid." And he was. But there was a lot more that he wanted. He was twenty-eight and he was a lawyer. And that's all he'd ever be until he retired and bought a yacht and had a twenty-year-old mistress because anyone he married through the course of his life wouldn't be able to love him—she would never know him. And this is not what he wanted.

"Here's your food. Two fruits and a veggie burger."

"I want a veggie burger. What is this shit?" Liam picked a seed out of his grape. "If there are seeds in all of these, I'm going to be really mad at you, Jane."

"I'll trade with you, Liam." Hardy handed him her plate and began to dissect her grapes by biting the fruit in half, sucking out the seeds, and spitting them in her empty teacup.

"Hardy, that's gross." She spit one at Liam.

"So, what did ya'll do last night?" Jane wanted to know.

Liam looked at Hardy across the table.

"I went to a movie with this guy, Jake.'"

Liam knew that's all she would tell Jane. He felt sorry for Hardy.

"What'd you see?" Jane wanted to hear about the terrible sex and the hangover. *Casablanca*.

"Where was that playing?" Jane was staring into Hardy's teacup as if trying to read the seeds.

"The Village." Hardy just couldn't give Jane the satisfaction of knowing that she had gone out with a balding, thirty-six-year-old man and then had sex with him so that he'd go home to his wife where he should've been six hours before.

"Oh." Jane couldn't think of any more ways to push the subject. She let it go.

Liam knew she was full of shit. Hardy and Jane weren't friends. They lived to lie to each other. Neither one really knew the other; he was the one who was told everything. It was all a competition. "Um, Hardy, which theater?"

"Jesus, Liam, who gives a shit?"

"I'd like to see it again some time." Liam stared at Hardy's breasts. She had a nice body. He wondered what his wife would be like. Not her. He wished he could just marry Jane or Hardy. But nothing works out that way.

"So look in the fucking paper, Liam. If you want to see it that badly."

"Ya'll, it's not that big a deal." Jane hadn't been listening. She wondered what

she would play for the audition.

"Liam, what the hell is your problem?" He was ruining Hardy's fun.

Jane looked up. She'd never seen Hardy this mad at Liam. "So, Liam, what'd you do last night?" She asked it mostly to calm Hardy down.

Jane poured milk in her cold tea. She could remember the time she added milk and lemon, thinking how cool she was to be drinking tea. It was English breakfast tea. Her father drank it every morning of his life, she was sure. She thought she would get him a lifetime supply for his birthday. And then she thought about how he would think it was a stupid present because his life was more than half over and what good is an endless supply of something with no one to use it. This is how her father thought.

Liam wondered if the cook wore gloves when he pulled the grapes off their stems.

Hardy watched the woman at the next table turn a page of The Lesbian Body and wondered if it was self-help or a novel.

"I went to a movie with a guy from the firm. It was a really shitty thriller. I don't even remember the name."

"How can you just forget the name of something? I mean, if it was that bad, it seems like you'd remember the name just so you wouldn't make the mistake of seeing it again." Jane was staring at Liam. She'd never noticed how green his eyes were. He rolled them at her.

The waitress came to clear the table. She reminded Liam of his mother. He thought about how devoted she was to his father and how he'd never seen them touch each other. He thought his father probably would've loved his mother if he had known how to.

Jane was tracing a pattern of water on the table top while Hardy tried to inconspicuously read the back of *The Lesbian Body*. Liam wondered if he would remember this day and where his sister was and how his parents met.

Liam coughed. "Guys, I'm moving down to Durham. I might go back to school or get a job with another firm. This just isn't working."

Jane stabbed a kiwi slice with her fork and placed it on her tongue. She rotated the fruit until it was lined up with a canker sore and let the acid seep into the wound. She winced.

"Why, Liam?" Hardy thought she might cry. "Everything's here, in The City. You have your job and us and your family. I don't get it? I mean, what more do you want?"

He wanted to fall in love, to be diligent, to have a child, to die young, to be the best at something, to grow up, to paint, to live forever, to pierce his tongue, to go to Heaven, to ride a motorcycle, to be someone's hero.

Jane's face and eyes were red. He could see she was trying to control her breathing, to think of anything else.

"It's not like we'll never see each other. I mean, we didn't go to college together, and here we are again."

Hardy threw a whole grape in her mouth and bit down as hard as she could. She was sure she chipped a tooth on a seed but continued to grind until it was safe to swallow.

"I know my father won't understand, but you guys. . ."

"We understand, Liam." Hardy felt obligated to act nonchalant. Jane was close to tears and she thought she might be sick. Suddenly, she felt so young. Like her

parents were telling her the family was moving and the only thing left to do was get her friends' addresses and buy postcards at the airport.

"I need to practice for my audition. I need to go home." Jane stood up.

"I'll share a cab with you." Hardy popped one last grape in her mouth and zipped her windbreaker.

"We could still do something. There's time." Liam was sure he loved them.

"I've got to go, Liam. I'll call you later." Jane reached in her pocket and threw two twenties on the table. Liam stared as Jane and Hardy walked away. At the door, Jane turned, smiled, and pointed at the man/woman coming out of the kitchen. She mouthed the words "Size D." Hardy stuck a cigarette on her lower lip and searched her pockets for a lighter. She pushed the door open and they walked out.

Liam leaned his head against the window pane and stared after them. Hardy hailed the cab while Jane wrapped her arms around her body. The wind was blowing her hair across her face. Jane would demand she be dropped off first and they would stare out the windows at opposite sides of the avenue. No sun or rain or snow today. Just wind.

KIM ILOWIT ————————————————

Fall

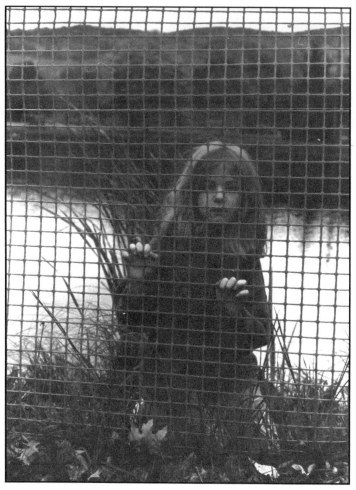

Black and white photograph, 10" x 8 "

CHARLOTTE ZOE WALKER ———————————

Winds to End the Drought

For a long time it was very still. The winds were so subtle they could not be detected. If you happened to feel one of these most subtle little airs, you might trace it to an old dog lying on the farmhouse porch, his tongue out, his sides lifting slightly with the feeble panting of his antique cooling system. The only breeze stirring for miles around under the hot sun came from the idling tongue of that old dog.

Then, while it was still so hot and sultry, another small wind began to stir. In your idleness, as you rested from the heat, you noticed it lifting a fly from a crust of bread, then setting it down again. Or was it the breath of another fly? Oh, too hot and subtle, these tiny winds. Where is the relief from the heat, from the lack of rain? The squash leaves are as yellow as squash flowers on the vines. For the first time in memory, zucchini has the dignity of scarceness, no new squashes on the vine. Where are the winds that bring rain?

Then one day the air seems a little gentler. A young wind moves out in it, declaring, I am here, I am the new dancer. Goldenrod bends and beckons. The friend picking blackberries reaches out for plump berries, tiny cups of cordial, and the bramble bobs away from her. She laughs as the berries bob back again, surrender to her fingers. A wind touches her cheek, feels so fresh against her eyes that her eyes become laughing air.

Late one afternoon the distant swoon of wind in trees sweeps across the earth. It sweeps through valleys and along streams, soughing around the great cities, finding its streaming path. The train in the valley takes up the surge of melody, echoes it in harmonica chord across the sunny plains. On top of a hill, two wanderers sit upon the rocks in silent bliss, their breath the most subtle echo in them of the trees' great song. But immediately they know of subtler echoes still: the breath of the small white butterflies which hover in the sunlight, the inner echo along the veins of leaves not high in trees but small by the rocks, trembling slightly as the great blowing continues. The trees give distance and love simultaneously, like magnificent dancers who dance only for the gods and yet see god in every humble watcher, yet have no time to pause, and only dance on and on, sweeping, reaching, gesturing into the sky, across the land. But there is no rain.

The weather has been good, at least, for haying. Steadily the nurturing, patient farmers have worked through the fields, their age-darkened red machines grinding across the land, leaving big rolls of hay like mythic presences on gleaming meadows. Few cows are left in this valley because of the hard times and the strange decisions of governments that do not understand the necessity, the nuturance of small farms in beautiful valleys. Yet, in one sun-drenched, windless field forty-seven cows cluster together to form, in thick, tail-switching black and white, the exact outline of the shade of one great maple, the one tree in their meadow. Only one cow refuses a place in that thick shade, and stands alone to discover what relative coolness its sense of space, its soft sighs and independent, switching tail can make for it.

And still there is no rain. There has been no rain for a very long time. For days now, the clouds have blown over the land. They approach too swiftly, it is clear that rain cannot fall from them before they sweep on. Yet the trees bend and dip and the sky

darkens briefly, and every feeling of rain is in the air. And it does not rain.

So that when the sweeping storm wind comes at last, when it really brings its wild lover the drenching rain, their arrival is a shock, a great surprise—something to dance to, something to marvel at. The old dog gets up from his spot on the porch. A white-haired woman comes through the screen door. They stand together now between the wooden porch pillars, hearing the Crack! of a breaking tree and watching calmly to see if it is one of theirs, if it will fall their way. No—their trees only dash about in the darkened air, only stir and shake the falling rain more fiercely. The great spruces bend wildly, like tall ships in a tempest, dipping beneath the billows, then spring straight up again. The dog and the woman smile and laugh into the stomping rain. And the air is still and new, the rain comes richly down.

NANCY JANKURA

Sophia

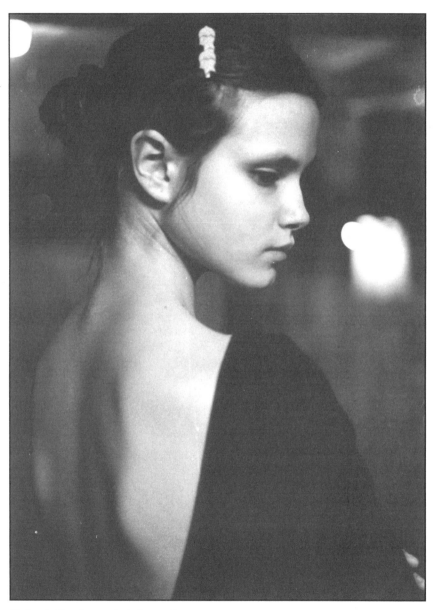

Black and white photograph, 9 1/8" x 6 1/4"

DEBORAH MILLER ———————————————

Z is for "Zoe"

The two girls sitting by the magazine rack in Chloe's Cut 'n' Dry have identical short, short haircuts. Cropped close at the neckline with half-inch wisps scattered about elsewhere like small, sharp pieces of fur, these haircuts differ only in color and the way the styling gel is dealt with each morning before school. Zoe Thorpe, the blonde, combs in a dime-sized squirt of gel each morning and works her fingers at her scalp just long enough for a little extra volume. Her dark-haired friend, DJ Bailey, coats both hands with gel, sinks her head inside her hands and pulls at the wisps repeatedly until they stand up on their own—solid, shiny, half-inch quills that haven't flickered once all day.

Zoe glances over at her mother rolling hair onto fat, pink perm rods and longs to be any place but here, in this chair next to DJ, in this "salon" her mother named after herself when the divorce was final last year and the loan came through. "Would you look?" DJ says and Zoe returns her attention to the *Soap Opera Digest* split open between them.

"What?"

"Frisco!" DJ announces and slaps down at page 37, pinning it into place on top of Zoe's thigh. "God, I mean, would you like, just look at him?"

"I am looking. You're bruising my leg."

"For sure," says DJ as she hoists the other half of the magazine into her own lap. "What is it with you, anyway?"

"Nothing. He looks great, DJ. Want me to kiss the picture? Here. . ." She grabs the magazine, presses it up to her face, and makes a loud, smacking sound.

DJ yanks it out of her hands. "That wasn't very nice. What'd ya do that for?" She looks as if someone has slapped her. "I thought you liked him, too."

"I do like him. I kissed him, didn't I?"

"Not like you meant it."

Zoe laughs. She never misses General Hospital. Most days, Frisco Jones is worth looking at. "I love him. You know that. I'm sorry, really. Okay? Friends?"

"Sure," DJ says. "I guess so. What's wrong?"

"Nothing, all right? I'm just not exactly looking forward to this." She glances over at her mother again, who is now busy soaking the fat, pink perm rods with waving lotion. "She's almost done with that. Then it's us. You go first."

"I always go first. You go first, for a change. I'm not exactly looking forward to it, either. Whatever it is."

"Come on, DJ, please?" Zoe begs. "Please?" Suddenly, the magazine is back in front of her face, held inches away from her nose. "With feeling this time," says DJ as she presses page thirty-seven in closer. "With true passion and I will think about it."

Zoe places her lips against the ones in the picture and shuts her eyes. She and Frisco are on a hot, tropical island. He is tugging gently at one of the strings on her string bikini. She does not push his hand away. When she opens her eyes, Chloe is snapping the dryer hood down over the woman with the perm. "Here," she says, tossing the magazine back to DJ as her mother advances. "Now, don't forget."

Except for the faint streaks of blue cupped beneath her large brown eyes, Chloe Thorpe could pass, even at a short distance, for one of her daughter's teenaged friends. Slightly built, with a training-bra sized bust, she comes across the room toward them to the beat of "Every Breath You Take." Pointing at the girls and shaking her finger at them, she mimes "I'll be watching you-oo" into the top of a can of Redken Foaming Mousse, swivels her hips, twirls once, curtsies, and hands the mousse over to Zoe.

"Cute, Mom," Zoe says, putting the can into the empty chair at her left. "Nice moves."

"Gee, Mrs. Thorpe," begins DJ, "you always play such good music in here. Do your other customers, like, mind it?" She points to the elderly woman in stall two studying herself in the mirror there. "That lady. Does she like it?"

"Mrs. Waldrop? I'm not sure," Chloe answers. "Never asked. Babette!" She calls the other beautician over. "Go find out if Mrs. Waldrop likes The Police, would ya?"

A few seconds later, when the woman's hesitant nod and brief, uncertain smile are reflected at them, Chloe sits down by DJ and says, "I think she's maybe being polite. Big band's probably more her speed, now you mention it. 'Spose I'd better bring in some Glenn Miller for her next appointment. You like him, DJ?"

"Huh?" she says.

Zoe sees the woman under the dryer waving in their direction. "Hey, Mom."

"You like him?" Chloe repeats.

"No, well," DJ says. "I don't think so. I mean, maybe I do. What group is he with?"

"Glenn Miller-who? That what you're trying to say?" Chloe asks, laughing. "I hear you, DJ. A little before your time, huh? No old-fogy stuff for us, right?"

"Right." DJ nods. "I just love Sting. He was in this movie the other night on HBO? With the girl from Flashdance. What's her name?"

"Mom. . ."

"Jennifer Beals," offers Chloe.

"Yeah. She is so thin. God. Did you see it?"

"Sure did. The Bride." Chloe drapes her arm along the back of DJ's chair. "Used to be The Bride of Frankenstein. Now, that was before my time." She puts her chin into her free hand and shakes her head, laughing again. "Come to think of it, so was Glenn Miller. 'Way before. Really. Sting has a whole lot more sex appeal, anyway. You know, he also did one with. . ."

"Mom. . ."

"Meryl Streep. Missed that one, though. I'd sure like to see the two of them. . ."

"Mom," Zoe hisses, determined to complete the sentence. "That woman over there has been trying to get your attention for five minutes."

"Well, hell, where's her vocal chords?" Chloe gets up. "Thanks, hon. Back in a flash. You two are next."

Once or twice a year, Chloe and Babette attend a beauty seminar in New York City. The styling tips they collect there usually interest DJ and Zoe a great deal, but today is different. Before they sat down today, Chloe held up an old-fashioned, straight-edged razor and said, "Three guesses what this is for." They still have not guessed.

Of the two girls, DJ is always more eager for innovation, but as Chloe comes back over now to get them, DJ leans in close and whispers to her friend, "There's hardly anything left to cut off. I don't feel so good, Zoe."

"Okay, who's first?" Chloe asks, flipping the razor open.

"DJ is," Zoe tells her. "What's the razor for, Mom?"

"You'll see in a minute. Come on, DJ."

Zoe feels DJ stiffen against her. "Geez, Mom, isn't this kind of soon? We just got these crew cuts last month. Why does it always have to be us?"

" 'Cause you're lucky. That's why," Chloe says. She takes DJ by the hand and tugs her up, out of the chair. "You wanna be a trendsetter, dontcha, DJ?"

"I think so."

"Sure you do. Everybody does," Chloe insists, leading her the few steps to the cutting chair. "Sit. By the time I get through with you, every kid in the tenth grade'll be begging for one." She looks at DJ in the mirror and pats her on top of the head. "Take these spikes, for instance," she says. "You'd be amazed at all the kids who've been asking how DJ Bailey does them."

"Really?"

"No lie," says Chloe as she settles her farther into the chair. "See that? You're already a trendsetter and you didn't even know it. Now, hold still, DJ. Hold real, real still."

Zoe watches her mother work. DJ—head down, shoulders hunched, chin-to-chest—looks like a rag doll in the grip of a child who likes to play beauty parlor. Just above the very shortest hairs at the nape of her neck, DJ is being monogrammed. She has been slumped over like this for the last fifteen minutes. To ensure precise letter-quality, she must maintain the pose unflinchingly.

"How much longer, Mrs. Thorpe? My shoulders are starting to ache."

"Not my fault you have double initials, DJ," Chloe says as she etches through the final arc. "Not easy letters, either. Lotta loops." She holds the razor at a nearly flat angle to the head and chips, a minuscule amount at a time. Where she has chipped, bare skin remains. Patterns. " 'Nother minute or two," she tells DJ. "Rounding the curve and heading for home, kid." The arc is hard, slow work; the razor seems to go in a hair at a time. Chloe's wrist bulges.

DJ's chair spins. Chloe gives her the hand mirror. "Here. Take a look back there. You like it?"

"Oh, yeah! It's great. Nobody's ever gonna believe this." The DJ in front smiles broadly at the DJ in back. "I can't get over it. It looks so real."

"It is real," Zoe says.

"Didn't even nick you once, did I?" asks Chloe.

"Nope," DJ replies, getting out of the chair and backing up for a peek over her shoulder. "I just love the way it looks. Thanks a lot. Really."

"Glad to do it, honey. You'll knock 'em dead."

By the time Chloe turns to say "Next!" Zoe is halfway through the front door.

Any day that she has after-school plans, Zoe presets the timer on the VCR for three o'clock and General Hospital is right there waiting for her whenever she gets home. Now, getting dinner ready, she shuttles back and forth between the kitchen and the living room as the show winds itself out. The plot, as usual, centers around Frisco and the notorious DVX spy ring. At the moment, there is a charming new double agent on with a bad English accent. He and Frisco are having a friendly, pleasant chat. Frisco, of course, thinks the man is on his side. He will no doubt be bound and gagged and

stuffed into a closet for hours, cursing his bad luck, but today Zoe is impatient with him. She punches off the VCR before the end of the tape and gets back to her work in the kitchen.

"You forgot to say goodbye!" she hears her mother shout from the front hall. At the table, Zoe sits down and starts assembling the sandwiches.

"I said, 'You forgot to say goodbye,'" Chloe repeats and steps into the room.

"Goodbye," Zoe says, slapping cold cuts onto bread, not looking up. "Ham and cheese okay?"

"Afraid your father might freak out?" Chloe asks. "Wouldn't wanna ruin the big weekend?"

"Mom. . ." Zoe begins, studying the inside of the mustard jar. She hasn't seen her father for months.

"Just 'cause your daddy's stiff as a piece of cardboard doesn't mean you have to be, too. Where's your spirit of adventure?" Chloe smacks the table with the flat of her hand. "Look at me when I talk to you! I'm still here. Don't you ever forget that. I'm not the one who left town."

"He got transferred, Mom. Don't make it sound like he deserted me, okay?" She lifts up her face slowly. "Look, I just didn't want to do it. My going to see Dad has nothing to do with it. I just didn't feel like being carved."

"What about my feelings, then? How'd ya think it made me feel when you took off like that?"

"I'm sorry." She reaches over and takes Chloe's hand. Chloe pulls it away. "Oh, cripe, Mom. What is the big deal? I just didn't feel like it, is all. DJ looked dumb. No offense, but she did."

"Well, " Chloe says, standing up, her voice abruptly calm. "Fine, then. Now, I understand." She turns and stomps out of the kitchen.

"Mom!" Zoe screams, the back of her mother's head visible to her now for the first time since she came home. She follows her into the living room. "Oh, God, Mom, what'd you go and do that for?"

Chloe smiles, "Babette needed the practice." She takes a blood-smudged piece of Kleenex off the back of her neck and looks down at it. "You have a problem?"

"Yeah, yeah, I have a problem." Zoe feels a large, hard knot filling her throat. "That looks really dumb. It doesn't even make any sense."

Just above the very shortest hairs at the nape of her neck, Chloe has been monogrammed with the letter Z. "Yes, it does," she replies, hands on hips, eye-to-eye with her daughter. "Sure, it does. You were watching. You saw how tricky the curves were to cut out. Babette needed the practice and C was just too tough for her. Makes perfect sense. Besides, now you get to look at what you missed."

"Z is for Zoe." Tears start down the side of Zoe's face.

"I guess," Chloe says, reaching out to touch her. "Aw, listen, honey. . ."

"Please." Zoe steps back. "What's it to you, Mom?" she demands quietly, evenly, wiping away the tears. "What's it supposed to stand for on your head?"

Chloe is silent for a moment, and then she says, "Zorro. TV guy in a long, black cape I used to like. Had very sharp sword. Remember the show?"

"Never even heard of it."

"Didn't think so. Must been before your time, sweetie-pie." Chloe wads the reddened Kleenex into a tight little ball and hands it to her daughter. "That Babette," she says, laughing. "It's a wonder I made it back here alive." She gives Zoe's cheek two firm, deliberate pats and walks away, grinning.

ERNEST M. FISHMAN

Library

Pinchville (pop. 5341) is the county seat of Harden County in upstate New York; its library is the Amelia Worthington Pinch Free Library, given to the village by Ezra Pinch in memory of his mother. Ezra never married; he lived with his mother until she died at ninety-seven, two years before the Great War. He lived alone in the big house on Elm Street for another fifteen years and died on Election Day, after voting for Herbert Hoover. They officially listed the cause of death as heart failure but the talk on Main Street was that demon rum "done him in." The obit in the *Pinchville Press* was glowing and extensive; it was revealed at Ezra's funeral that his not-inconsiderable, completely inherited fortune would be used to tear down the big house on Elm Street and build a brick-walled library with Palladian windows, a slate roof, and a cupola. A trust would be set up and the income used to maintain the library. He was not as specific in listing the contents of the library except that he ". . .encouraged the trustees not to acquire any racy French novels or poetry."

Sixty-five years after Ezra's death and sixty years after the official dedication of the Amelia Worthington Pinch Free Library, Sam Waterman, born at the Fitch Sanatorium in the Bronx two weeks after the dedication, now late of New York City, walked into the library and asked for a card.

Lace-collared, pince-nezed librarian Lucy Head said, through thin, unsmiling lips, "We do not give cards unless we feel that you are serious about borrowing."

"I'm here because I'm serious about borrowing."

"Well, then, fill out this card, and we will let you take out one book. And I will need to see a photo ID; a driver's license will do."

Sam had gotten his first library card at age four; the requirement at the Mount Vernon Public Library's Children's Room was that a prospective borrower had to sign the application card. This not only showed literacy but determination. A library card was a badge of honor in Sam's prekindergarten circle in those halcyon days before parentally arranged play dates and "quality time." For Sam's mother, encouraging her son to be an early reader was as important as encouraging him to be an early walker. She was the youngest of six; she and her sister had been born in Tottenville at the far end of Staten Island, across Kill Van Kull from Perth Amboy, New Jersey. With her four European-born older brothers, they spanned a generation. The oldest, Samuel, for whom Sam was named, adored his baby sister and was deified by her. As a young school teacher of twenty-two, instructing newly arrived immigrants in the strange language of their new homeland, he was frustrated by their inability to use the public library—it was closed Sunday, their only day off. He complained. They allowed him to open the library himself Sunday, and he took his baby sister along. Ease of library access was a given in the family.

Sam lifted his suede, supposedly pickpocket-proof wallet from his right hip pocket and tantalizingly removed its cards, searching for the elusive license with the long number. On Miss—not Ms.—Head's polished oak checkout desk he lined up the two-and-a-quarter by three-and-three-eighth-inches cards: The New York Public Library, white with maroon letters and the library lion; two interlibrary cards—one from downstate,

one from upstate, three college library cards from the three closest colleges; and one cardboard card (the only nonplastic, nonbar-coded one in his collection) from a small library in a nearby village (pop. 482).

"As you can see, Miss—it is 'Miss,' isn't it?—Head, I am serious about borrowing books," Sam said, "and I have an inter-county card that includes Harden County."

"We are not computerized, and we do not accept cards from other libraries. Too many people have lost their cards, and the Board of Directors decided that the expense of replacing them was too great."

"But why can I take out only one book?"

"That is only for the first three times. If you return those promptly, then you can take out up to four but only one from the bestseller list."

"Ok, do you have any works by Rilke?"

"He is not on the bestseller list, is he?"

"No, he was a poet, and he died just before this library was built, if your cornerstone is to be believed."

"Was he French? Our benefactor did not like French novels or poetry."

"He was German."

"I do not think we have anything of his."

"Thank you for your help, Miss Head. I'll just make do with the cards I have."

"We have our rules to follow, you know. That is the problem with the world today. Nobody's following rules anymore. We have the lowest loss rate in the county because we enforce our rules. That is a proud record for us. When you go out, be sure to latch the door properly. We have been having trouble with the lock."

DAVID DALTON _____

High Daddy & Sons

And so, the Terrible Long Night came to Attica. It was a black, bookkeeper's night, the sort of night printers use to make ink, that tailors use to line opera capes, that actresses use to line their eyes, that beetles use to shellac their shells, that piano-makers use for the black keys, that thieves use to wrap themselves in, that bookbinders use for the covers of bibles, that spiders use in their wedding mantillas, that bootblacks use to polish a parson's shoes, that magicians use to make top hats, that poodles use on the inside of their ears, and that Arabs use to make that terrible symbol before which the whole world trembles: zero. A black so black it put a hole in everything.

And it was during that night that High Daddy got lost.

After High Daddy had gone, so also did the sunny days. A general gloom settled on the land. The offhandedness, virtuosity, and lack of manners that marked High Daddy's reign gave way, under his successor Moonbones, to excruciating exercises in etiquette, ostentatious displays of adequacy, roll calls, napkin folding, and day after day of dull deliberation. The polkas and mazurkas of High Daddy's day were replaced by furious and joyless tea dancing.

Ah, that sooty Night Prowler! Moonbones: patron of miners, colliers, spelunkers, bats, and basements. One came from his presence powdered with a fine gray dust as if one had visited a small inactive volcano. He walked about his sepulchral palace, listlessly chanting long lists of random minutiae: high tide in Hawaii, low tide at Bainbridge Island, departures of trains from Paddington Station, the classification of tree-dwelling frogs, stops made by the Green Line bus, Ethiopian alphabets.

Moonbones was not so much the second king of Athens as its first accountant, hence the nickname "Pencils." He kept accurate records, counted the leaves that fell from the trees, the waves as they crashed on the shore; catalogued clouds, and divided them into ones that looked like dogs, ones that looked like bathing beauties, ones that looked like top hats. It was he, in fact, who began the custom of making lists.

Also attributed to him are such things as homework, jury duty, Formica, table manners, bureaucracy, inclement weather, statements, edicts, penalties for passing wind, grammar, football fouls, hotel stationery, internal revenue, railway schedules, memorial services, mouse traps, and the habit of saving scraps of string in balls.

He forbade (unsupervised) gossip, dancing schools, trousers, radios, pencils with your name printed on them, chocolate cigarettes, and comic books.

Collecting, sifting, and filing the past were his passion. He considered the present primarily a good place to store things. After all, there was nothing much to *do* any more. The Great Age had passed. Everything, it seemed, had already happened. All that was left was to record it.

As a memorial to his predecessor, Moonbones built a monumental cenotaph (the Kekropion, or Scalehouse) in the shape of a giant pineapple, High Daddy's favorite fruit. Like those at Stonehenge or Easter Island, it was a group of megaliths around which scholars crawled in dismay. To the rabble it was vulgarly referred to as the Tomb of the Unknown Thing.

High Daddy soon heard about this curious tribute to his memory and made one

of his frequent comebacks just to see it for himself. Upon arriving in Athens, High Daddy went directly to see the Scalehouse, already a celebrated place and not hard to find. His first impulse on seeing the giant pineapple mausoleum was to try to eat it. An uncharacteristic fit of decorum restrained him.

Outside the Scalehouse a carnival atmosphere prevailed. Postcards showing High Daddy inventing various things he'd never heard of were sold, along with multi-colored plastic "vestigial tails" that children attached to their backs to perform the Lizard Dance.

He paid his sixpence and went inside the great dome. In a sort of panic he began to run instead of walking through the rooms. The sound of religious skating music filled the air. "Rubber Onions!" High Daddy shouted to himself. He was incredulous. It was all so *beside* the point.

He left the Great Rotunda in disgust and entered one of the permanent exhibits. The artifacts seemed to vanish and reappear with alarming casualness. To High Daddy's relief, he came across a large sign that read: THINGS THAT CANNOT BE TOUCHED.

"Well, that explains it," he said to himself. The exhibits were displayed under glass jars and labeled: "Love of One's Cat," "Memories of Swans," "Seen Through Rear-view Mirror," "Delicate Phantoms That Desire Has Not Yet Raised," "Things Sent & Returned," and "Three Indelible Scents: May 47th, 137,802 B.C."

Children gawked at the ghostly assemblage, nervously chewing on chocolate crocodiles. Their parents were a little more skeptical: "Let them say what they like. We know what we know!"

Another room had a large cardboard lid in place of a door. A sign identified it as THE ANCESTRAL SHOEBOX. The exhibits, all in glass cases, stood in long rows and contained such unprepossessing items as High Daddy's socks, a ticket to the circus, a penny whistle with little yellow duckies painted on it, a magnetic banana used to attach notes to the refrigerator, a catnip mouse, a plastic sea horse with a striped ball set in it, felt barbells, a small stuffed rabbit, a broken cup featuring squirrels in baseball caps and some Polaroids showing a jolly baby in a red stretchy with "My First Christmas" stitched on it. Not a thing was missing, not even the view from the window. They had even saved the view itself! "In very poor taste," High Daddy thought with annoyance, and moved on to the next exhibit.

It was THE HALL OF NOISES. "Oh, I must see this!" he said out loud. It was a little disappointing for so infamous a noise-maker as himself. There were no shouts, no gurgles, no grunts, no roars, no croaks, no creaks, no squeaks, no bellows, no farts, no belches. Instead, there were such barely audible sounds as the short, flute-like whistle of the Lesser Antilles speckled toad. Then, silence. The sound of light rain falling. Silence. The strain of listening for things hardly above the threshold of his hearing almost made High Daddy faint.

In amongst the artificial foliage High Daddy spied an old love letter of his addressed to the goddess Athena. "By my blue bottom, I've looked everywhere for that letter and here it was all along. What luck!" But as he reached in to pull it out, the paper turned into some very sticky toffee substance through which an impudent face poked its head shouting out the sillier phrases from his love letter such as "Owlie, wowlie" and "My bunny wunny," etc. to High Daddy's acute embarrassment.

In his insatiable quest for order, Moonbones had converted High Daddy's Hippodrome (where the Neapolitan flea circus first performed) into a court of law. High Daddy walked into the first courtroom. Here people were being denounced left and

right for crimes they couldn't possibly have committed: impersonating a part of speech, reading between the lines. On the witness stand, a large, raggedy-eared dog was being cross-examined. The district attorney was badgering him to admit he'd been a fly in a former life. With some dignity the dog read from a prepared speech that seemed to be about the color of barns in August and the coolness of newspapers spread on a kitchen floor. "Cats and theology are two things that will just never mix," said High Daddy to himself.

"Why, the whole place has gone nuts since I was away," he moaned. "Nonsense here is as common as a bean in Boston!"

Just then, High Daddy caught a glimpse of Moonbones's Sphinxy head disap-

"It would take High Daddy years and years to think it through." Coco Pekelis

pearing down the steps of the Halls of Justice. He ran after the boy breathlessly, and when he caught up with him on the corner of Half Moon and Mole's Hat streets, he tapped him on the shoulder. As Moonbones turned around, his gelatinous features jiggled into a blur. When High Daddy got a closer look at him, he saw that his face was made of lime Jello. At once the Jello melted and out of the rubbery, dissolving face ran a dozen tiny rat-like kangaroos glancing to the right and left. They danced a fearful jig around a puddle of honey in the shape of Tasmania and then--before you could say Jack Robinson—they changed into a flock of marzipan pigeons decorating the top of an enormous cake.

With some relief he found himself out in the great rotunda again. A jollier, more expansive mood came over him.

Just then, though, High Daddy spied something as close to thin air as he'd ever seen. A pencil sketch of a man--life size!--coming towards him, talking to him, I tell you! It had a peculiar walk, a lamplighter's gait. It was so peculiar that High Daddy's first impulse was to hide.

"Unfinished!" (pause) "Never to be finished!" (long pause) mumbled the human pencil sketch. Somehow, High Daddy knew that this talking shade was his successor, Moonbones.

"Why, the fellow's emaciated! He's just not getting enough to eat! He's wasting away! I'll just nip around to the pie shop and get him a few pastries to fatten him up," High Daddy said to himself. But when he returned with a great armload of pies, Moonbones, now in the shape of a foot ruler (with the one-eighths of an inch clearly marked on him), simply walked through them. Alongside the human foot ruler ran a loud spoon shouting numbers from the Fibonacci series: 5, 8, 13, 21, 34, 55. . . "My word, this is a tricky business!" thought High Daddy to himself.

An afternoon with Moonbones was filled with pauses of different shapes. Some were in the shape of oars, some in the form of antlers, some were like the outline of Mt. Etna, some resembled flocks of miniature sheep. Soon the room was filled with these invisible objects and scenes. As Moonbones spoke--could it be?—he seemed to become the very things he spoke of: chairs, wheels, eggs, and trees. "How awkward for him," thought High Daddy.

Moonbones's words splashed on the ground like yeasty clouds and made little smoky explosions that smelled like rotten eggs. "Funny thing, that," High Daddy said thoughtfully. "I never noticed words could smell. I must make a note of that."

"Where--in the name of several slithering silver snakes--will this all end?" High Daddy asked impulsively. But before he had time to answer his own question, an even more unsettling sight caught his eye. Three balls bearing his own features rolled down a corridor, made faces at him, and disappeared behind a curtain. The curtain was being cut in half by a pair of scissors. They winked at him.

"It's Moonbones!" exclaimed High Daddy. "This is too wicked, really." In rapid succession Moonbones turned into a tea kettle, an umbrella, a sewing machine, a garden hose, a whatnot, a postcard, and a ball of string. His successor, a ball of string! thought High Daddy. It began to unravel and form itself into shapes so odd that we would one day have to call them Non-representational Art. But to High Daddy they were signs and portents.

"Enough! Enough! Enough!" sobbed High Daddy. "Why, why did I ever return? If this is history, history is a nightmare! Maybe this is just a bad dream! From now on dreaming will be confined to the night hours and last no longer than the twinkling of an eye. And I will never again go to bed after eating sour grapes."

Still, this dream business didn't explain everything. What is a dream, anyway? A conjurer's trick? A licorice ghost? The contents of your head emptied out in the middle of the night like a jumbled drawer? The contents of someone else's head? Whatever it is, it's a vexing business, and it would take High Daddy years and years to think it through.

RICHARD DOWNEY

Bianco

What I remember most about growing up in East Harlem was running. I ran to school, I ran to church, I ran to Jefferson Park. I ran to Tia Maria's for my father's cigarettes and I ran to Macelli's for my mother's Sunday veal. People on the block, they'd all be saying, "Angelo, you're always in a hurry. Slow down, you'll live longer." They were adults, big people. Big people could walk slow because they'd already lived longer. If you were a kid, it was either run or get caught. If you got caught, you got hurt.

Don't get me wrong. East Harlem was a great place to grow up, something always happening, the street was alive with things to do. Your block was your home. Half the block was your relatives and the other half your friends. By the Fifties, East Harlem was mostly Puerto Rican but you still had a lot of Italians scattered around. You had your Puerto Rican blocks and your Italian blocks. The Italians broke it down even more so you had the Calabrese on 108th Street and the Sicilians on 107th. Then they fine-tuned it to the town your grandfather came from: that would be another group, maybe a couple of buildings. I was on a Sicilian block, a San Sebastio building. Anyway, there were a lot of groups and you only belonged to one so that meant a lot of running if you wanted to avoid problems. It also meant you belonged to a gang.

From the time your mother let you down on the street alone, you were with a gang or you were nothing. You could tell the kids who didn't belong. They lived on the block but you didn't see them much. They came home from school and disappeared, only came out to trail behind their mothers, carrying groceries. When they passed you, they kept their eyes down. If you were in the streets, you were in a gang. It was your protection. People messed with you, they messed with all of you. Not that I couldn't handle myself one-on-one. When it got down to the hands I was OK. With gangs, though, it was seldom one-on-one. That's why, when we went off the block, we traveled as a group. From the time I was eight until I got drafted by the Army, I only felt safe if I was in a hurry or a couple of guys were with me. Later, when I joined the cops, I worked those same streets. People knew me, they'd tell me things. I was smart enough never to betray their confidence. I got things done, I moved on.

The streets taught me a lot. You had to think quick, use your head. It was good to have a friend to help you along. You needed those friends. If you had that going for you, you could get somewhere.

I was twelve when I started to learn some of these things.
Every Saturday a bunch of us went to the matinee at the Liberty, one of those big, sticky-floored movie houses they used to have before everything got split up into duplex, triplex, whatever-plex. There was myself, Dom and Bruno Pesce, Specs Pandella, Tony Guadino, and Joey Greco, all from the block. It was late October, and when we got there, we were surrounded by pirates, bums, ballerinas, soldiers, and monsters. We forgot it was the annual Halloween show with the $10 prize for the best costume. Mrs. Schmidt, the old lady who owned the Liberty since probably when the Dutch came over, was ripping tickets. She eyeballed us, we got no costumes, and had her usher, Babe Gutterez, see us to our seats.

"Any trouble, out they go," she said to The Babe.

The Babe winked and said, "C'mon." He took us down front.

"She's serious, amigos," The Babe said when he had us seated. "You're not going to be any trouble, right?"

"Right," we told him.

The Babe was OK. He was a white PR, a big, graceful guy, built like a Greek god, a stickball legend in the neighborhood. Everybody knew The Babe. He played with the older guys in the money games, he'd free-lance for different blocks. Team that had The Babe had to give points. The older guys would put up his ante, let him share in the winnings. That's how my father knew him: he played for our block a couple of times, an honorary Sicilian, and we beat the spread. His cousin Manny Alvarez was my number-one enemy in PS 107, a punk who was always behind me, saying things. We almost went at it a couple of times, but people broke it up. All that made no difference so far as what I felt about The Babe.

Anyway, we're seated and looking around at the chaos, kids all over, waving, hollering at each other, changing seats, a lot of costumes bought from Woolworth, some homemade jobs, nothing special and I then got this idea. I'm going to enter this contest and win. They were going to give away ten bucks up there and it might as well be me.

I told the guys, but no one was interested except Dom.

"You don't got a costume," he said to me. "They don't let you up there without a costume."

"That's because I haven't put it on yet, Dummy." I edged past him, going to the aisle. "You coming?"

We borrowed a few things going up the aisle, some lipstick from Donna Balducci, her friends going, "Ooooh," like there was something between us. I only wished. Fran Curci from the block had flour in a sock, and a kid I knew from PS 107 had cork and matches; he wanted them right back after the show. In the men's room I put my clothes on backwards. Dom buttoned me up, zipped my fly. I put burnt cork on my face, dusted the hair with flour and combed it forward. Dom painted a mouth on the back of my neck with the lipstick and hooked Spec's glasses on the back of my head. They rested a little above the painted mouth.

"How do I look?" I asked him.

"Like an asshole," he told me.

"Maybe that's what I go as," I said.

Going back in, we stopped by the boys. They're laughing now, starting to get the idea.

"I'm going to win," I told them.

"We're going to make sure you win," Dom assured me.

The lights were dimming, and old Mrs. Schmidt was up on stage adjusting the mike under a spotlight. The contestants were starting to form a line over in the right-hand aisle. When I got over there, The Babe looked at me and shook his head.

"What do you think you are?" he asked.

"Mr. Backwards," I told him.

He laughed and took off his clip-on bow tie. "Here," he said, "try this." He turned me around and clipped it on my collar.

On the stage Mrs. Schmidt was explaining the rules. Each contestant is called to the spotlight. The audience applauds. The three contestants with the most applause are in the run-off. The run-off contestants are again in the spotlight, and the one who gets

the most applause wins the $10. She calls the first contestant, a ballerina, who got a smattering of applause.

I slipped to the back of the line and watched Dom huddle with the guys, sending them in different directions. I could see them bending over knots of kids, whispering, then pointing at me. I waved, they waved. Soon a lot of kids were laughing. Dom took the middle aisle, and right in the center of that section is Manny Alvarez and his whole gang. Looked like they took up two rows. Dom was talking to Manny and Manny was shaking his head no but Dom kept on talking and soon Manny was talking to some of his guys and then Dom was talking to those same guys and they talked with Manny and finally everyone shook their heads yes. Next Manny was waving at me like we're friends and I waved back. I even smiled. Things looked good.

Of all the assorted costumes that go up there only two drew any applause. One was a pirate, lots of silk scarves and cummerbunds and flouncy shirts, knickers and leggings, a wooden sword painted silver. A lot of time went into that costume. I even applauded. The other was a little pudgy kid, maybe five years old, in a loincloth with a little bow and arrow. His mother had him all powdered up, even rouge and lipstick. He didn't want to come out, I don't blame him. His mother was pushing him, Mrs. Schmidt was pulling him. His lips were quivering, he almost cried. The girls went crazy for the kid, jumping up and down, squealing.

Then it was my turn.

"And what are you?" Mrs Schmidt asked me when I stepped into the spotlight. She said this with a voice and a face like she was inspecting bad cheese.

"Mr. Backwards," I said, then I turned, stuck my ass out at the audience, and then with both hands, I pulled the skin on my neck up and down so the lipstick lips under the hairline smiled and frowned, smiled and frowned.

They went wild. Yelling, whistling, stomping. It was something, all that noise. I walked to the side of the stage to join the others. It was in the bag; the last couple of kids were just going through the motions.

The run-off was me, Captain Blood, and Cupid. While they were setting it up, I saw Cupid's mother talking to Mrs. Schmidt. They were looking at me.

"I agree but I can't help it," I heard Mrs. Schmidt say. "You heard them."

The mother gave me that bad-cheese look. "At least let my little Roberto go last," she said.

I couldn't see into the audience too good but I knew my guys would be working, talking to everything male. With Cupid in that diaper, looking like he's going to cry, even I thought he was cute. I knew this was boys against girls.

Captain Blood was up first and he got a polite hand. So much for fancy needlework. Then I stepped up front, turned, waved my ass in a bump and grind, straightened up, shook my glasses with one hand, moved the lips on the back of my neck with the other. Sort of a Groucho Marx effect, Dom told me later.

Brought the house down. After the screams, they went into this chant—yeah, yeah, yeah, yeah—then another round of hoots, whistles, and yells. It was all guys.

Cupid didn't have a prayer. The girls held their own for a while with their high-pitched voices. Their cheers had good penetration but no legs, they died after thirty seconds or so.

Mrs. Schmidt tried to screw us into sharing the money.

"Well, well, well," she goes, "I guess it's a tie."

I heard Dom yell, "Do it again," then my new friend Manny, I'd recognize his

voice anywhere, he yells, "You better, yuh 'ole hag." Mrs. Schmidt could see the seats coming off the floor so she did the right thing, me against Cupid this time, and I won hands down. I even got some girls yelling. She had The Babe give me the ten. I guess she didn't want to catch whatever I had. When I got back to the seats, Rory Calhoun was riding across the West Texas scrub. I passed the ten down the aisle so everyone could get a look at it. I asked Dom how he got Manny Alvarez to root for me.

"I told him if you won we'd play him stickball tomorrow for the ten. In a way, he's our partner."

I looked at Dom, I couldn't believe it, but Dom was concentrating real hard on Rory riding into town.

Making that ten was pretty easy. Keeping it was something else. When we came out into that bright sunlight after three hours of movies, who did we find but Manny and his boys waiting for us. There were about fifteen of them. No wonder I won with all those voices turning baritone. They started walking with us.

"I think we'll play that game today," Manny said.

I looked at these guys. Most of these guys were older than us, seventh and eighth graders. Dom was looking, also.

"OK," Dom said, "we'll go back to the block, pick up the bats, a ball, some other guys."

Manny thought it over. "Fine," he said, "just leave Mr. Backwards here with us."

I didn't think this was too great an idea and I said so and Manny agreed. Just leave the ten, he said. Good faith. We were all walking downtown, Manny and his boys around us like a crescent. The talk was just smoke. The issue was the ten and who wanted it most. Nothing would happen here, too close to the movie house, too many people. But it would have to happen soon. There wasn't much more to talk about. At the corner the light was about to turn red.

"Move it," I yelled and we broke like a shot, bouncing off the hood of a car shifting into first. Specs just made it, almost falling. I looked back, I see the driver yelling as Manny and his boys flowed past him, that car looking like a rock in a stream.

We had the jump. We ran broken-field, around baby carriages, shopping carts, garbage cans, fire hydrants, old couples shuffling, arm-in-arm. I mean, we were really scooting. We needed two more blocks. Two more blocks and the shouts would start, people would notice twenty kids running down the avenue. Two more blocks, there might be a cop. Or, maybe someone would call a cop. Manny's boys would punk out in two blocks, go off laughing, calling us chickens. Two more blocks.

Then they caught Specs.

I heard Specs yell. When I looked back, about five guys had Specs, pushing him around like a rag doll. Dom and Bruno were just ahead of me; I yelled about Specs and we all pulled up. Tony and Joey were way out front; they didn't hear me. At least, that's what they said later. We walked back. Manny had Specs in a headlock, looking at us. Spec's glasses were at his feet. He looked naked without them. Skinnier. Manny's boys started to circle. I hoped it would be quick.

"OK, what do you want?" I asked.

"Guess," Manny said. He stepped on the glasses.

I was putting my hand in my pocket for the ten, giving one more look for a cop

when I saw The Babe across the street. He was walking home. The Babe always walked, he didn't ever have to run.

"Babe," I yelled, "I got your tie." I was jumping, waving like crazy, like I was on this raft and The Babe was an ocean liner.

It worked. He crossed the street.

"Thanks, Babe," I was really primed. "You're a sweetheart," I said. "Couldn't have done it without you." I had the bow tie in my hand, tried to pass it over the circle of Manny's boys around me.

The Babe wasn't listening. He was looking a Manny with Specs under his arm, the broken glasses at his feet. "Que pasa?" he asked, turning his gaze to Manny's boys all around us.

"Just foolin' around," Manny said.

"Why you got your arm wrapped around this flacito's neck, Primo, all your friends helping you?" The Babe wasn't happy.

The way I looked at it, The Babe was Jesus Christ, only he could hit two-and-a-half, maybe three, sewers. Manny let go of Spec's neck. The circle opened and we walked, Specs stooping to pick up what was left of his glasses.

Back on the block I bought malteds all around, then gave each guy a dollar. That left me with three and change. Not a bad day, considering. Then we sat back and told lies. Tony and Joey said they were on their way back, figured something was wrong. Dom and Bruno said they had it under control. They knew just who they were going to hit. It would have come out OK. Over my dead body, I kept saying, over my dead body they'd get the ten.

"I guess this means we don't play them stickball tomorrow," Dom said.

Even Specs laughed.

Later, we had a game of punchball in the street. A wild game, 43 to 39, everybody scoring. It was like a celebration. After the game Dom came over to me, wrapped his arm around my shoulder.

"Did we do it?" Dom asked.

"We did it," I told him.

"You were great," Dom said.

"You put it together," I said. I was thinking we almost took our lumps.

That's how it is. You got to have friends. It helps if they're smart, like Dom. It helps better if they got the power, like The Babe had then, like Dom has now. Then you don't have to run. You can walk any place you want.

THOMAS C. RAPIN

Gauguin

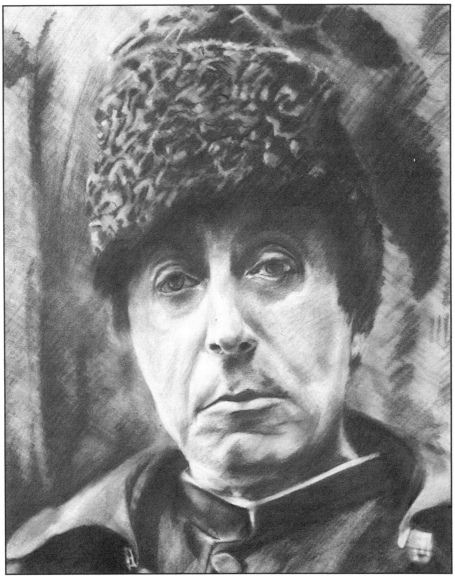

Charcoal on paper, 30" x 20"

PATRICIA MCKILLIP ─────────────────────────────

At Maggie's Falls

Down by the river, three hemlocks and a willow stand at the edge of the Schulyers' yard. The trees are immense, old. I wonder what it would be like to be a child here, wandering along the bank in the shadow of those trees, at an age when you think the river runs forever. I have just moved to this small mountain village; I intrude in people's lives like a reader into the middle of a story.

Hannah is taking me along the river to see the falls. She walks ahead of me, a slight, sturdy woman with curly, dark hair and a small, unobtrusive face younger than her age. Since she has a job where she knows everyone and is known, she assumes that even a stranger would know the details of her story: the point at which, for a while, time stops, and all events seem to eddy around that single moment.

"The falls is the first place Paul took me," she says, "when I moved here."

It is dusk, in midsummer. As we walk along the bank frogs mutter, knee-high wild flowers sway around us, break underfoot: yarrow, cow parsley, bachelors' buttons, asters. Fireflies telegraph frail, urgent messages. It was not from Hannah that I heard of Paul's death, but from someone else; Hannah simply pulled me into the midst of her stopped time, her moment that even I revolve around.

She walks ahead of me, wanting my company, but impatient with me, because when she looks at me she sees my face, not the face in her memory.

"He knew the names of all these flowers," she says over her shoulder. "He showed me where the wild ginger grows."

The weeds give way to plowed field bordered by the river. Rows of corn stand motionless in the dusk, leaves carved of malachite. I walk awkwardly along the tumbled earth. Something invisible whirs beside my ear: an owl? a beetle? a bat? I jerk away from it, doing a small, meaningless dance among the corn. Hannah doesn't notice.

Later, we walk along train tracks following the river. Weeds grow between the tracks; the train has not run this far in decades. I dodge blackberry brambles. Hannah, her bare calves broad with muscle, walks silently, too quickly for me. Her head is bowed; her outstretched hand bats weeds aside. Sometimes she walks over them, breaking their stems, and I walk into the fragrance of their dying.

They lived together for fourteen years, someone told me. Paul was killed in a car crash on these dark, winding country roads. I am not used to country roads yet, to the utter blackness that descends over them. I lived so long in the city I have forgotten what night is.

"There used to be beavers in this part of the river," she calls back abruptly, after a long silence. "We would come and watch them build their dams." She is almost too far ahead of me to hear. I wonder if she remembers whom she is talking to. I try to balance on a track and fall back onto the ties. This is a child's world, I think: the weedy tracks leading to other worlds, the still, moss-choked water, with with pearly frog-eggs, grunting frogs, deepening twilight, smells of grass and broken weeds. A world in which, tonight, there are no children, only two women walking in silence that is not shared.

I catch up with her eventually. She stands still on the tracks, frowning. Listening to something? Or to someone?

"I think it was here," she says. Then, impatiently, "No, maybe not."

"What?"

She makes a movement, a murmur. Then, remembering me, she makes an effort. "Where we saw the wild swan."

A dirt road angles away from the tracks. It is an old drive, to a once elegant house. Tall pines, a massive, tangled oak, elm and hawthorn trees rise among the stripling maples. I catch glimpses of the house through the trees, like a pale ghost in the twilight, a dark attic eye, a line of lacy gingerbread. It has bow windows, a porch that seems to curve around it forever: a place with few corners.

"Whose was it?" I ask. And silently: where are they, why have they left it to the ghosts?

"It belongs to the Lanes. They live in the city now. The falls are on their property."

Owning a waterfall seems as unlikely to me as owning a moon. Hannah strides ahead again, down the drive, slight under the tall, motionless pines.

I hear the falls: a gentle, musing sound that scarcely disturbs the evening. The drive curves toward the road; we cut across a grassy patch, to where a stray branch of some river has dug down into the limestone. Swathes of water pour from stone to stone, merge and flow away through the trees. We stand at the bank. Beneath us, the falling water slides away, slides away as smoothly as glass.

Hannah starts to speak, falls silent. I wonder what she is watching in the water, what reflections of the past glide into the night among the fallen leaves. She is still for a long time.

She gathers breath, says, "Maggie's Falls. That was what the Lane who built the house named it, after his wife. I guess she liked to come here."

She turns to point at something down the river. She touches my arm lightly, says my name.

STANLEY KONECKY ──────────────────────────

Knuckles and Fetlock Joints

He puts in ten to fourteen hours on the bench before the hot ovens, climbs the steps exhausted, takes a shower, spiffs himself up for worship. "If we hurry we can catch the double." I can't say no! Wooden horses, white and black, on brass poles, dance up and down, round and round; hurdy-gurdy music plays nonstop; mirrors and lights go in reverse direction to confuse dizzy childish sense.

To her he says: "I'm going to quit!"

"That's what you always say."

"This time I mean it!"

"I don't care what you do, just don't come to me for money."

"Lay off! I don't take that much."

"You gamble money away, the creditors are hounding us, now you take him with you!"

"What've you got to complain? You and the kids always have what to eat, a roof over your heads."

"Everything is so expensive. I'm on my feet all day, I have nothing to wear!"

"Who tells you to put in so many hours? Hire another salesgirl, get the cleaning woman to come in extra!"

"And how are we going to pay for more help? The store's not the mint!"

"Today's the last time."

"It's bad enough you go, then you complain you're tired. What happens if you get sick?"

"When did I ever miss a day's work? Anny, Anny, Anny, don't refuse me! I have a feeling today."

His unflinching confidence is irresistible.

"Here, take it already!"

She can't wait until the season in New York ends and he's reduced to placing bets with the bookie and playing gin rummy.

Out on the stoop, bloodied hands in my pockets or behind my back, I never have enough. For each card you were left with, each of the other boys got to hit your knuckles. A flat scaping hit with the whole deck counted one; a slash with two or three curled cards two; a chop straight down with the whole deck five; there were ways to fix the cards that made for more damage. "Ten for flinching!"

He pushes me against the wall with unexpected strength. What did I do? "The fighting between me and your mother don't mean nothin. That's the way men and women are. But a man who works hard as I do has to have some pleasure. So help me, as long as I have life left in me I won't be tied down." He releases me, winks, smiles. "Let's go!" Yes, let's go!

Tuesday, their day off, presents a permanent battlefield.

"This headache doesn't want to go away."

She continues to dry the morning's breakfast dishes and, without looking up

from the blue and white checked towel, calmly volleys: "Take some aspirin."

"You know how the movies hurt my eyes. It'll make my headache worse."

"Reading the racing form doesn't hurt your eyes?"

"Who said anything about the races?"

"You promised."

"I'll take you next week."

"Today's the last day for the Gregory Peck movie at the Loews.'"

"Don't nag! You can go without me."

Bristly beard clean shaven by the barber's straight edge, he smells of talc and after-shave lotion. I smell sweet gasoline exhaust fumes, parking-lot tar, and freshly cut grass.

"Okay, let's stay home. I'll fix lunch. At the rate we're going, we won't make the early matinee anyway."

And fifteen minutes later: "I'm feeling better. How's about hurrying lunch and going with me to the ponies. The fresh air'd do us good."

"You know I don't enjoy myself."

"We could go to the clubhouse."

"That's extra money. And I don't like it anyway."

"If we get there early enough for the double, we can get good seats in the grand-stand."

"You know you don't like to sit in one place."

"It's different if you come."

"Leave me alone! I don't want to go!"

"There's no sense spoiling the day. You don't mind if I go by myself?"

"Go!"

"You sure it's okay?"

"Go, already!"

"Hey Rob, you wanna go?"

I go with Dad to the track and learn to dope out a race on the *Daily Racing Form* scratch sheet. I'm going to reform him! A shrewd handicapper, studying past performances, he knows better but has to bet every race! So he manufactures reasons to favor one horse over the rest, listens to conniving touts to find out who's trying. In the shade of the grandstand among the motley, he holds court, gives advice, hands out edicts, explains why things happened the way they did or not the way they were supposed to and why they will happen the way he predicts. "Hey, Joe, can you lend me twenty 'til tomorrow?" On a winning streak, looking for trouble, he displays a wad of new hundreds and fifties.

"Don't tell your mother how much we lost!" I suspect he's dropped more than he's let me know.

"You can't change him! It only aggravates him when you insist he quit."

"You want me to say that it's okay to lose money we could use for other things? You want me to lie!"

"Momma, he goes troubled."

"A lot you know! Once he's out the door, he thinks of nothing but his bets. Were it another woman, at least, I'd be able to scratch her eyes out!" We're alone at the kitchen table; her eyes blaze. Her lips curl upwards. Then, as if connected by some invisible mechanism, our faces reshape into painfully pleasant, uncontrollable laughter.

"You say you love Momma, but it hurts her when you go."

"What d'ya want me to do? Will it make your mother happy if I cut my insides out?"

Dad and I reserve our grandstand seats, placing newspaper through their wooden slats. We hang around the paddock before races, stand in the crowd by the finish line for the race.

"You got anything?"

"They're goin with the three and the six."

Dad exchanges chatter with his cronies, while I discover the improvement in the breed. Gigantic beasts rigged to balance impossibly on fetlock joints the size of ball bearings, how do they hold themselves up? I'm nauseous, thinking he might pay for information. Curried, brushed; red, brown, gray; muscular necks; voluptuous manes; sensuous haunches; fiery nostrils; bred to be straddled and driven, the horses calmly wait for their final equipment. Clean white bandage taped around weak legs; saddle centered on the back, strapped snugly around the girth; harness placed over the head, bit mouthed; blinders hooded around the eyes. Occasionally, an entry is lathered or jumpy; rarely, even unruly. Hard-looking, diminutive jockeys, whips in hand, glasses up, take the reins, mount with a boost, jodhpurs beneath their colors—checkered, dotted, striped blouses. "The horses are on the track!" The blonde filly raises her braided tail, opens a black rubbery anus to allow clean dry manure to plop to the ground as she saunters off onto the track. The flags wave in the breeze, the sun breaks through a cloud.

"Put fifty to win on the six and for insurance ten to win on the three. At six furlongs the six horse won't quit. He's been runnin with better, he gets to the front in longer races and stops. Look here, he's ahead against allowance horses in 1:11 4/5, then he dies. None of these claiming pigs can touch him! They're goin with the three. The morning line has him at fifteen to one, he's twelve to one now, should be nine to five, he'll go off at eight to one."

Your horse will win, you know it; the feeling wavers; your magic wills it. If the six horse can't be touched, why hedge on the three? Six: Gold, Light Blue Diamonds, Blue Sleeves, Gold Cap—four-year-old, dark-brown colt; Three: Red, Black Hoops, Black Blocks on Sleeves, Black Cap—five year old chestnut gelding. A dull, gnawing hunger fills my chest as the silks go by, our horse not in there making the move he should. Later, whether we rip up our tickets or collect on the ten dollar line feeling smart, he treats us to pastrami or corned-beef sandwiches or manhattan clam chowder. Dad likes the flats with more room to run and thoroughbred clientele better than the trotters; Jamaica with its short stretch and easy turns better than Aqueduct or Belmont; New York Teddy Atkinson better than banana nose Eddie Arcaro; Ycaza sneaking in on the rail best of all.

"D'Errico's a crook. They're not runnin that horse today. They're lookin for better odds next time."

When the horse that figures doesn't win, Dad looks at me knowingly. When *the smart money* is dropped on a horse in the last few minutes of betting, odds dropping with each flash of the tote board, I see stampede. Dad is impressed if the animal wins, forgets if it loses. Sometimes, the figure horse D'Errico is going to hold back goes off at outrageously high odds and wins. With so many unknowns, you're free to write your

own story, to make your own wager. Dad wants in, will go to his grave uncertain whether honesty is fear or dishonesty is wrong.

I hold my tongue, place my tutor's bets, become his apprentice. Not bad for a kid who at nine hated his father and would never forgive him. Dad, all smiles, meets me coming home from school for lunch.

"How'd you like to go to Ebbets Field this afternoon?"

"You mean it?"

"I mean it!"

"C'n I take off from school?"

"Mom says it's okay."

I've never been to a big-league game before, only seen a few upstairs on Mr. Mendalow's black and white. I root for my Dodgers on the radio.

"Joe, he puts too much of himself into those games, he's impossible when they lose!"

Now, on the clearest blue-skyed spring afternoon, we sit in the left-field grand-stand, cool behind Pete Rieser.

"I put a bet on the Cubs. I got the odds. It's no fun for me unless I have something goin on the game."

First five races come up losers. With the few dollars we have left, we catch the winner in the sixth, a tip, parley the winnings in the seventh, win a photo finish by a nose. Suddenly we're even, maybe a little ahead. I'd like to go home.

"Look at the speed ratings on this horse. Never raced here but he's the class. Five to two! They're afraid to bet on an out-of-town horse. Put it all on him!"

"Dad!"

"Don't give me a canary!"

"It is now post time!"

The horses in the starting gate, the bell rings. "Big Red" breaks on top, is last at the first turn, keeps up with the pack for the first half mile, makes a move, is in front at the three-quarter pole, steadily pulls away, going past the finish line at least twenty lengths in front. Dad's arms are suddenly around me in a bear hug; I can hardly breathe. We kiss each other hard; his lips are sloppy wet; his moustache bristly, beaded with sweat, chafes my upper lip; there is a smell of nicotine on his breath. Then we trade a stack of bright yellow tickets for a bundle of bright green money. We did it! We don't have to go home hiding bleeding knuckles in empty pockets. Hallelujah! Momma won't be angry tonight.

IRIS LITT ────────────────────────────────────

Karl Marx Doesn't Know Everything

The photo Henry took of me on my birthday pretty much tells you where I was. I was standing in a field, leaning against an old skiff that used to be called Margaret but which had the name BOMBER, 1942 over-painted on it. Behind me and Bomber, potato fields stretched to the mottled sky over the North Fork of Long Island, where the sea was all around. It's a pity that when you look at the picture, you can't get the smell of a saltwater farm.

I wasn't exactly dressed for the setting but, then, it was Sunday. I was proud of the photo because I looked debonair in the style of the movie heroism of that time, in a beige trenchcoat, open at the neck just to the cleavage point, belt not buckled but tied around a tiny waist, my hair shoulder-length, very dark, my lips very red, my thin but well-shaped legs looking good in pumps, so that you'd think I was far older than four-teen.

You wouldn't have thought from the photo that tomorrow when the sun came up, I'd be out there wrenching the potatoes from the soil and dumping them in burlap bags that I'd lift and drag to the main pile—one-hundred-pound bags weighing ten pounds less than I did.

Mornings, when Aunt Sophie—the owner of the old cabin colony the government rented from her to house us—handed me my lunch bag, she would often say something like, "They ain't tea sandwiches, honey." I suppose that genteelness was written all over me, even though she didn't know it was really genteel poverty. Maybe it was my good grammar, or it might have been that I washed my hair every evening when I came in from the fields.

I thought of telling her that when the velvety summer nights enveloped the desolate circle of cabins on the long, straight, dusty one-lane highway, I often lay on my cot and read Karl Marx. The girls who slept in the five other cots in my cabin were out on the lawn, if you could call it that, and it was quiet. If she knew I read Karl Marx, I thought, she'd know that I was greatly in sympathy with the proletariat—*her*. But, somehow, I didn't mention it.

I had pointed out to Henry that the-Germans-and-Japanese-versus-us wasn't the only power struggle going on. There were also the haves and have-nots. He stood leaning against the Navy jeep looking at me funny. He was eighteen, a boy I would never have met if I hadn't come to the farm camp. He didn't read much, but he would look at me admiringly, not trying to be cool, and he told everyone that he thought I was smart and pretty. We both knew that we had little in common, and each of us was here for a short time, I for the summer, he to be shipped out who-knows-when, and that we were part of a larger scene that was going on all over the world—brief, chance meetings between strangers in a time of grief and danger.

The evening my roommate's boyfriend brought Henry over to the farm camp, he told me how he'd signed up right after Roosevelt's voice came over the radio on that cloudy winter day, and I told him how I was an air-raid warden back in my home town across Long Island sound, assigned to make sure that no ray of light escaped through curtained windows, light that would define the shoreline for the German bombers that

might come in from the Atlantic, skipping over the Island and the Sound and gloatingly achieving the mainland, us, Westchester County, and beyond, so that we felt like the protector of the entire country stretching west of us.

"So, then, this past May, when they announced in school that there was no one left to work in the fields," I went on, "I mean, all the men between seventeen and forty-five being taken, I figured this was more important than just being a warden." I paused. He was looking at me in a searching way, like he knew there was more to it.

"Besides," I added, "I wanted to get away from my mother."

"She bad?" he asked.

"Oh, no," I said, seized with the hopelessness of explaining my relationship with my mother. "She's good. Too good, I guess. Like I'm her whole life."

"Yeah," he said. "See what you mean. Listen, next Sunday's your birthday, so the girls are going to make Sunday dinner into a sort of party for you. So I'll see you then. I'll bring my camera. I want a picture of you for when I ship out."

"And one of you," I said.

Monday morning was tough after a nice Sunday, considering that we worked ten hours a day, from six-thirty to four-thirty, for forty cents an hour, twenty-four dollars a week, and we paid Sophie ten dollars for the cot and meals and got to keep fourteen dollars a week, more money of my own than I'd ever seen. I thought I'd put it away toward the college my mother said I'd never be able to attend.

That Monday, when the flat-top truck dropped us off at the fields, I was summoned into the farmhouse by Mr. King, the potato king, we called him, who'd shortened his name from Krasniewski, like a lot of the other farmers whose parents had come from Poland and bought up the fields here.

We sat down at the kitchen table, and Mr. King said I was a good worker and I could work on the picker instead of by hand.

I thanked him kindly. Of the thirty-four girls who'd signed up, eighteen had gotten on the Long Island Railroad and gone home, but I'd stuck it out, and now I was being promoted. Like the other fifteen girls who'd stayed, I was proud to be tough, able to endure the long days in the field, picking as fast as the Jamaican men the government had flown and boated in to keep the farms going.

So, on Tuesday, as I waited at the side of the road, clutching my bag with the baked-bean sandwich, I got on a different flat-top truck, the one that went to the pickers. This truck traveled faster to the farther fields, and you had to lie flat and hold on to the edge harder because the centrifugal force could easily send you and your brown bag flying off.

The picker seemed like heaven. You just stood there on a kind of running board and swiftly picked the stones out and let the potatoes go through. I was the only imported girl; the others were local workers. When I looked down at the hands of the other seven workers, I saw that only six of the fourteen hands had five fingers on them.

On Wednesday, I wore work gloves but the gloves started to get caught in the picker blades, and I pulled my hand out just in time and let the glove go in.

"No gloves, dear," the old lady next to me said. "Just be fast."

When the flat-top dropped me off after work that evening, a kind of sadness was in me. I think it was a mixture of Karl Marx and the fingers. I stopped to see Benjamin in the chicken house; he was the scrawniest of all the chickens. The other chickens didn't seem to pay him much notice, and his pinched little face made me want to protect him. He stood apathetically against the wire fence, but I usually threw him

some seed, and when he saw me, he jumped around and cackled. I had figured out that Sophie was selling all the fat chickens to the Army. After a lifetime of vacancies, she was cleaning up on the war effort. I figured that Benjamin's scrawniness had saved his life.

I went back to the cabin and sat on my cot. I had an unfamiliar feeling. Restlessness. My body did not ache as it had when I was picking by hand. I took my copy of *Das Kapital*, stretched out on the cot, and started reading where I'd left off. When the dinner bell gonged, I had trouble closing the book.

In short, Karl was saying that if you all stuck together and told your employer what you wanted, he'd have to give it to you because if he didn't, you could all refuse to do the work.

So, when a meeting of the girls was called in the dining room and they elected me president of the group, I thought of us as a kind of union. Actually, I hadn't found a best friend or any close friends among the girls; in some way, I was different from them, maybe because I always had my nose in a book. I talked mostly to Henry and Benjamin and the Jamaican men I'd worked with in the fields when I was picking by hand. But it made me happy that they liked me enough to elect me president. We decided that my first job would be to negotiate with Sophie to try to get some other kinds of sandwiches besides baked beans and mashed potatoes. Every day, we got whatever had been served for dinner the night before.

Of course, when I politely asked Sophie if we could have tuna fish or chicken salad some days, she said we all had to give up some things for the boys in the service, and those things were hard to come by, but she'd think about it, and I said we'd all think about it, too.

Sunday, my birthday, was a day of sun and clouds, and the vast sky was constantly changing over the fields. Dinner was at one, when everyone was back from church which, to Sophie's disgust, I never went to.

Henry drove up early. Before dinner, we went out to the skiff, and he took the picture of me and I took one of him. I felt kind of glowing, being the president and looking good and being fourteen and having an eighteen-year-old boyfriend. I was going to take Henry to see Benjamin on the way back from the skiff to the dining room, but he said I shouldn't be late to my own party.

There were mashed potatoes (we knew what kind of sandwiches we'd get for lunch tomorrow) and two chickens, and the girls had chipped in on a store-bought cake.

When I thought about it later, I was glad we'd taken the picture before dinner while I still felt happy, considering what happened next. Henry passed me the chicken platter. There was one regular chicken on it and one unbelievably scrawny one. I pushed away my suspicions for a minute, and then I burst out, "Aunt Sophie, what chicken is this?"

She shrugged. Her huge breasts flopped up and down under her kitchen apron.

"Never name anything you might have to eat," she said.

I pushed my chair back and ran out to the chicken house, but of course the familiar, scrawny little figure no longer stood against the wire fence. Henry followed me out and put his arms around me, and I started to cry.

"She killed him for my birthday party," I said. "It's like I killed him."

After awhile, he said, "Come on back inside."

The chicken was almost gone by then, and the girls cleared away the platter hastily. I ate some cake. They gave me a sun hat as a present. I gave Sophie a dirty look and said, "You shouldn't have done it," and ran out so I wouldn't have to watch her

The next week, things got even worse.

On Tuesday, Mr. King called me into the kitchen of his farmhouse and said, "The girls tell me you're president."

I nodded proudly. He told me that another boatload of Jamaican men had arrived at the camp down the road. Now he had more workers than he needed and he'd figured that he'd have to lay off five of the girls. He'd made a list of five who were smaller or slower.

"You're a good worker and you needn't worry," he said.

"I'm president," I said, "so it's not just me that counts. We work as well as those men. We work *hard*."

"You all do a good job," he said kindly, "but that's just the way farm work is. Supply and demand. These men have been cutting sugar cane all their lives. They're very fast and very strong. And they need the jobs. They have families back home in Jamaica."

I knew that was true, so I felt ashamed fighting for the girls, but I knew they didn't want to go home four weeks into an eight-week summer.

"We were told we had a job for the whole summer," I insisted. "You *promised*."

"I'm sorry." He sounded final.

And then I thought of Karl Marx.

I stood up. It gave me courage to look down at him.

"I'm sorry, too," I said, "but we're a union. If you fire one of us, you fire all of us."

His head jerked a bit in surprise. Then he got very calm.

"In that case," he said, "you're all fired."

I managed to get the situation saved. Using my own money for the long-distance call, I talked to the lady who'd recruited us at the school, and she got the five girls jobs on other farms. The rest of us worked out the summer.

In addition to this photo of me, I still have the picture of Henry somewhere in my photo box. He shipped out a few weeks later. He kissed me goodbye, my first real kiss. I got a letter from the Pacific, which I answered, but I never got an answer from him. I was pretty sure he'd gotten killed. Henry was dead, and Benjamin was eaten, and we were all fired even though we didn't stay that way but only because I'd compromised my most cherished principles.

But at least I knew what it was to work in the fields ten hours a day on baked-bean sandwiches and one jug of water for twenty-five people, and I still had ten fingers, and Aunt Sophie had added mashed parsnip sandwiches to the menu although it was doubtful improvement, and I was a woman of the world who'd been properly kissed, and although I had tried political activism and failed, I had at least learned that Karl Marx doesn't know everything. And after that it didn't hurt as much if my mother treated me like a baby because I wasn't any more. So Karl didn't know everything, and I didn't, either, but I knew a lot more than before.

TOM TOLNAY ——————————————————

The Bulge in the Wall

The mother is standing at the stove, stirring gravy in a pot, trying to forget. The father is seated on a chair on the porch, reading the business pages of the newspaper, trying to remember.

After she sets two plates upon the table in the dining room, the mother calls to the father, who reads a minute longer, folds the newspaper, gets up, enters the house.

Once he is seated at the table, the mother sits at the opposite end. They serve the meat and potatoes from the platter onto their own plates. They begin to insert food into their mouths. During dessert, the father discusses customers who are overdue with their payments, but his mind is wandering in the basement. The mother discusses a sale on wallpaper, but her mind is wandering upstairs.

Soon the father stands up, rubs his stomach, steps into the living room. With the remote he turns on the television, sits down on the sofa.

The mother stands up, goes into the kitchen, places the dishes in the dishwasher, turns on the machine. Removing her apron, she enters the living room, positions herself on the sofa. The mother and father aim their eyes at a network situation comedy. Occasionally, one or the other nods at the screen. But their attention is elsewhere: the father cannot remember and the mother cannot forget the bulge in the wall upstairs:

That morning, same as yesterday morning, and all mornings for the past month, the bulge was a little larger. Tomorrow, she knows, the bulge will be larger still.

Just before the news comes on, the mother turns off the television with the remote, pushes herself up off the sofa. The father hoists himself up, follows the mother toward the end of the house. They enter the bedroom, wondering out loud how their parents are doing in their respective, distant cities.

The father puts on pajamas, the mother a nightgown. They say good night, climb into bed. Facing the ceiling in the dark, the father wants to ask his wife a question. Lying on her side, eyes open, the mother wants to warn her husband. Neither says a word.

Next morning, after swallowing half a cup of coffee, the father announces that he is late. He pulls on a jacket, grabs the briefcase in the foyer, pecks the mother's cheek. Out the door he goes.

The father starts the engine, fuming the garage; the odor almost triggers a memory, but it slips away from him. As the car rolls out of the driveway, the mother waves goodbye from the doorstep.

In the train the father places his commuter pass in the seat clip. Now he searches his briefcase for the week's sales orders. Clickety-clack go the wheels over the tracks. Rain blurs the window.

At the house, the mother is gathering the soiled bed sheets. Before carrying the laundry basket down to the washing machine in the basement, she steps up the stairs and finds herself in the unoccupied bedroom, staring at the wall. The bulge is much larger this morning.

Before her eyes the wall begins to swell, and the center of the bulge bursts— chunks of plaster crash upon the floor, thickening the air. The mother, calmly resigned,

does not move out of the room.

In his office the father stops tapping numbers on the calculator. After picking up the yellow pencil on his desk, he stares out the window; an ambulance is racing, with flashing red lights, across the bridge. . .just then, it all comes back to him. The pencil snaps in his fingers.

At the house, the caved-in wall has weakened the ceiling, which now buckles and falls to the floor, causing another wall to topple. Windows shatter, shingles sail off the roof. The foundation trembles. Within minutes, the frame house collapses in a great dusty heap and is consumed by the earth.

The mother is never found. The father never returns.

DOROTHY BLOOM

One Morning Out West

Just a hint, a scrap of Rosemary Clooney on the radio singing "C'mon a my house, my-y house; I'm gonna give you every. . ." initiated an entire scenario in Bernece's head, beginning with a view of the soft, brown plain along the Columbia River and the brown hills rising above it, and the dry smell that one finds only west of the Rockies.

In the foreground she and the boy stand holding the reins of her pinto mare, the boy's black eyes aglitter and his hair in damp strands over his eyebrows. He is forever frozen in midstep, his arm outstretched toward her, and the gesture, which once puzzled her by its ambivalence now seems purely wistful and self-defeating. Rosemary Clooney, on the other hand, is all confidence in her ring of promises made and promises kept. Bernece tries to shake off the story by thinking about the color of her eye shadow but is amused that she cannot get rid of it. It is wholly contemporary as a virtual experience, this time in her mind, that she must relive. This time, in her mind, as before, standing on a dusty trail not far from the Hanford nuclear facility where her father worked on secrets, she eludes , as before, the dirty hands that haven't touched her yet, that will not touch her. Her boot is already in the stirrup, and she feels her weight on it as she swings herself over the saddle.

She hasn't thought of it in years, of her daily rides to the river between quitting her job at Dupont in Richland and going back to school. But she has been taken by the picture now and seduced by it and stands in front of the mirror with her hands in her hair, but seeing there her earlier self swing into the saddle and pull herself over the horn as she urges the horse into a dead run with the quick staccato beat of her heels against its flanks. The action must have seemed as unprecedented to the boy as to her, but, once she was freely running with the wind burning her face, she had absolutely exulted for reasons that probably could be guessed at but which weren't available at the time since she positively rode along on the crest of her feelings without seeming to express any curiosity about where they came from. She was beginning to think it cruel of the radio station to cause her so much pain as the memory of her triumphant dash back to the stable now took on the overtones of tragic denouement, a development she certainly hadn't foreseen.

Certainly in the intervening years it was natural to expect that there would be some development, growth beyond that first passionate rejection of hope and fulfillment, some reflection on the meaning of this or that event in one's life. But her overwhelming sense of experience denied brought her almost to the verge of tears. The wiry tensility of his slight bowlegged figure even now made her draw in her breath sharply, and she recognized her failure to gamble her predetermined life's course on a new and dangerous path. He was about seventeen, silent, obsequious, and seething, and hers for the asking.

When she had first started taking the mare out for a morning ride, the stable owner told her she couldn't go alone. He said you never know if you're going to get thrown, but you always know who's going to get sued if that happens. He assigned the boy to the job, and the boy was childishly grateful. He whooped and swung his rope and seemed so great in happiness it made her heart swell just to look at him, but he soon

became his hangdog self again as they moved out on the trail. They always went in the direction Bernece wanted to go. And she always wanted to go the same way because of the hills across the river, brown and soft as velvet.

It was very pleasant as the days went by to develop the thoughtless habit of the trail, letting the horses take them as they dreamt silently in the freshness of the morning. They began the ride on a trail a few yards from the corral. It wound through some alder woods along a creek that emptied into the river. It was dappled and cool in the woods, and easy. Bernece was not at all interested in actual nature, but once in a while the boy pointed out something to her. Once he saw a print in the mud by the river which he said a bear had made. And another time when he had gotten down for a drink he came back with a frog in his hands. He slipped it into her own hand, probably understanding that she would be embarrassed to drop it, and then pointed out to her rather forcefully the miracle of the frightened heart that she could watch beating under its slimy green skin. Life on the trail, she thought, was made of these insignificant events and experiences like the voices of baby turtles that go unheard until they pipe all together and make a whispered little roar. It was of not thinking, of dreaming, of riding slowly down the stream, just now and then pausing to let the horses graze fresh grass, walking, letting the mare decide when to move and when to stand still until the trail broke out of the woods and wound through the sage desert and down to the river. She relished the feel of the words that she sang. "Tumbling along with the tumbling tumble weed," she sang, and laughed as she watched words live as weeds and roll and roll until they were stopped by a ragged sage brush growing in their path, as she and her horse, Lucy, ambled along at their somnolent pace. In the distance the hills were blue under the river haze. At their feet the gray-green brush rattled about in a light breeze, and the sun glinted off the rock chips scattered over the hard ground. It would be getting hot, the sky beginning to turn white from the heat. "I'm boiled," she said to the boy just as he paused next to her to smile, and she felt grateful for the cool wind that dried the sweat on her neck and whipped her shirt like a sail and filled it with wind. Otherwise it seemed as if he surely must discover how she had noticed his broad, flat lips that slipped apart over his square teeth and especially the black one that she wanted to touch with her finger.

But this was not the place for him to linger with smiles. Not the little cowboy. He flicked his horse ever so lightly over the rump with his thong, and then, standing in the saddle, "Yippee yay," flew off to the river bank as if a Remington painting had come alive, a remnant of another time like the stones in the river that would tell some remarkable story if you knew how to read about their birth in the center of the earth and their subsequent adventures in earthquake and volcano just by picking them up and turning them over in your hand. She knew people who could do that but she was sure she never could. But if she could, then she could say to herself, "So this is how it was."

While the boy cantered back and forth by the river's edge, Bernece used the time to practice gaits and in general improve her horsemanship. By the time she could make out the contours of the hills across the green river, the boy would already be a mile ahead of her treating his quarter horse to a drink from the river. The oily swells on this morning looked more threatening than usual. She walked over to where he stood, seemingly hypnotized by the regularity of the river's flow. and asked him if he ever went swimming there.

"Heck no," he said and grinned at her. She looked away from him quickly before his tooth could break her heart.

The boy mounted his horse then, and they rode off together as if they were connected in some new way.

"I'd like to climb that mountain over there," Bernece said.

"Heck, you want to get killed?" The boy grinned again and said, "You need real equipment to do that." He said, "You can't send a boy to do a man's work."

"Would you dare?" she asked. He turned his head to look back at her.

"Nobody ever dared me," he said.

"Well, I do," Bernece said recklessly.

That is, that from her vantage point at the dressing table where she was finishing her nails, she supposed reckless was the word. In those days she might have been surprised to know how twenty years of the expected would mold her. She checked the mirror to see if a trace of the other was evident at all and saw nothing that was not soft and round and without conflict. She looked down at the dressing table and saw all that so perfectly validated the face: her silver-backed brush, the envelope of opera tickets her husband had left for her that morning, the flowers. Had they ridden less quickly back toward the woods, taken their time to gather their disorganized thoughts and consolidate, and clarify, and articulate them, then they might have been better able to leave their grief to dissipate in the wind. Because he surely mourned also. But the next step had to be taken before the first had been qualified, and their failure lay in the pause. As they dismounted to rest a few minutes out of the sun as they always did and recover from the heat that exhausted every leaf and vessel, they seemed a little surprised at finding themselves standing so close together. Silent, they watched the horses nibbling on the sagging grasses and drinking from the rapid little stream. In some way a transition had been lost, and time had become an enemy.

"I guess you've got lots of boyfriends," the boy sad.

"A few," she lied.

"I been with a girl a few times," he said to reassure her, as she thought now.

He took a step toward her, reached out his hand, found empty air.

She, aching for the touch of that dark hand, had already slipped into the saddle and started the run back to the stable. Dust swirled in the air over the corral. Sweat ran in dirty rivulets down the faces of the other hands there. "You ought to fire that kid," she said handing over the reins to one of the men. "For all the attention he paid to me, might just as well have been by myself." It would have been nice if she had paid more attention to the horse, worn out by that run in the heat. But she hadn't thought of that until now. And she never rode horseback again, though she had tried to get her own daughter, who was afraid of horses, to sign up for lessons at camp. Once thing she had learned over the years is that you can't make people do what they don't want to do.

Bernece took a last critical look at herself, picked up the tickets, and put them in her bag. She had been wasting time mooning when she should have been planning how she would introduce her idea at the 9:30 conference. There wasn't a taxi to be seen when she got out on the street, and she thought it was just her luck that she would be late this one time when her back was up against the wall.

GINNAH HOWARD ───────────────────

Rope and Bone

His shirts he hangs on the back of the chair, one on top the other so they won't wrinkle. On the end of the kitchen table he begins to fold the rest of his clothes, piling them up by kind: underwear, jeans, bandannas. Like the women in the laundromat do. As the stacks spread, Rena's friend, Del, moves her papers over to make room. While he folds, he listens to his son's laughter above the TV. For a moment he feels like he lives here again. All the dents and cracks are familiar. The half-stripped table he started last winter, waits.

While he stands in this kitchen, sorting socks and rolling them into lumpy wads, he watches Rena. He watches Del.

"You do good work," Rena says. "Did Marion teach you that? You never did laundry when you were with me."

He looks up at her to see if she's being nasty, but she just smiles and goes on rinsing the glasses.

He watches Del cross off and write, chew on her pencil, and write some more. She says she's fixing a poem. Fixing a leaky hose, fixing the toilet. Fixing a poem? She reads parts to Rena. Rena says, I don't get the "She wept." Then Del x's out a line and looks up at the ceiling like she's waiting for words to drop from above.

His shirts need buttons. Rena used to do them. Marion doesn't. "You got any thread?" he says.

Rena turns and drops her jaw.

He ignores this. "I need white thread and a needle."

She goes up to her room to find them.

He follows her as far as the foot of the stairs and calls, "And dark thread. Dark blue thread."

He pulls Ben's hair lightly as he passes his chair.

"What you doing, Dad?" Ben says, not looking away from the screen.

"Sewing buttons."

"Well, when this is over, I'll help you. Okay?"

"Okay, sure."

Rena returns with the whole sewing box and a crack about how she's fresh out of thimbles. He ignores her again.

He checks each of his shirts, sets aside the ones missing buttons. Several have rips in the elbows, torn pockets. Maybe next week. He smiles at the picture of himself: Steve Riglioni, Pagan Biker, busy with his mending.

He settles himself into a chair and pushes aside all the piles, careful not to disturb Del's papers. When she looks up, he motions her to go on. Everything's under control.

No buttons. He searches through the box. None. He does not want to get into this business with Rena again. Carefully he explores the box, layer by layer, once more. Not one button. Besides they have to be small and like the rest. He sits and stares at the shirts spread before him.

Then he laughs and looks down his front. He counts the buttons from his neck to his waist and the empty spaces on the shirts before him. Then with a tiny pairs of scissors, he snips off the buttons he needs from the pockets and the parts he tucks in his

pants. He lines them up in a row, ready.

He looks over at Rena. She sits by the window, smoking a cigarette, staring out at the bright blue sky. The sun touches her white blouse, her black hair. He had forgotten her hair: wild, curly hair that always gets away from clips and scarves.

In the little pin cushion he finds a bunch of needles. He chooses one with a small golden eye. He lifts the needle to the light, pushes his cap back, and, squinting, pokes the white thread through the tiny hole the first try. He pulls the thread down to make it double and ties the ends together in a knot at the bottom.

Putting on a button shouldn't be too hard. He straightens the shirt in front of him, lines the little white plastic circle up across from the hole, then slips the needle under, lightly holding the tiny rim with the nail of his forefinger. In jabbing for the opening, the button shifts a little . Once it's fastened down, it'll be easier. As he recalculates the exact spot, he notices there are three tiny punctures. Tracks left by the missing button. This changes things.

He lifts the shirt onto his legs and pushes back from the table. From underneath he pokes the needle through one of the little dark holes and then slips the button over the point. Carefully, so as not to tangle the long thread, he pulls it all the way out. He puts the needle in another hole of the button, finds the second dark speck with the point, pushes it part way in, and from below draws the thread down with one final tightening tug. The button is trapped. He relaxes his fingers.

Then he notices Rena looking at him. He keeps sewing, keeps his brow wrinkled. The kitchen is quiet. TV voices murmur in the distance. He sees Rena turn back to the blue sky, the kind of bright blue that only comes in February.

February. One year ago this month he ran out of this kitchen, on Rena's voice, on Rena standing with a maybe-loaded gun screaming, You ever touch me again I'll kill you. Left his sons, John and Ben, on the dark stairs, listening. Slammed the door so hard the old window cracked.

A late icy February night. No bright blue sky, no pretty Rena then.

Somehow he got to Marion's. The drive from Grantsville to Utica is still a blank in his mind, but the next morning there he was passed out on the front seat in the alley behind Marion's apartment.

The thing with Rena was that every new fight, she brought up all the old crap again. Sometimes before he even got in the door, she screamed, You son of a bitch. Then she always got to how many years they'd been married. She'd look up like she was talking to God and say, Five years. Ten years. Eighteen years — real disgusted. But the night she got out the gun, she didn't bother reminding him of the years. Somewhere she had found out about Marion. When he came home late, she was waiting on the stairs. She jumped on him and started clawing him in the face like a crazy person. Then he ended up slapping her. She went nuts, started biting and throwing stuff. All the while yelling, I'm not like my mother. I don't have to put up with your shit. Then it seemed like out of nowhere she had his gun, aiming it right at him. That was when he got the hell out.

After a few days at Marion's, he went home. Piled on the porch was all his stuff: boxes and bags, all his pictures. Everything. And a note. Something about how he never listened, how she was done with living with someone who couldn't hear, how there was a person inside her body. A note that said if he tried to get in, she'd call the cops. That the next time he heard from her, it'd be through her lawyer. That this time she meant it.

When he started banging on the door, he saw her go to the phone. He left. Let her cool off, start to miss him. Three days later, painting up on a scaffold, he got a

registered letter from some woman lawyer in Bleeker. Lot of big words he never did read. Boiled down to a legal separation, a visit with the kids Sundays, and fifty a week.

But that was a year ago. Most of the war's over. Today he feels good. Home for his Sunday visit. He's given her the promised fifty, plus fifty from before. He's painting full time, even though it's winter.

He watches Rena. She lights another cigarette. She looks at him and smiles. He goes on sewing. The second button's easier. Yes, today Rena's being friendly. She may change any minute, but today she's got the white flag up. She crosses the kitchen, reads over Del's shoulder.

"I'm almost ready," Del says. "Then I'll read it to you, see if it's clear."

Rena starts pulling stuff out for dinner. "Well, I like the last part, 'make a will/ and wait.'" She raises her arms and laughs.

He's always liked Rena's laugh, every part of her moves. He remembers the good times when she laughs. He watches the rise of her breasts, the curve of her belly. Out of the corner of his eye follows her ass as she bends to get potatoes out of the cupboard.

Yes, today he feels fine.

"When you finish that, I got some socks you can darn," Rena says.

"Okay," he answers, biting the thread, "but I have a price."

"You're right about that. Morning, noon, and night. I'm aware of your rates."

He looks in her dark eyes, wants her to remember some of those times.

"How about getting me a beer?" he says.

"Get it yourself. And don't start drinking so early. Next you'll be getting loud and obnoxious. Start telling me what to do," Rena says while she's reaching in the refrigerator, opening him a beer.

He sits and drinks and sews. Only three more buttons to do. Rena peels potatoes at the sink. Del sits across from him, her small hands at rest on the table now. She reads softly to herself, her lips moving, her head bouncing a little. He leans forward, but he can't hear the words. Then she begins to copy it all over, her tongue reaching out to lick her upper lip every few lines.

Del, now here's a woman hard to figure. Different. Her slanted eyes and bony cheeks. Del, always a little distant. Maybe a couple years older than him. Forty-four, forty-five. Stayed in that cabin all alone. Her man only there some weekends. He never had any teachers like her. He talked to her husband a couple of times, years ago. Always with his kids, seemed to love those kids. A strange guy. Shot himself in the head. How could anyone do that? Think about it, sure, but do it? Now there was a guy who looked like he had it together. Should've stopped by his place and smoked some good weed with him, told him. . .yeah, life's a bitch, but it can be fine. Once he asked Del, How come a lovely lady like you isn't married? I didn't like being married, was all she said.

"Ready," Del says. She clears her throat, raises the paper from the table. Rena stops cooking. He puts down the shirt and leans forward again. Del's eyes touch his and blink, like she only just realized he's there. She smiles and starts to read.

He likes the sound of it. Women and men. . .Rope and bone. . .From alien planets...Speaking in tongues untranslatable.

Del reads on.

It seems like Del's as pissed with the woman as she is with the man.

Del stops. Right away Rena starts with the questions.

He leans his chair back and, balancing against the shelves, pulls another beer from the fridge. He tosses the cap into the basket by the sink and drinks. He sews and

listens to the women, but they don't tell what he wants to know: why the woman's a rope, why the man's a bone.

He watches Del. What would Del be like in bed, her cat-stretching body, her teardrop tits, rising and falling on top of him? But she never sends him any signals. A flick of her shoulders says, "I don't do one night stands." Hey, he's serious, too, but, well, another kind of serious.

Still pushing the needle back and forth through the little holes of the button, he asks, "Is that how women feel? That they're so different from men?"

He sees Rena's surprise: the jerk of her head, the widening of her eyes. She stares at him.

"I don't know about women," Del answers, "but I've felt all those things."

"Amen," says Rena, and turns back to the frying chicken.

"Well, I don't know, darlin's. I don't know about us being so different. Look at it out there: the sun shining, that bright blue sky. Why I could just take the two of you into that big old bed. We could have a fine afternoon."

Del laughs.

Rena laughs too. "You must be smokin' some good stuff, baby. Dream on," she says.

Steve hangs another finished shirt on the back of the chair. "I'd like a copy of that poem," he says.

Del hesitates, looks over her first sheet, then with a smile, pushes the new copy across the table to him.

"Thanks," he says and folds it into many squares to tuck in his wallet.

"He wants it for That Woman," Rena says, banging the lid down on the potatoes. "As if she could relate to 'standing at the sink washing diapers.' She doesn't know anything about that: having kids or having no money." She jerks open the refrigerator door and pulls out the milk.

"Now, Rena, don't start," he says and caresses her bottom, feels her familiar warmth in his palm. She moves away. Leaves his hand in midair. She gives him no chance to fan any fires. That night with the gun, it was like Rena went round a corner and she never came back. She must have told him she meant it a dozen times through the years. This time she did.

He tries to push a dark thread through the eye. His aim is careful, but each time only part of the thread enters the hole. He wets the end to a point in his mouth like his mother used to do. He is surprised by this memory. He sees her sitting in an old rocker, sewing. Curving over her shoulder is a tall brass lamp with gold fringe hanging from a big white shade.

"You know what I just thought of, Rena? Back when I was maybe seven or eight, living on Ramsey Street, and every night after dinner my mother sat down under an old brass lamp and sewed." He closes his eyes. "I see all the rooms. Up in the attic where me and Jimmy slept. In the mornings I listened to the pigeons."

"Oh," Del whispers, and her hands move in the air, "that's one of the things I remember most. The pigeons up under my grandmother's eaves, right outside my bedroom window. Did you ever try to make that sound? I used to listen and listen and try."

He tilts his head and leans forward like he hears something, something off in the distance. He laughs. Then slowly he draws his head down into his shoulders. His chest swells. He begins to wobble his neck, and out of his throat there comes a gargled coo.

Del giggles, "That's it." She tries, fails totally, tries again.

Rena comes to the edge of the table. She bends toward him over the piles of clothes and really looks at him. "Steve?" she says. Then she laughs and sits down in the chair beside him. She begins to pull her neck into her shoulders.

"What're you doing? What's that funny sound?" Ben says as he comes through the door, wearing his father's black leather jacket.

"What's it sound like?" Steve says.

"Sounds like a pigeon."

"Well, that's what it is. A pigeon."

"A pigeon here in the kitchen?" Ben says and begins to search.

When Ben turns away, Steve coos again.

Rena and Del laugh.

"What's so funny?" Ben says.

"It's your dad, Ben. Show him, Steve," Rena urges, wrapping her arm around the boy's waist.

Again he lowers his head, swells, waggles his neck, and coos.

Ben snaps his fingers. "Cool, show me how."

"Show us all," says Del.

Ben sits down on his father's lap. Ben has Rena's beautiful face: the same big, soft mouth and dark eyes. But his body is all Steve. Tight and square, already a little man at ten. Steve moans. "You sure are getting big."

Ben grins. "Do the pigeon."

Steve sets aside the shirt.

"First of all, you don't just do it. To start you have to, you have to become a pigeon."

Rena's eyes widen again.

They are all watching and ready. The phone rings. The pigeon disappears.

"Answer it, Ben," Rena says.

Ben doesn't move. It rings again.

"Ben," she repeats, her voice rising.

Steve pushes him lightly from his lap, and Ben creeps to the hall.

Rena yells, "One of these days, Ben, one of these days." Almost to herself she says, "They're threatening to turn off the phone. They'd be doing me a favor."

Ben calls from the hall, "Mom, it's John. He wants a ride from town. He's at Joan's."

Now Rena's look is all charm.

"Steve, the Pinto isn't running. Could you?" She gives him her Beautiful Smile.

"Tell him I'll come get him if my car starts," Steve hollers to Ben.

Rena leans toward him. "You having trouble with your car?" She shakes her finger. "I told you not to buy that car. I mean it already had 90,000 on it. It was a torpedo when you got it."

How quickly she turns. He shrugs. He is not, goddammit, he is not going to get into it with her today. He wishes he had a dollar for every fight they've had over old cars.

"I can go if you have any trouble," says Del.

"I think it'll run. Come on, Rambo," Steve says to Ben. "Let's go get your brother." He takes the last two beers from the refrigerator and eyes the bottle on top. He'd like a shot for the cold, but Rena stares at him hard. Instead he takes his jacket off Ben as Ben starts for the hall. "Get your own coat," he says to the whines of protest.

He sets the beers on the edge of the cabinet and begins to rummage through a drawer.

"What are you doing?" Rena says.

He opens a beer, takes a long drink, takes another, lets her wait. "Where's a screwdriver. What'd you do, rearrange the whole house?" He means to keep it light, but just the thought of the carburetor puts him on edge.

And, of course, Rena doesn't let it go by. She never does.

"You got a problem with me rearranging the whole house?" she asks, her hands go to her hips, her chin angles toward him. He knows her fingers will curl into fists next. They do.

"A screwdriver, Rena, all I want is a screwdriver."

"In the hall closet," she says, her back to him now, her hands stirring something on the stove. "Steve," he can hear she's sorry, "talk to John about Joan. No good's going to come of a seventeen-year-old messing with someone who's thirty and got two kids." She faces him again.

"Rena, you know he won't hear it."

"Talk to him anyway. Please."

He nods, downs the rest of the beer, and puts the last can in his pocket. He moves into the hall, passes his and Rena's old room, empty now, closed up for the winter. The closet surprises him: an old saw, a hammer, a screwdriver, a rusty pair of scissors hang on the wall. Beneath, Rena has nailed a magic-markered sign, "Return Or Else." Here's another Rena he did not know. He sticks the screwdriver in his pocket and squats to help Ben pull his boots over thick socks. His throat tightens where Ben's small silky head rests beneath his chin. He looks for a pair of gloves, doesn't find any.

They go out the front. Rena has fastened a long strip of duct tape across the cracked glass. Maybe he'll fix it one day. It's probably been Exhibit A for her story about how he slammed out one February night, leaving her with half a cord of wood on the porch. He's heard it himself four or five times.

"Shut the door," he reminds Ben who leaves it wide. "And, Ben, do what your mother says. When she asks you to get the phone, do it right then."

Ben doesn't respond.

"Ben, do you hear me?"

"Yes," he says, cocking one shoulder just like Steve does.

The daylight is gone, taken over so quickly by February darkness. It's a lot colder out. They get in the front seat. He opens the last beer, drinks, places the can between his legs. Again wishes he had a couple shots to dissolve the knot in his throat, something to lift the heaviness he now feels.

He pushes down on the pedal, turns the key. It starts up and immediately dies. He bangs the dash lightly with his fist. A rebuilt carburetor costs $150. He doesn't have that kind of money this week. He's not going to ask Marion. He finishes the beer, his fingers numbed by the freezing metal. Ben plays with two army men, firing them softly across his knees.

"All right, when I holler, I want you to turn the key like this." He mimes the motion. "Then right away push down on the gas like this. When it starts, kind of flutter it like this. Listen and I'll tell you when to start and when to stop. We've got to do it just right."

On Ben's face is a look of complete concentration.

"You have mittens in your pocket?"

Ben shakes his head no.

He pulls the seat forward and gets out. Ben slides over, the top of his head barely visible above the wheel. He rolls down the window a few inches so the kid can hear him and closes the door. He zips his jacket as far up as it goes and moves to the front of the battered Chevy.

Through the kitchen window, he watches Rena and Del moving around the table, putting on cups and plates, the knives on one side, the forks on another. He watches the flow of their arms, the swing of their hips.

Their lips move. He leans toward them.

HIGH-SCHOOL POETRY ─────────────────────────

CHRISTOPHER LOTT————————————

Christian Hill

dripping icebox man sells souls
daunting rainbow brite towers and grins
fatwoman with yellow arms grills Grade A beef
upon hastily constructed plywood pooldeck
youngest son an insect among uncut grass
another waters the house long since sagged
ivory satellite beams
prenumbed sports action inside

Day²

Can blue be shocking?
Certainly more than math.
We are not bound by
Fragmentation,
Our knees free us from goat's milk.
The Weird Sisters
Contrast our playground
And the Flux Capacitor
Belays our calm.
You don't understand a word we're hearing.
Leaping and bounding
O'perch these coolers
And become a can of soup
Before the Grandmaster Reebok
Eats you alive.

KEN MACLEISH

Looking Out the Window

the rain makes a sound like a faraway fire,
pushes the wet air, laden with wet nimbi, through the screens,
against the dirty glass, the cobwebbed plastic frame, garnished with fly corpses, filling
up the little wire cells that make the hills tree sky
look like a digital cook-up a massive cock-up,
a pain when you want a massive blue sky
and what you get is a million little squares of blue
which might or might not be sky
when laid end-to-end how many times around the equator or to the moon and back
and, likewise with the pastures far off, the trees,
ancient fractal creatures of infinitesimal detail,
trunk limbs twigs & leaves cells proteins & helices atoms protons quarks to who
knows—it's difficult to say from here, anyway,
as their several hundred shades of green
are chopped into pixels of several hundred shades of green, like a posse of mosaic tiles
chopped up blended pulverized & dumped out anywhichway,
just a bunch of squares wanting meaning,
not like the glorious thing revealed when you just look before remembering
that the screen is there (because once you allow the damn thing under your skin,
it stays there, and the more you want it out, the more it stays—
you'll always see it), glorious, like the top hat shape,
angles & planes slightly skewed at the top of a ubiquitous smoothskin gray tree
 species,
summer ragged, with branches stuck out willy-nilly,
shimmering as the leaves turn their pale bellies upward, in the breeze
with a noise like gravel falling over itself,
and the filtered, wide-angled sun bronzing the many-armed chambers
in the hearts of this tree & its compatriot trees,
chopped into a million cells delivered,
regimented for your enjoyment,
courtesy of this sun-showered screen.

BETH RENCKENS ——————————————————————————

Tanka

The changing of leaves,
as they float on their frail wings.
Drifting to the ground,
the fingers of the tree are brown.
Winter's tongue laps at their trunk.

KATHERINE GRAHAM MORRIS

Goodnight, Sweet Prince

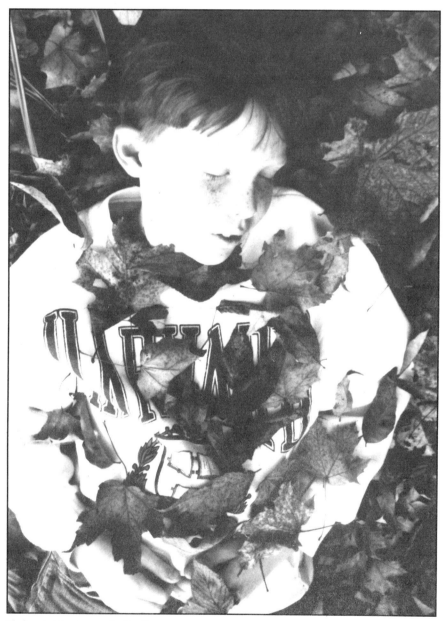

Black and white photograph, 6" x 4"

AARON SAXER

The Woods

The mountains have their deep purr—
valleys, canyons, and crevices—
each has its own flowing nature.
The hills have their problems—
smaller than mountains,
they stretch themselves.
But the woods, the woods—
they are the gentle beds of earth,
the rooms where healing takes place,
the home for my final rest.

GUNNAR JAECK

Ever Family

I've the blood of a German and
the heart of a Scot.

My hands are the smith's
and I've a poet's eyes.

Mountains, wine, and diamonds
are mingled in my veins.

There's an entire babbling species
but I've only got one voice.

If my flesh is the water and
my soul is of fire,
I be the mist.

If my mother is the sea and
my father is the storm,
and I'm all the sky in a single star,
then the jokes of my heritage
are only children.

RICK STINSON ─────────────

I've heard the same story
Five times from five tongues:

The First dripped with pious tallow,
sweat-caked age, and the rancid stench
of a chaste eighteen years;

The Second was tied in knots,
bovinely twitching and blindly staring laughter,
all coming too quick and so wrong;

The Third, withdrawn,
once able to wail
with a baroque carnival huckster's glee
and now, after witnessing the act of which it speaks,
sinking into an edgy silence.

The Fourth coursed with electricity,
promising gaudy, forbidden excitement,
licking its spoken syllables
and sending down contemptuous showers of sparks
spat, raining down on all.

The Fifth spoke in mildew
soaked in expensive perfumes;
tears came and I ran to the bathroom
retching, emptying myself.

And, now, kneeling there,
a Sixth, my own,
limps gamely in circles,
trying to sort these contradictions,
whispering a desperate rosary against them.

CHRISTOPHER RAE GREENLEY ─────────

Accent
for Isa Pinana

I hear it every time I read the words:
an accent rich as Midas's touch,
full of character, precious life,
vivid as a dream in my mind. It comes so clear,
like the blue sky on a winter morning,
or the blackened underside of a summer storm cloud.
Beside me, inside my head, never gone,
it comes as an errant, warm breeze.
I am alone, without despair, with the accent,
playing songs, talking with ease.
Days of loneliness may return,
but joyful thoughts remain,
glimmering like moonlight over dew-drenched fields,
shining as from an unseen light.
My trained vision shows the glow;
it appears as a pearl in the haze.
Even in the fog I rejoice in memories,
a brighter, smiling day, glittering, mirthful eyes.
They pierce the heart of a sad man,
forbid entrance to woeful reminders, the bleak future.
It's the voice, the accent,
its laughter and its tears that vanquish
frowns, fears, fade work's strain,
bring out the accent within.

ROWENA SMITH ————————————

Chicken Tonight

We watched
as it ran
without a head
the blood smearing
its coat of feathers.
It ran about
in no apparent pattern
from person to person
as if to ask
give it back
please oh give my head back.

But we just stood
as it dropped to the ground
the nerves no longer
sending signals
to a brain not there.

Tonight
dinner was chicken.

PADRAIC MACLEISH

The Pig

However people belittle or berate
 the one what puts bacon upon my plate

Or shout and screech of stink and slime
 know not the swine to be sublime.

Great thinkers though they may not be
 they lead a better life than me.

So, do not pass by; stop and chat;
 give the portly pig a pat.

COURTNEY COLANDO ───────────────

I Take My Hands

I take my hands
And mold your body,
Limb by limb;
Slash by slash.
I use this tool
To justify a wrong;
To make you
My masterpiece.
A crimson red
Drips on my canvas
As I make this murder into art.
What was once rage
Hangs upon my wall.
No more lies now.
You hang there,
Opened, to the world.

COURTNEY COLANDO
and STEPHANIE HAGAKORE

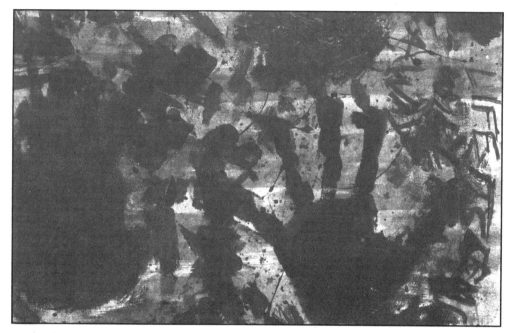

Mixed media on canvas paper, 11 3/4" x 15 5/8"

SCOTT THOMPSON ─────────────

Juxtaposition of Revelations 20:7

weightless sadistic fucked-up beats
keep thrashing about my pregnant head
love of morphine and androgynous psychosis
as i wallow in a craftsmatic adjustable bed
i sit on my hands with a chemical band
illiterate bastard disco chick
and there's no place like home
in a gothic-esque dome where gothic-esque ruby shoes click
click click nachos, dead of night
night of dead souls wandering wasteland
alcohol cigarettes seraphim scars
after an hour taste bland
writing on fogged windows saddens the soul
to the point of dismal abyss
and i'm always amazed by the cigarette haze
hanging over the room as a lisp
toxic substances pollution insane thoughts
that plague my cellophane mind
distinct subtly arcane
and nothing but random miscellaneous rantings
deluded polluted psychosis induced memoirs
caused by increasing pantings
knock knock tick tock the clock chases life
while i choose to live like ginsberg or keats
and the song in my head like the craftsmatic bed
raves on to the block-rockin' beats

NICHOLAS GARELICK

Ear

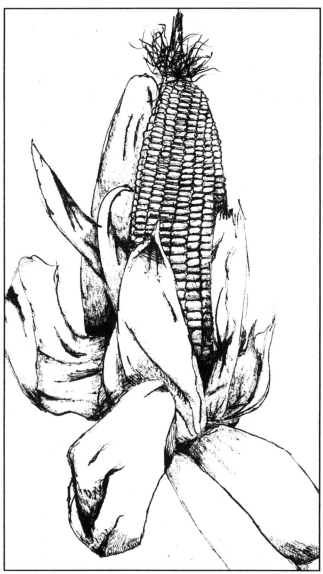

Pen and ink on paper, 12 3/4" x 7"

BRIAN NAYOR

Deviation

To be helped is a burden
On the back of the jackass I am:
How can I ever repay?
To live is to suffer
Death prolonged:
How long are my days?
To want is to feel unneeded,
Just as in the songs I love;
And to live with the animals is to be a
Real man,
In the sleet, without gloves.

SUMMER KILLIAN ———————————

Ink

a slip of paper
carried by the wind
floated through my open window and landed
softly
 on
 my lap.

I thought about you,
thinking, if you were a small slip of paper,
how I should love to be the pen
in the hand of the one showing us
how
 to
 love

what beauty we could create!

LEAH DAIGLE

Shoebox

the empty shoebox
in the back of my closet
yearns for someone's words

hurt like an angel
fallen down from the sky
its broken wings are stitched together

a single tear
falls into the lake
is dissolved in shivers

DANIELLE DART

Hurtin' Love Obsession

My shoes have no strings
 attached,
the soles are worn down.
My tired feet hurt,
the blisters are painkilling pillows.
I somehow have a padlock
 attached to you,
the key went
scratching down my throat,
and my burning melted the key
into a silver heart.
For you only.

CRYSTAL COLANTUONO ———————————————

I'm Guilty

If not letting go is a crime,
If wishing is forbidden,
If it is a sin to dream
Or be too savage, too long to fit in,
If hoping for a better tomorrow
Means forsaking today,
If wanting the impossible
Means I'll pay,
If wanting to sit among the stars
And kiss the night is not right,
If I am condemned for wanting to be free,
To fly, like a bird,
I plead guilty. I plead guilty
To all the crimes I've committed
Then and now,
And I'd gladly do them again
And not care how people stare
Or what they say behind my back.
At least I know
Adventure Is something I'll never lack.

STEPHANIE BUSSMANN

An Unpaid Bill

A muffled cry into a coffee cup,
now empty,
on the table,

left me with broken love
and some crumbs.

An unpaid bill.

MOIRA DWYER —————————————

Adoring

Shameful; my coarse hand brushes
a strand of golden hair
from your smooth, pale cheek.
A delicate touch takes a photograph
and the pleasure is sustained a moment longer.
A calm sea willingly runs up
the rugged shore.

REBECCA BURK

Similar

This person was like a disease
I became immune to it
It stopped making me sick

This person was like a newborn
It grew and so did I

This person was like a can of soda
After it was empty
it rolled around and was recycled
and became a metal ring on a pencil
something completely different
from what it had been

This person was like a match
It could warm or hurt

This person is a memory
never forgotten
woefully missed

BRITTNEY LAUREL SCHOONEBEEK————

Clone

She, with those golden locks
an everlasting grin that pleased everyone
pastel blue maryjanes that, somehow, we both wore
our pink skirts, white tees, and faux fur jackets

We were extravagant together

She, with her German shepherd Keanu
Keanu—her favorite actor
and most definitely mine—
we sat an aisle apart at his new movie

Both of us didn't eat—the very same way

She, number one in our economics class
what a pretty brain
we sat in neighboring rows
and sighed every day at twenty after

They glanced not once but twice at us

She, her pearly whites so perfect
her flawless, pure life
like the star on top of the Christmas tree

All alone, yet in the very same world

She, the queen in the black silk skirt
the artificial angel of sorts
we both danced there that night
both of us tired
we, who clapped for the winner

Together, as one

JENNIFER COLLETTI

Eavesdropping

Buzzing by,
A little fly
Stops to sit and wait.

Don't know why
He chose to spy
Upon our hushed debate.

Perhaps he sides with me.

MEGAN ALICINO ———————————

Under My Plum Tree, at Twelve

Two black cats
hold a secret rendezvous.
They whisper the cat language,
meows I long to know.
 And part,
blending into night,
leaving two pairs of
 yellow,
 glowing eyes,
illuminating the midnight sky.

SCOTT ROBERTS ───────────────

The Cat

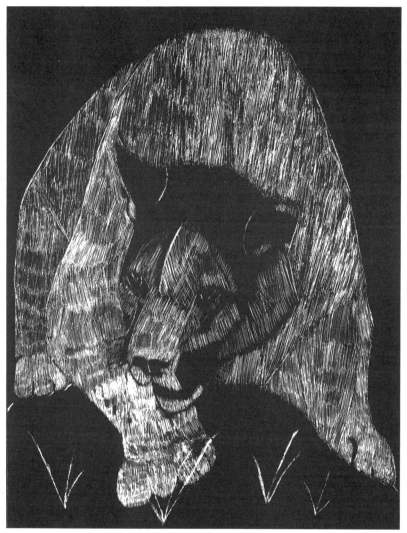

Scratchboard, 11' x8 1/2"

CHRISTOPHER BUSSMANN ────────────

Domain

And she came dressed in robes,
a crown of laurel upon her head,
and she smelled of beauty and sorrow
and of all things lost among the trees.
And, like a dim recollection
of our faded, pagan past,
she slipped into the forests of time and fog.
A legacy that died with honor.

Calming Existence

The sheets wrap around my body
as I fold my arms behind my head
and contemplate the dream.
Mass hysteria, its face like a lover
who vanished without a trace
or a father
who never called to ask how you were.

DANIELLE HAUPTFLEISCH ────────────────

Beginning

Arrogant iris,
sticking her leathery tongue
at you;

Shy, meek periwinkle
smiling bright,
a gentle tinge of blue;

Sweet-smelling lilac
standing tall,
holding bouquets
of perfect, aromatic little faces.

Yet, perhaps brightest
of them all—
the tiny crocus,
breaking through ground,
beginning the spring thaw.

RACHELL BULKA FERENS ———————————————

Heroin

Your skin is so pale
(I guess your pusher had a sale).
You and your goofballs, cocaine, and hash:
You say you're tired of grass.
You'll give everything (including your heart)
just for a little of what you need;
then you say, "Till death do us part."
You end up wanting her all the time.
If you get caught with her,
you'll be fined, or worse.
Won't you give her up now?
Why don't you listen to me anymore?
Once rich, now you're poor.
You're so isolated, so distant;
What happened to your dreams?
Did the monster under your bed make you scream?
You've become a thug.
I can't believe I lost my brother to a drug.

SHAWNA CHAMBERLAIN

Angel Child

Don't want to be an angel child
anymore
Don't want to live anymore
that way
Only their angel child
perfect in their eyes
Not going out
Not talking
Best friends lost
No one understood
She wasn't mad
But the perfect angel child
has flaws
people never see
Her only wish
to dance
with him in the shadows
The walls are closing in
the only person who ever understood
Left a long time ago
gone to the place of forever
Just this once
the angel child wants to be free
imperfect
in her own eyes
no one else's
Angel child

JEN HUBBELL —————————————

Red Roses

Red roses, falling to the ground
The color of blood all around
A vision his mind can't erase
Petals floating gracefully

He never stopped to look
Never took the time
To think about past or future
Now he wonders why he's always alone

He's been out of luck since I first saw him
Now he's in the middle of an ocean, too broken to swim
He killed the ladybug that landed next to him
He killed the chance we had

Black roses, silent on the ground
The stillness of death all around
Petals, drenched with his tears
Thorns, pricking his fears

MEGAN FALSETTA ──────────────

The Flower Necklace

There is a small, wooden box
with a simple clasp.
An antique box,
painted figures on its cover,
little dancers wearing pink and yellow dresses,
frozen in time,
innocent little children.

I open that old box,
its contents few:
a crumpled photograph;
a necklace of flowers, rare and beautiful.
It brought glamour to the wearer.

The necklace calls to me, my hands.
It whispers to me to clasp it around my neck,
its thorns painful, stinging.

I remember those thorns,
spears piercing into soft flesh,
driving their teeth into my neck like vampires,
draining away the life within my veins

but those flowers,
those rare and beautiful flowers
make this body desirable, wanted, loved.
They transform my figure,
my horrid flesh,
baggage attached to bones.

The box's lid holds a mirror.
I look deep into that mirror,
seeing my disfigurement:
wrinkles, scars around my neck,
the price of beauty.

I look away,
putting the flower necklace back,
closing the box,
turning the key in the lock.

I can still feel those thorns,
the cold they bring.
I can still see the mirror, my hated image,
within the circle of my failure.

LEAH WILLCOX————————————————

Condemned Theatre Building

Its dark and empty spaces
 are like a vacant womb of red velvet
 seats with their bottoms folded
 close to their chests like fetuses waiting
 to be entertained—hungry movie-goers
 who sit
 heads
 tilted
 back
 eyes fixated on images that grow and dart
back and forth and back. . . and. . .
 forever will the empty seats
 their dusty velvet cushions
 await rebirth
 in the dark and empty theatre

KELCY KIMMERER

The Bathroom Mirror

An old, cracked mirror
nailed, crooked,
into the rusty yellow tile
of the bathroom wall.
Doubled specks of toothpaste
crusted against crystal.
A human enters the soul of glass,
gives it life,
as if it could remove itself,
walk away.

DESIREE BIRDSALL ————————————

Fog

Falls from the vast night sky,
falls from the tops of forest trees.

Sweeps across the chilled land,
in and out hidden, wondrous caves,
onto the unsuspecting.

Rises from the deepest valleys,
slowly, from warm blades of grass,
rises from hidden mountain peaks.
Rises to heaven.

JENNIFER OLES

Eagle

Pen and ink on paper, 8 1/2" x 5 3/4 "

NATHANIEL SHUTTERS ─────────────

Airplane

I fly through the air,
noisily,
oil streaking my body.
I fly faster and faster
and the wind tries to pull off my wings.
I stall,
I fall and fall,
the earth coming closer, closer.
Suddenly my engine roars,
I flip, escaping death,
earth fading away as I climb
but I stall once more;
powered by failing batteries
I try to land,
the earth coming closer, closer.
I land,
a neat, quick landing,
bruising my nose,
my batteries dead.
I hear voices saying
I barely made it home
and I remember:
I am an airplane,
a small plane,
a model.

ELIZABETH BOWERS

Frost

The frost is on the windowpane
 Its glaze on the mirror.
You stand and look into the eyes
 Of the monster who seems to take over
The bridge where teardrops
 Gain power from the ice
That hangs from the roof of your soul
 Owning answers.
You look outside,
 Your body takes over
The cliff where people fall,
 That exhilaration the mother of bravery.
See yourself in the frost
 Melting and leaving the pane.

JESSE PARMENTIER ——————————————

Delicate

Delicate thoughts
mirror silence,
lingering on what was,
was not,
steal beauty from the shadows
of what could have been,
enjoying our oblivion.

JOHN GALBRETH

Trip

If I were a snowmobile
I would be the most precise snowmobile on earth
my engine purring like a kitten
roaring like a lion
my triple pipes humming
gas flowing
my fox shocks absorbing bumps better
than water sucked in by a sponge
my rear suspension keeping my body
from moving up and down
Traveling many miles
I would whip all competition
enjoying two feet of blowing snow
the groomers out
my headlights bright
I would be happy
wanting to compete
until my driver steers me into a tree
making me scream
weakening me
Knowing my garage waits
I would make my way in the dark
still in one piece
waiting for repair
thankful for sleep

JOHN DOWNEY

The Dance

While dancing
I am touched by the sacred.
My spirits soar,
becoming one with all existence:
I am the lover, the stars, the moon, the beloved;
the winner, the singer, the vanquished, the song.
I am master and student, teacher and slave.
Dancing the dance of creation,
I merge into joy,
I dance,
 dance,
 dance,
and I become the dance.

SARAH RICHELLE ERICSON ─────────────

I Used to Think

I used to think
that someday
I could fly
over the trees,
far beyond the clouds,
singing with birds.
I could touch
the white, cozy clouds;
watch
the earth below;
soar
through the air
like a hawk,
arms opened wide,
feeling the wind.

Now, I know
it was just a dream,
a fantasy;
shot, like a hawk,
out of the sky:
Bang! It falls
in front of me.

And the hawk,
like me,
can never fly again.

BILL BROWN

The Man Who Wasn't Himself

As he lies down
eyes closed
face white as a ghost's
His blood runs dry
He looks at himself
lying quietly
moving to feel his own face
His hand passes through himself
as the lies told
His eyes open and see the truth
They come together
He lies awake
truth found
He dies awake
He dies eyes open

AMANDA CLARK

Ballerina

Round, round,
and round
the ballerina spins.
The music plays
loudly for her,
for her ballerina
dressed in blue.
The ballerina dances
with few
and little moves.
With grace
she spins
on the ice-mirror pond.
The ballerina's eyes
are closed.
Now, she closes hers, too,
spinning
round and round.
They both spin.
At last
the clumsy little girl
stops, discouraged.
The ballerina,
dressed in blue

ABIGAIL MILLER ——————————————

Can You

Do you see the beauty in what I see,
 the breathless grace of a fallen tree?
Can you know the truth I know,
 when I look at the pure snow?
Will you find it in your heart,
 to understand that I will never part?
Can I show you who I am,
 without fear of reprimand?

DANIELLE FULLINGTON

with your cold
hands
you grab my
thoughts
and
squeeze
you steal my
security
and throw it into
oblivion
you invade my
head
without my permis-
sion
and invite your companions to
live
to thrive inside my
brain

CHRISTOPHER DAPKINS ───────────────

Cosmic Click

I am in orbit.
I wait, ponder: to lie or to sit;
to sit and bask in dark, only stars;
to frolic with moon and stars?

I am the eye.
I am the cosmos's optic nerve.
The signal courses through my feet,
cracking the sand,
traveling down, down to the liquid rock.

I am just a probe
the earth sends up, like a tree.
Only difference is, I see.
And I marvel at time.

JENNIFER CLARK

Antique Grave

A weathered barn stands,
Weakened by storms.
Wind blows through it,
Like a breeze through a corpse.
The wood shifts and sighs,
Moans its agony
To the world—
The years gone by,
All it has seen,
Its burden grown heavier
Each day.
The flimsy floors sag
Under the weight of tin roofing,
Old nails.
Rising from the dusty earth,
The barn's monumental stature
Casts a shadowed spell
On roses and weeds alike,
Cascading wooden grief
Over humble blades.
All life pushed out.
Slowly, like time,
The rusted, antique grave
Waits for season's change.

JENNIFER CLARK

Spanish Church

Black and white photograph, 8" x 10"

JASON BROWN

The Range in the Desert

The lizard ran toward its prey,
a man on a horse rode by.

A country taught its conscripts
its unloving intent in the scrawled fire,
the singing protocols
of the quick and dead.
The wounded gunner, his missions done,
fired absently into the sun.
And, chained by outrage, the clerk
sat sweating at his wartime work.
The cold flights bombed again, again,
opening craters below, a lunar plain.
Men were paid for raids
that used up cities, used up states.
Their actions meant nothing
to the deceased and,
at last, the vanquished ceded victory
to their conquerors.
Profit and death grow marginal:
only the mourning and the mourned recall
the wars we love, the wars we win;
and the world is what it has been.

The lizard's tongue licks angrily
the shattered membrane of the fly's wings.

FEDERICO GARCÍA LORCA

Cancion del Jinete

Córdoba.
Lejana y sola.

Jaca negra, luna grande,
y aceitunas en mi alforja.
Aunque sepa los caminos
yo nunca llegare a Cordoba.

Por el llano, por el viento,
jaca negra, luna roja.
La muerte me esta mirando
desde las torres de Cordoba.

/Ay qué camino tan largo!
/Ay mi jaca valerosa!
/Ay qué la muerte me espera
antes de llegar a Cordoba!

Córdoba.
Lejana y sola.

BEN HARNETT, Translator

Song of the Horseman

Cordoba,
distant and alone.

Black horse, wondrous moon;
provisions fill the saddlebag.
They are, these roads, well-known to
 me,
yet never shall I arrive at Cordoba.

Past the plains, through the wind,
black horse, crimson moon.
Death watches over me
from the towers of Cordoba.

What a long road!
Oh, what a valiant horse!
Oh, death, you are watching over me
on the road to Cordoba.

Cordoba, distant and alone.

HIGH-SCHOOL FICTION ————————————

A Song for Elise, and for Me

The sound of waves at the river's end. There, where the river loses herself in the sea. My ears ring still. I close my eyes, I hear the sound, I can sculpt it into waves, steady and loud, all night long. Train tracks, parallel to the river, running with her towards the sea. Trains that drive into the sea. Sound of waves on rocks.

My ears ring still. All the way home. Snow, light but worrisome, dying against my windshield. I am going too fast, faster than my headlights; they follow me illuminating the road behind me while I head into the dark and snow. I am out here. Very far from town. Passing cars, heading the opposite way. They sound like waves as well, coming in, faster and faster, to break suddenly against the road next to me and be gone.

My ears ring still, and I can hear them. The greatest fuckin' band in the world. I treasure this ringing of the ears acquired in the cellar of the guitarist/singer of the greatest fuckin' band in the world. An amazing band in every respect. I am still there. My body jerks still in the grip of the music. I am not going. He is still playing, he has to shout to be heard. The music, a miraculous thing, almost an accident, falls together, spills into my ears. Rips them open as it comes. They ring, still, the music long gone.

How many times did I ride this road down, in the backseat, on family vacations and day trips. The snow falls and it is night and no one leans his head against the window and looks out at the night, so big and black, and thinks not of where we are going. No child in the backseat tonight, no one. Nothing. Only bitter old Ahab here at the helm. Driving into the sea. With a sound of waves on sand.

It is a long drive. Down the river, from song to song, I am younger now, smaller than the piano keys I am caught between, smaller than the song that comes from them. Für Elise. The Beethoven song. Very pretty. For Elise. And who is Elise? What became of her? How I listened to that song. How I made up the mythology of Elise, knowing no more than the music and the two-word title atop the sheet. I imagine her standing atop a cliff in clothes that billow in the wind. She looks down at a European village and a European river that runs across it, through it and beyond, to the edge of all that she sees. Music, remembered, rises through her. A song her piano teacher played for her. She has no head for the playing of music, no fingers for the keys of the piano. But she is passionate in her love for it, and in her love for those who can create and execute it. They are all that she longs to be. They are her idols. She bangs at the piano again and again, distraught that the pure force of her passion is not creating something beautiful. Down the river, from song to song, back on the road now, heading back, back into town.

Underwater. The snow is very thick. His house was almost at the border, so close to the line between the two states. When I arrived there, it was twilight, and I could see nothing on either side of the border. His front lawn. The snow beginning, coming from the other side of the border. Now my car goes, in a dream, a steady drone of wheels swallowing dirty slush and a steady ringing of the ears. Away from the front steps. Towards town. Back from the edge, and into the heart of this familiar state. What have I learned? I know what Elise knew, atop the cliff I made for her.

I lingered too long. It is a silly desire, but I should like to see the stars right now, or the moon, some universal focal point. These starlights, when they come, are sorry

guides. They rise up out of the snowy gloom to announce hope and joy, look, I am here, follow me, and then they are gone in a flash of dirty yellow, and I am alone again. I have nothing to follow. The road, an angry thing, a dead snake thrashing in the mud.

A house. I must be following them back into the haunts of man, into the more civilized portions of the dark. The wide empty dark. A light, in a window, behind a piece of glass. What is it illuminating, and for whom? Darkness lit up is no less repulsive to the mind. I am a poor poet and a poorer musician. I fear that I embarrassed myself tonight when I attempted to play with them. I should not have done that. I should have kept my fine guitar in its fine black case and just sat there, enjoying the music. I should not have insulted it. Inextricably tied up, caught in the strings, chained to my inexperience. My choppy amateur chords. Oh, hell. It is in the backseat now, and I cannot apologize enough to it. It deserves so much better. I am not such a bad player. It is possible that I was merely nervous.

It is in the backseat now. And what if I were to turn this thing down some road I have never passed before, and drive to its end, and hid with it in a barn until the snow all melts, eating nothing, never sleeping, until spring comes if necessary, playing and playing? For months and months, never stopping. So when I emerge and greet again the night (it will be a cloudless night and there will be stars, yes, stars and a fat full moon to see me), I will be a truly good player.

Leaving his house, for a few brief moments, I was lost. I turned down some strange road, and then another, and found myself among so many alien sights that I turned around and went back and started over. It was so odd to feel such a complete loss of all bearings, streets and houses that all looked so foreign that they could not be of any help to me at all.

There are no longer any cars out here. They have all decided to remain where they are. The news of the storm has frightened all of them back into garages, dens, warm lairs. I am the only one out, above the clouds, under the river. Her bed is warm and comforting to a weary traveler. These woods, like the woods in a poem, snowy and dark. All the monsters gone. The werewolves all asleep. It would be very easy to get out and bed down beneath pine trees and sleep. Their thick evergreen arms keeping the snow from my face. It would be very easy, among the pine needles and quiet, to dream that music back together again. To be there again, in his cellar. I could start from the ringing of my ears, that bare rudiment that is all that remains to me now. From these I could slowly reassemble that hallowed cacophony. It would take some time. But this night will last a very long time. It can last me as long as it takes. It would be so easy. Under the clouds still pouring down snow. And once the music was rebuilt, the song in my arms again, what need would there be to wake up? I could sleep forever in the arms of such a thing.

The greatest fuckin' band in the world. I am, so they told me, the second person in the world to hear them. They played me their entire catalogue of six songs. And such good songs they were. Some day they will sit on a stadium stage and look out at the seething masses of the tens of thousands of humans that have gathered to hear them play. Although such a concert would, I am sure, disgust them. Every one of those people at that concert that they would never play, every one, will drive all the way home that night, a snowy night, treasuring the ringing of the ears that they now have, something real, given by the greatest fuckin' band in the world directly to them. They will all feel what I am feeling now. Why does it seem so peculiar to me? No one could hear them and not believe that they are the greatest. I know this. They are that good.

Elise. She is going somewhere. She cannot remain too long. Her passion is untempered, and on that cliff the music almost breaks her, so strongly does she recall it. It is everything. She remembers it all so fondly, the sound of it, played for her alone. By him, her wonderful teacher. I see her at the highway's edge in clothes that billow in the snowy wind. But she does not see me. Blinded by her love. She is too busy there at the highway's edge, eyes closed. Hearing the descending chords still ringing in her ears. The chords that he played for her. She has such love and respect for him, player and creator. All that she longs to be. She can't see anything. Faster the snow, faster I drive. It all comes down.

I must be drawing closer to town now; I can hear a train's whistle. It is the same pitch as this ringing. They blend into one sound. It is going in the same direction. Down on the tracks, parallel to the river. Going with her. So close. The snow falling on the steel and the frozen edge of the river. Into her raw-gut middle, where the water still flows towards the sea. Covering the choked edges. The train speeds by, and people locked inside stare out at the snow falling into the water. They are going in the same direction as I am. Sound of the water, when it has all gone, what ringing it will leave. That time that I stood beside the rails and, after the passenger train passed, how the rails still hummed in its wake. Residue of sound. Residue of something huge and implacable. The impossibility of struggling. Struck me on the head, dragged me down. Bolts, chains, great iron wheels...something so big and powerful, something like music. Something like a train. I hear it all, she heard it, Elise, at the edge. The ties sprinkled with sand and coal. Freight trains. Huge and implacable. Run over. Caught beneath those wheels. The bolts and chains and the black sweaty iron. We, she and I, run over. And the train still moving, shrinking into the distance, its refrain diminishing. And as we lie dying, run over by that train, we hear still a ringing in our ears, and the tracks still hum after the train's passing.

A van, a sign of human life at last, came up behind me and swung around me, passing me as we flew around another curve. A jackal laughing into the dark in front of me. And eyes in her walls staring out of membranes of drug-induced lunacy, stupidity, seeing me. Those eyes, so awful to behold. They left quickly, mercifully, for to stare too long at them would drive all the warmth from me. Leering masks of death, living death. Not dead. Rolling towards death. So am I, but the waters they are drowning in prevent them from seeing it.

It was a very long way to his house. Almost to the border. I could find it again now. The river again, and the train tracks beside it, going together from his front door to the sea. Across all of the borders, in all directions, off the ground, underwater, in a dream. My ears ring still—in the morning they will not ring any more. I will have lost that. The train will have vanished entirely. All this land, dark, divided up by day into states and nations. In the dark, I cannot see any of it now. I must trust what I learned long ago. I am driving away from no border. The states are gone. The nation never existed. This night is all. This snow will never stop. This dream will not end. Underwater still, sounds reach us, train whistles, human voices, music. The ears ring still, remembering what we may have heard.

NICK SWIFT

The Apple Orchard

It was undoubtedly the most beautiful day of the year. The wind was slowly blowing through the trees, making their branches bend slightly. The sun was shining down, not with the immense heat it is capable of, but with gentle rays. Usually the sun was hidden by clouds, but today it was blue. Summer was at her peak; her beauty would fade, beginning tomorrow. Boston seemed to be green, the brightest green that its citizens would ever see.

Teddy was strapped into the back seat of the jeep, next to his sister, two years his junior. Teddy tried to read his book of poetry, a birthday gift, but he felt carsick. He wasn't very disappointed; he didn't have a high regard for poetry, anyway. He passed the time watching the scenery whip by. The jeep was new, and still had that "new car" smell. Playing with her parents' camera, his sister seemed to be in a deep trance. They had removed the film, and despite the camera's value, allowed her to play with it. She pretended to capture the scenery, knowing that the pictures would never be put into a photo album.

Their parents ignored the children; they carried on an intense conversation about modern teaching methods. Teddy's father was a professor at Boston College, where he taught English courses, mostly literature and creative writing. His mother taught English at a local high school, the very one that Teddy and his sister would attend one day. Teddy's father was writing a novel dealing with some adolescent boy and his views.

The conversation between his mother and father concerned the lack of effort that their students put into their work. Excepting his wife, Teddy's father talked angrily of high-school teachers who didn't prepare students for college. Teddy's mother took offense at that, and they dropped the subject. They tried to talk about the weather.

Teddy longed to write in his journal, a habit his parents had encouraged some years ago. Knowing that writing would make him sick, he asked his parents how long it would take to reach their destination. They estimated that they would arrive in an hour. Teddy watched the scenery. He noticed that buildings were slowly being replaced by trees. Then the trees ruled, and there was not a building in sight. They would soon be there. He remembered that the last time they went to the garden there was not a single person there besides Teddy and his family. Teddy wondered why people would not take the opportunity to visit such a beautiful garden.

The best part was the orchard; Teddy could run around without fear of destroying a *valuable* flower. He remembered climbing the trees, despite constant pleading from his parents. When they arrived, he would leave his parents' side, and try to find Mr. Adams. Mr. Adams was responsible for the upkeep of the garden, and he had no help. Despite the time-consuming task, he always found time to play with Teddy. Teddy wondered why he had never seen any other staff. It worried him, and he became anxious with questions. When he asked his parents about the staffing, they simply ignored him. He did not know whether this was intentional, but didn't bother asking again, just in case.

His parents must have been absent-minded this morning, because they dressed him in his white New York City T-shirt. He remembered their last visit, when he came

home with grass stains on all his clothing. He didn't bother to remind them, as he feared it would lead to numerous warnings and restrictions.

When they finally arrived, the scene was identical to the last time. There was only one other car in the parking lot, and Teddy guessed it belonged to Mr. Adams. It was a white car, the brand unknown to Teddy. It looked new, and Teddy was surprised that Mr. Adams would be able to afford such a vehicle. They walked across the parking lot, through the heat. It was a long walk, and Teddy was curious as to why his parents did not park closer. Again, he didn't bother commenting, not wanting to ruin the day. The gate that guarded the garden was open, and they walked through. It was a large, metal gate, with thick, steel bars, and it must have been three times Teddy's height. The gate seemed senseless if there was no charge to enter.

They continued walking and saw no one else. Teddy's parents admired the flowers, which were of various colors. They lined the gate and spread for acres within the gates. In what must have been the center of the garden, there was a large marble fountain, a statue of an older man, with a young boy standing on the man's knee. The boy seemed to be urinating, but water excreted, instead.

Teddy began to run towards the trees in the distance but was halted by his father. He informed Teddy that he should not be wandering off again, but they would stay together, as a family. Teddy thought this a great injustice, but considering the mood of his father, he obeyed.

It seemed like hours before they were even remotely close to the orchard. Although the flowers were breathtaking, Teddy longed to climb the trees and throw apples. He knew it would not be allowed. He wondered if Mr. Adams would recognize him. He knew that he would recognize Mr. Adams; he could not be mistaken for anyone else. His white hair peeked from the sides of his dark blue hat. His face was full of wrinkles, and his nose was larger than normal. His hands had more hair than Teddy would have liked, but they were the hands of a loving man. Teddy thought he must have been nine hundred years old but knew that to be impossible.

When they finally reached the orchard, Teddy ran around, and his parents didn't restrict him except for a few warning calls when he was out of sight. He climbed the trees and threw apples but couldn't see Mr. Adams, even from such a great height. He threw apples against the gate and watched them smash, their juices running down into the dirt. The now-wet soil looked worn and tired. He felt bad about that and, after the seventh apple, stopped.

He wandered to a stream that he did not recognize. He followed it for a distance. It broke off into four branches, the water splashing slowly and harmoniously against the rocks. The water never turned white, but remained clear: Teddy could see the life that it held. The fish and frogs and salamanders seemed infinite in number. He tried to catch a fish, but failed, and decided to continue along the river's edge. He came upon a large mound of dirt, which looked as if it had been placed there not long ago. The pile was larger than Teddy himself, perhaps even bigger than his father. The pile spooked Teddy, but he felt strangely attracted to it. Despite his urge to play on the dirt, he resisted and moved on. He was curious to see where the river crossed the gate. But despite the long time walking, he didn't even see the gate, which should have been visible from a great distance. Teddy gave up on that idea and turned back, toward his parents. He knew that they would be angry if he was gone much longer. When he reached the point where the river divided into its four parts, he saw a man near one of the apple trees.

Teddy hurried to the man, and when he reached him, called his name. He said it softly, so as not to startle the old man. But when the man turned around, he was not Mr. Adams, at all. He was much younger, but he seemed just as friendly as Mr. Adams, and Teddy asked, "Have you seen Mr. Adams?"

The man responded in a nice tone. "No, Son, I'm sorry. Mr. Adams left us more than three months ago."

Teddy had no response, other than a sigh.

"Can I help you?" The man asked. He continued to dig around the roots of a tree as he spoke. Mr. Adams always stopped to talk. The young man picked an apple from the ground and ate it as he talked. Juice dribbled out of his mouth, and a piece of apple fell.

"No," Teddy told him. "What's your name?

"Seth."

"Hi, Seth," Teddy said, his spirits lifting, "my name is Teddy."

"Well, it's nice to make your acquaintance."

They talked for a while, and Teddy told the man that he had to leave to meet his parents.

When he finally reached his mother and father, he realized that they hadn't even noticed his absence. They walked together, among the apple trees, as his sister snapped pictures of each one. She never ran out of film, and kept snapping.

They all reached two trees that seemed different from any of the others; taller, they had a great deal of space around them. It was as if they were the rulers of the orchard. Standing in the middle of the two trees was Seth, who must have hurried here, as it was a good distance from where Teddy had seen him just a short time ago. His parents, admiring the tree on the right, seemed not to notice Seth. Teddy climbed the tree on the left, talking to Seth as he climbed. Teddy had only climbed a few branches, when his parents summoned him. He took an apple and threw it at his sister, not out of malice, but in a playful way. His father scolded him for endangering the camera and didn't seem the least bit worried about his sister. Teddy came down quickly, expecting the reprimand to continue, but it didn't.

His parents asked Teddy to climb the right-hand tree to retrieve a few apples. Teddy was glad for the chance to climb, but he liked the other tree better. He grabbed a couple of apples and noticed that every apple looked perfect. In fact, he could not find one with a defect. He climbed back down, and each member of his family bit into an apple, as Seth watched from a distance.

His sister was indifferent to the taste. But his parents were shocked: they had never tasted apples so delicious. They continued to eat, picking others before they finished their first ones. But Teddy could not understand his parents' joy. He thought the apple was disgusting, and quickly spit out the chewed portion. His parents became angry and forced him to try another. Again, he spit out the chewed portion and hacked in disgust. His parents stopped their busy tasting and tried to force another apple into his mouth. He refused and sat on the ground. They would not stop harassing him, and he ran. He still had both apples he had tried, one in each hand.

He took one and threw it at the gate, but it did not smash as before. It stuck between two bars. Disappointed at the results, he threw another. It too stuck between two bars. He was very surprised. He turned back to the tree. What he saw astounded him.

Both of his parents, and his sister, were in the tree, picking all the apples they could. His mother, in a dress, was climbing higher and higher, in a desperate search. They seemed obsessed with the fruit. Teddy looked at the base of the tree and saw Seth standing there. He was staring up, with a great smile on his face as Teddy's family collected as many apples as they cold carry.

Teddy stood for only a moment, then turned and ran toward the parking lot. He ran out of the orchard, through the great garden of flowers. Each flower seemed contemptuous of his radical decision. They all seemed to question his loyalty. He continued running. He ran through the gate and tripped over a branch. How the branch came to be there, he did not know. It was not there when he and his family entered the garden. He fell on the black pavement, skinning his knees. He stood up quickly and ran again, across the parking lot, the blacktop hot under his feet. When he reached the jeep, he was denied entrance, as the doors were locked. He slumped against a tire, noticing that his shirt had numerous grass stains. He violently ripped off his shirt and threw it underneath the jeep, disgusted by its appearance.

KATIE KEARNEY

selection from Seizing the Seakhawk, *a proposed sequel to*
The True Confessions of Charlotte Doyle *by Avi*

There was a sputtering of bubbles as Captain Jaggery burst up, out of the waves, cursing all the while. He looked for his ship, and when he saw it, he didn't try to call out. That dang-blasted crew, he thought, grabbing a piece of driftwood. The ship sailed into the setting sun.

Now, only one night had passed and the captain was shivering from cold. He was about to give up when he saw another ship coming his way. Captain Jaggery thought, at first, that he was hallucinating but, like a mighty beast rising with the dawn, the ship came. He thought about letting go of the board, swimming for the ship, screaming, but he knew that sooner or later his arms and legs would give out.

It seemed like an eternity before the ship came near enough for Jaggery to yell and wave. They heard him and the helmsman changed course to intercept him.

The ship was almost twice the size of the Seahawk and the bowsprit had an eagle with two heads on it. Each time the ship dipped into the waves, both eagles surfaced with foam in their beaks, as if they were mad. As the ship hove closer, Jaggery could

The ship approached Jaggery and he swam for it. The men on board threw him a rope. When the crew was sure that he held the rope, they pulled Jaggery up. So as not to draw suspicion, Jaggery made up a story to tell the sailors and the captain of the Double Eagle:

> He was the captain of a small fishing vessel that had gone
> too far out to sea. The crew were not very experienced sailors
> and instead of taking the boat back to shore, they had only
> brought the vessel further out to sea. One day, the helmsman
> fell, exhausted, at the wheel and lost control of the craft.
> Before they could regain control, the ship had crashed into
> a large rock. With the vessel taking on water, they had to
> do something fast, but all their efforts lead them nowhere.
> When at last they gave up, Captain "Schmitt" put all his
> crewmen into lifeboats, waiting until everyone was safe. But
> there was no room for him. Instead of insisting that the crew
> *make* room for him, "Schmitt" jumped into the cold, dark sea.
> He never saw his crew again, but the board he was holding
> looked like a piece of wood from one of his lifeboats.

The crew of the Double Eagle believed this story and they took Jaggery, now called Schmitt, back to the United States and on many other voyages before they caught up with the Seahawk.

Charlotte stood on the deck of the Seahawk as it pulled up to a pier on the shores of beautiful Scotland, on the island of Hebrides. The trip had been uneventful, with the

exception of a few minor storms. Charlotte had gone on many a voyage since she last saw her family, and she missed them very much, but she also knew what they probably thought of her, and she decided to go home when this voyage ended. She would need a gift for her mother to appease her and distract her from the fact that Charlotte had become a sailor.

In awe, she stared at the ship they had docked near. It was almost twice the size of the Seahawk and its name, the Double Eagle, fit the bowsprit well. One of the men on the ship seemed familiar, but he walked away before Charlotte could get a good look at him.

After the crew of the Seahawk unloaded their cargo, they had shore leave; they would see some of beautiful Scotland. Charlotte went into the city, instead, to buy her mother's gift.

While she stood, looking into shop windows, Charlotte noticed someone staring at her from the alley way. He looked like the man from the Double Eagle. Before Charlotte could confront him, he disappeared.

While buying her mother a wonderful Scottish bracelet made in the year 1621 in the Highlands, in a city called Glenfinnan, Charlotte forgot the man in the alley. The bracelet was a gold band, with gems pressed into its gold.

When Charlotte returned to the ship, she saw strange men on the deck. She also saw that the Seahawk's men were gathered in a group apart from the strangers. When they noticed her, they called her over and told her their situation. The six strange men wanted to sign on, but the crew had grown used to each other and didn't want anyone else to join them. Their vote had ended in a tie, so Charlotte was asked to cast the deciding vote. After much consideration, Charlotte voted to have the men sign on.

There were two Scotmen, one American, one Englishman, one Frenchman, and one Swede. The two Scotsmen were Kurgan MacKinnon, who appeared as big as a house and Duncan MacLeod, who was big, too, and had long, dark hair and mysterious, dark brown eyes. The American was Richard Ryan, who looked to be about 24, with dirty blond hair and kind brown eyes. the Swede was David Yist, who looked like Richard, except that he seemed younger and was scrawnier and he had a strange look about him, as if he was always angry. The Englishman was Hugh Fitzcairn, who seemed to like his drink a little too much, and had wild dark hair. The Frenchman, Pierre Noel, was almost as big as MacKinnon.

That night, Jaggery sneaked onto the Seahawk. He tried to convince the new men to mutiny. When only McKinnon and Noel agreed, Jaggery, in a rage, went on a shooting spree. The crew, hearing gunfire, came to Charlotte and the others' rescue.

CONTRIBUTORS

MEGAN ALICINO, Cooperstown, completed her junior year at Cooperstown Central School in June, 1997. She is a journalist for the school newspaper and is involved in Cooperstown's Exceptionally Talented and Creative program. She has been writing for as long as she can remember. Her hobbies are soccer, tennis, and drawing.

NICK ALICINO, Cooperstown, has long been involved in the study of the writing of poetry. While teaching English at Cooperstown Central School for the past sixteen years, he has encouraged and helped students with their own writing. Most recently, he organized a community "open mike" series.

LORI ANDERSON, Albany, earned her MFA at the Iowa Writers Workshop. She has two collections of poetry, *Cultivating Excess* (Eighth Mountain Press) and *Walking the Dead* (Heaven Bone Press). She teaches at Skidmore College.

AARON BEATTY is a junior English and psychology major at Hartwick College in Oneonta. He loves writing and would like to thank Mom, Dad, Kat, Adam, Elizabeth, Alycyn, Eric, Jackie, and Steve (just to name a few) for all their love and support.

CAROLYN BENNETT, for most of her adulthood, has led a literary life as editor, publisher, book designer, poet, short-story writer, and journalist. Chapbooks of her poetry were published by Slow Motion Press and Outland Books. *A Thing Among Things*, her first collection of short fiction, was published in 1993 by Birch Brook Press. She is the Director/Curator of the Zadock Pratt Museum.

ROBERT BENSEN, Oneonta, is Director of Writing at Hartwick College in Oneonta. The winner of the Robert Penn Warren Award in 1995, he also received a National Endowment for the Arts poetry fellowship in 1996.

CASSIA BERMAN, Woodstock, is a poet (*Divine Mother Within Me*) who has been living in the Woodstock area since 1980. During the 1970s she was active in the New York City poetry world. She also writes on the intersection of spirituality, the arts, and everyday life for national and local publications, edits, and teaches t'ai chi, qi gong, and workshops on the Divine Feminine.

HOLLY BEYE, Woodstock, is best known for her wildly farcical satiric dramas, *Cats Meow*, recently done at LaMama La Galleria, and *Clean. . .*, in this summer's Extended Arts Festival, in the City. She is founder, producer, and actor with Holly's Comets in Woodstock.

DESIREE BIRDSALL, Davenport, completed her freshman year at Delaware Academy in Delhi in June, 1997. She started writing poetry in the sixth grade as an assignment and progressed from there. In her spare time, she likes to swim, play volleyball, read novels, and just have fun.

PEGANNE BLASK, Cooperstown, was born and reared in San Antonio, TX. She graduated from the University of Arizona in 1990 with a BFA, emphasizing her interests in photography and fibers. The following summer, she accompanied her husband to Cooperstown, where they reside and where she continues her roles as wife and mother while teaching, writing, and taking photographs.

DOROTHY BLOOM, Oneonta, grew up in Minneapolis, studied English and history at the University of Minnesota, married a veteran, bore children, always wanted to spend quality time with a typewriter. Her fiction is the result of this on-again, off-again relationship that has weathered the storms and successes of life with Harry Bloom and their five children.

HARRY BLOOM was educated in Minneapolis and received BA and MA degrees from the University of Minnesota. He did further graduate study at UC Berkeley, became a high-school English teacher, and wrote a novel, *Sorrow Laughs*, published in 1957. Harry cherished literature and other arts as transcendent and mysteriously significant, but though he liked to regard himself as a writer, it was his teaching that he believed had real value, and it was surely his teaching that former students hold tenderly in their memories.

ELIZABETH BOWERS, Cooperstown, completed her freshman year at Cooperstown Central School in June, 1997. She loves writing poetry and fiction. She is honored to be published in the anthology, although this is not her favorite poem. She wishes to congratulate all who are published.

MAUREEN BRADY's fiction and nonfiction works include *Folly, Give Me Your Good Ear*, and *The Question She Put to Herself*. A resident of Mt. Tremper and Manhattan, she has received grants from the Ludwig Vogelstein Fdn., the Barbara Deming Memorial Fund, and others; and has been a fellow at The MacDowell Colony and Villa Montalvo.

CHARLES BREMER's recent work in black-and-white photography explores the relationship of the human body to common objects. He works outdoors with a dark backdrop; the images in this new series focus on tools to control the landscape. His wife, Martha, has served as his principal model for twenty-five years. He lives with his family in Otego.

DORIS BROSNAN, Sidney, was born in New York City. She holds a BA in Psychology from CUNY, and a MSED from SUCO. Inspired by the community of writers in the Catskills, Doris experiences writing as dancing the words, but also as a challenging maze of decisions. She is a language-arts teacher and reading specialist on the elementary level, and she loves kids.

BILL BROWN, New Berlin, completed his freshman year at Unadilla Valley Central School in June, 1997. This is the first year he has written poetry. His teacher, Robin Solomon, has greatly helped him with his writing. His favorite poet is Sylvia Plath.

JASON BROWN, Laurens, completed his freshman year at Laurens Central School in June, 1997. He has been writing poetry since fifth grade. He loves to play baseball.

REBECCA BURK, Hartwick, is a student at Cooperstown Central School.

STEPHANIE BUSSMANN, Cooperstown, completed her sophomore year at Cooperstown Central School in June, 1997. She began writing after her freshman English teacher, Mr. Alicino, opened the doors to the literary world for her. She enjoys traveling and photographing anything outdoors.

CHRISTOPHER BUSSMANN, Cooperstown, graduated from Cooperstown Central School in 1997. He has been writing since he was a freshman.

ALAN CATLIN, Schenectady, has been publishing poetry and fiction for more than twenty years. His most recent chapbooks are *The Terminal Beach at Sunset* (UBP), the award-winning *Black and White in Color* (Mississenewa Press), and *Shelley and the Romantics* (Adastra Press).

PEG CAWLEY, Maryland, a self-taught photographer, prefers black and white so she can control the final print in her makeshift darkroom, especially pursuing form in architecture and reflections of nature. Under her other hats she is Professor Emeritus of Music, SUNY, Oneonta and a letterpress printer.

SHAWNA CHAMBERLAIN, Jefferson, is sixteen years old. Her hobbies are writing, hanging out with her closest friends, and playing basketball.

AMANDA CLARK, Jefferson, completed her sophomore year at Jefferson Central School in June, 1997.

JENNIFER CLARK, Cooperstown, graduated from Cooperstown Central School in 1997. She will attend Vassar College in the fall to study liberal arts. She has been studying photography for four years and writing for three.

ARTHUR L. CLEMENTS, Vestal, teaches at SUNY Binghamton. His book of poems, *Common Blessings* (Lincoln Springs), received the American Literary Translators Association Award for translation into Italian and publication in a bilingual edition, *Benedizioni Comuni.*

SUSAN DEER CLOUD CLEMENTS, Vestal, is a prize-winning writer who has had numerous poems and stories published in anthologies and journals. Her two books are *The Broken Hoop* and *In the Moon When the Deer Lose Their Horns.* She is a 1993 recipient of a NYFA Fellowship.

STEVE CLORFEINE, Wallkill, has written and adapted texts for performance—original theater pieces, poetry readings, interdisciplinary collaborations—since 1978. He has performed and taught workshops throughout the U.S. and Europe and regularly teaches writing and theater residencies in public schools. He was a member of Meredith Monk's Company, The House (1975-86).

COURTNEY COLANDO, Pine Hill, completed her sophomore year at Margaretville Central School in June, 1997; she has been writing since she was ten. Other than writing she enjoys expressing herself in painting and photography.

CRYSTAL COLANTUONO, Jefferson, is seventeen. She has been writing since the fifth grade. She is somewhat eccentric, believing in witchcraft. Her poetry has appeared in *Gallery of Artistry.*

JENNIFER COLLETTI, Milford, completed her sophomore year at Cooperstown Central School in June, 1997. She lives in the country outside the village. She has been writing since she was in elementary school, and it is the thing she loves most to do. She plans to continue writing as her career after high school.

NANCY VIEIRA COUTO's poetry collection, *The Face in the Water,* was published in 1990 by the University of Pittsburgh Press. Her poems have appeared in such magazines and anthologies as the *Black Warrior Review, The Gettysburg Review, Salamander,* and *The Pittsburgh Book of Contemporary American Poetry.*

LEAH DAIGLE, a seventeen-year-old high-school senior, lives in Rotterdam. She has been writing since she was in the fifth grade. Her first poem was published when she was eleven years old. Her hobbies, besides writing, are reading, drawing, and listening to music.

DAVID DALTON, while writing the story in this collection for his son, Toby, found use at last for years of forced labor on Greek irregular verbs and mythological bric-a-brac. He lives in Delhi with his wife, the painter, belle-lettrist, and dropout, Coco Pekelis.

ENID DAME is a poet, writer, and teacher living in High Falls and Brooklyn. She teaches writing at New Jersey Institute of Technology and co-edits *Home Planet News* with Donald Lev. A poem of hers was co-winner in the 1997 Many Mountains Moving Poetry Competition.

DANIELLE DART, Jefferson, completed her sophomore year at Jefferson Central School in June, 1997. Her influences are Courtney Love, Jimi Hendricks, and William Shakespeare. Her hobbies are horseback riding and playing guitar.

MARJORIE DEFAZIO, Unadilla, has written and directed for TV, radio, and the stage. With Anne Brady, she compiled and edited *Raising Our Voices, Women Up Through the Ages,* a selection of poetry about women, by women. Her published work includes a book of her poetry, *A Quiet Noise.* For more than a decade, she was a theater critic in New York.

LOUISE BUDDE DELAURENTIS, Ithaca, has been publishing her poetry since 1963. In 1995, she published a chapbook of previously published poems titled *Traveling to the Goddess.*

REBECCA DEMULDER-MIETZELFELD, Unadilla, is a visual artist, arts educator, and writer. She is a founding member of The Wild Women Artists' Collective and Art ConnX. Her paintings, assemblages, and collaborative installations have been widely viewed across New York State. She lives in the Catskill foothills with one husband, two kids, two cats, and two dogs.

JOHN DOWNEY, Otego, completed his sophomore year at Unatego High School in June, 1997. John was born in New York City and moved to Otego seven years ago. He dreams of becoming a sportscaster.

RICHARD DOWNEY, Otego, is a retired New York City teacher, currently employed as a "Mr. Mom." When the kids are in bed, he escapes to the word processor to continue writing his book. Problems of point of view and how to fling the hero further into the abyss seem easier after trying to resolve the argument started because "he looked at me."

GRAHAM DUNCAN's poems have been published in over ninety periodicals and have been frequently anthologized. Poems are forthcoming in *The Comstock Review, Newsletter Inago, Pivot, Rag Mag,* and a dozen other places. He lives in Oneonta.

MOIRA DWYER is a high-school student from Cooperstown. She is currently studying poetry with Nicholas Alicino, a revered English teacher, in the Exceptionally Talented and Creative program at Cooperstown Central School.

FRANK C. ECKMAIR, Gilbertsville, printmaker and papermaker, has had his works appear in numerous collections in the U.S. and from England to Tokyo. He has built hand papermaking mills on several continents. He has organized exhibits and written catalogues for GANYS. His most recent book, *Houses of Memory* (wood engravings), was published in 1996 by Caliban Press.

BOB ENGSTROM-HEG, Oneonta, is a retired fisheries biologist. He grew up in western Washington and was a sailor in WWII. He is a poet and storyteller (member of the Storytelling Center of Oneonta). His poetry has appeared in *The Christian Century, The Other Side, Midwest Poetry Review, Lucidity,* and other journals.

SARAH RICHELLE ERICSON, Jefferson, completed her junior year at Jefferson Central School in June, 1997. Her interests include participating in sports, especially soccer, and music. She is very fond of writing poetry. She finds it quite relaxing.

ALF EVERS, Woodstock, was born in New York City on February 2, 1905. He attended high school in New Paltz. He spent one year at Hamilton College and two years at the Arts Students League, New York City. He has authored many books, including *The Catskills From Wilderness to Woodstock, Woodstock: History of an American Town,* and *In Catskill Country.*

MEGAN FALSETTA, Laurens, who completed her freshman year at Laurens Central School in June, 1997,

was born April 30, 1982. She has been writing poetry since elementary school. Her favorite author is Dean Koontz.

MARGOT FARRINGTON, Treadwell and Brooklyn, is the author of *Rising And Falling* (Warthog Press). For four years she was Executive Director of Poets For City Schools in New York City, and worked with Alternative Literary Programs upstate. She has published and performed her work since the early 1970s.

RACHELL BULKA FERENS, Summit, who completed her freshman year at Jefferson Central School in June, 1997, has been writing poetry and songs for four years. She enjoys playing her guitar and listening to Nine Inch Nails and Marilyn Manson.

ALLEN C. FISCHER, Saugerties and Brooklyn, brings to poetry a background in business where he was director of marketing for a large corporate travel firm. His poems have appeared in *American Literary Review, Indiana Review, Pivot, Poetry, Poetry Northwest, Prairie Schooner,* and other journals.

SALLY FISHER, West Delhi and Manhattan, has published poems in *Field, New Directions, Poetry East, Chelsea, Tar River Poetry,* and other magazines and anthologies. Her book about art, *The Square Halo,* was published by Harry N. Abrams in 1995. She has worked for The Metropolitan Museum of Art since 1977, both on the staff and as a free-lance writer and editor.

ERNEST M. FISHMAN, Treadwell, lives in an old farmhouse between West Delhi and Treadwell. He writes fictional accounts about real people and true stories about imagined characters and events.

PETER FORTUNATO is the author of two poetry collections and the winner of several prizes for his work, including the 1990 Ruth Lake Memorial Award for the poem "Smilin' Jack." He is married to the poet Mary Gilliland, and lives with her in Ithaca, where he maintains a counseling and healing practice. He is currently at work on a novel about growing up as an Italian American in the Hudson Valley.

THEA FOTIU, Cooperstown, attended Hartwick College, where she studied fine arts and poetry. She is currently attending the State University at Oneonta to receive a Bachelor's Degree in Studio Arts. This is her first publication.

BETTY ANN FRALEY, Oneonta, teaches costume design and construction at SUNY Oneonta, where she is also the resident costume designer. She is an artist and writer living in the country with her dog, Molly, and two cats. Her painting and writing have been published in numerous magazines and books.

CAROL FROST, Otego, has published six books of poems, including *Chimera* and *Liar's Dice,* both of which were widely praised. Born and raised in New England, she is currently writer-in-residence at Hartwick College in Oneonta. Her most recent books are *Pure* and *Venus and Don Juan* (TriQuarterly Books/Northwestern University Press).

RICHARD FROST, Otego, has published three books of poems : *The Circus Villains, Getting Drunk with the Birds* (Ohio University Press), and *Neighbor Blood* (Sarabande Books). He won the Poetry Society of America's Gustav Davidson Memorial Award and has held a CAPS fellowship and an NEA creative writing fellowship. Frost is a working jazz drummer and is Professor of English at SUCO.

DANIELLE FULLINGTON, Stamford, completed her sophomore year at Stamford Central School in June, 1997. In her spare time, she enjoys listening to many different types of music, reading, going to concerts, and biking. She also likes to write stories and poetry.

JOHN GALBRETH, Laurens, completed his freshman year at Laurens Central School in June, 1997. He en-

joys snowmobiling and watching stockcar races.

NICHOLAS GARELICK, a 1997 graduate of Delaware Academy in Delhi, lives on Federal Hill II, just outside Delhi. He has always been interested in art and will be attending Fredonia State, where he will be majoring in illustration and graphic design.

MARY GILLILAND was born in Philadelphia, grew up in the New Jersey suburbs, and attended Cornell University, where she is a Senior Lecturer in the Writing Program. She has studied carpentry and Zen Buddhism. She lives in Ithaca, in the Finger Lakes Region. Her poetry, essays, and translations of modern Greek poetry have appeared in magazines and have been anthologized.

PIERO GIOIA, Walton, was born in Queens on December 2, 1972. He attended Hobart and William Smith Colleges in Geneva, where he studied art history and studio art. His work focuses on the concept of chiaroscuro, creating the contrast of light and dark. He mainly uses charcoal or oil sticks to create his impression of chiaroscuro.

MARY GREENE's work has appeared in a number of small magazines, including *Sojourner* and *First Intensity.* Her chapbook, *Where You're Going in this Dream,* was published in 1993. She lives in Narrowsburg, where she writes for a local newspaper and teaches writing to children and adults.

CHRISTOPHER RAE GREENLEY, Delhi, has been published in his school creative writing magazine. A 1997 graduate of Delaware Academy in Delhi, he will be going into the United States Army. Aside from poetry, he has several novels floating around in his head.

LOUISE GRIECO's work has appeared in *Blueline, Lyric,* and other journals, and will soon appear in *Thirteenth Moon.* She has given readings in and around the Capital District, and recently completed the New York State Writers Institute Poetry Workshop with John Montague. She raised her family—two kids, many poems—in Albany. The kids have grown and gone their own way; so have the poems.

STEPHANIE S. HAGOKORE, Highmount, is a junior at Margaretville Central School. She enjoys movies and concerts and four-wheeler bike riding.

BEN HARNETT lives in the town of Cherry Valley. He is a 1997 graduate of Cherry Valley Central School. He has been studying Spanish outside of school for a year. He enjoys reading all types of literature, painting and sketching, and listening to classical music.

LISA HARRIS, Trumansburg, won Bright Hill Press's 1996 Fiction Award for *Low Country Stories* and has been a two-time recipient of a Constance Saltonstall Residency for Fiction, was a finalist in *Nimrod's* 1997 Katherine Anne Porter fiction contest for her short story "Splitting Sticks and Lifting Stones."

DREW HARTY, Treadwell, is fascinated by the illusions created by light in the shifting patterns of soil, rocks and water. They seem to him a window he can look through into a place he can never fully know. With the camera, he is an explorer whose challenge is to discover the next successful composition from the patterns of light.

DANIELLE HAUPTFLEISCH, Franklin, completed her sophomore year at Delaware Academy in Delhi in June, 1997. She first started writing poetry at the age of nine. She is very grateful to her family, especially her father, for helping and supporting her as she develops her writing ability.

ANDREA HAZLETT grew up in Treadwell with her parents and younger brother. She attended A.L. Kellogg Elementary School and Delaware Academy in Delhi. In high school she enjoyed hockey, basketball, and volunteering. She is now majoring in physical therapy at Daemen College in Amherst. She plans on obtaining a

masters degree in physical therapy.

RICHARD HENSON, Margaretville, is a Professor Emeritus of Philosophy at Rutgers University; he also taught at Swarthmore, Cornell, Utah, and Michigan. He has published in professional journals on ethics, philosophy of language, etc. He is married to Amie Brockway of Open Eye Theater in the Catskills, for whom he writes, directs music, gofers, and enacts many characters.

MIKHAIL HOROWITZ, Saugerties, is the arts editor of the Woodstock Times and the author of *The Opus of Everything in Nothing Flat* (Red Hill/Outloud, 1993), and *Big League Poets* (City Lights, 1978), now out of print in all the finest bookstores. As a performance poet, he's perpetrated his parodies and blown his ballads in clubs, coffeehouses, colleges, and correctional facilities across the country.

GINNAH HOWARD lives in Gilbertsville. Her work has been accepted for publication in *North American Review, Permafrost, Phoebe,* and *A Room of One's Own.*

JEN HUBBELL, Cooperstown, completed her freshman year at Cooperstown Central School in June, 1997. She has been writing for about a year. In her free time, she likes to play the piano, listen to music, and read.

KIM ILOWIT lives in Oneonta with her husband, three children, a dog, and four cats. Next to them, her favorite thing is taking black and white photographs of the ordinary, everyday life that surrounds her.

GUNNAR JAECK completed his junior year at Cooperstown Central School in June, 1997 and lives in Hartwick (the capital of Middle of Nowhere). He has been writing fiction and poetry for as long as he can remember. He is proud to consider himself a vegetarian "wuss" and a conservative anarchist.

NANCY JANKURA lives with her daughter, Sofia, her dog, Hannah, and cat, Rueben, on forty-five acres near Oneonta. Nestled with the snakes on "that side of the river," she plans to have her photography studio ready by winter '97. Nancy graduated from SUNY Albany with an MLS. She works for a local publishing company.

PHYLLIS JANOWITZ is a poet and Professor of English at Cornell University. She lives in Ithaca.

CHRIS JONES has been in business since 1976, and has traveled internationally for dozens of Fortune 500 companies. During the 1980s he produced photographs for use in corporate annual reports but burned out in the '90s. He has retired to his barn studio in Delhi and immensely enjoys the trials of country life with his beautiful wife and children.

INA JONES lives in Cobleskill. Her short fiction, memoirs, and poetry have appeared in various literary journals. A forthcoming issue of *Sing Heavenly Muse!* will include "Aunt Lena's Wedding." Her poetry was most recently in *West Branch.*

PIERRE JORIS, left Luxembourg at eighteen and has since lived in the U.S., Great Britain, North Africa, and France. In 1992, he returned to the Mid-Hudson Valley. He teaches in the Department of English at SUNY Albany. He has published more than twenty books and chapbooks of poetry as well as several anthologies and many volumes of translations.

KATIE KEARNEY, New Berlin, completed her freshman year at Unadilla Valley Central School in June, 1997. She began writing in junior high school, inspired by a class project. She is an avid reader.

MILTON KESSLER, Binghamton, was born in Brooklyn in 1930. He joined the faculty of SUNY Binghamton in 1965. He has published six collections of poems, the most recent *The Grand Concourse,* reprinted in 1993, and *Riding First Car,* with etchings by Robert E. Marx, in 1995. In 1994, his poem "Thanks Forever" was displayed on London Underground.

SUMMER KILLIAN is a seventeen-year-old poet from Hartwick. She will attend Ithaca College this fall, majoring in psychology. She has been writing poetry for about four years and wishes to continue writing and sharing her poetry with others.

KELCY KIMMERER, Cooperstown, is a 1997 graduate of Cooperstown Central School, where she was an active member of the Exceptionally Talented and Creative program. She has been accepted by the School of Visual Arts in New York City and is going to France through the AFS exchange.

JANICE KING, Woodstock, sells books, teaches, and writes poetry. Much of her work is rooted in her western background. Over the past twenty years she has collaborated with musicians, visual artists, and other writers and is currently one half of the Bardettes with fellow poet Nancy Rullo.

STANLEY KONECKY was born in New York City and lives in Oneonta, where he teaches and writes.

MIKE KRISCHIK, Meridale, is forty-seven years old and undergoing a change of life.

DOROTHY KUBIK is a free-lance writer from Hamden. Her poetry and articles have appeared in a number of periodicals. Her book, *A Free Soil—A Free People: The Anti-War in Delaware County, New York,* was published this spring by Purple Mountain Press.

JOSEPH KURHAJEC, Treadwell and Paris, a sculptor and printmaker, has exhibited his work for thirty-eight years. He has shown at the Guggenheim and Whitney Museums and throughout the U.S. Internationally, European museums have shown his work.

TRISH LAPIDUS, Oneonta, graduated from Indiana University with a BA and received an MAT from the University of Maine. She writes poetry, fiction, essays, and a journal. A resident of Oneonta, she keeps busy with family and social work.

JANET LAUROESCH received her BFA (1981) and MFA (1983) for work in the visual arts. Since then, she has been a practicing artist, graphic designer, arts educator, author, and avid traveler. Although somewhat nomadic, at the time of publication she was a resident of Ithaca, along with her husband and two sons.

ADAM LEFEVRE, New Paltz, is a poet, playwright, and actor. His book, *Everything All At Once,* was published by Wesleyan University Press. His plays have been produced in New York City and around the country. He makes his living as an actor on stage, in television, and in films.

MARTHA LEIGH, a professional photographer in Mt. Vision, has been using a camera to view the world since 1972. The images in this anthology were made while living in a poor neighborhood in New York City in the 1980s documenting the lives of women welfare recipients struggling to raise their children alone.

NATON LESLIE's poetry and essays appear in magazines nationwide. He has received a National Endowment for the Arts Fellowship in Poetry, and one of his recent essays will be appearing in *Best American Essays: 1997* (Houghton/Mifflin, eds. Atwan and Frazer). He lives in Ballston Spa.

DONALD LEV lives in Brooklyn and High Falls, where he distributes newsprint publications of cultural interest and co-edits, with his wife, Enid Dame, the literary tabloid *Home Planet News,* now in its nineteenth year of publication. His most recent book is *Twilight,* published by CRS Outloudbooks (Claryville).

JENNY LIDDLE, Halcottsville, is a graphic designer, but has recently been experimenting in writing as well. She has lived in Delaware County for almost eleven years, along with her husband and three small children. Together they raise beef, free-range chickens, vegetables, and many flowers.

LYN LIFSHIN, Schenectady, has a new book, *Cold Comfort* (Black Sparrow). She is the subject of a documentary film available from Women Make Movies, Not Made of Glass (and the book of the same title). She has published over one hundred books, recently *Blue Tattoo* and *Marilyn Monroe Poems,* and has edited four major anthologies including *Tangled Vines.*

IRIS LITT, Woodstock, has written advertising, magazine articles, confession stories, and many other "writing-to-order" endeavors for a living. For a nonliving, she has written short stories and poems for small-press publications. Her book of poetry, *Word Love,* was recently published by Cosmic Trend Publications. She teaches "Writing Poetry—and Getting it Published" and "Poetry as a Healing Force."

CHRISTOPHER LOTT, Hartwick, graduated from Cooperstown Central School in the spring of 1997. He has been writing poetry for four years and is currently leading a campaign for the capitalization of Earth.

KEN MACLEISH, Middlefield, graduated from Cooperstown Central School in 1997. He has been writing poetry ever since his brain almost exploded after reading *Howl* as a freshman. He will be released to the benevolent custody of Bard College this summer.

PADRAIC MACLEISH lives in Middlefield, Otsego County, where he attends Cooperstown High School. He enjoys playing the banjo, reading, writing, and life in general.

TONY MARTIN's paintings have been shown extensively in New York City, upstate, and around the country. Reviews have appeared in *Art in America, The New York Times,* and a number of books. Work in permanent collections includes the Hirshhorn and Everson museums. He lives in Treadwell and Brooklyn.

DAVID MATLIN's book *How the Night Is Divided* (McPherson & Company, 1993) was nominated for a National Book Critics Circle Award. His new book, *Vernooykill Creek,* will be published by San Diego State University Press in the Fall of 1997. Recently of Shandaken, he teaches in the MFA Creative Writing Program at San Diego State University.

PATRICIA MCGUIRK has been published in a number of small presses, including *The Lucid Stone, B.A.D. Press, Conscience,* and *The Neovictorian/Cochlea.* She has also published a small collection of poems with a few other Albany poets called *Vision's Instant.* She works for the New York State Education Department.

PATRICIA MCKILLIP, Roxbury, moved to the Catskills from San Franscisco nearly ten years ago. She is primarily a novelist, writing science fiction and fantasy for adults and young adults. Occasionally she turns out a short story and has written several scenes for the Open Eye Theater.

KATE MCNAIRY has work appearing in *Flying Horse, Many Waters,* and forthcoming in *California State Poetry Quarterly.* She lives in Scotia with her husband and two dogs.

JOAN MCNERNEY's work has been printed in more than ninety literary journals and anthologies and featured on radio and cable television stations. Her books of poetry include *Crossing the River Rubicon* (Morgan Press), *Noah's Daughters* (Holmgangers Press), and *Crazy Flowers* (University at Houston Arts Public Press). She lives in Ravena.

WALTER MEADE, born in Roxbury in 1915, spent the larger part of his life as a dairy farmer, with his wife, Letha, and their daughter, Donna. From the early 1970s to 1980, after retiring from the farm, he worked as a teacher of nature studies and as director of the Manhattan Country School Farm. Finally, he pursued a lifelong interest in wildlife and photography and produced his book *In the Catskill Mountains: A Personal Approach to Nature* (Purple Mountain Press). He died in 1993.

ABIGAIL MILLER is fifteen years old. She was born in Des Moines, Iowa, but moved to Cooperstown, six years ago. She has one brother who graduated this year, two sets of stepparents in different states, a cat, and a hamster. Her writing is an important part of her life, bringing her freedom that she cannot find in Cooperstown. When she finishes high school, she wishes to continue writing.

DEBORAH MILLER is a two-time recipient of the PEN syndicated Fiction Award. Her short stories have appeared in numerous literary magazines and newspapers, including the *Antioch Review* and the *St. Petersburg Times.* She lives in Hudson with her husband and two children.

SAM J. MILLER, Hudson, is an eighteen-year-old of Slavic descent. He puts his highest faith in art to bear witness when nothing else will. He will be attending Rutgers University in the fall. This is his first published story.

JO MISH, Laurens, is an artist -in- residence at Hartwick College and the Master Printer at the Farmers Museum in Cooperstown. He also edits two area school anthologies, *Kites and Kings* and *The Catskill Review,* and does arts-in-education programs in music, dance, and poetry.

ANDREA MODICA, Oneonta, teaches photography at SUNY Oneonta. Her photographs are widely published. Her books include *Minor League* (Smithsonian Institution Press) and *Treadwell* (Chronicle Books).

JOHN MONTAGUE, Schull, Ireland, and Albany, was born in Brooklyn and "returned" to County Tyrone as a child. He worked as a journalist for *The Irish Times* before published *Poisoned Lands,* his first book of verse. He taught at University College, county Cork, for sixteen years and now divides his time between his home in Cork and the States, where he is Distinguished Professor in the Writers Institute, SUNY, Albany.

KATHERINE GRAHAM MORRIS, Cooperstown, completed her sophomore year at Cooperstown Central High School in June, 1997. She began photographing after she received a good 35-mm camera three years ago and has had a photo displayed at an exhibit at the Black Smith Art Gallery. She would like to become a zoologist and work with organizations that help save mistreated and endangered animals.

BRIAN NAYOR, Jefferson, was inspired for the poem in this anthology by a sudden spurt of word manipulation, which was generated from frustration and depression, the song, "Estranged," and a deadline to orate something creative for the next open mike. He was born July 25, 1981, in Smithtown, Long Island. His hobbies include the cinematic arts, quality music, physical fitness, and what not, to use my imagination.

JENNIFER OLES, Delhi, a 1997 graduate of Delaware Academy, will be a freshman at Marywood University, Scranton, PA this fall, where she will study art education. She is interested in skiing, hiking,, tennis, and reading and writing.

LADY OSTAPECK, Cherry Valley, was born in Brooklyn. She feels that it was fortunate that she lived through the Depression. The best things were free: the seasons, the library, the sun and the moon, the Metropolitan Museum. The Museum was her second home and all the art settled into her subconscious. That subconscious is now the source of her intuitive talent.

STEVEN OSTROWSKI lives with his wife and two children in Rotterdam. His poems and stories have been published in literary journals such as *Plainsongs, Oasis, Wisconsin Review, Blood + Aphorisms,* and *Willow Review.* He is a co-author of a nonfiction book about literature and culture called *Beyond the Culture Tours* (Lawrence Erlbaum and Associates).

TOM O'BRIEN graduated from Adelphi University in 1967 with a BA in history. He is past president of Agard Construction and currently is a director of Certified Tutoring Service. Now living in Oneonta, he is exploring black and white photography.

RICHARD PARISIO was born in Brooklyn in 1954. He has worked as a science teacher, and as a naturalist in the Everglades, FL; Assategue Island, MD; and the Pocono Mountains, PA. Currently, he is an environmental educator for the New York State Department of Environmental Conservation and lives in Ulster Park.

JESSE PARMENTIER completed her junior year at Cooperstown Central School in June, 1997. She lives in Fly Creek, and is sixteen years old. This is her first poem written outside of class assignments, but she does do a lot of writing and reading. She also plays the oboe and piano, and enjoys listening to music.

COCO PEKELIS is working on a sequel to her best-selling book of unreasonable advice, *Everything I Know I Learned on Acid*—winner of the 1997 Firecracker Award.

MICHAEL PERKINS, Glenford, is a poet, novelist, critic, and editor. He is the author of *The Secret Record* (William Morrow), criticism; *Dark Matter* and *Evil Companions*, novels; and *The Persistence of Desire, Praise In The Ears of Clouds*, and *Gift of Choice*, chapbooks.

DONALD PETERSEN, born in Minneapolis and raised in Oconomowoc, WI, attended Carleton College, the Sorbonne, the University of Iowa, and the Indiana University School of Letters. In 1956, with his wife Jeanine, he moved to Oneonta to raise four children, to continue writing, and to teach in the State University College.

PALLINE PLUM, Apalachin, is a sculptor, photographer, and graphic artist who only writes when she can't help it. At times, she works with combinations of words and visual images, and exhibits and/or publishes them together. She holds graduate degrees from Queens College and the University of Michigan and was a fellow of the VCCA and Sculpture Space.

WALTER PUTRYCZ was born in England and has been a photographer for more than thirty years. He l lives in Franklin, in Delaware County.

THOMAS RAPIN, Margaretville, has taught and lived for twenty years in the Catskills, the landscape providing him with a renewable resource for the content of his work, and becoming germane to the spirit of that work.

BETH RENCKENS is sixteen years old and completed her freshman year at Cooperstown Central School in June, 1997. She has lived in Cooperstown all her life. She has been writing poems for many years, but began to really enjoy writing about two years ago. She also loves to ski, rock climb, and play field hockey.

EARL W. ROBERTS III lives in Oneonta. He has pastored United Methodist churches and served on various boards of the church for twenty-five years. During those years, he wrote religion articles for several newspapers. He began writing poetry and fiction three years ago and has had a few poems published.

SCOTT ROBERTS, Oneonta, graduated from the Oneonta Senior High School on June 27, 1997 and will begin his art studies at Hartwick College in August. Scott is interested in doing comic-book art, but he also sculpts. He has had roles in several high-school musicals and plays.

BERTHA ROGERS, who lives between West Delhi and Treadwell, is the founding director of Bright Hill Press/Word Thursdays. Her poetry has been published in *Pivot, Yankee, Confluence, Slant*, and others. Her books include *Sleeper, You Wake*. Her numerous grants and awards include MacDowell and Millay Colony fellowships. Her visual art has been widely exhibited.

SHARON A. RUETENIK is the Children's Librarian at Wilmington Memorial Library. She sometimes lives in Delhi.

ANN SAUTER lives in Oneonta with her two daughters, Kathleen and Virginia, and her husband, Paul. She is planning to become a meteorologist and to become Oneonta's weather girl.

AARON SAXER completed his freshman year at Cooperstown Central School in June, 1997. He has lived in Hartwick for fifteen years. He has been writing for the past three years. His hobbies include bike riding, writing, and reading.

ANTHONY SCALICI grew up on Staten Island, is a Navy vet, traveled as a construction worker to live in various places, has an MA in education, and has lived in Cooperstown for twenty years. He is married, with two children, and still believes that poetry is the highest form of language expression.

BARBARA SCHECK, Treadwell, has been making paper art and handmade paper since 1979. She has exhibited nationally and internationally: in the United States, Guam, Germany, and Japan. Her work is in private and public collections. She teaches papermaking workshops in her studio and has lectured on her art.

GERALD SCHECK, Walton, born in Weehawken, NJ, has lived in Delaware County for the past thirty years. He has shown his sculpture, paintings, and prints nationally and internationally. He is presently teaching at SUNY Delhi.

BRITTNEY LAUREL SCHOONEBEEK is sixteen and completed her junior year at Delaware Academy in June, 1997. She lives in Delhi. She has an immense and passionate interest in writing. She actively writes poetry and short stories in her free time and is also a member of the school's creative writing club.

JOANNE SELTZER, Schenectady, has been published in *When I Am an Old Woman I Shall Wear Purple* and many other anthologies. Her work has appeared in a variety of literary journals, including *Karamu, The MacGuffin, Sistersong*, and *Waterways*.

DANIEL SHAPLEY, Oneonta, and Salt Point, is a student of English and writing at Hartwick College, where he edits the student newspaper *Hilltops*. He is presently the editorial and administrative intern at Bright Hill Press/Word Thursdays. He knows the beauty of a succinct contributor's note.

TIMOTHY P. SHEESLEY, Otego, was born in 1955 in Columbus, OH. He received a BA from SUNY Oneonta; was designated Tamarind Master Printer by the University of New Mexico, Albuquerque, NM; and received his MFA from the Tyler School of Art, Temple University. He has exhibited his work both nationally and internationally. He is the owner and master printer of Corridor Press in Philadelphia.

NATHANIEL SHUTTERS, fifteen years old, completed his freshman year at Laurens Central School in June, 1997. He lives in Mount Vision. He has been writing for a while. His hobbies are coin collecting, airplanes, and camping.

SUSAN SINDALL's poems have appeared in *Prairie Schooner, Pivot*, and many other journals and anthologies, including this one. She's looking forward to an entire year in Shady.

SCOT ALAN SLABY, Oneonta and Bridgeport, WV, is a senior English major at Hartwick College and former intern with Bright Hill Press/Word Thursdays. He was the editor of *Desideratum*, Hartwick College's literary magazine for the 1995-1997 issue. He is currently studying the art of writing short stories, and he is spending Fall 1997 in Florence, Italy, studying Italian literature.

PAUL SMART is an upstate journalist, editor of *The Mountain Eagle*, author of *Rock 'n Woodstock*, and a

successful ghost who lives on Cemetery Road in West Kill.

JORDAN SMITH , Clifton Park, is the author of three collections of poems, *An Apology for Loving Old Hymns* (University Press, 1986), *Lucky Seven* (Wesleyan University Press, 1986), and *The Household of Continuance* (Copper Beech Press, 1992). He has received grants from the John Simon Guggenheim Memorial Foundation, the Ingram Merrill Foundation, and the National Endowment for the Arts. He teaches at Union College.

ROWENA SMITH, Jefferson, completed her sophomore year at Jefferson Central School in June, 1997. She has been writing since junior high school. She enjoys reading, horseback riding, and games of intellectual challenge. She plans to become a lawyer.

NORMAN SNYDER, West Delhi and Manhattan, has made documentary photographic essays across the U.S., South America and Japan. His work has appeared in more than twenty-five books and in such magazines as *Time, Smithsonian, Du,* and *Newsweek.* He is the originator of *The Life Library of Photography,* and author and editor of *The Photography Catalog* (Harper & Row,1976).

MATTHEW J. SPIRENG, Kingston, is the assistant city editor for the *Kingston Daily Freeman.* His poetry has appeared widely and won several awards. *Out of Body,* his poetry collection, was a finalist in the Four Way Books 1996 Intro Series competition.

SUSAN FANTL SPIVACK, Cobleskill, writer and storyteller, tells traditional, contemporary, and her own stories and poems to audiences of all ages. She teaches creative writing in public schools, and her writing regularly appears in literary journals and anthologies. "The Game of Life" began as a spoken-word story at Cafe Lena in Saratoga Springs.

MARILYN STABLEIN, Kingston, is the author of a collection of stories, *The Census Taker: Tales of a Traveler in India and Nepal,* and a collection of personal essays, *A Climate of Extremes: Landscape and Imagination.* She has formed a band, Bardo Motel; they perform in the Catskill region. She is also a visual artist.

BOB STEUDING, Olive Bridge, who teaches humanities at Ulster County Community College, is a State University of New York Exchange Scholar and serves as poet laureate of Ulster County. Among his books are *Ashokan; Winter Sun; Gary Snyder; The Last of the Handmade Dams: The Story of the Ashokan Reservoir; A Catskill Journal;* and *Rondout: A Hudson River Port,* published by Purple Mountain Press.

RUTH STONE was born in 1915 in Roanoke, Virginia. Her numerous honors include the Bunting Fellowship, two Guggenheim Fellowships, the Delmore Schwartz Award, and the Shelley Memorial Award. She is Professor of English at the State University of New York, Binghamton. She lives in Vermont.

RICK STINSON, South Kortright, graduated from South Kortright Central School in 1997. He will attend Bennington College in Vermont this fall.

F. BJORNSON STOCK lives in Cherry Valley, where he celebrates family, writing, and teaching. He frequently translates poetry from Danish, Norwegian, Catalan, and Spanish into English. *Hij studeert ook Nederlands.* Frank is the author of two chapbooks: *Drawing Water* and *the willow's amber hearth.* Sometimes he thinks he is Asian by desire.

JULIA SUAREZ was born in New Jersey, but has now lived most of her life in Oneonta, where she teaches writing and literature courses at Hartwick College, her alma mater, tends her garden, and shares an old house with her dog, Crispin.

NICHOLAS SWIFT graduated from Delaware Academy in Delhi in 1997, where he was an honor roll student. He will attend Boston College this fall, where he plans to study finance and English. He is an avid reader and hopes someday to become a writer or editor.

SCOTT THOMPSON, South Kortright, eighteen and a 1997 graduate of South Kortright Central School, has had several poems published in collections in the Syracuse area. He is also the creator and author of *The Esoteric Manifesto,* an on-line saga that can be found at http://members.aol.com/scotthfd. His hobbies include playing tennis and watching *The X-Files.*

ELLEN TIFFT, Elmira, has had two hundred poems and eighteen short stories published in such magazines as *The New Yorker, Poetry, The Yale Review,* and others. She's been included in many anthologies. Her novel, *Moon, Moon, Tell Me True,* was published October 6, 1996 by Xenos Book, Riverside, CA. Surprisingly it is thriving.

ROBERT TITUS, Oneonta, is a professor of geology at Hartwick College. In recent years he has taken up popular writing about the geology of the Catskills. His articles can be found in *Kaatskill Life* and *The Woodstock Times.* He has done two books for Purple Mountain Press.

JOANNE TOBEY, Westford, is a photographer, painter, graphic designer, and editor. She has lived in Westford for four years.

TOM TOLNAY, Delhi, founded Birch Book Press in 1982. The press specializes in letterpress editions of literature and popular culture produced by hand at Birch Brook's facility in Delhi. He has three books of fiction in print, and has published dozens of stories and poems in national consumer, genre fiction, and literary magazines, ranging from the *Saturday Evening Post* to *Ellery Queen Mystery* to *The Literary Review.*

THOMAS TRAVISANO, Oneonta, Babcock Professor of English at Hartwick College, is the author of *Elizabeth Bishop: Her Artistic Development* (U. Virginia: 1988), co-editor of *Gendered Modernisms: American Women Poets and Their Readers* (U. Pennsylvania: 1996) and author of essays in *Georgia Review, Gettysburg Review, New Literary History,* and elsewhere.

JOSEPH TREMONTI , Delhi, is a writer, photographer, and computer artist currently living and studying in Athens, Georgia.

JANINE POMMY VEGA, Bearsville, is the author of twelve books. Her latest, *Tracking the Serpent: Journeys to Four Continents,* will be coming out from City Lights Books in August 1997.

MARIE VICKERILLA, Margaretville, was born in Totowa, NJ in 1952. She graduated with a BFA from California College Arts and Crafts. She received an MFA from Milton Avery School of Arts at Bard College.

HELLA VIOLA, Walton, after raising a family in Staten Island, has lived in Delaware County for the past twelve years. She was educated in New York City, and her mezzotints and photographs have been exhibited nationally. She is currently employed by LVA-NYS in Sidney.

CHARLOTTE ZOE WALKER, Gilbertsville, a 1987 recipient of the NEA Fellowship in Fiction Writing, has published a novel, *Condor and Hummingbird,* as well as several short stories. She is the editor of *Sharp Eyes: John Burroughs and American Nature Writing* (Peter Lang, 1997), and has organized two conferences on nature writing at SUNY Oneonta, where she is a professor of English.

DAN WILCOX is a member of the poetry performance group "3 Guys from Albany" and has what is perhaps the world's largest collection of photos of unknown poets.

HILDA MADER WILCOX, Cooperstown, after publishing her collection of poems, *Proving the Pudding,* and establishing the Writers' Workshop of Central New

York, finally gave up the struggle with her muse and settled down to teaching at SUNY Oneonta and seeing four of her poems selected for the Dell paperback anthology *Waltzing on Water*. Putting off retirement as long as possible, she alternates part-time college teaching with travels.

LEAH WILLCOX has lived in the hamlet of Roseboom for most of her life, and this June she completed her freshman year at Cooperstown High School. She has been writing for as long as she has been observing. Her love for poetry is matched only by her love of art, which she doesn't spend enough time doing.

MALCOLM WILLISON, Schenectady, has been writing poetry for the last forty years or so, and began including the Catskills about 1975, from the Hudson River perspective. He joined the Washout Group in 1978, and began publishing more regularly. He is busy manuscript editing nonfiction, mostly social science and history, and teaching, principally sociology, peace studies, and environment, and increasingly literature.

CHARLES D. WINTERS, Mt. Vision, staff photographer at SUNY Oneonta, has pursued his love of camera and film through freelance landscape, portrait, scientific and anthropological photography. His most recent work, with anthropologist Dr. Jeanne Simonelli, is a book exploring the juncture of Navajo life, tourism and archeological history at Canyon de Chelly, AZ. *Crossing Between Worlds* will be published in 1997.

MELORA WOLFF lives in East Meredith. She has taught creative writing at SUNY Binghamton and writing at Hartwick College and elsewhere. Other poems have appeared in *Penumbra*. She is a graduate of Brown and Columbia Universities.

BARBARA WRENN, Roxbury, moved, in 1990, to the Catskills from New York City, where she had been a designer of painted finishes and a writer of how-to articles for magazines for nineteen years. She studied writing at Dartmouth with Jack Hirschman. She is developing a series of short stories about her 1940s New England childhood.

CALLIE WRIGHT, Cooperstown and New Haven, is currently an English major at Yale University, where she just finished her freshman year. During the summer of 1997, she is interning in the Multimedia Department of the National Baseball Hall of Fame in Cooperstown. Back at Yale in the fall, she will be a Master's Aide in Branford College and will work for the Yale Literary Magazine.

CAROL ZALOOM, of Saugerties, is an illustrator who specializes in linoleum cuts. Her work was selected for *Print* magazine's *Regional Design Annuals* in 1995 and 1996.

ANN ZERKEL lives in Weaver Hollow near New Kingston every summer. During winters she lives in Iowa City and teaches literature and writing at Kirkwood Community College in Cedar Rapids, Iowa. One of her poems appeared in *The Word Thursdays Anthology* (Bright Hill Press, 1995).

ACKNOWLEDGMENTS ───────────────────────────

Grateful acknowledgment is made for permission obtained from the authors to publish material that was previously printed in the following publications: Megan Alicino: "Under My Plum Tree, At Twelve," *How Do You Spell Raspberry.* Aaron Beatty: "Eight," *Desideratum*, 1997. Cassia Berman: "Love Poem," *Species Link: Morning at Osel Chloing* and *Divine Mother within Me.* Rebecca Burk: "Similar," *How Do You Spell Raspberry.* Christopher Bussmann: "Domain," "Calming Existence," *Self-Immolating Poetry and Art.* Stephanie Bussmann: "An Unpaid Bill," *Self-Immolating Poetry and Art.* Alan Catlin: "Mahler's One Thousand and One Nights in New York," *Prickly Pear.* Jennifer Colletti: "Eavesdropping," *Self-Immolating Poetry and Art.* Nancy Vieira Couto: "Chemical Sins," and "After the Engaging Diversions," *Black Warrior Review.* Graham Duncan: "Wants," *Rag Mag*, "Letter to Our First Guests at the Shore," *Poem.* Moira Dwyer, "Adoring," *How Do You Spell Raspberry.* Sally Fisher: "Audience: Three Poems (2. 'James Brown Live at the Apollo')," *New Directions*, #49. Carol Frost: "Crows," *Venus and Don Juan* (TriQuarterly Books, 1996); "Pity," *Volt* and *Venus and Don Juan.* Richard Frost: "The Annunciation," *The Gettysburg Review* and *Neighbor Blood* (Sarabande, 1996). Mary Gilliland: "Leveled: 1," "Leveled: 2," and "Leveled: 7," *Nimrod, International Journal of Prose and Poetry.* Christopher Rae Greenley, "Accent," *Ariel.* Lisa Harris: portions of "In and Out of Boxes: A Process Map," will be printed as a complete story, "Splitting Sticks and Lifting Stones," *Nimrod, International Journal of Prose and Poetry*, 1997. Danielle Hauptfleish, "Iris," *Ariel.* Ginnah Howard: "Rope and Bone," is an excerpt from a novel of twenty stories previously published in *The Glens Falls Review 7;* Phyllis Janowitz: "Peter's Transport," *Ithaca Women's Anthology* and "Rattle and Roll," *Prairie Schooner*, Milton Kessler: "Secret Love," and "At Three AM," *Grand Concourse* (MSS, SUNY). Summer Killian, "Ink," *How Do You Spell Raspberry.* Kelcy Kimmerer, "The Bathroom Mirror," *How Do You Spell Raspberry.* Dorothy Kubik: "Stone Wall," *Kaatskill Life*, Summer 1988; Naton Leslie, "A Myth of Hands," *Cimarron Review* and "Nineteenth-Century Women," *High Plains Literary Review*, David Matlin: excerpt from *How the Night is Divided* (McPherson and Company). Ken MacLeish, "Looking Out the Window," *Self-Immolating Poetry and Art.* Padraic MacLeish, "Pig," *Self-Immolating Poetry and Art.* Walter Meade: "Sounds of Spring," *Kaatskill Life*, Spring 1992. John Montague: "The Dance," *John Montague: Collected Poems* (Wake Forest University Press). Richard Parisio: "Follow that horn, those birds," *The Woodstock Journal*, October 1996; "Looking for the rock where Whitman sat," *Chronogram*, July 1995. Donald Petersen: "Upstate Lilacs," *The American Scholar*, Spring 1982; and as a broadside on handmade paper by Frank C. Eckmair, as part of an exhibit titled *The New York Landscape.* Earl W. Roberts: "Visit To A Seminarian," *Wordplay* and *Backspace.* Bertha Rogers, "Easter Monday," *Downtown.* Brittany Laurel Schoonebeck: "Clone," *Ariel.* Joanne Seltzer: "Travels in Missouri," *Havens for Creatives* (Acts Institute, Kansas City, 1993). Daniel Shapley: "Narcissus," *Desideratum*, 1997. Scot Alan Slaby: "Culling," *Desideratum*, 1997. Paul Smart: "Full Circle," *The Mountain Eagle.*; Jordan Smith: "Local Color," *The New England Review*, "For Appearances," *The Yale Review.* Matthew J. Spireng: "Picture Puzzle," *Poet Lore*; "Survival," *The Chattahoochee Review.* Bob Steuding: "Up Into the Balsams," and "Mountain Poem for Richard," *A Catskill Mountain Journal* (Purple Mountain Press, Fleischmanns, NY, 1990). Julia Suarez: "Litany," *The Ecotone*, the newsletter of Pine Lake, Hartwick College's environmental center, Winter 1996; "Counting Out," *English Notes*, Hartwick College English Department, May 1996. Robert Titus: "A Night on Overlook Mountain," *Kaatskill Life*, Fall 1994. Thomas Travisano: "Elective Affinities: The Making, and Reading, of "Skunk Hour" will be printed as part of the chapter, "Elective Affinities," in the forthcoming book, *Exploring Lost Worlds: Lowell, Jarrell, Bishop, Berryman and the Making of a Postmodern Aesthethic.* Charlotte Zoe Walker, "Winds to End the Drought, " *Art on the Wind.* Leah Willcox, "Condemned Theatre building," *Self-Immolating Poetry and Art.*

NOTES ─────────────────────────────────

Page 48: Lori Anderson: the epigraph for "My Cruelty," is from "Language Acquisition," in *The Pink Guitar*, by Rachel Blau DuPlessis (Routledge, New York, 1990: 86).

Page 91: Malcolm Willison, "Illegal Camera: Amsterdam, 1942: [Sarah Boxer, "Photography Review: Just Beyond the Placid images. . . ," New York Times, August 23, 1996, p. C27 (description of photograph by Lydia Riezouw, Amsterdam, 1942, in review of "The Illegal Camera: Photography in the Netherlands During the German Occupation, 1940-1945," Jewish Museum, NYC]

───────────────

Out of the Catskills and Just Beyond: Literary and Visual Works by Catskill Writers and Artists, with a Special Section by Catskill High-School Writers and Artists, was designed and composed by Bertha Rogers and Daniel Shapley, utilizing Adobe Pagemaker 6.0. The typeface is Adobe AmeriGarmnd BT. The front and back covers were designed and composed by Bertha Rogers, utilizing Benquiat BT and Footlight MT Light typefaces. The book was printed on 60-lb.offset, acid-free, recycled paper in the United States of America by the Courier Printing Corporation, Deposit, NY. This first edition is limited to copies in paper wrappers.

LIST OF SUPPORTERS ─────────────────────────────

Bright Hill Press is grateful to the following individuals and businesses
for their generous support of
*Out of the Catskills and Just Beyond: Literary and Visual Works
by Catskill Writers and Artists*
*with a Special Section
by Catskill High-School Writers and Artists*

──────────

Stewart's Shops - *Saratoga Springs, NY*
The Delhi Telephone Company & Catskill on Line - *Delhi, NY*
Katinia Mudworks - *Oneonta, NY*
Frank Lumia Real Estate Plus - *Delhi, NY*

Burton Clark, Inc. - *Delhi, NY*
Certified Tutoring Service - *New York, NY*
East Brook Llama and Alpaca Farms - Walton, NY
John, Julie, J.T., and Sara Hamilton - *Delhi, NY*
Chris' Flowers - *Walton, NY*

A Special Affaire, Ltd./Ray's Fine Wines & Spirits - *Delhi, NY*
Laura Chalfin, M.D. - *Delhi, NY*
Coldwell Banker/Timberland Properties - *Margaretville, Andes, & Delhi, NY*
Computers, Peripherals, and Upgrades - *Oneonta, NY*
Cup and Chaucer Cafe - *Walton, NY*
D. G. Publishing - *Delhi, NY*
Decker Advertising, Inc. - *Delhi, NY*
The Delaware National Bank of Delhi - *Delhi, NY*
Delhi Animal Hospital - *Delhi, NY*
The Green Thumb - *Hamden, NY*
Home Goods of Margaretville - *Margaretville, NY*
James M. Johnson Agency, Inc. - *Delhi, NY*
Lans Transportation, Inc. - *Delhi, NY*
Main Street Bovina - *Bovina Center, NY*

LIST OF SUPPORTERS

Mid-County Auto Body and Glass, Inc. - *Delhi, NY*
Thomas E. Schimmerling, Attorney - *Delhi, NY*
Wickham Pontiac/Oldsmobile/Ford & Wickham Fuel Oil - *Delhi, NY*
Wightman Lumber Company - *Portlandville, NY*

Alfresco's Italian Bistro - *Oneonta, NY*
Barlow's General Store - *Treadwell, NY*
Butternut Graphics - *Laurens, NY*
Buena Vista Motel - *Delhi, NY*
County Tire and Area Sewage Disposal - *Delhi, NY*
The Country Emporium - *Walton, NY*
Courier Printing Corp. - *Deposit, NY*
Crescent Pet Lodge - *Oneonta, NY*
Dave's Auto Care - *Oneonta, NY*
Delhi Paint and Paper - *Delhi, NY*
D.G. Electric - *Delhi, NY*
Dubben Brothers Hardware - *Delhi, NY*
Elena's Sweet Indulgence - *Oneonta, NY*
Elizabeth's Hair Studio - *Walton, NY*
Gallery 53 Artworks - *Cooperstown, NY*
Hamilton Critical Care and Emergency Consultants/
Community Memorial Hospital - *Hamilton, NY*
Bruce J. McKeegan, Attorney - *Delhi, NY*
MoonDreams - *Cooperstown, NY*
Paisley's Country Gallery - *Andes, NY*
Papa's Family Diner - *Walton, NY*
Parker House Gifts and Accessories - *Delhi, NY*
Kelley Snodgrass, Chiropractor - *Delhi, NY*
The Smithy-Pioneer Gallery - *Cooperstown, NY*
Story House Corporation - *Charlotteville, NY*
Webb and Sons, Inc. - *Delhi, NY*